How to
Survive and
Prosper
as an Artist

· · · · · · · ·

Caroll Michels

How to Survive and Prosper as an Artist

· · · · · · · · · · ·

SELLING YOURSELF
WITHOUT SELLING
YOUR SOUL

FOURTH EDITION

AN OWL BOOK

HENRY HOLT AND COMPANY

NEW YORK

Henry Holt and Company, Inc.
Publishers since 1866
115 West 18th Street
New York, New York 10011

Henry Holt® is a registered trademark
of Henry Holt and Company, Inc.

Published in Canada by Fitzhenry & Whiteside Ltd.,
195 Allstate Parkway, Markham, Ontario L3R 4T8.

Library of Congress Cataloging-in-Publication Data
Michels, Caroll.
How to survive and prosper as an artist : selling yourself
without selling your soul / Caroll Michels.—4th ed.
p. cm.
"An Owl book."
Includes bibliographical references and index.
ISBN 0-8050-5504-5
1. Art—Vocational guidance—United States. 2. Art—United
States—Marketing. I. Title.
N6505.M46 1997 97-16240
707'.1'073—dc21 CIP

Henry Holt books are available for special promotions
and premiums. For details contact: Director, Special Markets.

Fourth Edition 1997

Designed by Victoria Hartman

Printed in the United States of America
All first editions are printed on acid-free paper. ∞

10 9 8 7 6 5

This book is dedicated
to the memory of
MARLENE FINNEY.

Contents

Acknowledgments

A very special thanks to the Alden B. Dow Creativity Center, Midland, Michigan, for providing an opportunity to research and prepare material under the most ideal circumstances that was used in this new edition and in the third edition.

Introduction

In 1978 I began counseling visual and performing artists and writers on career management and development. I set up my own business and called myself an "artists' consultant."

Ranging in age from twenty-one to more than eighty-four, clients have included painters; sculptors; graphic artists; poets; playwrights; novelists; cartoonists; journalists; photographers; craft artists; theater and film directors; film and video artists; performing artists; choreographers; dancers; classical, jazz, and pop musicians and composers; and opera singers. They have included well-known artists, unknown artists, emerging artists, self-taught artists, midlife career changers, artists fresh out of school, and college dropouts. My clients have also included groups of artists, artist couples, arts administrators, curators, gallery dealers, art consultants, critics, arts service organizations, and theater and dance companies. I have assisted a rabbi, a retired executive of Macy's department store, a retired host of a television variety show, a gossip columnist, ex-offenders, corporate executives, architects, psychiatrists, psychologists, lawyers, and editors.

When I first began working with artists the majority of my clients lived in the New York City area. However, today, through phone consultations I help artists nationwide, as well as those who live in Canada, Europe, and South America. I also meet with many artists in person in East Hampton, New York.

Up until a few years ago, I described my profession as an artist's career development consultant. Today, I refer to my profession as

"career coach and artist advocate," a job title that better describes the work that I do.

I have advised and assisted artists in developing such basic career tools as résumés, artist statements, biographies, and brochures. I have provided information and advice on exhibition, performance, and commission opportunities. I have advised and assisted in the preparation of book proposals and grant proposals, and public relations campaigns. I have advised artists on how to negotiate with art dealers and to prepare for studio visits.

I have also counseled artists on complex and seemingly less tangible career problems such as developing goals and helping artists learn to see themselves in relation to the world at large and as a participant in the specific world of art and its various components. I have also counseled artists on handling rejection as well as success and on maintaining momentum and overcoming inertia.

However, the most significant aspect of my work is helping artists to take control of their careers.

Calling myself an artists' consultant and "hanging out a shingle" was not an easy task. For valid and comprehensible reasons, deeprooted skepticism is intrinsic to all arts communities. Initially, it was difficult to reach artists and convince them that what I had to say and offer was worthwhile.

I jumped this major hurdle when a writer from the *Village Voice* wrote an article about me and why my services were needed and necessary. It was only one journalist's opinion, but the endorsement was set in type, and I was deemed legitimate!

Literally an hour after the *Voice* article hit the newsstands my life changed drastically. I was swamped with phone calls from artists eager to set up appointments.

Nevertheless, after nearly twenty years of counseling artists, I still find it is not uncommon to be questioned about why I am qualified to give artists advice. Some of my specific accomplishments are sprinkled throughout this book, cited to make or emphasize a point or convey an experience. Although I am no longer doing artwork, I have always been proud that I was able to live solely off my earnings as an artist. I exhibited at museums and cultural institutions throughout the United States and in Europe. I established a solid track record for winning grants and corporate contributions. I developed and implemented all

of my own public relations and publicity. And I was regularly published in newspapers and periodicals.

Managing my own career was something that *no one person* taught me. I learned from several individuals, positive and negative encounters, trial-and-error experiences, and personal intuition. This book contains information and advice derived from these experiences and encounters, as well as those of my clients. I have offered perceptions, observations, and advice that would have been invaluable to me when I first started to make a career as an artist.

What artists need most is objective advice, but what they usually receive is reinforcement of a myth of what it is like to be an artist. All too often artists are characterized as underdogs, and accordingly this image is reinforced throughout their careers. I can't promise that all of my advice is objective, since my personal experiences come into play, but the original incentive to write this book came from realizing how much underdog philosophy was being published under the guise of "nuts and bolts" career management. Much of the reading material published in the 1970s and 1980s flatly stated that the way the art world operates will always remain the same, and it is naive to try to change it. Other publications were more subtle, but the tone was patronizing: "Yes, artists, you might be creative, talented, and have a lot to give to the world, but there are 'others' who *really* know what is going on, *others who know best."*

Although in the 1990s, books on career management for artists are more plentiful and some publications emit tones that are more optimistic and empowering, the attitudes displayed by artists and many members of the art world continue to reek of the master/slave and victim/victimizer mentality.

This book addresses artists' roles in advancing and bettering their lot, taking control of their careers, learning to market their work, learning to exercise self-motivation, and approaching and managing their careers as other professionals deal with theirs. In other words, artists should apply many of the same techniques that other self-employed professionals use to make their careers work.

You will rarely find the word *talent* used in the forthcoming pages. The belief that an artist has talent is a subjective judgment, and there is no guarantee that a talented artist will be successful or that a successful artist is talented. When I use the words *success* and *successful* I

am referring to the relative level of achievement within a specific category, not the inherent talent of an artist.

Measuring my success as an artists' career coach is very similar to measuring my success as an artist. In both professions I have achieved immediate success, long-range success, and no success. I have received direct feedback, indirect feedback, and no feedback. I have felt successful in my work when my clients have followed up and used the leads, information, and advice that have enabled some of them to win grants from foundations and government agencies, fellowships to artist-in-residence programs in the United States and abroad, and invitations to exhibit and perform. Clients have received press coverage and have had their work published. In some instances I have been successful in providing information and advice that was put to immediate use, and in other cases it has taken several years to see any new development.

Although many of the examples and anecdotes I use to illustrate or make a point involve visual artists, performing artists and writers will also be able to identify with many of the situations. All artists in all disciplines will get something out of this book.

This book will not provide all of the answers an artist is seeking, nor does it contain everything an artist needs to know about the art world. However, it fills in the gaps that have been omitted, overlooked, or ignored in other publications; it elaborates on subjects that have been inadequately covered and challenges some basic notions about what being an artist is all about. It contains advice, opinions, and impressions that will not be particularly palatable to members of the art world—*including artists*, the media, funding agencies, patrons, art dealers, administrators, curators, and critics—because it also explores the ills and injustices of the art world and sheds some light on who is to blame.

The art world is in dire need of reforms and structural changes. These changes will not happen overnight, but they *will* happen if more and more artists take control of their careers, reject the image of artists as sufferers, and refrain from practicing a dog-eat-dog philosophy when it comes to competing with other artists.

Some time ago I gave this same lecture to a client who has been seeing me since I began counseling artists. He had been represented by a dealer for more than three years, during which time his work substantially increased in sales and in value.

From the beginning of their relationship, much against my judgment, the artist refused to have a written contract with the dealer drawn up. However, the artist accepted and acted upon my advice to learn to market his work, independent of the annual one-person show he received at the gallery. Eventually, he became highly skilled in initiating new contacts and following up on old ones. Both initiatives resulted in many sales.

When the dealer saw what was happening, she added some new stipulations to their oral agreement, which originally set forth a specified commission on all work sold through the gallery. She began charging "special commissions" for special circumstances, circumstances in which she was not directly involved either in initiating a sale or in doing the legwork or paperwork to make it happen. The artist, who was afraid to challenge the dealer because he felt that it would jeopardize their relationship, acceded to her demands.

I pointed out to the artist that, apart from money, a principle was at stake, and that each time an artist compromises a principle, his or her career and the status of artists in general, now and in the future, are set back another notch.

I advised the artist to confront the dealer with a proposal that was more equitable. If the artist must give the dealer a commission on every work sold, even if the sale did not originate with the gallery, the dealer should give the artist something in return, such as a monthly advance against future sales. I pointed out that if the artist had a written contract, chances are the dealer would never have tried to impose an arbitrary commission formula. I also pointed out that the artist had adequately proved his market value and selling power to the dealer, who was deriving steady revenue from the sale of the artist's work, a situation that the dealer would not want to give up easily. *It had not occurred to the artist that he had bargaining power.*

Such occurrences are common in the art world—unnecessary dilemmas and frustrations created by middlepeople who have usurped power from artists and by artists who allow their power to be usurped.

Artists, by the fact they are artists, have power. *Artists provide thousands of nonartists with jobs!* Examples of nonartists who depend on artists for jobs include dealers; gallery staffs; curators; museum staffs; arts administrators; critics and journalists; corporate art consultants and advisors; federal, state, and municipal employees; teachers; framers; accountants; lawyers; and art suppliers.

Yet more nonartists than artists make a living from art, and nonartists make *more* money from art than artists! This inequity exists, as do many others, because artists, the "employers," individually and collectively have not yet recognized their power.

Another problem among artists is a diffusion of power. Although there are more artists than ever before, as the community of artists multiplies it simultaneously divides into different factions, movements, self-interest groups, and trends. There are artists who segregate themselves into pockets of racial, sexual, and ethnic identity. Everyone is vying for the same bone; no one wants to share it.

On the other hand, some aspects of the art world are in good shape and are getting better all the time. Much headway has been made in art law, legislation, and artists' rights.

More colleges and universities are providing fine-art students with career development information through courses, seminars, and workshops. And more art dealers and arts administrators are entering the art world with degrees in arts administration, and they are better prepared than many of their predecessors with the marketing and business aspects of art. They are also, one hopes, more sensitive to the needs of artists and the public's understanding of art.

If I didn't believe that there is a lot of room in the art world for many artists to make a decent living, I certainly never would have started a consulting service or written a book about art-career management. There is ample opportunity for artists, even within the still imperfect art world.

Most of the structural changes in the art world will come about only through artist pressure, artist initiative, and artist participation. While the prospects of radically changing the art world might seem overwhelming to any one artist, one of the most important contributions that any artist can make is to *restructure and take control of his or her own career.* The following chapters will elaborate on why this is important and provide options, suggestions, and advice on how to make it happen.

Keep in mind that it took me *several years to build a career* as an artist. It also took a lot of time to learn, master, and apply the skills that are described in this book. I mention this to help readers counteract sensations of being *overwhelmed* by all of the suggestions and information that are provided in the forthcoming chapters. My career did not develop overnight; it was a slow but constant buildup. I absorbed in-

formation that I needed to know at the time when I needed to know it. When I listened to my inner voice, I moved forward; when I didn't, I stumbled.

The addresses of organizations, programs, and publications referred to in the text are listed in the Appendix of Resources at the back of the book. For readers who wish to contact me, I have included my address at the end of this book (see page 317, "About the Author").

How to
Survive and
Prosper
as an Artist

.

1

*L*aunching or Relaunching Your Career: Overcoming Career Blocks

*A*s an artist you have experienced the exuberance of creating something you like, which might be the culmination of a direction in your work or might articulate something new. It felt good. The goodness screamed out. You mastered and controlled. The power felt good. Your expectations were rewarded.

However, producing something you like and believe in does not resolve the question of how to use your creation to survive and prosper. For artists, the question is particularly complex because of the difference between survival and prosperity as defined by artists and those in other professions. For an artist, *survival* often means bare-bones existence; *prosperity* may be keeping your head above water. In other professions, *survival is* keeping your head above water; *prosperity* is success.

Being an artist means believing you are an artist; making a living as an artist requires mastering many of the skills and professional attitudes shared by successful self-employed persons engaged in other occupations. Equally important, it is necessary to overcome the career blocks that are particular and indigenous to the fine arts field.

In the book *A Life in the Arts: Practical Guidance and Inspiration for Creative & Performing Artists*, the author and psychotherapist Dr. Eric Maisel pinpoints twenty types of creative blocks that artists often experience:

Blocks from parental voices, personality blocks, personality trait blocks, self-censorship, self-criticism, world criticism, world-wariness, existential blocks, conflicts between life and art, fatigue, pressure paralysis, environmental blocks, social blocks, skill deficits, myths and idealizations, self-abuse, anxieties, depression, and incubation and fallow periods.[1]

Although these problems and limitations are presented as *creative* blocks, they are the very same obstacles that encumber *career* development.

Rejecting the Myth of the Artist

Over many years our society has created a myth about what it means to be an artist. Perpetuated consciously and subconsciously by artists and nonartists, this myth is based on trading off many of the things that other people value for the right to be an artist.

For example, the myth tells us that struggle, complexity, and suffering are necessary components of creativity, and without these key elements an artist will stagnate. The myth tells us that the desire for comfortable lives and financial success will ultimately poison and distort art, that a true artist is concerned *only* with art and anyone else is a dilettante. The myth tells us that *real* artists do not discover themselves. Other people do, preferably when the artist is dead!

The myth warns us about *selling out*, although the majority of artists who are concerned about this issue are not in a position to sell out, nor are they quite sure what it means.

The myth says that artists are expected to be flamboyant, provocative, moody, weird, or antisocial. Writer and social critic Tom Wolfe suggests that this stereotyped image of the artist was formed in the nineteenth century, based on the style and behavior of writer and art critic Théophile Gautier. Wolfe writes:

[W]ith Gautier's own red vests, black scarves, crazy hats, outrageous pronouncements, huge thirsts, and ravenous groin . . . the modern picture of The Artist began to form: the poor but free spirit, plebeian but aspiring only to be classless, to cut himself

forever free from the bonds of the greedy and hypocritical bourgeoisie, to be whatever the fat burghers feared most, to cross the line wherever they drew it, to look at the world in a way they couldn't *see*, to be high, live low, stay young forever—in short, to be the bohemian.[2]

Many of the basic problems of artists trying to enter the art world and sustain a career there are created by their feelings of insecurity and helplessness. There is a direct correlation between how artists see themselves and where art-world power is currently centered. For example, the term *stable of artists* is commonly and casually used by both artists and dealers alike. It refers to the artists who are represented by a gallery, but it implies much more, and, unfortunately, as a metaphor it works well. It suggests that artists are like herds of animals that need to be contained in an environment where their master can control their lives.

Artists for a Better Image, better known as the ArtFBI, is a not-for-profit organization concerned with the stereotypes of artists in contemporary society. As a national information-gathering and advocacy group, the ArtFBI collects and monitors examples of stereotypes of artists as portrayed in literature and in the media. The organization has compiled a videotape of artist stereotyping, entitled *TV Bloopers and Practical Jokes: Media Representations of Artists*, extracted from popular television shows. The address of the ArtFBI is listed in the appendix section "Arts Legislation and Artists' Advocacy."

PERCEIVING "FINE ARTIST" AS A VALID PROFESSION

In our society, there is a myth that suggests that to be antibourgeois, a free spirit, and classless, one should not have an occupation. The myth implies that being an artist is a state of mind and casts great doubts on whether being an artist is a valid profession.

Seeds of doubt suggesting that fine art is not a valid occupation are planted and reinforced, for example, by educators who, under the guise of providing career advice, emphasize *alternatives to fine art* and steer students into applied arts fields. Medical and fashion illustration,

set design, graphic design, industrial design, and commercial photography are viewed as viable alternatives to painting, sculpture, and fine art photography. Students in art school are encouraged to take a lot of education courses to have something to fall back on. If we were educated to believe that being a fine artist is a valid profession, there would be fewer artists needing an occupational backup. Has a law student ever been advised to take a lot of education courses to have something to fall back on?

Even a book offering career advice to fine artists warns, "It is unrealistic, wishful thinking on the part of any fine artist to believe that he is going to earn his living by works of art. Should it happen in the course of time, it would be a great bonanza—but don't count on it."[3] The implication is that an artist can seriously dabble in art but shouldn't take it seriously as a profession!

Although the cautious advice given to artists comes from people who are trying to be helpful, it is advice based on other people's experiences, as well as on hearsay and myths. Other people's reality should not be your reality, nor can it be.

Believing in other people's perceptions is a disastrous trap. However, artists sometimes find it attractive, hoping that it can be a shortcut on the road to success or shield them from confrontations. Ralph Charell, author of *How to Make Things Go Your Way*, observes:

> If you filter the perceptions you receive through mediators, you deprive yourself of a direct encounter with the event itself. The more you come to depend on the perceptions and opinions of others, the less of yourself you are able to put into the equations of various experiences of your own life. Soon, if the process continues, your life becomes dim and pale and you are eventually at sea, tossed and buffeted, alone under a starless sky, without an internal compass of your own.[4]

DUAL CAREERS AND LOW INCOME EXPECTATIONS

Art educator Ronald H. Silverman clearly sees the correlation between how artists are viewed as low-income producers and the low priority

art is assigned in school curriculums. Pointing out that substantial evidence indicates that more than 90 percent of school-age children do not connect art with a means of acquiring money or earning a living,[5] Silverman goes on to say:

> While these figures may reflect pervasive cultural attitudes which stereotype artists as starving Bohemians, they may also be the consequence of current art education practices. Teachers are either ignoring the economic impact of the arts or they are telling their students that an interest in art has little if any economic career implications. Although these approaches may be the honest view of well-intended teachers, they do not square with the facts. They may also be the key deterrent to art becoming a part of the basic school curriculum.[6]

Low expectations of artists' earning power have given rise to the practice of dual careers. While few question its symbolic implications, the concept of dual careers for artists is a widely accepted norm that is readily encouraged and propagated. For example, the academic dean of an art college condones the practice of dual careers:

> We are teaching [artists] that having a dual career does not necessarily mean that you make less art. After all, what's the point of having all your time free to make art if you have no money for materials and supplies? This no longer means that artists have to wait on tables. There are many more opportunities and diverse choices for the artist today than ever before. They may go into arts administration or arts-related services.[7]

The phrase *dual career is* a euphemism for *holding two jobs,* and under the Judeo-Christian work ethic it is emblematic of fortitude, stamina, dedication, and responsibility. But in reality, anyone engaged in a dual career for any length of time understands that it creates a life-style of frustration, confusion, stress, chaos, exhaustion, and guilt.

INSUFFICIENT TRAINING OF FINE ARTISTS

Even when students persevere and select fine arts against all odds, they may enter their careers questioning the propriety of earning a living as a fine artist. Moreover, they usually haven't the foggiest notion of how to begin.

Artist and author Jo Hanson believes that

> artists are set up for difficult career adjustments by the omissions from art education, and by the self-image projected through the art sub-culture that discourages, and even scorns, attention to business management and competence in it. In attitudes and preparation, I believe most of us begin with several strikes against us. We find, through difficult experience, that we must work our way up to zero to get in a position to go forward. I speculate that "successful" artists are the ones who figured things out early in their careers and could follow a clear line toward their goals.[8]

In the third edition of this book I described my experience in 1986 when the College Art Association held its annual conference in New York City. Responding to an open call for panel discussion topics, I submitted a proposal suggesting that the conference include a panel focusing on the importance of including career management courses in fine-art college and university curriculums. Although the response to the idea was less than enthusiastic, I did not receive a total bum's rush, and was given fifteen minutes to state my case at a session called "Special Projects," a potpourri of topics not valued enough to warrant panel discussions.

Five of the fifteen minutes had to be used to establish my credentials to this particularly credential-conscious audience. With a limited time allotment I managed to make the point that hundreds of students are being graduated each year ill equipped to handle the realities of life after art school or navigate the maze of confusion surrounding the art world.

There was polite clapping, and a few members of the audience later told me they were in agreement with my position. But it was apparent that career courses for fine artists were not on most educators' list of priorities.

In many schools even the mention of "career" and "life after school" is discouraged—or, as one recent graduate of an art school in an Ivy League university complained, "My teachers made me feel guilty when I asked questions that were in any way related to the business aspect of art or how to go about finding a gallery. I was chastised for admitting that I was concerned about making a living from photography."

Some academics who discourage career advice at the college level believe that students should be sheltered from real-life survival issues while in school. But many fine arts faculty members are opposed to career development courses for selfish and self-serving reasons: they are aware that today's student artists will become tomorrow's practicing artists, and eventually artists with whom they will compete for gallery, museum, and press attention, so there is much resistance to imparting any sort of information that could possibly give these future peers a career edge or jeopardize their own pecking order in the art world.

Career development information is not only opposed by academia for self-serving reasons, but it has also been used as a scapegoat to explain the ills of the art world. For example, the book *Has Modernism Failed?* by Suzi Gablik contains a reprint of a brochure announcing a series of workshops called "The Business of Art and the Artist," sponsored by the Maryland Summer Institute for the Creative and Performing Arts, the University of Maryland, and the U.S. Small Business Administration. Gablik concludes that the workshop was

> another telling example of how much career progress, even in art, now depends on making organizational values an intrinsic part of one's life. . . . The assumption is that success in the higher corporate world of art requires training in the techniques of business administration, and it leaves no doubt that the principles and practices of corporate management now produce the psychological model shaping even the lives of artists.[9]

The development of a program on survival skills for artists—one that covers such topics as health hazards, contracts, copyright, estate planning, insurance, and record keeping—is hardly an indication that artists are motivated by corporate institutional and organizational

values. But Gablik is not the only misguided individual who believes in the myth that it is far nobler for artists to drive a cab to support their art than to derive a living from creating art!

SCHOOLS THAT ADDRESS REAL-LIFE ISSUES

More and more headway is being made to help fine-art students prepare for the transition from art school to real life.

In preparation for this edition of my book, I contacted 156 schools in the United States with four-year fine-art programs, most of which were accredited members of the National Association of Schools of Art and Design. A letter was sent to each school to enquire whether a required or elected credit or noncredit course or workshop were offered on professional practices and career planning that were specifically geared for *fine-art students.*

Forty-one of the schools responded, a bit over 25 percent, and out of the 41 respondents sixteen of the schools *required* students to take a career development course as a prerequisite to graduation. These included the Art Academy of Cincinnati in Ohio; California State University at Hayward; California State University at Long Beach; Carson-Newman College in Jefferson City, Tennessee; Loyola Marymount University in Los Angeles; Maryville University in Saint Louis; Moorhead State University in Moorhead, Minnesota; the Oregon School of Arts and Crafts in Portland; San Diego State University; San Jose State University; Texas Tech University in Lubbock; Thomas More College in Crestview Hills, Kentucky; the University of Montevallo in Alabama; the University of South Dakota in Vermillion; the University of Southern Maine in Gorham; and Virginia Commonwealth University in Richmond. The career planning course at Maryville University in Saint Louis has been mandatory for B.F.A. candidates for over twenty years.

Sixteen of the respondents offered courses in professional practices as electives. These included the Atlanta College of Art in Georgia; California State University at Fullerton; California State University at Sacramento; the Center for Creative Studies in Detroit; the Cleveland Art Institute in Ohio; the Columbus College of Art and Design in Ohio; the California Institute of the Arts in Santa Clarita; the Lyme

Academy of Fine Arts in Old Lyme, Connecticut; Sonoma State University in California; the Tyler School of Art of Temple University in Philadelphia; the University of Akron in Ohio; the University of Arkansas at Little Rock; the University of Minnesota in Minneapolis; the University of Nebraska in Lincoln; the University of Texas in San Antonio; and the University of Wisconsin in Madison.

All of the mandatory and elected professional business practice courses conducted by the aforementioned schools award credit hours, ranging from one to four credits.

Schools that offered noncredit workshops or seminars specifically for fine artists included the Cooper Union for the Advancement of Science and Art in New York City; East Carolina University in Greenville, North Carolina; the Kansas City Art Institute in Kansas City, Missouri; the University of Illinois at Urbana-Champaign; and the Rhode Island School of Design in conjunction with Brown University in Providence.

Most of the required and elected courses covered a range of topics, including marketing, presentation materials and documentation, grant writing, résumés and artist statements, art law and copyright, applying for graduate school, publicity, exhibition installation, and gallery relations.

In addition, at the Academy of Art in Cincinnati, the mandatory junior seminar taught by Carol Grape also included information on how to budget money and live after graduation. Loyola Marymount University's required senior seminar included a forum to help students deal with the issue of professional rejection.

At the University of Montevallo, which requires all senior B.F.A. candidates to take a three-credit senior seminar, the chairwoman of the art department, Dr. Sandra J. Jordan, meets with each new transfer and freshman art major *and their parents* during the first day of freshman orientation. "An important part of this meeting focuses upon a discussion of careers in the arts," said Dr. Jordan. "Research into retention indicates that students perform better in school when they are focused upon a professional goal, and when they receive family support for their academic decisions. Thus, we decided to both address the parents' concerns about their child's choice of major and give students an opportunity to learn about career possibilities at the very beginning of the higher education experience."

In the statement of goals of the course "Professional Practices" at the Cleveland Art Institute, Professor Mark Hollern, who designed the program, wrote:

> Working as a professional artist is not as unstructured and easy as is often thought. It demands a multitude of skills, abilities, and information that we will discuss and practice. Being a professional often is the difference between having a difficult career versus having success and satisfaction in your field.

The course is conducted each fall and spring semester. Among the topics covered are business writing and public speaking.

One of the most novel and expansive career courses is conducted at California State University at Long Beach. Entitled "Issues in the Arts," the course is *required* of all B.A. and B.F.A. candidate art majors. Initially, the course was created in 1993 by Beverly Naidus and was later taught and expanded by Nancy Floyd, who is now on the faculty of Georgia State University, where she has developed a similar program in conjunction with other staff members.

At California State University at Long Beach each of the sixteen classes that are held each semester is devoted to a particular theme. Some themes focus on business and survival skills; others introduce students to a variety of issues related to contemporary art and artists' careers. For example, topics include "The Education of the Artist," "The Role of the Artist in Contemporary Society," and "Racism and Sexism in the Art World."

"Some of the themes cause dissension among students," said Floyd. "Intense debates often develop, and the classroom seems more like the *Oprah Winfrey Show*! Depending on a student's background and life experience, some students are shocked by some of the topics as well as some of the attitudes expressed by their peers. For other students the course reinforces beliefs and knowledge that they already had."

Designed to introduce students to alternative ways of thinking, "Issues in the Arts" also presents traditional viewpoints of the art world and traditional methods of marketing work. It also encourages students not to fear alternative solutions and to develop opinions of their own.

Although many more art schools are acknowledging the impor-

tance of preparing students for real life (certainly many more than in 1986 when I presented my case before the College Art Association), schools that offer career planning courses are still in the minority. Artists who are planning to enter B.F.A. or M.F.A. programs should consider application to those colleges and universities that offer professional practice programs for fine artists.

CONFRONTING MONEY ISSUES

How much do you want to earn as an artist, and how much are you willing to spend in order to earn it? Thoughts of money are ever present and, depending on one's situation, the thoughts are in the forefront of one's mind or are nestled in the subconscious.

How much is my work worth? How much am I worth? How much do I need this year, this month, this week? What can I afford? How much should I be earning?

There are artists who have identified with poverty for so long that when money finally comes their way they are consumed with enormous guilt, a theme that dominates their existence. There are artists who become Little Johnny One-Notes, churning out whatever made money in the past, in fear that venturing in new directions will bring them back to Poverty City. And there are artists who attach so many stigmas to the concept of prosperity that they undervalue their work, riding the train to martyrdom.

"Money Martyrs think it is 'morally superior' to ignore their financial needs and often become victims,"[10] write Annette Lieberman and Vicki Lindner in the book *The Money Mirror: How Money Reflects Women's Dreams, Fears, and Desires.* They also point out that "artists believe, often with validity, that financial rewards are bestowed on artistic products that are not the best. They say that they have not earned much money for their work because, it is 'good' or 'pure.'[11]

"Almost all of us have struggled at one time or another with money shortfalls and found ourselves face to face with overwhelming fears,"[12] writes author Tad Crawford in another very good book, *The Secret Life of Money: How Money Can Be Food for the Soul.* Through stories and myths from around the world Crawford helps us understand why money is so much more than the useful tool we may think it to be. He

discusses how money secretly influences our lives, why money is so easily worshiped, and why money sometimes feels more important than life.[13]

The most common money-related mistake artists make is a reluctance to invest in their own careers. Although artists are willing to spend relatively large amounts of money on work materials and equipment, they are miserly and skimp when it comes to other important aspects of career development, such as travel, presentation tools, publicity, and mailing lists, and such preventive medicine as using contracts, hiring lawyers and accountants, and engaging the services of other professionals. Subsequent chapters discuss why these expenditures are important. But it simply boils down to this: *If you are not willing to invest in your career, who is?*

An artist's reluctance to make crucial career investments is sometimes spearheaded or aggravated by the attitude of a nonartist spouse or mate, particularly if the artist does have a separate bank account. If "family funds" are being used for career expenditures, an artist might experience subtle or not so subtle pressure to generate art sales in a relatively short amount of time or provide some sort of *tangible* justification that career investments are not a waste of time and money. Although it is not always possible, it is important for artists to sensitize their mates to the reality that earning a decent part-time or full-time income from sales and commissions is certainly possible, but it can take time. Help them understand that when instant gratification occurs, it most likely happens during the process of creating work and not in the early stages of launching a career.

INTIMIDATION OF VISUAL ART

Many people are intimidated by visual art, including many of those who buy and sell art.

The fear of visual art is perpetuated throughout our schooling, beginning as early as kindergarten, as we are bombarded with conflicting messages about the importance and relevance of visual art in our culture. Often visual art is presented as a "filler" subject—not in the same league, for example, as science, mathematics, or history. But by adulthood visual art is perceived as a discipline that can only be ap-

preciated and understood by someone possessing a high IQ or a substantial background in art history.

On the other hand, random interviews with members of the public inquiring about preferences in music will produce immediate and confident responses. People are eager to tell you that they like jazz, country and western, classical, or rock and roll!

But ask the same public about their preferences in visual art, and their responses are laced with hesitation and discomfort. Often defensive platitudes are offered such as "I don't know anything about art but I know what I like."

Art historian and lecturer Carol Duncan described an experience with a department of motor vehicles inspector during a test for her driver's license:

> Upon discovering that I taught art history, he felt compelled to tell me of his dislike for Picasso, probably the only modern artist he could name. For a good fifteen minutes, while I did my turns and stops, he complained steadily about modern art. "I'm not stupid," he kept saying, "but that art doesn't say anything to me." Indeed, there was nothing stupid about him. But he felt that someone was telling him he was stupid by holding up for admiration expensive and apparently meaningful objects he could not comprehend. Students in the state college I teach often indicate such resentment—or else they are full of apology for not liking modern art.[14]

Educational systems that give mixed messages about visual art have contributed to the shaping of a society of individuals who do not value or trust their own opinions and feelings about visual art.

As a result of the public's intimidation of visual art and insecurity about their beliefs and feelings, a power structure has developed within the art world comprised of intermediaries whom we have come to depend on as sources of truth. We actually believe that *good* art can only be determined by the judgments and decisions of art dealers, critics, curators, academics, and art administrators. Unfortunately, many people within the art world believe this myth, including artists!

If members of the public were self-confident about their preferences in art, the strength of the power structure would diffuse. For

example, art dealers would be acknowledged as sales personnel, a title that reflects their *real* occupation versus the messiah-like image currently awarded. Arts-related professions would be recognized as occupations that were created around artists, and not, as it often seems, the other way around! Or as arts administrator Ted Potter pointed out: "Curators, administrators, directors and art dealers are all really flight attendants for this thing called art. . . . Art and the creative artists are what it's all about."[15]

*V*ALIDATION AND ARTISTS' INSECURITY

Self-validation has much more staying power than the type of validation that artists often seek from the art world. But the ability to validate your own artwork does not always come easy nor does it come quickly.

Emphasis on gaining approval from the art world has become so commonplace that few artists question the negative implications of looking for validation from external sources. For example, in her book *The Practical Handbook for the Emerging Artist*, Margaret R. Lazzari, who is an artist, earnestly writes:

> there are two ways to have your artwork validated, that is, recognized as significant and meaningful by others. One way, the "mainstream" method, is to have your work recognized by people within the museum/gallery system, such as curators, dealers, and critics. These people are art professionals who are entrusted by society at large with evaluating, displaying, buying, selling, and preserving artwork.[16]

For artists not seeking mainstream validation Lazzari goes on to say that "validations for these artists cannot come through the traditional gallery-museum system, but through alternative means. Artists must identify the audience who is interested in what they make, and find ways to bring the work to them."[17]

The types of validation that Lazzari describes encourage artists to give away their power in deference to "those who know best."

Contrary to Lazzari's message, David Bayles and Ted Orland, authors of the book *Art and Fear*, take a much healthier approach to the issue of validation, reminding us that

> courting approval, even that of peers, puts a dangerous amount of power in the hands of the audience. Worse yet, the audience is seldom in a position to grant (or withhold) approval on the one issue that really counts—namely, whether or not you're making progress in your work.[18]

AWE OF NEW YORK AND SELF-IMPOSED REGIONALISM

Artificial barriers and provincial attitudes about the art market can deeply restrict artists' career development. Many artists believe that their market is limited to their city of residence, or that some sort of universal censorship is imposed, illogically concluding that there is no market *anywhere* for their work if they are unable to find a receptive audience in their hometown. Artists living in large cities such as New York, Chicago, and Los Angeles, for example, are as likely to engage in this form of provincialism as artists living in towns and small cities.

The myth of equating career success with exhibiting work in a New York gallery is highly imbued in the minds of artists and nonartists. In all of the many years I have traveled throughout the United States and in Canada to conduct workshops on career development, the question always arises: *"Do I have to show in New York to make it in the art world"?* Although my answer is always an ardent "no," in most instances members of the audience do not hear me or want to hear me because they have been brainwashed to believe that being represented by a New York gallery is pivotal to career success.

Because of the importance that has been attributed to exhibiting in New York, some artists will *pay anything* to have a show in a New York gallery. Naive attitudes, feelings of neediness, and the extraordinary pervasiveness of the belief of the myth of New York have contributed to the growth of vanity galleries in New York (and in other cities, see page 106).

ADOLESCENT CAREER GOALS

The phrase *successful artist* loosely describes a person who has achieved some degree of fame and/or fortune. Depending on whom you ask, the definitions of fame and fortune can vary considerably.

Although, as previously discussed, some artists equate success with having a show in New York, other artists equate success with being reviewed in a leading art trade publication, while other artists equate success to being featured on the publication's front cover! Some artists describe success as having their works included in the "right" private collections, and other artists believe that success is being represented in the "right" *museum* collection. Some artists define success as having a solo show at a museum, while others view success as nothing less than an invitation to exhibit in the Whitney Biennial or Documenta. To some artists the sale of a work at five thousand dollars is a sign of success; to other artists anything above fifty thousand dollars is an impressive number.

Although attainment of these goals is not insurmountable, it is *naive to believe that achieving any one of these goals, or a combination thereof, will lead to career success that spans a good portion of adult life.* Yet an astonishing number of artists' belief systems is centered around adolescent aspirations, and for many such artists these aspirations have become obsessions.

In practical terms the meaning of the phrase *successful artist* could describe, for example, an artist who earns a living doing what he or she loves doing best: creating fine art. Many artists are able to derive a healthy part-time or full-time income doing what they love doing best without being swept away with all of the illusions surrounding the mystique of how to be successful in the art world. But because these artists' names are relatively unknown, the existence of alternative forms of career success is also relatively unknown, and adolescent attitudes prevail.

THE MYTH OF SCARCITY

Nancy Anderson, in her powerful book *Work with Passion*, points out that:

There are two ways to look at the Planet Earth: (1) It is contracting and shrinking—therefore my chances are scarce. Colloquially put, "there ain't enough to go 'round so I've got to get mine!" (2) It is expanding and growing with opportunity—my chances are based on abundance. The choice is mine, and time is my ally.[19]

Unfortunately, many artists have adopted the philosophy that "there ain't enough to go 'round so I've got to get mine!" The "shrinking" mode of thinking is also reinforced by other members of the art world. The foolish platitudes that *there are too many artists* or *there are too many artists for the number of commercial galleries* throw artists into panic attack or a chronic state of anxiety; some artists develop sharp elbows. A belief in scarcity is played out in many areas of an artist's career. Some artists sell their work at low prices because they have come to believe that the *only buyer* for their work is the buyer who makes himself or herself known at that given time. Some artists exhibit at galleries under unfavorable terms or circumstances because they believe it is their *only chance* to show their work and they must seize the moment. Many artists withhold from fellow artists introductions and referrals to art world contacts because of a *fear there isn't enough to go around.*

In the long run, if the "community of artists" were truly functioning in a healthy capacity, whether on a national, regional, or local level, my occupation would be deemed obsolete because artists would be exchanging information and banding together to change the many basic inequities in the business of doing art. Unfortunately, a *fear of scarcity* has created a lack of a sense of community among artists. A fear of scarcity is largely responsible for why artists often feel isolated from each other.

DENYING ART IS A BUSINESS

Another stumbling block in career development for artists is not realizing or coming to terms with the fact that if you want to sell and/or exhibit work, art becomes commerce and it is a business. The next chapter, *Launching and Relaunching Your Career: Entering the Marketplace*, looks at the business aspects of art and examines some of the ways in which artists can successfully enter the marketplace and sustain a career.

To launch or relaunch a career that is earmarked for success, artists must learn to transcend career blocks and emphatically reject the myth of the artist. The myth, like racial and religious prejudice, is subtle and sneaks up without warning. Do not underestimate the extent to which aspects of the myth can affect, influence, and limit an artist's career.

If artists go along with the myth, they must accept the consequences of leaving their careers in the hands of others. If artists do not develop and expand meaningful goals and act on these goals, their careers will be formed, manipulated, and eventually absorbed by people who have goals that are meaningful only to them. Artists become a means to the ends of others.

2

Launching or Relaunching Your Career: Entering the Marketplace

If you walk, just walk, if you sit, just sit,
but whatever you do, don't wobble.
—*Zen Master Unmon*

An artist who wants to sell work must enter the marketplace, a highly structured world made up of many networks. There are two ways to enter—haphazardly or with a plan. Unfortunately, most artists enter haphazardly, which means short stays and unhappy endings.

As artist and author Jo Hanson points out: ". . . artists have the same need as other people to set goals and plan their careers, and attend to the business of their work—and be good at it."[20] Hanson goes on to say that if artists "fumble through too much of their working life before discovering the need to plan and focus, the possibilities of choice and decision can close down significantly."[21]

Entering the marketplace with a plan means that your tools are lined up (see the next section) and your psyche is tuned up. How well you tune up your psyche depends on how thoroughly you have rejected the myth of the artist, have developed personal goals, and have been willing to act on these goals and get yourself moving. A good plan also includes having a well-thought-out philosophy about money: how much you want to earn as an artist, and how much you are willing to spend in order to earn it.

\mathcal{H}OMEWORK: DOWN TO BASICS

The following homework includes basic investments necessary to launch, relaunch, and sustain an artist's career. Some investments require money, some require time, and some require both.

Read, Note, File, and Retrieve

During the last twenty years the art trade publications field has expanded and diversified, with each of the art disciplines having at least two or three newspapers, tabloids, and magazines that focus on *real art news* rather than reviews and critical essays. These publications contain valuable information on numerous aspects of the business of art and the business of being an artist, including grant, exhibition, and employment opportunities, legal and accounting advice, health hazards related to the arts, and arts-related legislation.

There are publications with a regional focus, such as *Artweek*, devoted to artists living in the Northwest, Southwest, Alaska, and Hawaii; *Art New England*, geared to artists in the Northeast; *Art Papers*, for artists in the Southeast; *FYI*, for artists in New York City and state; and *Chicago Artists' News*, for artists in the Midwest. There are also publications of national interest, such as *Options* and *Art Calendar*. *CARNET* and *Agenda* are two of the publications that serve Canadian artists. In addition, there are periodicals that specialize in various disciplines, such as *The Crafts Report*, *Sculpture*, *Afterimage*, and the *Surface Newsletter*, published by the Surface Design Association. The addresses of these publications can be found in the appendix sections "Career Management, Business, and Marketing," and "Periodicals."

Become aware of the numerous local, regional, national, and international arts service organizations, and take advantage of their various programs, services, and publications. Throughout the appendix, many service organizations are listed that have a regional, national, or international focus.

For example, the *National Association of Artists' Organizations Directory* lists many of the organizations that offer assistance to visual and performing artists, writers, and filmmakers, with detailed information on services, publications, programs, and facilities. In addition, *Artlines: An Annotated Guide to Organizations and Publications Essential to Artists* provides information on arts organizations lending support to artists.

Both publications, as well as other useful references, are listed in the appendix (see "Arts Service Organizations").

Many arts service organizations serve the needs of special interest groups. Examples include the Asian American Arts Alliance, Inc.; the Association of Hispanic Arts, Inc.; the Society for the Arts in Health-care; the National Center on Arts and the Aging; the Disabled Artists' Network; and Deaf Artists of America. The addresses of these and other arts service organizations are listed in the appendix sections "Arts Service Organizations" and "Disabled Artists."

If you are using the Internet, there are Web sites that provide information on services and opportunities for artists. These are described in chapter 7, "Marketing Art on the Internet and Services to Artists," and in the appendix section "The Internet."

With the plethora of information available, there is no excuse for artists not to be well versed in what is going on in their own profession.

Read, note, file, and retrieve—or practice what authors Judith Appelbaum and Nancy Evans refer to as the "pack-rat process."[22] Set up a file and contact system that is imaginative and considers the present and the future. Contacts and information that might not necessarily be of interest or apply to your career now could be important and relevant in the future.

Review the files on a regular basis. Unless you have a photographic memory, you will forget a lot of information that has been clipped and stored away.

Set up files for various categories, those that make sense and have meaning to you. My file system includes the following categories: grants (visual arts, general arts, performing arts, music, film/video, and writing); artist-in-residence programs; art colonies; international connections; alternative space galleries; museums; art consultants and art advisors; curators; collectors; professional art organizations; management organizations; loan resources; consulting services; legal, accounting, and insurance information; employment opportunities; mailing lists; public art programs; and slide registries.

I spend an average of three hours a month in the library updating and adding to the files. Developing the system and organizing and deciphering cryptic notes and messages that I had written over the years took about three weeks of work. It was a mere three-week investment, but it has paid off in many ways. For example, much of the material contained in my files was used to write this book.

Mailing Lists—The Usual and Esoteric

Starting and developing a good mailing list requires a lot of time and energy, but it is well worth the effort. Like a file/contact system, a mailing list can and should be used over and over again. It should be updated on a regular basis to reflect the changes you are making in your career (new contacts) and the ever-changing scene in the art world (the names usually stay the same, but the institutions and organizations might fluctuate). A good list implies quality more than quantity, meaning that your list should include the names and addresses of people who can do something for your career—directly or indirectly—now or in the future.

Do not wait until you need to use a mailing list to put one together. Develop a list when "nothing's happening" so that when something happens it will not become one of the thousand other chores you have to do in connection with exhibition/performance planning.

When artists are having an exhibition, it is common practice to use the mailing lists of the gallery. Unfortunately, gallery lists tend to include everyone who has signed the gallery guest book, which does not necessarily mean that all of the names are of interest to you. Many gallery lists and lists compiled by arts organizations are not updated on a regular basis. In some cases the lists are shortsighted and they do not contain a comprehensive representation of an arts community.

Following are the major categories that should be included in a comprehensive arts mailing list:

Directors of galleries and alternative spaces
Museum and independent curators
Curators of corporate art collections
Art consultants and advisors
Directors of public art programs
Interior designers and architects
Art critics
Editors of international, national, regional and local arts
 publications
Editors of interior design and architecture publications
Arts and culture editors of magazines and newspapers
Producers of local and national arts-related television and radio
 programs

Assignment editors of local and national television and radio
 programs
Editors of trade publications (see page 26)
Fans and collectors

Mailing lists in the categories cited above can be purchased. For ex-
ample, the names of directors of galleries and alternative spaces can be
obtained from *Art in America,* which makes these names available on a
computer disk. The disk is based on information supplied in the *Art in
America Annual Guide to Museums, Galleries, Artists.* In addition, the PR
Profitcenter computer database is available on a disk. It contains the
names and addresses of thousands of magazine and newspaper editors
and talk-show producers.

ArtNetwork in California sells mailing lists in various arts-related
categories; and I have mailing lists available for purchase that are up-
dated on a regular basis. These lists include art consultants, national
and regional arts press contacts; New York City press contacts; New
York City critics; museum and independent curators; and public art
programs and slide registries. The addresses of mailing list resources
are listed in the appendix sections "Mailing Lists" and "Press Relations
and Publicity."

If you are using mailing lists to write *cover letters* (see page 53),
make sure that the lists you purchase *include the names of specific indi-
viduals.* It should not be a list that is addressed to such generic titles as
"gallery director" or "curator."

If you are compiling your own mailing list the following resources
will be of assistance:

The names of museum curators are listed in the *American Art Direc-
tory* and *The Official Museum Directory.* Both of these publications are
listed in the appendix under "General Art References."

The names and addresses of international arts publications can be
found in *Ulrich's International Periodical Directory.* The names and ad-
dresses of arts publications and interior design and architecture publi-
cations with a national and regional focus can be obtained in the
Media Personnel Directory.

The names of newspaper feature and news editors and of journal-
ists who write about the arts can be obtained in the directory *America's
Largest Newspapers* and *Editor and Publisher Annual Directory of Syndicate
Services Issue.*

The names of radio and television show producers are listed in *Bacon's Radio/TV Cable Directory*.

For those interested in key press contacts in California and/or New York City, the directories *Metro California Media* and *New York Publicity Outlets* are excellent resources. Both publications are updated every six months. Information about these publications and the ones listed above can be found in the appendix section "Press Relations and Publicity."

Listings of art consultants and advisors are contained in the *Art Marketing Sourcebook; Art in America Annual Guide to Museums, Galleries, Artists;* and *International Directory of Corporate Art Collections*. Information about these publications can be found in the appendix "Corporate Art."

The names of interior designers and architects can be obtained through local chapters of the American Society of Interior Designers and the American Institute of Architects (see "Corporate Art" in the appendix). The names of interior design and architecture publications are listed in the appendix section "Interior Design and Architecture."

One of the most underexplored areas of an arts-related mailing list is the inclusion of trade publications. Trade publications often include articles about new and unusual uses of the materials that they promote. For example, if you are a sculptor working with glass, the names of trade publications in the glass industry can be obtained from *The Encyclopedia of Associations, Writer's Market*, and *Internal Publications Directory*. Articles in trade publications that feature the work of an artist can lead to corporate commissions, acquisitions, and sponsorships.

If you are living in a place other than where you were born or raised, include the names of newspapers in your hometown. The names of alumni publications issued by the college or university you attended should also be on your mailing list. Always write a cover letter to accompany any material that is sent, pointing out, for example, that you are a native of the area or an alumnus or alumna.

A comprehensive mailing list should also include the names of local publications that offer free listings to announce an exhibition, performance or cultural event.

Career Advisors

An artist's career advisor is a relatively new occupation, and as in the case of many emerging fields it is still going through the growing pains

of defining itself and establishing boundaries. Although I refer to myself as a career coach to artists and an artist's advocate, I am, in effect, a career advisor. During the past nineteen years I have kept abreast of some of the activities and business practices of those people who have shared my occupation. Since I have been credited for pioneering this field and I have had the benefit of observing how other career advisors operate, what we share in common and where we differ, I offer the following pointers and advice:

An artist's career advisor assists artists with various aspects of career planning. A *good* career advisor should be knowledgeable about the many facets of the art world and the many options and opportunities available to artists.

Specifically, a career advisor should be able to provide artists with support for a wide range of career-related responsibilities and tasks. For example, a career advisor should be able to advise on the development of effective presentation materials; public relations and press relations; and establishing prices for artwork. A career advisor should be able to provide an overview of the various art markets and provide assistance with marketing strategies, grant proposals, exhibition proposals, and proposals for commissioned work. And a career advisor should know how to proceed once a dealer makes a verbal commitment to represent an artist.

The job titles of *art consultant* and *art advisor* are often confused with the job title of *artist's career advisor.* However, unlike an art consultant or art advisor, a *career advisor to artists should not buy or sell artwork.* In order to serve artist clients most objectively and ethically, career advisors should not represent any one artist or be involved in any endeavor that is a conflict of interest.

Because conflicts of interest should not happen, it does not mean that they do not happen! Out of all of the services a career advisor should provide, the most important is the role of *artist advocate.* However, the ability of a career advisor to perform an advocacy role is the crux of the problem that involves issues related to conflicts of interest. Career advisors who are *also* art dealers cannot serve artists in an advocacy capacity because they are influenced by factors that they perceive to be in their best interests as a dealer. Moreover, career advisors who are *also* publishers who solicit paid advertising from artists, or charge fees to be included in artist sourcebooks (see page 119), cannot serve artists in an advocacy role because they must be looking out for

their best interests as publishers whose livelihood relies, in part, on artist-paid advertising.

Be leery of career advisors who promise to place you in a New York gallery. In some instances, the gallery of choice will be a vanity gallery (see page 106) or it is engaged in other unsavory business practices. One New York gallery that is regularly used by a career advisor requires artists to guarantee that their work will be sold prior to the exhibition opening! Artists are asked to sell their work to a third party; the purchaser pays the dealer; and the dealer pays the artist and deducts a 50 percent commission! Another New York gallery associated with a career advisor requires each artist to pay several thousand dollars for a full-page ad in an arts trade publication.

Some career advisors provide their clients with competent advice and services and rigidly avoid areas where there are conflicts of interest. However, other advisors straddle the gray areas or plunge way over the fence. Other career advisors might not have an impeccable code of ethics but their advice follows more traditional lines, and it tends to encourage artists to maintain a status quo and give away their power to the "powers that be."

There are also career advisors who have had very little experience in the art world, and although their intentions might be honorable, the advice and services they provide reflect their limitations.

Before working with a career advisor, learn more about the person's career background and reputation. This can be accomplished by requesting client references and written materials that describe services, fees, and arts-related credentials. Approximately 90 percent of my clients are referred by other artists who have used my services, or they have read my book, or they have attended a career workshop that I have conducted.

Do not be afraid of changing career advisors or of using different advisors for different purposes depending on their strengths and fields of expertise. Do not expect a career advisor to solve a problem overnight that most likely you have spent the better part of your life creating.

Know the Law
In the early 1960s a friend of mine lost approximately 150 paintings in court. He gave his work to a Washington, D.C., gallery owner on consignment without a receipt or any form of written agreement.

After six months he asked to "borrow" some of his paintings in order to enter a juried show. The dealer said that she didn't have his paintings and didn't know what he was talking about.

The artist hired a lawyer. It took another six months for the case to go to court. On the day of the trial, the dealer brought a majority of the lost paintings to the courtroom. She had a simple explanation: she told the judge that the artist had given her all of the paintings as a *birthday present*. The judge believed her. She was free to keep the paintings and do with them what she wished. Case dismissed.

With new legislation and changes in laws that protect artists from being victimized, much has changed in thirty-five years. But undoubtedly a day does not pass that some artist is ripped off by an opportunist or discovers a hitch in what seemed a straightforward deal. *The majority of new legislation will not do an artist any good unless he or she hones up on the legal rights of artists and understands how these rights affect or may affect an artist's work and career.*

"Artists should never feel intimidated, helpless or victimized. Legal and business considerations exist from the moment an artist conceives a work or receives an assignment. While no handbook can solve the unique problems of each artist, the artist's increased awareness of the general legal issues pertaining to art will aid in avoiding risks and gaining benefits that might otherwise pass unnoticed,"[23] writes Tad Crawford in his book *Legal Guide for the Visual Artist*, which should be on the top of your list of books to buy. This book is written in down-to-earth language and covers a comprehensive range of subjects that should be near and dear to an artist's heart, including copyright, wills and estates, sales by galleries and agents, income taxation, studios, and leases. It includes examples of sample contracts and agreements for a vast number of situations that an artist might and probably will encounter.

The third revised edition of *Legal Guide for the Visual Artist*, published in 1995, addresses issues relating to multimedia art, including work that combines still pictures, text, music, and film or video; digitization of information; delivery of new media, such as CD-ROM, computer networks, and cable television; and interactive projects. It also includes a new chapter that is devoted to copyright and the digital revolution.

Legal Guide for the Visual Artist is among several publications available

that zero in on the nitty-gritty of art law. It would be superfluous for me to paraphrase or try to cover the ground that has already been covered by people far more experienced and knowledgeable on the subject. However, the "Law" section of my appendix provides a solid list of references, both publications and organizations. Many of these publications and organizations provide sample contracts, as well as advice for numerous arts-related legal situations. If you require additional information before a contract is signed, or if you find yourself in the unfortunate situation of needing legal advice after an agreement has been consummated, or for whatever reasons, there are many excellent places to turn.

Not being able to afford a lawyer specializing in art law is no longer a valid excuse! For example, Volunteer Lawyers for the Arts (VLA) in New York City offers free legal consultation and legal services, at minimal administrative fees, to artists and nonprofit organizations. More than forty Volunteer Lawyers for the Arts programs are located throughout the United States, some of which were created by arts councils, arts organizations, state bar associations, law firms, and law schools. Services offered, eligibility requirements, and administrative fees vary. In addition to offering legal assistance to individuals, many VLA groups offer seminars on various art-law-related topics and publish resource books, such as *An Artist's Guide to Small Claims Court*, which is applicable to artists in New York City, and the *VLA Guide to Copyright for the Visual Arts*. The "Law" section of the Appendix lists Volunteer Lawyers for the Arts groups and publications, including the *VLA National Directory*, which describes VLA programs in the United States and in Canada.

COPYRIGHT

Without a copyright, once a work of art enters the public domain, the artist loses all rights to that work. This means that if a work of art is sold or exhibited without a copyright it can be freely published and reproduced. The artist has nothing to say about it and is not eligible for any kind of financial remuneration. Therefore, it is imperative that all work have a copyright.

The 1978 Copyright Act has made copyright procedures very simple. It is not retroactive, so all copyright transactions prior to January 1, 1978, are governed by the old law. But the 1978 law is straightforward and easy to comply with. Simply stated, *any artwork is protected by*

copyright as soon as it comes into being as long as an artist places a copyright notice on the work. This consists of "Copyright," "Copr." or "©," the artist's name (or abbreviation by which the name can be recognized or an alternative designation by which the artist is known), and the year of creation. The copyright lasts for the duration of the artist's life plus fifty years.

Copyright protection is available to artists working in every medium, including printing, photography, painting, sculpture, drawing, graphics, multimedia, models, diagrams, film, tapes, slides, records, and compositions.

Although you are not required to formally register your copyright, there are certain advantages that mainly concern your rights if anyone tries to infringe on your copyright.

The ins and outs of copyright and how it affects the visual and performing arts are covered in many publications, including *Legal Guide for the Visual Artist, VLA Guide to Copyright for the Visual Arts,* and *VLA Guide to Copyright for the Performing Arts.* In addition, a *Copyright Information Kit* can be obtained free of charge from the Copyright Office (see "Law" in the appendix). Be sure to specify that you are requesting the kit for visual artists.

CONTRACTS

Most visual artists do not use contracts. Performing artists and writers use contracts as regular parts of their professional lives. Why are visual artists reticent about using contracts?

Some artists are averse to the use of contracts because they naively believe that people who sell, buy, and exhibit art are good, kind, and trustworthy by virtue of their involvement with art. However, most artists who resist using contracts are struggling with the issue of psychological leverage, and erroneously believe that they have not achieved a level of recognition or success that permits them to ask for what they want.

Requiring art dealers, art consultants, exhibition sponsors, and clients to use contracts is not a sign of mistrust. Rather, it shows that you take yourself and your work seriously, and you are demonstrating good faith in wanting to maintain a smooth working relationship by ironing out in advance any possible conflicts or misunderstandings.

If an art dealer, art consultant, exhibition sponsor, or client is opposed to using a contract, it usually indicates either that the individual

is extremely naive and unenlightened in professional business practices, or that he or she is engaged in unethical business practices and does not want anything in writing that could be used against him or her in court. Another reason dealers and art consultants resist using contracts is that they prefer to see themselves as mentors rather than as business professionals, and they find the use of contracts is not in keeping with their self-image.

If your dealer dies, is your artwork protected from becoming part of his or her estate? If your dealer files for bankruptcy, is your work protected from being used to pay creditors? Is your work insured while it is in a dealer's possession, and is it insured for the full retail value? Is a dealer entitled to a commission on studio sales under all, some, or no circumstances? Should artists split dealer/client discounts? Is an artist required to pay advertising expenses for an exhibition? If so, how much? A good contract should be comprehensive and farsighted.

Protect yourself and your artwork by using contracts when you deal with galleries, art consultants, collectors, exhibition sponsors, and clients. Specific contracts such as consignment agreements, exhibition agreements, and agreements for commissioned work will be discussed in subsequent chapters. The appendix section "Law" lists publications that provide sample contracts, including *Business and Legal Forms for Fine Artists* and *Business and Legal Forms for Photographers.* Both publications also include instructions for preparing contracts for a variety of situations and a kit of tear-out contracts. The forms and contracts in both publications are available on disk for Mac or PC.

ARTISTS' ESTATES

On a number of occasions I have been contacted for advice by family or friends of deceased artists who left no instructions regarding the disposition of their artwork. Particularly when many pieces of artwork are involved, it can be an overwhelming responsibility to make decisions without guidance, instructions or suggestions from the artist. On the other hand, if a deceased artist's friends and relatives are not conscientiously seeking a solution that is in the best interest of the artist, there is a good chance that the artwork will not long survive the artist's death.

In the publication *Future Safe: The Present Is the Future* published by the Alliance for the Arts, the authors point out that:

As an artist, you are used to being your own best resource, so it will come as no surprise that you must take the initiative in planning for the survival of your work. You must give yourself time. The process of making a will and planning for the care of your work can be seen as an act of self-respect. The commercial success of your art should not be a factor in your planning—you have spent a lifetime making this art and it deserves to survive.[24]

It is important to come to terms with estate planning, preparing a will, deciding on a beneficiary or beneficiaries, and providing the beneficiary with instructions or guidelines on the disposition of your artwork.

Depending on various career-related factors estate planning for artists can be relatively simple or quite complicated. It is wise to consult an attorney and/or an accountant who is experienced in estate planning for *artists.*

To learn more about the subject of artist's estates there are good resources available in addition to *Future Safe.* The Women's Caucus for Art has published the workbook *Estate Planning for Artists,* and Canadian Artist's Representation Ontario (CARO) has published *Estate Planning for Visual Artists.* In *Legal Guide for the Visual Artist* an entire chapter is devoted to the artist's estate.

Volunteer Lawyers for the Arts in New York City has initiated the Artist Legacy Project that provides free and specialized estate-planning services to visual and performing artists and writers. The Alliance for the Arts sponsors the Estate Project for Artists with AIDS. Organizations and publications cited in this section and other resources are listed in the appendix under "Estate Planning."

Accounting

Closely allied to the subject of law is accounting—your tax status, or lack of status, whichever may be the case.

A few years ago I was invited to speak at a conference dedicated to the business of being an artist, sponsored by a college in an affluent suburb of New York City. The audience was comprised of artists from the area, and from the tone of questions and concerns I quickly ascertained that this was not a group of full-time artists but rather of "Sunday painters." The college had also invited guest speakers from the

visual and performing arts and from the publishing industry. During the discussion period I was surprised to find that the person who received the most questions was the guest accountant, and from the level and content of questions it was easy to tell that this audience was very abreast of tax laws governing artists, particularly those related to deductions.

This situation is quite a contrast to the attitude of the many full-time artists I am in touch with. How often I encounter serious and devoted artists who are living underground as far as the IRS is concerned, afraid to prepare a tax return for fear they will have to pay taxes on meager earnings. It is ironic that the artists who probably have the hardest time proving themselves "professional" versus "hobby" artists in the eyes of the IRS are the ones most up-to-date and knowledgeable on tax issues.

I am not going to expound on the morality or virtues of paying or not paying taxes, but what is of concern is that too many artists are spending too much energy agonizing over taxes, energy that takes them away from being artists.

One of the reasons artists are squeamish about taxes is the deep-seated myth that being an artist is not a valid occupation and the government will tax an artist in an arbitrary way. The fact is that the occupation of artist has been duly recognized by the IRS for a number of years, most specifically in the 1969 Tax Reform Law.

"An artist actively engaged in the business or trade of being an artist—one who pursues art with a profit motive—may deduct all ordinary and necessary business expenses, even if such expenses far exceed income from art activities for the year," writes Tad Crawford in *Legal Guide for the Visual Artist*. "The regulations set forth nine factors used to determine profit motive. Since every artist is capable, in varying degrees, of pursuing art in a manner which will be considered a trade or business, these factors can create an instructive model. The objective factors are considered in their totality, so that all the circumstances surrounding the activity will determine the result in a given case. Although most of the factors are important, no single factor will determine the result of a case."[25] (The nine factors are listed in Crawford's book.)

"The working artist who is not yet making a profit from art activity has an alternative to being taxed as a hobbyist,"[26] writes artist and au-

thor Jo Hanson in the preface of the excellent publication *Artists' Taxes: The Hands-on Guide* (see "Accounting and Bookkeeping" in the appendix). Hanson, who endured five tax audits in the 1980s, parlayed her experiences into a book that presents clear and detailed advice to artists.

Federal tax laws frequently change, and many of the changes directly affect artists. The Tax Reform Act of 1987 is having an adverse effect on artists in many ways. For example, income averaging (which was very helpful to artists whose income varied widely from year to year) has been abolished. Under the old law a business had to be profitable two out of five years to avoid being treated as a hobby. Under the new law the business has to be profitable *three out of five years*; and the new law makes it tougher for self-employed artists to take their home-office expenses as a deduction. This deduction cannot exceed an artist's net income from the art business, as opposed to the gross income limit under the old law, and the portion of home space claimed as an office or studio must be used *only* for the art business, and on a regular basis.

Some business-related tax deductions artists should be aware of include insurance premiums; studio and office equipment; telephone bills; telephone answering service (on a separate business line); attorney's and accountant's fees; dues in professional organizations; books and professional journals; admission charges to museums and performances; protective clothing and equipment as well as associated laundry bills; commissions paid to dealers and agents; promotion expenses, including photographs, ads, résumés, and press releases; repairs; training and education expenses and tuition for courses that improve or maintain skills related to the profession; shipping and freight charges; the cost of business meetings (such as meals) with agents, patrons, professional advisors, dealers, et cetera, regardless of whether the relationship is established or prospective; business gifts; and automobile expenses for traveling to an exhibition or performance, delivering or picking up work at a gallery, purchasing supplies, driving to courses and seminars, et cetera.

These are only some of the tax deductions that affect artists. The list certainly is not all-inclusive, and there are special rules and regulations governing the application of many of the deductions listed above. Because of the intricacies involved in knowing tax regulations

and tax-law changes, if you personally do not keep abreast of the ins and outs and changes, it is very important to *maintain a relationship with an accountant who specializes in the tax problems of artists.*

Art tax law is a special field, and not all accountants are familiar with the various intricacies. Case in point: Barbara A. Sloan, the author of the *Do-It-Yourself Quick Fix Tax Kit,* is an artist and an art business consultant. Although she is *not* an accountant, she is called upon by certified public accountants for advice in behalf of artist-clients.[27]

Many accountants who specialize in the arts are affiliated with organizations such as Business Volunteers for the Arts (see appendix under "Accounting and Bookkeeping"). Some accountants who specialize in the arts often advertise their services in art trade publications, such as the ones listed in the "Periodicals" section of the appendix. If you are unable to find an accountant through a good recommendation, do not hesitate to ask the accountant you do find for a list of references of artists whom he or she has helped in the past. Check out the references to make sure that the clients have been satisfied customers.

Insurance: Insuring Your Health, Work, and Future

HEALTH INSURANCE

One of my clients broke his leg. He was in the hospital for three weeks and then was an outpatient for several more weeks. During the first week he was hospitalized he learned that he had won an art competition with a cash award of five thousand dollars. But his jubilation over the award was eclipsed when he also learned that his barebones hospitalization policy (a so-called fringe benefit of the college where he was teaching) would pay only meager benefits toward his hospital bills and doctors' fees. Thus, he had to use his entire cash award to pay the bills.

One could elaborate for pages about similar and even worse stories involving artists who do not have health insurance or who are not adequately covered. For many years artists were subjected to exorbitant *individual* rates for health insurance. They were ineligible for *group* rates because of the nature of being a self-employed artist, a unit of one. However, times have changed and many organizations offer group plans. Some of the national organizations that offer group rates to members are listed in the appendix section "Insurance and Medical Plans."

The book *Health Insurance: A Guide for Artists, Consultants, Entrepreneurs and Other Self-Employed* by Lenore Janecek is a comprehensive handbook on the subject of health insurance. It discusses various types of insurance programs, what to look for in a health-care policy, and various insurance options. It also covers insurance needs that are particular to self-employed individuals, including disability insurance and pension programs (see page 38).

STUDIO AND WORK INSURANCE

"All-risk" insurance policies are specifically designed for artists and their particular needs. They include those developed by the National Artists Equity Association and the International Sculpture Center (see "Insurance and Medical Plans" in the appendix).

The National Artists Equity Association's policy insures artwork created by the insured (paintings, drawings, sculptures, etchings, and similar works) during the course of completion, work that has been completed and is being held for sale, and work that has been sold but not delivered. The policy also covers artists' materials, tools, and supplies. It does not cover studio furniture, an art library, or works of art by others in your possession or care.

The policy insures against risk of direct physical loss or damage to the insured property, with the following exceptions: wear and tear; inherent vice; latent defect; gradual deterioration; insects; vermin; mechanical breakdown; damage sustained because of or resulting from any process or actual work upon the property; breakage of fragile property; extreme temperature; war risks; nuclear radiation; weather exposure; delay or loss of market or use; unexplained loss; mysterious disappearance; inventory shortage; loss or damage from fraudulent, dishonest, or criminal acts; loss or damage occurring in transit by mail, except registered mail; and theft from any unattended vehicle (unless the property is in the custody of a public or common carrier).

The policy covers insured work on your premises, on exhibit, and in transit within and between the United States, its territories or possessions, and Canada. There is a $250 deductible for each claim. The minimum amount of insurance you can purchase is $15,000.

The International Sculpture Center offers insurance that covers artwork and work in progress in your studio, in transit, and on exhibition. It covers your artwork as well as that of others you may have in your possession. Perils covered include fire, windstorm, breakage, theft,

collapse, riot, vandalism, explosion, hail, water (including flood), earthquake, and collision. There is a choice of deductibles that applies per loss. Commissioned work is insured at the full commissioned price.

In addition, the company Huntington T. Block insures the work of individual artists, and also offers a business package policy if your studio is in a separate location from your home. Connell Howe Insurors Inc. offers a craft package policy consisting of general liability protection, products and completed operations liability protection, medical payments coverage, and content coverage while work is on display.

The addresses of the above-mentioned organizations and companies are listed under "Insurance and Medical Plans" in the appendix.

PENSION PLANS: INSURING YOUR FUTURE

Not everyone is going to retire. Some of us reject the notion on principle, and others will not have any choice in the matter because they will not have stored up a nest egg. If you are heading for the latter category, or if you fall into the first category and are forgetting that bad health might necessitate a change in your plans, or if you are in neither category and basically haven't thought about retirement because you are just getting started, consider this: artists can now participate in pension plans, a fringe benefit once bestowed only on members of society who were willing to devote most of their lives to working for someone else. Now there are pension plans for self-employed persons that *offer financial security for your future.*

Keogh plans are pension plans for the self-employed. However, even if you are employed by a company with a retirement program, you may maintain a Keogh plan and make an annual contribution of up to 20 percent of your net self-employment income, or $30,000 (whichever is less), to the plan. Your money can be invested in a trust, an annuity contract from an insurance company, a custodial account, a special U.S. Government retirement bond, or one of certain face-amount certificates purchased from investment companies. Money contributed to a Keogh plan is tax deductible and no taxes are levied on the growth of your investment until the funds are withdrawn. There are penalties if you withdraw the money before the age of 59½, unless you are disabled.

Another kind of pension plan, an Individual Retirement Account (IRA), is available to anyone who is not covered by a company retire-

ment plan, or anyone who is covered by a company plan but has an adjusted gross income of less than $25,000 ($40,000 for a married couple). In an IRA you can invest up to 15 percent of your adjusted gross income, with a ceiling of $2,000 per year ($4,000 for a married couple who are both working; or $2,250 for a married person with a nonworking spouse). As in a Keogh plan, the money you place in an IRA is tax deductible. There are penalties if you withdraw the money before the age of 59½ unless you are disabled.

For further information on self-employment retirement plans, write to your local Internal Revenue Service office. The addresses of other pension-plan resources are listed in the appendix under "Pension Plans and Savings and Loans Programs."

Credit Unions

Credit unions are financial cooperatives that are owned and controlled by their members and offer a range of services. For example, the Artists Community Federal Credit Union (ACFCU) is a federally insured credit union that offers special loans to help artists establish a national credit rating. The ACFCU also provides bridge loans to assist artists who have been awarded grants. If an artist's cash-flow needs are not in sync with the funding sponsor's payment schedule, the ACFCU will advance the needed money, using as collateral grant award letters from established funding agencies. Artists in all disciplines are eligible for ACFCU membership, as are people employed in the arts community.

In addition, The Chicago Artists' Coalition has a credit union for its members that offers regular savings accounts; vehicle, home equity, and student loans; and IRAs. The addresses of both organizations are listed in the appendix section "Pension Plans and Savings and Loans Programs."

Artists' Health Hazards

Health hazards to artists is a relatively new area of study, because it has only been recognized in recent years that various materials used by artists are directly responsible for a multitude of serious health problems, including cancer, bronchitis, and allergies.

Solvents and acids used by printmakers are responsible for many health problems; dirt and kiln emissions have created problems for

potters; resins and dirt in a sculptor's working environment and gases and vapors used in photography are also responsible for various ailments. Toxic chemicals in paints are directly linked to cancer, including pigment preservatives used in acrylic emulsions and additives such as those used to protect acrylic paints during freeze-thaw cycles. In addition, improper ventilation is a common abuse, and its side effects are directly responsible for temporary discomfort as well as permanent damage.

Performing artists are also directly affected. Toxic chemicals are found in concert halls and theaters, on stage, in dressing rooms, in makeup rooms, et cetera. Health problems are created by such things as poor ventilation; certain types of aerosols, acrylics, and plastics used in sets and costumes; photographic chemicals; asbestos; sawdust; gas vapors; dust; and machine oil.

If you are not already aware that the materials you might be using in your studio or work environment are considered taboo, it is time to investigate.

The Art and Craft Materials Institute, Inc., certifies 90 percent of all art materials sold in the United States. The institute provides information on hazardous products and publishes a newsletter. Arts, Crafts and Theater Safety (ACTS) is a not-for-profit organization that provides information on health and safety in the arts. Serving artists and arts organizations worldwide, ACTS answers inquiries and provides copies of educational and technical materials. It also publishes a monthly newsletter. ACTS was founded by Monona Rossol, who wrote the very informative book *The Artist's Complete Health and Safety Guide.*

The Center for Safety in the Arts, founded by Dr. Michael McCann, pioneered the dissemination of information on health hazards in the arts. Dr. McCann is also the author of the important book *Health Hazards for Artists.* Due to funding cutbacks the center is no longer able to respond to telephone or written inquiries. However, it is continuing to publish a quarterly newsletter *Art Hazards News.* The center's extensive resource library is currently being housed at the School of Health Sciences at Hunter College in New York City.

Information about the above-mentioned organizations and the names of other excellent publications that are available on the subject of health and safety in the arts are listed in the appendix section "Health Hazards."

*M*INIMIZING EXPENSES

There are many ways to keep expenses low in order to afford the necessary initial financial investments to launch and sustain your career. Some of the ways are described below.

Bartering

Bartering has been in existence for thousands of years. Artists can trade their artwork and special skills for career-related supplies, materials, and equipment. You can also save money on various daily living expenses so that you can allocate more funds for your career.

Some of my clients have bartered with doctors, dentists, printers, restaurants, food stores, plumbers, carpenters, and electricians.

The bartering phenomenon has expanded into big business, and barter organizations and clubs exist throughout the United States. The names of barter organizations can be found in the Yellow Pages Business-to-Business Directory under "Barter and Trade Exchanges."

In addition, Barter.Net, a Web site on the Internet, provides a listing of bartering networks (see appendix section "The Internet").

Using Apprentices

You can save money and time by using the services of an apprentice. Apprenticeship programs provide artists with students who want studio or work experience. Some apprenticeship programs are structured as a barter: free assistance in return for learning and developing new skills; other programs require an artist to pay an apprentice a reasonable hourly wage.

Local and state arts councils can provide information on apprenticeship programs. College and university art departments are also good sources. For example, the Fine Arts Department of Pratt Institute in Brooklyn, New York, offers an internship program in which graduate students receive credit hours for serving as an apprentice to a professional artist. The University of Southern Maine in Gorham offers a similar program. In addition, the Great Lakes College Association sponsors a student-intern apprenticeship program which makes available apprentices in the visual arts, theater, writing, music, dance, and media. In the visual arts, apprentices are available in painting, sculpture,

photography, crafts, all areas of design and commercial art, and architecture.

The *National Directory of Arts Internships* lists the names of artists throughout the United States who use apprentices. Each listing describes eligibility requirements, applications procedures, and a description of what the position entails.

For additional information about apprenticeship programs see the appendix section "Apprentices and Interns."

Surplus-Material Programs

You can save money on equipment, supplies, and materials by using surplus-material programs. These programs are located throughout the United States and are administered by various arts agencies. Their main source of supply is the General Services Administration, which donates to public agencies and nonprofit organizations a variety of materials, machine tools, office machines, supplies, furniture, hardware, and construction equipment. In return, many of the agencies make the supplies and equipment available to artists. A surplus-property agency exists in every state. Contact your local arts agency for further information, and see "Surplus-Material Programs" in the appendix.

3

Presentation Tools and Packages

The first chapter of this book, "Launching or Relaunching Your Career: Overcoming Career Blocks," covers some of the difficulties artists encounter in career development, including the cause and effect of the public's fear of visual art. It points out that many people *in the art world* are also intimidated by visual art, although they are unlikely to admit it. Consequently, presentation materials such as résumés (see below), press clippings or excerpts (see page 50), artist statements (see page 51), and cover letters (see page 53) are important props because they help insecure people determine that it is okay to like your work!

This chapter will present guidelines for preparing presentation materials and suggestions for maximizing their effectiveness.

An Artist's Résumé

The specific purpose of an artist's résumé is to impress gallery dealers, curators, collectors, grant agencies, juries, and anyone else in a position to give an artist's career upward mobility. However, since an artist's résumé has purposes other than seeking employment, it requires its own special structure.

A résumé should reflect your achievements in the arts field. It should not be a thesis about what you hope to achieve or an explanation of the meaning of your work. Keep résumés pure—free of narratives that justify or describe your work's inner meanings.

Keep in mind that the *intrinsic purpose of a fine-arts résumé* is to impress people with your credentials. Therefore, if your achievements amount to more than can be listed on one sheet of paper, use another sheet. *Who said that our lives have to be limited to one page?* One-page résumés were created for the purpose of obtaining employment, giving a potential employer an overview of one's employment history prior to a personal interview. However, obtaining employment is not the purpose of a fine-arts résumé.

On the other hand, if you have substantial achievements, consider a résumé as a tool that highlights your accomplishments and eliminates minor credits. Use such phrases as *exhibition highlights* or *selected exhibitions, selected collections,* and *selected bibliography* to convey that this is only a sampling.

If you use the format of exhibition highlights or selected exhibitions, make sure that you keep for your own use a complete résumé that lists *all of your accomplishments.* This documentation is important to a curator, for example, who is preparing a catalog to accompany a retrospective exhibition.

If you are applying for a teaching job in the art field, a fine-arts résumé should accompany your teaching résumé.

The following are suggestions for structuring a résumé and the order in which categories should be listed:

NAME, ADDRESS, AND PHONE NUMBER.

PLACE OF BIRTH. Places of birth can be good icebreakers. You might share a regional or local background with the reader.

BIRTH YEAR. Artists under twenty-four and over fifty sometimes object to putting their birth year on a résumé in fear of the stigma of being considered too old or too young. If a person is negatively influenced by your age, it is a strong indication that his or her judgment is poor, and you wouldn't want to be associated with that person under any circumstances.

EXHIBITIONS/PERFORMANCES. List the most recent exhibitions/performances first. Include the year, exhibition/performance title, name of the sponsor (gallery, museum, or organization), city, and state. In addition, list the name of the curator and whether it was an invitational or a juried

show. (If you won an award, mention it in the "Awards and Honors" category described below.)

If you have had four or more one-person shows, make a special category for "Solo Shows" and begin the "Exhibitions/Performances" section of the résumé with this category. Make another category for "Group Exhibitions." If you have had fewer than four one-person shows, include the shows under the general heading "Exhibitions/ Performances," but code the one-person shows with an asterisk (*) so they stand out, and note the code on the résumé. For example:

EXHIBITIONS. (*Solo Shows)

1997 *Objects and Images*, Alternative Space Museum, New York City. Curated by Charlie Critic. Invitational.

 *Smith Wheeler Gallery, Chicago, Illinois.

 Spring Annual, Hogan Gallery, Detroit, Michigan. Juried by Peggy Panelist and Joe Jurist.

COMMISSIONS. List projects or works for which you have been commissioned, including the name of the project or medium, the sponsor (institution, company, or person), and the date.

COLLECTIONS. List the names of institutions that have purchased your work, as well as corporations and well-known collectors. If you haven't been "collected" by any of the above, omit the category (unless you need to pad the résumé with the names of relatives and friends).

BIBLIOGRAPHY. List all publications in which you have been mentioned or reviewed and any articles that you have written related to art. Include the name of the author, article title, name of the publication, and publication date. If you have been published in an exhibition catalog, include the name of the exhibition and the sponsor. If something was written about you in the catalog, credit the author.

AWARDS AND HONORS. Include grants or fellowships you have received. List any prizes or awards you have won in exhibitions or competitions. Include artist-in-residence programs or any other programs that involved a selection process. If you won an award that was associated with an exhibition, repeat the same information that was listed in the

"Exhibitions/Performances" category, but begin with the award. For example:

First Prize, Sculpture. *Spring Annual*, Hogan Gallery, Detroit, Michigan. Juried by Peggy Panelist and Joe Jurist, 1997.

LECTURES/PUBLIC-SPEAKING ENGAGEMENTS. Use this category to list any lectures you have given and/or radio and television appearances.

EDUCATION. This should be the *last* category. Many artists make the mistake of listing it first. This suggests that the biggest accomplishment in your life was your formal education!

The following is a sample résumé:

Terry Turner
15 West Main Street
Yourtown, U.S.A. 12000
500-832-4647
Born: Washington, D.C., 1967

*Selected Exhibitions (*Solo Shows)*

1997 WINTER INVITATIONAL, Whitehurst Museum, Whitehurst, Illinois. Curated by Midge Allen.

OBJECTS AND IMAGES, Alternative Space Museum, New York City. Curated by Charlie Critic. Invitational.

*Smith Wheeler Gallery, Chicago, Illinois.

SPRING ANNUAL, Hogan Gallery, Detroit, Michigan. Juried by Peggy Panelist and Joe Jurist.

1996 ILLUSIONS, Piper College, Lakeside, Pennsylvania. Curated by Abraham Collins.

1995 *Pfeiffer Gallery, Düsseldorf, Germany.

*Limerick Gallery, San Francisco, California.

TEN SCULPTORS, Kirkwood Park, Denver, Colorado. Sponsored by the Denver Arts Council. Invitational.

1994 PITTSBURGH BIENNIAL, Pittsburgh Cultural Center, Pittsburgh, Pennsylvania. Curated by Mary Clark and Henry North.

HANNAH, WRIGHT, AND TURNER, Covington Gallery, Houston, Texas.

1993 THE DRAWING SHOW, traveling exhibition organized by the Southwestern Arts Center, Tempe, Arizona: Seattle Museum, Seattle, Washington; Minneapolis Museum, Minneapolis, Minnesota; Virginia Museum, Richmond, Virginia; and Miami Museum, Miami, Florida.

Commissions

Outdoor sculpture, Plymouth Airport, Plymouth, Massachusetts. Sponsored by the Plymouth Chamber of Commerce, 1997.

Mural, Bevington Department Store, New York City. Sponsored by the Bevington Corporation, 1997.

Outdoor sculpture, Hopewell Plaza, Chicago, Illinois. Sponsored by the Downtown Citizens' Committee in conjunction with the Chicago Arts Council. 1996.

Public Collections

Whitehurst Museum, Whitehurst, Illinois.
Pittsburgh Cultural Center, Pittsburgh, Pennsylvania.

Corporate Collections

Marsh and Webster Corporation, New York City.
Avery Food Corporation, New York City.

*Bibliography (*Reviews)*

*Bradley Mead, "Terry Turner Opens at Smith Wheeler Gallery," *Chicago Artist News*, February 1997.

*John Short, "Emerging Artists Featured at Whitehurst Museum," *Whitehurst Daily News*, January 16, 1997.

Nancy Long, "Winter Invitational at Whitehurst Museum," *Museum Quarterly*, Winter 1997.

Midge Allen, *Winter Invitational Catalog*, Whitehurst Museum, Whitehurst, Illinois, 1997.

Beth Ryan, "Ten Sculptors Show at Kirkwood Park," *Sculptor's Monthly*, June 1995.

Mary Clark and Henry North, *Pittsburgh Biennial Catalog*, Pittsburgh Cultural Center, Pittsburgh, Pennsylvania, 1994.

Awards and Honors

First Prize. Sculpture. SPRING ANNUAL, Hogan Gallery, Detroit, Michigan. Juried by Peggy Panelist and Joe Jurist, 1997.

Fellowship. Denver Arts Council, Denver, Colorado, 1996.

Fellowship. Minerva Hills Artist Colony, Minerva Hills, Montana, 1996.

Second Prize. Sculpture. International Sculptor's Competition, Essex, Ontario, Canada, 1995.

Project Grant, Pittsburgh Cultural Center, Pittsburgh, Pennsylvania. Juried, 1994.

Lectures/Public-Speaking Engagements

Lecture, Pratt Institute, Brooklyn, New York, 1997.

Lecture, Art Department, University of Colorado, Boulder, Colorado, 1996.

Interview, "Culture Hour," WRST TV, Detroit, Michigan, 1995.

Lecture, Covington Gallery, Houston, Texas, 1994.

Interview, "The Drawing Show Artists," WXYZ Radio, Tempe, Arizona, 1993.

Education

Art Department, Ross College, Huntington, Iowa, B.F.A., 1987.

Thin Résumés

Few of us can begin careers with heavyweight résumés full of fancy exhibition/performance credits and citing articles and reviews in lead-

ing publications. But the anxiety of having a thin résumé should not prevent you from putting a résumé together. I like the reaction of a painter whom I was assisting with a résumé. She studied the various category headings and replied: "How exciting. I can't fill in all of these categories, but look at all of the things I can look forward to."

While it is not advisable to pad résumés with insignificant facts and data, a few things can be done to fill up a page so that a résumé does not look bare. For example, double-space between each entry and triple-space between categories. Use "Collections" to list the names of any well-known people or institutions who have your work, even if they did not purchase it. Include student shows in the "Exhibitions/Performances" category and use "Awards and Honors" to list any scholarships or teaching assistantships you have received in graduate or undergraduate school. If you have teaching experience in the arts, list this experience in a new category, "Career-Related Experience" or "Teaching Experience."

Less Than Thin Résumés

Over the years I have had many clients who had no formal art training, and/or when they first came to me they had no exhibition history nor had they sold any work. In other words, when they were in the beginning stages of marketing their work, none of the suggested categories in a fine arts résumé would have been applicable.

In such cases I always recommend dealing with the dragon head on! Abandon the use of a formal résumé and prepare a narrative entitled "Background Information" that states that you are self-taught. The narrative should combine a biographical statement (see page 50) and an artist statement (see page 51).

This format was used by one of my clients, a self-taught artist who began painting at the age of forty. His "background information" narrative contained three short paragraphs, or a total of sixty words. It stated that he had no formal training; it mentioned where and when he was born; and it included a few sentences about his work.

Once he began a focused effort to gain exposure, his lack of academic and art-world credentials was of no consequence. As a result of his first group show, he received an enthusiastic review from an art critic in *The New York Times*. By the end of the second year he had a one-person show in an alternative space in New York City; and by the third year he had a two-person show in a New Jersey museum.

Updating Résumés

The following advice might sound silly, but artists are often very neg-
ligent about résumés: a career changes and accomplishments occur,
update your résumé. If you have been invited to participate in an
exhibition/event in the future, add a new category to the résumé,
"Forthcoming Exhibitions." If an article is planned in the future, add a
new category, "Forthcoming Articles."

A painless, time- and cost-effective way of updating a résumé is to
have it word-processed on a computer. Once the information is stored,
a résumé can be updated in a matter of minutes.

Excerpts from Publications

If you have received good reviews, excerpt the most flattering quotes
on a separate sheet of paper and attach it to your résumé. Credit the
author, article, and publication, and give the date. If you have not
been reviewed in a periodical but an exhibition catalog contains prose
about your work, include the relevant quotes on a separate sheet of
paper, credit the author, and give the exhibition title, sponsor, and
date. Although many artists present an entire article, unless the key
phrases about you are *underlined* or *highlighted*, chances are the article
will not be read.

Biographies

A biography is a synopsis, written in prose, of your career accomplish-
ments. It highlights various credits listed on your résumé. In certain
instances, a bio is used in lieu of a résumé, such as for a handout at ex-
hibitions and to accompany a press release (see page 78). (The narra-
tive style makes it easy for a writer to include biographical information.)
A biography can also be used to accompany a résumé when you are
submitting slides to dealers, curators, and corporate art consultants
and advisors. Following is an example of a biography, based on the
sample résumé on pages 46–48.

> Terry Turner's paintings have been exhibited in solo and
> group exhibitions in galleries and museums throughout the
> United States and abroad, including the Whitehurst Museum in
> Whitehurst, Illinois; the Smith Wheeler Gallery in Chicago; the
> Limerick Gallery in San Francisco; and the Pfeiffer Gallery in
> Düsseldorf, Germany.

In addition, her work is in public and corporate collections, including those of the Pittsburgh Cultural Center and the Avery Food Corporation in New York City.

Ms. Turner is the recipient of numerous awards and honors. She received fellowships from the Denver Arts Council and the Minerva Hills Artist Colony in Minerva Hills, Montana.

Terry Turner was born in Washington, D.C., in 1967. She received a B.F.A. from Ross College in Huntington, Iowa.

Like a résumé, a biography should not be a thesis that explains the meaning of your work. Save such explanations for an artist statement.

Artist Statements

Many artists assume, somewhat naively, that everyone is automatically going to "get" or comprehend their work on the exact level on which they intend it to be perceived. Although an artist statement can be an effective tool in helping insecure people better understand your work, one does not have to be insecure about visual art to appreciate the aid of an artist statement.

But translating visual concepts into clear prose is an exercise that often meets with much resistance. For several years, I have conducted workshops on a variety of career-related subjects, including developing artist statements. Many workshop participants anticipate preparing an artist statement as eagerly as they might a tooth extraction. And I often find the task of getting artists to describe their own work in a meaningful and interesting way not unlike pulling teeth!

As a warm-up exercise, participants are asked to describe the work of an artist whom they admire. For the most part, passionate adjectives and poetic phrases flow with unrestrained ease. But after the warm-up, when artists are asked to describe their *own* work, dry abstractions and clichés fill the page.

Although artists vehemently criticize the overintellectualized style of writing used in leading art magazines, many believe that their work will not be taken seriously unless they *imitate what they despise.*

An artist statement can be used as a tool to help dealers, art consultants, and advisors sell your work, and as background information in helping writers, critics, and curators prepare articles, reviews, and

exhibition catalogs. In addition, an artist statement can be incorporated into a cover letter (see page 53) and into grant applications (see chapter 9).

An artist statement can focus on one or more topics, such as symbols and metaphors, materials and techniques, or themes or issues underlying or influencing your work.

Avoid using weak phrases that reflect insecurities, confusion, or doubt, such as "I am attempting," "I hope," or "I am trying." The statement should be coherent, direct, and energetic. Here are some examples:

> I use images and materials best remembered from childhood to create works that are evocative of the pleasures and dangers of being a child. The sculptures employ my own sense of optimism and humor in the way that children often show resilience and strength regardless of their circumstances. I create the atmosphere of a partially told story, so that people can arrive at their own conclusions using my clues and their own experience. *Ruth Green, Monterey, Massachusetts*

> Sacrifice and its relationship to birth, decay, death, and rebirth are conveyed in my work. In my paintings I create a space where living forms experience their own sacrificial process by changing from one state of being to another. The image of a tree is used as a generator of life forms and a valuable link in the process of decay. Alluding to the biblical references that fire transforms the sacrificed living forms into a state of smoky transparent vapors, I use steel wool and a palette knife to transform and remove forms from the canvas or wood panels, leaving ghost-like subtle images of what used to have a heavy and solid presence. *Howard Lerner, Brooklyn, New York*

> The inner images that are incorporated into my paintings are symbols of life, fertility, and repose; icons that have been an integral part of art in all cultures since primitive times. I assemble these images in ways that highlight their natural beauty and abstract form. Each painting is a synthesis of the varied cultural influences that have shaped my visual consciousness. When these influences converge into a painting, the ordered complexity that results is intended to convey a simple message: reverence for life! *Roger Sandes, Williamsville, Vermont*

The inner space of common materials holds great mystery, drama and beauty. Using an optical polarizing microscope with a built-in camera, I photograph the interior life of familiar objects and elements. Crystals, minerals, concrete, chemicals, plastics, vitamins, ceramics, metals, alloys, and biological and pharmaceutical materials, for example, are rich sources of exploration and discovery. I record and capture the natural designs, inherent colors, symmetry, and the intricately composed internal structures lying deep within these minute and unchartered worlds. *Arnold Kolb, Midland, Michigan*

Cover Letters

The use of a cover letter is more than a courtesy; it can provide a context to help people view your work. Some people need the context of art-world validation, such as the information provided in a résumé (see page 43). Some people are not concerned with glitz but want to know what your work is all about. Others need a combination of glitz and substance. An effective letter can cover all grounds.

It should include the following:

(1) *An introductory paragraph* stating who you are and the purpose of the letter. For example:

I am a sculptor and am writing to acquaint you with my work.

(2) *A brag paragraph* that plucks from your résumé a few credentials. For example:

I have had solo exhibitions at the Wallace Gallery in Chicago, and my paintings have been included in group exhibitions at the Contemporary Art Museum in Fairfield, Arizona, and the Ridgemont Museum in Spokane, Washington. In addition, my work is in public and corporate collections, including those of the Whitehurst Museum in Whitehurst, Illinois, and the Marsh and Webster Corporation in New York City.

Or:

My photographs have been exhibited at museums and galleries, including the Alternative Space Museum in New York City; the Hogan Gallery in Detroit; and the Covington Gallery in Houston.

In addition, my work is in various public and corporate collec-
tions, including those of the Whitehurst Museum in Whitehurst,
Illinois; and the Marsh and Webster Corporation in New York
City.

(3) *A short artist statement.* For example:

I use images and materials best remembered from childhood to
create works that are evocative of the pleasures and dangers of
being a child. The sculptures employ my own sense of optimism
and humor in the way that children often show resilience and
strength regardless of their circumstances.[28]

(4) *A concluding paragraph.* For example:

Enclosed is a brochure featuring examples of recent paintings. If
you find my work of interest I would be pleased to send addi-
tional material.

Or:

Enclosed are [slides, photographs] featuring examples of recent
paintings. If you find my work of interest I would be pleased to
arrange a studio visit in the near future.

If applicable, a cover letter can point out that you are including
copies of press reviews or essays by curators. For example: "I am en-
closing copies of reviews written by Mary Smith, art critic of the *Daily
Times,* and John Jones, contributing editor of *Art Monthly.*" Or, "I am
enclosing a reprint of the introduction to the catalog of the traveling
exhibition *Northwest Artists* written by curator Helen Homes."

And, *if applicable,* include a paragraph listing the reasons you are
contacting a particular gallery or curator. For example: "I have visited
your gallery on several occasions, and believe my work shares an
affinity with the work of the artists featured." Or, "I attended the ex-
hibition *Modern Dreams* and, judging by the selection of artists featured
in the show, I thought that you would be interested in my work."

Depending on your career stage, it might not be possible to include
a brag paragraph, reviews, or essays, but an artist statement can be in-
tegrated into the letter regardless of whether you have been working
as an artist for ten months or ten years.

When you write to a dealer, your cover letter can also include in-
formation regarding the *retail* price of your work (see chapter 4, "Pric-
ing Your Work"). For example, "The retail price of my paintings
ranges from three thousand to five thousand dollars." The advantage

of referring to prices in the initial contact letter is to weed out those people who are only selling art in a low price range.

Writing a cover letter and including any one or all of the elements outlined above is no guarantee that you will get what you want. However, with a well-written cover letter you have a better chance of making an impression and setting yourself apart from the hundreds of artists who send packages to dealers, curators, collectors, and exhibition sponsors with form letters, insipid letters, or no cover letters at all.

ⱱISUAL PRESENTATIONS

Since few dealers and curators will view original work at a first meeting, most artists have been stuck with the slide package system. This system was designed for the convenience of dealers and curators. It is certainly not in the best interest of artists.

It is also an absurd method of presentation. With few exceptions, your slides are examined without the aid of a slide projector, light box, or hand viewer, and while glancing at a group of tiny images the person viewing your slides makes a decision in about fifteen seconds on whether your work is of interest.

Thus, after completing a work, you must create an artificial viewing situation that will present the work advantageously in a slide or photograph. Unless the work happens to *be* a photograph, this is not the way it was intended to be viewed or experienced. (The idiocy of the slide system is further heightened when photographers are requested to present slides of their prints!)

Often, because of the importance placed on good photographs, an artist is guided and influenced during the creation process by how well the work will photograph!

The section "Rethinking Presentation Packages" (see page 58) suggests some new ways of presenting visual materials. But if you are unable to change immediately to a new presentation form, following are some pointers on how the slide system can work best for you.

Slides and Photographs

"Artists are being rejected who would be accepted into many galleries with more representative slides. They are shooting poor slides because

they haven't taken the time to find out how to do it right. They haven't learned that it is as easy to shoot good slides as it is to shoot bad ones," points out artist Nat Bukar, the author of the informative book *How to Photograph Paintings.*[29]

When artists photograph their own artwork, there are some advantages, namely, saving money, documenting work on your own schedule, and not relying on another person's vision of how the work should appear in photographic form. However, only photograph your work yourself if you can really do it justice. *How to Photograph Paintings* and other books that present guidelines and tips for photographing artwork are listed in the appendix section "Photographing Artwork."

If you are unable to take professional-quality slides and photographs, use a photographer experienced in *art* photography. Decide before the shooting how you want the work to look in a photograph and what features you want emphasized. If the final result falls short of your expectations, reshoot, and, if necessary, continue to reshoot until you have what you want. If your work contains details that get lost when the piece is photographed as a whole, shoot separate photographs of the details you want emphasized or clarified.

Since you are going through the time and expense of a photography session, shoot in color and in black and white. Color slides and prints can be used immediately (for dealers, curators, grant applications, slide registries, and other presentations). Black-and-whites, as well as color prints, can be used later for public relations and press packages (see page 78 for requirements).

Since slides and photographs are lures to get dealers and curators to see your work in person, if they are unimpressed with the work as it appears in photographs, it is unlikely that they will get to your studio. However, for photographic purposes, do not glamorize a piece of work with special effects that misrepresent what the viewer will actually see in person. Ultimately, the deception will catch up with you.

When preparing slide presentations to dealers and curators, artists tend to submit many more slides than are necessary, and without discrimination. If you have never had your work photographed, shoot all of the work, but reserve the older work for personal documentation and future use. Dealers and curators are interested in your current direction and do not want to see a slide retrospective in the initial pre-

sentation. It is also important that you *show slides of only one medium.* If you paint and draw, show slides of your paintings or drawings, but not both. This advice sounds strange, and it is, but dealers, curators, and jurists want consistency. Keeping art media separate is part of their definition of consistency! However, you can work around this illogical rule by showing one dealer slides of paintings and another dealer slides of drawings.

What you show to whom depends on the particular dealer or curator. If you are living in an area where there are relatively few galleries, art centers or museums it is relatively easy to ascertain who is interested in what. But in order to implement an effective marketing program it is necessary to expand your efforts beyond your home city or town. The section "Rethinking Presentation Packages," beginning on page 58, explains how this outreach is possible.

One of the biggest problems with slides is that many people do not really know how to read them. Therefore, a viewer should be spoonfed. All slides and photographs should be labeled with the dimensions of the work, the medium, the title (if any), your name, a copyright notice, and the year the work was created. Notations should be made on the frame or margin to indicate the direction in which the slides or photographs should be viewed. It is intimidating for a viewer to have to hem and haw over the right way to view work. The viewer's embarrassment can create a negative atmosphere, meaning that your work is not being viewed under the best circumstances, and this can lead to a negative response.

Another effective way of presenting work in photographic form is to enlarge some of the slides to at least 5-by-7-inch color prints or use large transparencies. This helps to eliminate doubt about whether a viewer can read the slides. Transparencies are excellent for this purpose.

The number of slides that you submit will depend on the circumstances in which you are submitting slides. This information is discussed in the following section "Rethinking Presentation Packages" and in chapter 9, "The Mysterious World of Grants: Fact and Fiction."

An excellent source for duplicating slides is Citizens Photo in Portland, Oregon. It produces high-quality and cost-effective duplicates. For a small additional charge, labeling information and viewing notations are imprinted directly on the slides. The address of Citizens Photo is listed in the appendix section "Photographing Artwork."

Rethinking Presentation Packages

A few years ago I began keeping track of the number of presentation packages my clients annually sent to galleries, art consultants, and curators. I learned that generally it takes *fifty* exposures of the *same body of work* to generate *one* positive response.

This means that on the average, fifty people must see slides, photographs, or other visual representations of the same work in order for an artist to receive an invitation to exhibit or spur interest in establishing a consignment relationship, sale, or commission opportunity. Although artists have sent fewer than fifty packages and received good feedback (in one case three packages led to the sale of three paintings), such experiences are by far the exception rather than the rule.

The *good news* is that the number of packages most artists send—between twelve and fifteen a year—does not even begin to approach an effective market penetration level that justifies any sense of defeat or rejection if the response is unfavorable.

The *bad news* is that preparing fifty packages that contain traditional presentation materials, including slides, a résumé, an artist statement, press clippings, a cover letter, and a self-addressed stamped envelope, can be unwieldy, costly, and time-consuming.

Artists spend an average of twelve to twenty-five dollars on a typical presentation. The high cost factor coupled with much wasted time (waiting for packages to be returned by uninterested parties or tracing lost material) makes it apparent that *there has to be a better way*!

Brochures

One of my first clients to publish a brochure did so in conjunction with an open-studio event (see page 132). She had considered using a brochure for a long time, but was troubled by its negative connotations—unfortunately, some people sneer at brochures as a marketing tool, another one of those groundless taboos that have crept into art-world protocol.

One thousand brochures were printed, one third of which were used to accompany an invitation to her open studio. The brochures were sent to New York area galleries, private dealers, art consultants, curators, friends, and people who had previously expressed interest in

or purchased her work. In the months following the open studio she sent brochures to galleries, private dealers, art consultants, and curators nationwide. With each brochure she sent a cover letter in which she offered to send a set of slides if the recipient found her work of interest.

I asked the artist to keep track of the response generated from the brochure for a twelve-month period. Here are the results:

- Brochures were sent to 329 art consultants, private dealers, and galleries. She received 48 responses.
- Out of 48 responses, 12 people requested slides; 7 people retained the slides for future consideration.
- The artist developed consignment relationships with two galleries in California, and one gallery each in New Jersey, Connecticut, and Alabama.
- She was invited to have a one-person exhibition at an alternative space in New York City.
- Two paintings were sold at the open-studio event, another painting through the art dealer in New Jersey, and another piece at the one-person show.
- In addition, several copies of the brochure were sent to dealers and art consultants with whom she had previously worked, resulting in the sale of two additional paintings and a corporate commission.

Translating the results into dollars and cents, in one year the artist quadrupled her income from the sale of artwork as a result of using a brochure.

The cost of the brochure, including printing, layout, and design for one thousand copies and envelopes, was $2,392. The artist spent another $533 for the design and printing of a letterhead for cover letters, making the total cost of the project $2,925. The brochures were sent via first-class mail, which, at the time of the mailing, came to a postage rate of fifty-two cents each. Thus, the final cost of each package was $3.44.

If the artist had continued to use traditional slide packages, which cost her $25 each, she would have spent $8,225!

Various factors will determine the cost of a brochure, including the number of color images, the paper stock, the size and shape, and the

print run. Another consideration is where the printer is located. (Generally printers located in cities where real estate is expensive tend to charge higher prices because of their high overhead.) Although the artist cited in the above example spent $2,392 for one thousand copies of a 7½ -by-9-inch brochure and one thousand envelopes, it is very possible to produce a well designed brochure for considerably less money.

In addition to drastic cost savings, there are other important benefits of using a brochure rather than a slide package:

- Compared with a slide package, which generally pulls a 2 percent response rate, the response rate of a brochure is generally between 6 and 14 percent.
- A brochure allows work to be reproduced in a larger format. The visual impact is much more effective than the tiny image of a slide.
- The use of a brochure also resolves the problem of having to wait for materials to be returned for recirculation. Often several months pass before material is returned, creating false hope that you have won someone's interest, when in reality the package is accumulating dust, the victim of a forgetful or disorganized dealer.
- Brochures are easier to handle and quicker to assemble, though each brochure must be accompanied by a cover letter (see page 53). It is likely that you will follow up on more leads or contacts and send out more large mailings when your time involvement is minimized.
- Brochures can also serve as sales tools for dealers and consultants.

It has now been well over seven years since my clients began using a brochure to make initial contacts with dealers, curators, corporations, potential collectors, and the press. Through a process of trial and error and tracking the results, I offer the following pointers:

A small, basic brochure is as *effective* as one that is large in format and has been lavishly designed. A basic brochure can have one or two folds and, for example, be in a size range of 5 by 7 inches or 6 by 9 inches. It can contain one to three four-color visual images, a short biographical narrative (see page 50), and an artist statement (see page 51). It should also include the artist's name, address, and phone (and

fax and E-mail) numbers. As an option, it can also include a photo-
graph of the artist and excerpts from reviews (see page 50).

The use of a short biographical text in lieu of a résumé is a good
way to avoid the use of dates (which ultimately can *date* the brochure),
and more information can be packed into a prose format. A biograph-
ical narrative is also a helpful tool for those artists who are at the be-
ginning stages of their career and have a relatively small amount of
career-related credits.

Some artists are under the false impression that a brochure needs
the validation of an art critic. In fact, some artists have actually re-
sorted to paying critics to write an essay for their brochures. If the no-
tion were true that it is imperative for a brochure to contain a critical
essay, this would imply that a brochure lacking an essay is ineffective.
This is most definitely not the case!

Shannon Wilkinson, president of the New York–based Cultural
Communications Corporation, a public-relations firm that publicizes
and promotes clients, exhibitions, and special projects in the fine arts,
points out that some of the critics who are commissioned to write es-
says for artists are "becoming highly overexposed."[30] The negative
consequence of this overexposure is that dealers and curators are able
to recognize quickly those artists who are participating in the distaste-
ful syndrome of paying for a review, otherwise known as "vanity
press."

Ill-advised artists are spending large amounts of money to secure
the seal of approval from critics, and as Wilkinson also points out,
some critics and career consultants "are making substantial profits
from artist-commissioned essays . . . and will have far easier retire-
ments because of artists."[31]

Keep in mind that the recipient of the brochure is most interested
in *visual information,* and in most instances long essays are distractions
and they go unread.

Brochures must be accompanied by a cover letter (see page 53).
Without a cover letter the brochure can easily be misconstrued as an
exhibition announcement that requires no response.

When you receive a request for a slide package as a result of using
a brochure, include with the slide package and self-addressed stamped
envelope another copy of the brochure and a short letter reminding
the person that he or she requested slides. Resubmitting the brochure
a second time is necessary because often there is an incongruity

between the image portrayed in a slide as compared to an enlarged version in the printed format. The viewer might not recognize that it is the same piece of artwork.

Select visual images that will translate well in a printed format. If you are inexperienced in having your work reproduced, a good printer will be able to advise you of the suitability of the image or images you have selected and the likelihood of technical problems.

If you are planning a brochure with more than one visual image, all of the visual images should be from the *same body of work,* and the work should reflect your most current direction.

Avoid "kiss of death" phrases or information that can sabotage your efforts. Such "no-no's" can include, for example, mentioning that you are *currently* taking art courses, or comparing your work to other artists. And if you are involved in a dual career that has no bearing on the work you are doing as a fine artist, do not refer to your other occupation.

Order a *minimum* of two thousand brochures. To maximize the effectiveness of a brochure it is necessary to *keep the momentum going* and send out brochures on a continuing basis. Do not get discouraged if you do not receive an instant response. As previously mentioned, brochures bring in a higher response rate than a slide package, but responses can sometimes be immediate or come in dribs and drabs over a long period of time.

For many artists, career advancements and art sales can be attributed to the use of a brochure. For example, a painter who had been employed as a legal secretary for many years gave her brochure to the law firm's partners. Although the partners knew that she was an artist, interest in her work was spurred when they saw her work "in print." One partner purchased three paintings.

As a result of a brochure, another painter received invitations for eight solo and group exhibitions at galleries throughout the United States during a twelve-month period.

For another painter, the brochure helped a collector make a decision in the artist's favor. Trying to decide between the work of two artists, the collector asked the dealer if she had any written information available on the artists. When the dealer presented the collector with my client's brochure, he was thoroughly impressed and made a quick decision in favor of the artist with the brochure.

Other Presentation Packages

An oversized postcard with a visual image on one side and background information on the reverse side has also proven to be an effective means of generating interest. The postcard must also be accompanied by a cover letter (see page 53).

If you are not ready to publish a postcard or brochure to make *initial* contacts with dealers, curators, and potential collectors, limit the number of slides that you send to three. Your package should also include a résumé (see page 43), an artist statement (see page 51), and a cover letter (see page 53). In the cover letter, offer to send additional slides if the recipient finds your work of interest. Depending on the price of the slides, it may or may not be cost-effective to enclose a self-addressed stamped envelope.

Videotapes

Using the medium of video to present work is another effective alternative to slides and photographs. It is particularly advantageous to sculptors and other artists who have difficulty showing work in still photographs or slides.

Dick Termes, who paints on spheres, is an artist who had difficulties presenting his work through slides. He resolved the problem by using videotapes, and eventually developed three separate presentations. The shortest tape is seven minutes long and includes an overview of his work, background music, and a narration by the artist, who also appears on camera. The tape also features shots of Termes's home and studio, a geodesic dome he built himself in rural South Dakota. He offers a longer tape to those interested in seeing detail shots of the paintings. A third presentation was developed for the purpose of introducing his work to museums and university galleries.

As a result of the video presentations, Termes was invited to exhibit in museums and university galleries throughout the United States and in Japan. He has sold work to museums and corporations, and various public art programs have commissioned him to do projects.

Generally, it costs one thousand dollars per minute to produce a videotape, but Termes was able to keep costs at a minimum by recycling leftover footage from television programs in which his work had been featured. In addition to production studio rental costs and editing

expenses, each videotape copy cost him two dollars plus postage. His package also contains a résumé, a cover letter, and a brochure.

Dick Termes points out that the biggest advantage of using video presentations is that "you can control what the viewer is seeing, including details that might ordinarily be missed in a photograph, and to a certain extent create a mood in which the work is being viewed, through the use of background music."[32]

If you are considering the use of videotape to present your work outside the United States, keep in mind that the videotape must be compatible with foreign systems. For example, if you are contacting galleries and museums in Europe, it is necessary to convert a video formatted for use in the United States to the PAL system (except in France, which uses the SECAM system). Although most countries have facilities to do the conversion, generally it is more economical if you do the conversion in the United States. And, needless to say, it would not make a good impression if you sent a museum or gallery an unsolicited videotape that had to be converted before being screened.

In recent years I have seen videotapes produced by art consultants that show a range of work by artists they represent. No doubt, in the near future, dealers will use videotapes to feature the work of gallery artists. Video presentations will make it possible for dealers to represent more artists without actually keeping artwork on the premises, thus resolving the issue of limited space and reducing insurance costs.

Presenting Work on the Internet

Marketing art on the Internet is discussed in chapter 7. Web sites offer artists opportunities to have their work seen by gallery dealers, art consultants, collectors, curators, public arts agencies, architects and interior designers, and art journalists.

When considering the Internet, videotapes, brochures, or other visual presentations that are not slide packages, be prepared for negative criticism from peers as well as others in the art world who suffer from petty jealousies or lack understanding of basic marketing principles. Many artists, as well as dealers, are afraid of making a move outside of the archaic and illogical rules of art-world etiquette. But there are also many people in the art world who are looking for fresh, imaginative, and effective ways to find new audiences.

5 TREAMLINING PAPERWORK

This chapter and the previous chapter, "Launching or Relaunching Your Career: Entering the Marketplace," outline various tasks, tools, and homework assignments for career development. One of the surest ways to set yourself up for defeat is to become overwhelmed by administrative work.

In the book *Conquering the Paper Pile-Up: How to Sort, Organize, File, and Store Every Piece of Paper in Your Home and Office*, author Stephanie Culp describes a situation that is shared by many artists:

> They say we are living in the Information Age, and indeed, there does seem to be a staggering amount of information to be gleaned from every imaginable source. . . . This abundance of information has given rise to the phrase "information anxiety. ". . . As the paper arrives, the information-anxious folks adjust their level of anxiety upward several notches with every few inches of papers that get added to the existing piles of papers with information yet to be absorbed. The overworked and understaffed small business watches the papers multiply at a frenzied rate.[33]

You can avoid a state of inundation if you aim to accomplish one goal or task at a time, if you do not attempt to do everything simultaneously, and if you learn to streamline paperwork. This is possible if you use a computer, or hire someone to use a computer for you.

Computers can drastically reduce paperwork and repetitive chores. Résumés, cover letters, mailing lists, and artist statements can be stored on a computer and updated in a matter of minutes. A computer can be used to store a variety of information and perform many services, from storing inventories and price lists to creating invoices and contracts. In addition, most word processing programs are capable of creating slide labels.

Special software programs are also available. Although some of the programs were originally designed for art galleries, many of the services they perform can be useful and applicable to artists. For example, Art-Stacks for Macintosh computers includes a database for inventory control; sales transactions; invoices; a library to keep track of reference

books; a Rolodex and mailing lists; and labels for slides, shipping and mailing. With the program you can also maintain a visual record of your inventory. High-resolution images can be scanned from slides, transparencies, photos, or directly from the original art. Sound Data, Inc. offers various Art Management Systems programs, including ArtWatch for Galleries, ArtWatch for Collectors, and ArtWatch for Artists.

Art and Craft Organizer, developed by Faben, Inc., is a software program that was specially designed for artists. It performs numerous functions, such as maintaining an inventory of work, establishing a mailing list, and tracking business expenses and sales tax. The program is continually improved based on feedback from artists.

The use of business forms specially designed for artists is another good time-saving tool. The book *Business and Legal Forms for Fine Artists* by Tad Crawford offers tear-out forms covering a range of needs, including a contract to create a limited edition, an artist's lecture contract, and a licensing contract to merchandise images. Crawford has also compiled a similar publication for photographers titled *Business and Legal Forms for Photographers*. Both of these books are also available on disk in Macintosh or PC formats.

And, yes, artists can have secretaries! Once a system is developed for disseminating presentation materials and reaching various markets (see chapters 4, 5, 6, and 7), an assistant can take over. A workable system does not require full-time energy. This is something that can be accomplished in a few hours a week.

For additional information about publications, computer software programs, and the other organizational aids cited above, see the appendix section "Organizing Paperwork."

4

Pricing Your Work:
How Much Is It Worth?

Within the same week, two artists called me for appointments. Marsha was in her forties and had a successful career as a real estate agent, but planned to leave her job to paint full-time. She arranged to have a one-day weekend exhibition at a suburban library located outside of New York. In one afternoon she sold $18,000 worth of work. The highest-priced painting sold for $6,000. Prior to the library show, she had never had an exhibition or sold work.

Katherine was also in her forties, but had worked full-time as an artist for more than twenty years. She had exhibited in many well-known museums and was represented by galleries on the East and West Coasts. She had received fellowships from the National Endowment for the Arts and grants from state agencies and private foundations. Her work had been reviewed in leading American and international arts magazines. Katherine's paintings ranged in price from $5,000 to $7,500.

Why is an artist new to the art world and without art-world recognition able to sell work in the same price range as an established artist whose six-page résumé is filled with impressive credentials?

Marsha brought to her new career the philosophy and concerns she had learned in the business world. She recognized the value of her time and valued her talent. Her goal was clear: to derive a decent income from doing what she liked doing best. It was inconsequential whether her work found a home on the walls of a museum or over a living-room couch. Unlike Katherine, she was naive about the criteria

used by the art world in pricing work. In this case, ignorance was definitely bliss!

Conflicting Agendas

Setting a price on a work can be a grueling task. Most artists tend to undervalue their work, in the belief that their careers haven't measured up to the criteria necessary to justify charging higher prices. This tendency is reinforced by dealers and art consultants whose pricing agendas are rarely in an artist's best interests.

A primary concern of many dealers is to move work quickly, and, unfortunately, low prices are correlated with making a fast buck. The pricing policies of the majority of dealers basically reflect the amount of money *they think* their constituencies will spend on art.

Few dealers understand that they could sell more work, and at higher prices, if they took the time to help the public understand an artist's vision and the multilayered process and rigorous discipline involved in creating visual art—from conceptualization to actualization.

Most dealers establish a price range based on the hearsay of other dealers or fall into the trap of believing the myth that the work of unknown artists has little value. Reluctant to move out of established parameters, few dealers will admit that they are vying for a particular price market. They camouflage the "fast buck" philosophy and adherence to a pricing system based on the status quo by using various gimmicks aimed at undermining an artist's work and/or career. For example, an artist is told that his or her résumé does not have the "right" credentials to justify selling work at a higher price. Or the work is attacked on the basis of size, materials, or subject matter. One of the typical ploys used to weaken an artist's self-confidence is an accusation that the work is derivative.

More often than not, artists heed a dealer's self-serving pricing advice, erroneously believing that dealers know best.

ℙRAGMATIC PRICING, MARKET VALUES, AND SELF-CONFIDENCE

Setting a price on artwork necessitates homework. You need to consider and integrate three factors: *pragmatic pricing*, understanding how much it is really costing you to create a work of art; *market value* considerations; and *confidence* in the price you set. Self-confidence is of paramount importance if you hope to get what you want and negotiate with strength.

You can achieve pragmatic pricing by maintaining careful records and keeping tabs on the amount of time you spend creating work, from conceptualization through development to completion. Pragmatic pricing must also include the cost of overhead and materials, prorated accordingly.

For example, if work-related costs, such as studio rental, utilities, professional fees, transportation, dues and publications, postage, documentation, and materials, total $10,000 per year, and you create an average of fifteen pieces of work each year, the overhead expense per work is approximately $667.

After calculating an overhead cost per piece, assign an hourly or weekly value to your time. For example, if one piece required twenty hours and you want to be paid $20 an hour, assign a labor charge of $400. Total the overhead cost and labor cost. In the examples cited above, the total of the overhead and labor costs is $1,067.

Be sure that the price set for your work includes a 100 percent reimbursement of labor, overhead, and material expenses *in addition to* any obligatory sales commission. In other words, a commission should not be paid on labor, overhead, and materials. For example, if labor, overhead, and materials total $1,067, and the work is sold at $2,000 *without a dealer*, your profit is $933. However, if the work is sold for $2,000 through a dealer who charges a 50 percent commission, you are losing $67.

In many instances, after determining the costs of time, overhead, and materials and comparing the proceeds of a sale, artists discover they are working for less than a dollar an hour!

Set a price that builds in a sales commission and profit margin, regardless of whether you sell with a dealer. The amount of profit is a personal decision.

If fabrication costs (for example, foundry fees) are high, these costs must be deducted *before* a dealer's commission is calculated. This "understanding" should not be left to an oral agreement. It must be stated in a contract (see page 31).

You can determine a seemingly elusive market value by visiting many galleries, finding work that is allied to your own, looking at prices and the artists' résumés, and comparing their career levels to your own. But keep in mind that other artists' price ranges should serve only as guidelines, not as gospel, because many artists make the mistake of letting dealers determine the value of their work.

Knowing the amount of labor, materials, and overhead spent on creating work and becoming familiar with market values can help you build confidence for establishing prices. But, of course, the process of gaining self-confidence is quickly accelerated when work is sold at the price you want.

On several occasions I have assisted artists in negotiating prices with dealers. In one case, although a dealer thought the artist was overcharging, the artist would not budge from her position. The dealer passed, only to return to the artist's studio six months later with a client who paid the original asking price.

Another situation involved a better-known artist who had consistently sold a minimum of 75 percent of his work in previous one-person shows. A new show was planned and he wanted to double his prices. However, the dealer was afraid the artist was pricing himself out of the market. A compromise was reached: the artist doubled the prices of the pieces that were near and dear to his heart and increased the prices on the other works by 50 percent. He sold work in *both* price ranges.

I also advise artists to set a value a few hundred dollars over the price they actually want. This way there is bargaining leverage and dealers believe they are participating in pricing decisions.

No MORE REGIONAL PRICING

Artists sometimes wonder if they should charge certain prices in large cities but lower the prices if the work is shown in the boondocks. The answer is an emphatic no. Regional pricing is insulting. It penalizes your market in large cities and patronizes your market elsewhere. It

also supports elitist notions that people in small cities or rural areas are incapable of valuing art.

The chances are, if you are an artist in a rural area or small city and are affiliated with a local gallery, you have been persuaded to price work at what the dealer thinks the local market will bear. If you also connect with a gallery in Chicago, for example, make sure the prices in the local gallery are in accord with what the dealer in Chicago is charging. Prices must be universally consistent, whether your work is sold in Vienna, Virginia, or Vienna, Austria.

Developing Price Lists

When assembling a price list, *always* state the retail price, and make sure the word *retail* appears on the price sheet. The danger in stating a "wholesale price" or "artist's price" is that it gives dealers carte blanche to price your work in any way they see fit. The "wholesale price" is construed as an artist's bottom line, and many dealers feel justified in selling work for as much as several hundred percent above the wholesale price and pocketing the difference. Recently a gallery in New York known for requiring artists to state their wholesale prices sold a sculpture for $25,000. The artist received $2,500! The transaction was completely legitimate because the artist stated in writing a wholesale price of $2,500.

Another problem with wholesale pricing is that it prevents artists from establishing a *real* market value. For example, if you are using wholesale prices and have relationships with more than one gallery or art consultant, it is highly conceivable that your work will sell for vastly different prices in different cities or within the same city.

When establishing a retail price, assume a dealer will take a 50 percent commission. Do not adjust the retail price if a dealer's commission is lower. Do not work with dealers who require a commission higher than 50 percent.

A price list can also state your discount policy. Guidelines for developing a discount policy are described in the following section.

Developing a Discount Policy

Shortly after beginning a consignment relationship with a gallery, an artist named Steven was informed by the dealer that a client was interested in buying one of his paintings. The client had previously purchased work from the gallery, and the dealer offered a 20 percent discount, which she asked Steven to split.

New to the gallery world, Steven was unfamiliar with discounts, an issue that had not been addressed in a consignment agreement issued by the gallery. Steven was confused and talked to a friend with more gallery experience. The friend confirmed that artist/gallery discount splits are usual occurrences.

Steven complied with the dealer's request. The painting was sold and he received a check equaling 40 percent of the retail price—the dealer had deducted a 50 percent commission and another 10 percent that represented Steven's share of the discount.

Many artists split discounts without analyzing what discounts actually symbolize or represent. For a gallery, the main purpose of giving discounts to a collector is to reward loyalty and patronage, and to create an incentive for the collector to remain a client. As a token of gratitude, awarding a discount is a public-relations gesture. But is it logical or ethical for artists to be required to share or absorb public-relations expenses of a gallery, and if so, under what circumstances?

Steven was a new gallery artist, and the discount he allowed was a public-relations token that directly rewarded the collector's *previous* patronage of the gallery and of *other* gallery artists. How would Steven have responded if he had been required to contribute 10 percent of the painting's sale price toward exhibition announcements for other gallery artists, or toward a generic brochure tooting the horn of the gallery?

If the 50 percent commission charged by most dealers can in any way be justified, this hefty amount provides a very adequate cushion that enables dealers to offer clients discounts without infringing on an artist's profit. It also provides enough flexibility for dealers to split commissions with art consultants and interior designers.

The time to discuss discount splitting is *before* beginning a gallery relationship. This means *before* any work enters the gallery for exhibi-

tion and/or consignment and *before* an agreement has been signed. If a dealer insists on splitting all discounts, you have the option of not working with the gallery or suggesting a compromise of splitting discounts only if (1) the client has previously purchased *your* work and/or (2) the client is simultaneously purchasing more than one piece of *your* work. If a dealer is in agreement with this arrangement, it *must* be stated in writing.

Some dealers have been known to deduct a discount from an artist's share of a sale when in actuality a discount has not been given. This situation can be prevented if an artist requires a copy of a *bill of sale* or *invoice* or uses an *artist sales contract*. An artist sales contract is a contract between an artist and a collector that not only covers important copyright issues but also states the purchase price of the artwork. Examples of a bill of sale, an invoice, and an artist sales contract can be found in *The Artists' Survival Manual* by Toby Judith Klayman, with Cobbett Steinberg. Pullout versions of the forms are included in *Business and Legal Forms for Fine Artists* and *Business and Legal Forms for Photographers* by Tad Crawford. These resources are listed in the appendix section under "Law."

Of course, an unscrupulous dealer overpowered by greed can always find ways of deceiving both artists and clients even when a sales contract or bill of sale has been used. Once the deed is discovered, however, it is much easier to go to court with a good contract in hand than with a handshake or spoken understanding.

Gallery discount policies vary as much as commission policies. A survey of ninety-five commercial galleries in Chicago indicated that 46 percent of the galleries split discounts with artists, 22 percent of the galleries fully absorbed discounts, 2 percent of the galleries required artists to fully absorb discounts, and 30 percent of the galleries either did not address the discount issue or offered miscellaneous comments.[34]

The survey also revealed that galleries that fully absorbed discounts tended to charge artists less of a commission. For example, of the galleries that required splitting discounts, 2 percent charged commissions higher than 50 percent; 73 percent charged commissions of 50 percent; 11 percent charged commissions ranging from 25 to 40 percent; and 14 percent charged varied commissions, but the range was not indicated. Of the galleries that fully absorbed discounts, none charged

commissions over 50 percent; 43 percent charged commissions of 50 percent; 33 percent charged commissions ranging from 25 to 45 percent; and 24 percent charged varied commissions, but the range was not indicated. Galleries that required artists to fully absorb discounts charged commissions of 50 percent.

Discounts on Studio Sales

Awarding discounts on studio sales is another issue about which there is much confusion. Over the years a strange protocol has developed according to which artists are *expected* to offer clients a 50 percent discount on work sold from their studios. It is one of those chicken-or-egg situations: which came first, artists volunteering a 50 percent discount or clients demanding a 50 percent discount because the artwork was not being sold in a gallery or through an agent? Regardless of how this precedent started, it should be abolished with haste.

When a studio sale is imminent, it is easy for an artist, seduced by the excitement of the moment, to abandon powers of logic and reason and succumb to some rather unreasonable requests concerning the terms of a sale, such as granting a large discount. To avoid being caught off guard, vulnerable, or tongue-tied, always keep a price list on hand that states *retail* prices and your *discount policy*. For example, your policy could be the same as that offered to dealers: 10 percent if more than one piece of work is simultaneously purchased, and 10 percent for clients who have previously purchased work.

There are other options, such as offering different discounts to collectors who have previously purchased work and to collectors who are simultaneously purchasing more than one piece. Or you can give discounts based on a sliding scale according to the retail value, say, 10 percent for work priced up to $2,000 and 15 percent thereafter. Or you can have a policy of offering no discounts under any circumstances!

A discount range of 10 to 15 percent provides the flexibility needed to negotiate with clients who insist on a larger discount. Whether or not you acquiesce is a personal decision, but studio discounts should not exceed 25 percent.

Clients who expect a 50 percent discount on studio sales and balk at a lower rate need to be reminded that artists have overhead expenses just like all other businesspeople—and just like art dealers.

Consequently, granting discounts of 50 percent is unrealistic and impracticable.

Unfortunately, within the art world, guidelines regarding discounts do not exist. Much of the time, dealers' policies are based on hearsay or greed, and artists' policies are manifestations of confusion and feelings of powerlessness. But although the results of the Chicago survey[35] illustrated that most galleries require artists to split discounts, some dealers are fair and seem to understand a discount's intrinsic meaning. At least this is a beginning, a beginning that could quickly become a norm if more artists refuse to split discounts, or at least specify the circumstances under which they will agree to this practice.

Set the same high standards for pricing work as you do for creating the work. Do not be afraid to negotiate. The extent to which you compromise is a personal decision and greatly depends on the status of your ego and bank account, and how well you are able to exercise powers of logic.

Odds and Ends

Questions regarding pricing also arise when artists are presented with opportunities to have photographs of their work used in periodicals, annual reports, books, posters, calendars, and other print media. *Pricing Photography: The Complete Guide to Assignment & Stock Prices* by Michal Heron and David MacTavish is an excellent resource for establishing prices for a multitude of situations. Although it is geared for photographers, art directors, and graphic designers, the book can be very helpful to fine artists for establishing prices and fees for various circumstances when a photograph of their artwork is used for commercial purposes.

Closely aligned to the subject of pricing are commissions paid to dealers for the sale of work. This topic is discussed in chapter 8, "Dealing with Dealers and Psyching Them Out." Resources for additional information about pricing can be found in the appendix section "Pricing."

Public Relations: Keep Those Cards and Letters Coming In and Going Out

In the early 1980s, choreographer and artist Laura Foreman and composer John Watts distributed a poster throughout New York City announcing an upcoming collaboration called *Wallwork*. The poster included the dates, place, and times of the performances, as well as a phone number for reservations. However, if you called the number you were informed that there were no seats available and no new names were being added to the waiting list.

The fact was that *Wallwork*, as a dance and music performance, *did not exist*. However, *Wallwork* did exist as a conceptual performance: "a performance which completely emancipated itself from the performance medium. What you see—the poster, the sign, the image, the expectation, the media fantasy—is what you get."[36]

Wallwork could have quietly taken place, its purpose and existence known only to the artists who conceived it. But in order for *Wallwork* to achieve optimum effectiveness, its message had to reach a large audience. So, as posters were being distributed, Foreman and Watts sent out a special news release to members of the press, defining *Wallwork* and its purpose:

> WALLWORK aborts the audience's expectations and critiques the medium of performance while using it; . . . creates a found audience of thousands of people—all those who pass by the posters become participants in the (conceptual) creation of the performance.

WALLWORK asks questions such as these: Is art what the artist says it is? Is it publicity or is it "art"? Is art beckoning you into a vacuum? What is the nature of performance? Do the fantasies of artists feed the expectations of an audience? Who is the audience? Why do people most desire that which they can't have? How does an artist "perform"? After a performance, is there anything left? Can an artist create a performance of the mind?[37]

Although it was not the intention of the artists to use *Wallwork* as a self-promotion vehicle, publicity was a key part of the performance and a key to making it a success. Several newspapers in New York covered the story, including *The New York Times*. Critic Jack Anderson wrote:

The final paradox of a paradoxical situation is that *Wallwork*, a non-existent dance, is more interesting than many dances that do exist. It stimulates thought. It conjures up ideas. And one does not have to sit through it in an airless studio on a hot night. One can think about it at leisure. *Wallwork*, though something of a hoax, has its own strange validity.[38]

Many artists are offended by self-promotion because they believe it taints their work and self-image. Others are offended by some forms of publicity but accept other forms that they consider in good taste. Still others are averse to publicity only because they are not receiving it. And some artists are offended by self-generated publicity but do not question publicity generated by an art gallery, museum, or organization on their behalf. Often, in such cases, an artist does not believe that the gallery, museum, or organization is doing enough.

Writer Daniel Grant gives two perspectives on the publicity issue:

Publicity has become a staple in the art world, affecting how artists see themselves and how dealers work. On its good side, this publicity has attracted increasing numbers of people to museums and galleries to see what all of the hullabaloo is about and, consequently, expanded the market for works of art. More artists are able to live off their work and be socially accepted for what they are and do.

On the other hand, it has made the appreciation of art a bit shallower by seeming to equate financial success with artistic

importance. At times, publicity becomes the art itself, with the public knowing that it should appreciate some work because "it's famous," rather than because it's good, distorting the entire experience of art.[39]

The questions that Grant raises about what constitutes art appreciation and good art and what distorts the art experience have been asked for hundreds of years, many years before the great media explosion came into being. They are questions that will continue to be debated and discussed, within the context of publicity and without. In the meantime, this chapter will discuss basic public-relations tools and vehicles for developing an ongoing public-relations program for your career.

Public appearances, demonstrations, and lectures are vehicles that offer excellent exposure and can also provide income. They are discussed in chapter 10, "Generating Income: Alternatives to Driving a Cab."

THE PRESS RELEASE

A press release should be written and used to announce and describe anything newsworthy. The problem, however, is that many artists are too humble or too absorbed with aesthetic problems or the bumps of daily living to recognize what about themselves is newsworthy, or they view the media as an inaccessible planet that grants visas only to Barbara Kruger and Roy Lichtenstein.

A press release should be issued when you receive a prize, honor, award, grant, or fellowship. It should be issued if you sell your work to an important local, regional, national, or international collector. Use a press release to announce an exhibition, regardless of whether it is a single show in a church basement or a retrospective at the Whitney Museum or a group exhibition where you are one of two or one of one hundred participants. A press release should be issued to announce a slide and lecture show, demonstration, performance, or event. It should also be issued to announce a commission.

In addition, a press release should be issued after you have lectured, performed, demonstrated, exhibited, or completed the commission.

Some publications are primarily interested in advance information, but others are interested in the fact that something took place—what happened; what was seen, said, and heard; and who reacted.

A press release should also be issued if you have a new idea. New ideas are a dime a dozen, particularly if you keep them to yourself. What might seem humdrum to you could be fascinating to an editor, a journalist, a host of a radio or television interview program, or a filmmaker looking for a subject. Personality profiles also make their way into the news.

Why Bother?

Press releases can lead to articles about you. Articles can help make your name a household word, or at least provide greater recognition. Articles can lead to sales and commissions. Articles can lead to invitations to participate in exhibitions or performances, and to speaking engagements. Articles can help you to obtain fellowships, grants, honors, and awards.

Keep in mind that recipients of a press release should not be limited to national art trade publications. Certain consumer publications and television programs should also be included in your mailing list. This point is well taken by Shannon Wilkinson, a public-relations specialist in the arts:

> There is an entirely new generation of art consumer in the U.S., and its members do not read art magazines or critical reviews. The birth of the blockbuster exhibition in the 1970s educated an entirely new audience of art consumers. These baby boomers, who were entering college when the visual arts were thrust into the popular media through blockbusters, and corporate support of the arts, are now approaching their 40s. They are the largest segment of new home buyers in America. They are making money. They read popular consumer magazines. And, they watch television. Artists need to think beyond the traditional art media for coverage, increased visibility, and sales. Besides television, popular four-color magazines, and high-circulation daily newspapers throughout the country, have more general arts coverage—artists' profiles, features, and soft stories—than ever before.[40]

Resources for obtaining arts press and consumer press mailing lists are included in the appendix sections "Mailing Lists" and "Press Relations and Publicity."

Press releases that I wrote and distributed concerning some of my own projects generated articles in *The New York Times, Life, Art Direction, Today's Art, Architectural Forum, House and Garden, Playboy, New York, The Washington Post,* and *Progressive Architecture,* and syndicated articles in more than one hundred newspapers throughout the United States (via the Associated Press and United Press International). In Europe, my press releases generated articles in the *International Herald Tribune, Paris Match, Der Spiegel, Casabella,* and *Domus.* These articles then generated invitations to exhibit at museums and cultural centers throughout the United States and in Europe. In addition, some articles led directly to commissions and sales.

An excellent way of keeping track of whether your press release was reprinted, or whether you were mentioned or featured in publications, is to use a clipping service. For a reasonable fee, a clipping service will monitor specific geographic regions and send you copies of articles that mention your name. The names of clipping services can be found in the Yellow Pages under "Clipping Bureaus."

A press release has many uses. The material it contains *does not have to be published to generate a response.* For example, a press release can lead to an invitation from a curator to participate in an upcoming theme show. It should be sent to people on your mailing list who have expressed interest in your work, have purchased your work, or are representing your work in some capacity. This *internal* use of a press release can bring tangible and intangible rewards by basically reminding people that you exist and that your career is moving forward.

Dos and Don'ts

A press release should tell the facts but not sound like Sergeant Friday's police report. It should whet the appetite of the reader, inspire a critic to visit the show, inspire an editor to assign a writer to the story, inspire a writer to initiate an article, inspire television and radio stations to provide coverage and interviews, and get dealers, curators, collectors, influential people, and the general public to see the exhibition or event.

The fact that an exhibition or event is taking place is not necessarily newsworthy. What the viewer will see and who is exhibiting can

be. A press release should contain a *handle*, a two-sentence summary that puts the story in the right perspective. A handle does not necessarily have to have an aesthetic or intellectual theme. It can be political, ethnic, scientific, technological, historical, humorous, and so on. Editors and writers are often lazy or unimaginative about developing handles. Give them some help.

Although a reporter might not want to write an article exclusively about you or your show, your handle might trigger a general article in which you are mentioned.

Press releases have an amazing longevity. Writers tend to keep subject files for future story ideas. Although your release could be filed away when it is received, it could be stored in a subject file for future use. My releases have resulted in articles or mentions in books as much as six years after they were issued!

If writing is not your forte, do not write a press release. Get someone to do it who is good with words, understands the concept of handles, likes your work, and finds the experience of writing in your behalf enjoyable. *You serve as editor.* Too often artists are so excited about a press release that they relinquish control of its content and let a description pass that understates or misinterprets their intentions. On its own, the press has a field day in this area. It does not need any encouragement.

Many artists believe that they do not have anything to say. Use a press release to articulate your thoughts about your work and motivations (see "Artist Statements," page 51). Learning to do so is particularly useful for preparing grant applications and for face-to-face encounters with people who are in a position to advance your career. It is also a good way to prepare for interviews.

A press release should be written in an appropriate journalistic style so that it can be published verbatim. In fact, many press releases that meet professional standards are published word-for-word in newspapers and magazines. "Meeting professional standards" means that your press release is grammatically correct and contains no spelling or typographical errors. It should be free of critical content or boastful prose about your work. Although it is completely acceptable to include a quote or quotes from critics and art world personalities that praise your talents, this type of information should appear *in quotation marks* along with the name of the quoted source. It should also be free of flat sentences that are empty in content such as the popular phrase that all too often appears at the very beginning of some press

releases: "The Ajax Gallery is pleased to present the work of John Doe." And as a courtesy to editors, a press release should be double-spaced so that, if necessary, it can be easily edited.

Do not use a press release to exercise your closet ego or show off your academic vocabulary. Who wants to read a press release with a dictionary in hand? Avoid using art criticism jargon and long sentences that take readers on a wild-goose chase. Writing over the heads of readers is guaranteed to breed intimidation. This kind of release ends up being filed under "confusion"—in the wastebasket. Here is an example:

> The . . . exhibition presents the work of six differently motivated artists. . . . They each arrive at their own identity through an approach based on the dynamic integration inherent in the act of synthesis, synthesis being the binding factor which deals comprehensively with all the other elements involved in the creative process, leading ideally to an intuitively orchestrated wholeness which informs both the vision and the process.[41]

What to Include

The headline of the release should capture the handle and announce the show, award, commission, or event.

The average arts-related press release that I receive is destined for the wastebasket because it loses my attention in the first paragraph. For example: "A group exhibition featuring the work of sixteen abstract artists opens at Highgate Gallery on June 1, 1997. The exhibition features paintings, drawings, and sculpture." Although this opening paragraph provides basic information, it does not spur interest in attending the show, except perhaps for the sixteen artists' parents, relatives, and friends.

The first paragraph should contain the handle; use strong sentences that capture reader interest. For example:

> Imagine dirigibles hovering over the World Trade Center or a NASA space shuttle parked on your block. These events would never happen in real life unless, of course, they were a project of an ambitious sculptor. Even then, the construction would be very daring if not too costly; however, The Rotunda Gallery's new show, "Sculptor's Drawings," provides sculptors with the opportunity to indulge such fantasies.[42]

In 1979, during performances, New York artist Francine Fels began sketching Alvin Ailey's dance "Revelations." "It had such an ongoing magical effect that I wanted to hold the moment forever, to make the experience constantly alive and give its impact permanency," said the 65-year-old artist. Six years later, Fels completed fifty paintings based on hundreds of her sketches.[43]

So profound is a grain of sand that some people continue to see worlds within these particles of ancient rock. This experience applies to the recent wall reliefs by Lydia Afia, entitled "BEHIND GLASS: Windows of Fallen Light," on exhibition January 4th through 20th, 1988, in the windows of Tiffany & Company.[44]

The lead or second paragraph should also contain information known in journalism as the "five *Ws*": who, what, when, where, why, and sometimes how.

Subsequent paragraphs should back up the first paragraph. They should contain quotes from the artist and, when possible, from critics, writers, curators, and others. Let them toot your horn; it is more effective.

A short biography should also be included (see "Biographies," page 50). The biography should highlight important credits such as collections, prizes, awards, fellowships, exhibitions, and other significant accomplishments. In addition, it can mention where you were born and/or where you went to school.

Letterhead

When possible, a press release should be issued by the sponsor of your exhibition, event, prize, award, or commission. If the sponsor routinely issues press releases, provide the sponsor with resource materials including an artist statement (see page 51), a biography (see page 50), a résumé (see page 43), and, if available, press excerpts about your work (see page 50). If the press release focuses on an upcoming exhibition, provide a description of the work that will be included in the show. If the press release focuses on a commission, provide a description of the project. Ask the sponsor to provide you with a draft of the press release before it is issued.

However, if the sponsor does not issue press releases, request permission to use its letterhead with an understanding that the sponsor

can approve the final copy. The release should include, as a courtesy, a paragraph about the sponsoring organization or gallery—for example, a historical sketch and a description of its activities or purpose.

If the sponsor does not have a qualified person to handle public relations, provide your name and home telephone number and identify yourself as the press contact. To determine whether the sponsor's public-relations representative is qualified, use the following criteria: the person is willing to cooperate and is not threatened by your aggressive pursuit of good press coverage; you have a good rapport with the person; and he or she *really* understands your work.

If you are unable to use the sponsor's letterhead, issue a press release using your own stationery, and identify yourself as the press contact.

Press Kits

In many ways a press kit is similar to presentation packages that are described in chapter 3 (beginning on page 43). It is a package of material that is usually enclosed in a sturdy folder with pockets. It includes, for example, a biography; a glossy 5-by-7-inch or 8-by-10-inch photograph of the artist with caption and photo credit; a glossy 5-by-7-inch or 8-by-10-inch black-and-white and/or color photograph(s) of your work with captions and photo credits; if available, a brochure (see page 58); copies of articles by you or about you; copies of reviews that you have received; a quote sheet with press excerpts; and a business card.

A press kit is a flexible tool that can be adapted for many purposes. For example, it can be used to publicize an exhibition, performance, or commissioned project. It can also be used to publicize a lecture series or workshop (see page 191). If a press kit is being used to publicize a particular event, it should include a press release (see page 78) devoted to that event. The press release can also be used to help generate a feature article about you and your work.

A press kit is not intended to be sent to everyone on your mailing list. For example, the press list that I make available to artists (see appendix section "Press Relations and Publicity") contains more than 280 names of national and regional art and consumer publications and television and radio contacts. Because of the focus or format limitations of the publication and broadcast media, it would not be ap-

propriate to send everyone on the mailing list a press kit. Deciding who should receive a press kit depends on the goals you want to accomplish. It also depends on the suitability of publication or broadcast media. In most cases, a list of prime contacts can be narrowed down to twenty to twenty-five names.

If the press kit is being used to generate publicity about a particular event or if it is being used to generate interest in a feature article about you and your work, it should be accompanied by a special cover letter known as a "pitch letter" (see below).

Other Types of Promotion Packages

Most of the names on your mailing list should receive a basic promotion package that contains an exhibition announcement and a press release. Although many artists only send out an exhibition announcement, accompanying it with a press release is very important, particularly when contacting people who are unfamiliar with your work.

The basic promotion package can be enhanced and customized for specific markets. For example, along with the press release and exhibition announcement, you might want to send photographs, slides, and/or a brochure (see pages 55 to 63) to a select group of critics and curators.

Pitch Letters

Pitch letters are easier to compose after a press release has been written because it can incorporate the "handle" (see page 81) that has been prepared for the press release. To illustrate this point, excerpts from a press release succeeded by a pitch letter follow:

"CHOCOLATE THROUGHOUT THE LAND!"

FEATURING ARTIST PETER ANTON

OPENS AT THE BRUCE R. LEWIN GALLERY,

NEW YORK CITY

The United States ranks 10th in chocolate consumption with the average American consuming approximately ten pounds a year. Artist Peter Anton's passion for chocolate far exceeds the national average. Through his sculptures he pays homage to his addiction by dedicating his next one-person exhibition to "the food of the gods"

at the Bruce R. Lewin Gallery in Manhattan. Entitled CHOCOLATE THROUGHOUT THE LAND! the exhibition opens on April 26, 1996.

"Chocolate is rich in taste and equally rich in history," said Anton, pointing out that the Aztec Emperor Montezuma drank 50 goblets of cocoa a day. Louis XIV discovered chocolate when he was given a wedding gift of cocoa imported from Mexico. He was so enthusiastic he created the official court position of "Chocolate Maker to the King."

"CHOCOLATE THROUGHOUT THE LAND!" will present a selection of familiar chocolate forms that are sculpturally interpreted with ceramic-like plaster material. It will include giant boxes of assorted chocolates, approximately 4' x 3' x 9". The character and properties of each boxed chocolate are portrayed in Anton's sculptures. Some of the candies are randomly pinched or bitten open to reveal various centers including creams, nuts, jellies, and caramels.[45]

The following is a pitch letter that evolved from the press release:

Dear (name of editor):

The United States ranks 10th in chocolate consumption with the average American consuming approximately ten pounds a year. My passion for chocolate far exceeds the national average. I am an artist and through my sculptures I pay homage to my addiction by dedicating my one-person exhibition at the Bruce R. Lewin Gallery in Manhattan to "the food of the gods." Entitled CHOCO-LATE THROUGHOUT THE LAND! the exhibition opens on April 26, 1996. I believe the exhibition will be of interest to your readers.

Chocolate is rich in taste and equally rich in history. For example, the Aztec Emperor Montezuma drank 50 goblets of cocoa a day. Louis XIV discovered chocolate when he was given a wedding gift of cocoa imported from Mexico. He was so enthusiastic he created the official court position of "Chocolate Maker to the King."

"CHOCOLATE THROUGHOUT THE LAND!" will present a selection of familiar chocolate forms that are sculpturally interpreted with ceramic-like plaster material. It will include giant boxes of assorted chocolates, approximately 4' x 3' x 9". The character and properties of each boxed chocolate are portrayed in my sculptures. Some of the candies are randomly pinched or bitten open to reveal various centers including creams, nuts, jellies, and caramels.

Enclosed is a press release that describes all of the work that will be featured in the exhibition, and other background materials.

I have participated in exhibitions in museums and galleries throughout the United States, including the Austin Museum of Art in Texas; the Castellani Art Museum in Niagara, New York; the Aldrich Museum of Contemporary Art in Ridgefield, Connecticut; and the Allan Stone Gallery in New York City. I have also had a one-person show at the Henri Gallery in Washington, D.C. This is my second one-person show in New York City.

Please let me know if you require additional information.

Sincerely,
Peter Anton

Keep in mind that if you are preparing a pitch letter to entice a publication or television program to do a feature story about your work (when an exhibition, performance or other event is not the focus), a pitch letter can be sent without an accompanying press release. However, it would be appropriate to include other support material, such as a press kit, with the pitch letter.

Additional sources of information about press releases, press kits, and pitch letters can be found in the books *Six Steps to Free Publicity* by Marcia Yudkin and *Fine Art Publicity: The Complete Guide for Galleries and Artists* by Susan Abbott and Barbara Webb and in other publications that are listed in the appendix "Press Relations and Publicity."

PUBLICITY FOR UPCOMING EXHIBITIONS AND PERFORMANCES

If you are invited to exhibit or perform, do not rely or depend on the sponsoring organization to do your public relations. Create an auxiliary campaign (which might end up being the primary campaign). Try to persuade the sponsor to cooperate with your efforts. If the sponsor agrees to collaborate, volunteer and *insist* on overseeing the administration.

Doing your own public relations or taking control of the sponsor's operation is important because of the following: (1) For various illogical

reasons, sponsors can be lax, disorganized, and unimaginative in the public-relations area. Many sponsors do not realize that if they develop an effective, ongoing public-relations program they not only promote their artists but also make their institution or gallery better known—both of which can offer prestige, and financial rewards in the present and future. (2) If you are in a *group* show or performance, the sponsor will probably issue a "democratic" press release, briefly mentioning each participant, but little more. Your name can get lost in the crowd. Sometimes participants are not even mentioned. (3) Sponsors' mailing lists are usually outdated and full of duplications, and very few lists show any imagination for targeting new audiences. (4) Sponsors can be negligent in timing press releases and announcements so that they coincide with monthly, biweekly, weekly, and daily publication deadlines. Sometimes they do not take advantage of free listings, or if they do they send only one release prior to the opening of the exhibition or performance, even though the show runs for several weeks.

Designing Announcements

A few years ago Braintree Associates of New Jersey, a company that uses Jungian symbolism in fund-raising, placed a small broken-egg symbol on a direct mail solicitation to raise money for a charitable organization. As a result, the dollar amount of contributions its client received increased 414 percent. The broken egg was not mentioned in the fund-raising letter, and, according to a follow-up poll, donors claimed not to have noticed it.

Each month I receive hundreds of exhibition announcements from artists nationwide. But the vast majority of communiqués contain neither a subliminal nor a conscious message that would stimulate my interest in attending the show or inspire me to pick up the phone to request additional information.

This is not to suggest that symbols of broken eggs should be incorporated into exhibition announcements, but the results of the Braintree campaign illustrate the importance of visual information in getting a message across.

The use of exhibition announcements as an extension of an artist's creativity and very special way of looking at the world is all too often a neglected aspect of public relations. For various reasons, artists, curators, dealers, and other exhibition sponsors do not analyze the pur-

pose of an announcement, the results it should achieve, or what it should communicate.

There is a direct correlation between announcement design and exhibition attendance. Well-executed announcements can stimulate interest in an exhibition, and the more people that are in attendance, the greater the chances are of increasing sales and commission opportunities. Creative announcements can also generate press coverage and invitations for more exhibitions.

Generic invitations, those that omit visual information and merely list the name(s) of the artist(s), exhibition title, location, hours, and dates, are frequently used for group exhibitions to resolve the problem of selecting one piece of work to represent all of the exhibiting artists. A generic solution may also be used because some artwork is not photogenic and loses its power when reproduced in photographic form. But the most common reason generic announcements are used is to save money.

Granted, generic announcements are less expensive than four-color cards, but a successful announcement does not need to be in color or contain a photograph of actual work. For example, for an exhibition entitled *Reflections*, organized as a memorial to artist Jane Greengold's father, a square of reflective paper was attached to a card accompanied by a text describing *reflections* as a metaphor for her feelings and thoughts after her father's death.

For an exhibition entitled *Paintings at the Detective Office*, artist Janet Ziff's announcement contained a drawing of a mask to which two actual sequins were attached.

Taking a more minimal approach, for the exhibition entitled *Lost Watches*, artist Pietro Finelli's announcement contained only basic who, when, and where information, but the intriguing exhibition title and text were printed in silver ink on a thick piece of gray cardboard that was pleasurable to read and touch.

To announce the group exhibition at the Educational Testing Service in Princeton, New Jersey, entitled *Myth America: Selling the American Woman: Through Her, to Her, and Short*, artist Debora Meltz, who also served as the show's curator, designed a black-and-white announcement shaped as a reminder tag for a doorknob, with a string inserted into the hole.

In each of the above examples, without using photographs of actual exhibition artwork or costing a lot of money, the invitation did

more than announce a show. Each invitation also gave the recipient a sense of the artist, and was in itself an *invitation to respond to the artist's message* with intellect, humor, compassion, pleasure, or whatever emotions and sensations were evoked.

Exhibition announcements should be given tender loving care. Cutting corners might ease time and money pressures in the short run, but short-term thinking can backfire. Boring publicity tools usually bring boring results.

Advertisements

Dealers pour thousands of dollars into advertising each year. "The art magazines . . . are publicity brochures for the galleries, sort of words around the ads, and [they create] total confusion between editorial and advertising," observes writer and critic Barbara Rose. "The only way you can really get your statement, your vision, out there to the public is to put it up on the wall. And to be willing to be judged."[46] If Rose's observation is correct, and I am convinced it is, it implies that whoever is buying or exhibiting art on the basis of seeing it published in art magazines cannot differentiate between a paid advertisement and a review or article. Thus, everything that is in print becomes an endorsement.

But according to Nina Pratt, a former art-market advisor, many dealers are misguided when choosing advertisement content and design and when selecting publications where advertisements are placed. She criticizes the use of "tombstone" ads, those without visual information (what I have referred to as generic advertising), and she believes that many galleries lack an overall or specific advertising strategy and rarely employ important target marketing concepts. Dealers repeatedly place ads in the same art periodicals without analyzing whether the readership is actually the primary market or the only market a gallery wants to reach. There is an excellent potential market in non-arts-related publications. For example, a dealer who already has collectors from the business community, or wants to develop such a clientele, would find it advantageous to advertise in publications that businesspeople read, such as the *Wall Street Journal*.[47]

If you have to pay for your own advertising space to announce an *exhibition*, think twice about spending your money. (Paid advertising to announce a performance or event for which tickets or reservations

are required is entirely different). Unless you are willing and able to buy multiple ads, month after month, bombarding the public and art world with your name (just as an ad agency launches a campaign to promote Brand X), I am not convinced that paid advertising is a worthwhile investment for an *individual artist*.

In recent years an unfortunate precedent was established with galleries requiring artists to split the cost of an advertisement or pay the entire amount. In most instances galleries have a monthly contract with one or two art trade publications. Therefore, an ad *with the gallery's name* appears month after month. The gallery benefits from the name repetition, but an artist, whose name only appears once in an ad (during the one month the exhibition is up), derives no benefit from the multiple-insertion approach.

However, if you have no qualms about participating in bribery, sometimes an ad will guarantee that your show will receive editorial coverage. Some of my clients have had firsthand experience in this area. For example, a sculptor telephoned a weekly New York paper about getting press coverage for a group exhibition. She was transferred from department to department until someone in advertising told her that if she bought a display ad there was a good possibility the show would be covered. Another client was approached by the editor of an art publication after he had written an excellent review of her work. He asked her for a payoff. Instinct told her no, and she politely turned down his request, but she had many misgivings about whether she had done the right thing.

On the other hand, if your gallery or sponsor is willing to buy advertising space in your behalf, by all means tell them to go ahead. As I previously mentioned, many galleries have annual advertising contracts with arts publications (and some publications make sure that their advertisers are regularly reviewed, a corrupt but accepted practice).

For additional thoughts and ideas about paid advertising, the sections "Advertising," "Choosing Media," and "Ad Content" in Nina Pratt's book *How to Find Art Buyers* provide excellent insights and tips (see the appendix "Career Management, Business, and Marketing").

Step by Step

The following schedule is based on a six-month time period. Not everyone has six months to plan a public-relations campaign. If you

have a year, spread the responsibilities accordingly, but don't start the two-month or three-week plan (for example), until two months or three weeks before the actual opening. If you have only a month to get your plans together, the schedule will have to be condensed, but do not eliminate the following tasks.

SIX MONTHS BEFORE OPENING

ESTABLISH A PUBLIC-RELATIONS BUDGET. Find out what the sponsor is doing about public relations so that your efforts are not duplicated. Try to coordinate efforts. Make it clear what the sponsor is paying for and what you are paying for. Budgetary considerations should include postage, printing (press releases, press kits, photographs, duplication of mailing lists, invitations, posters, catalogs, or any other printed materials), and the cost of the opening. If you are involved in a group show, try to coordinate your efforts with other participants. If the sponsor has little money to appropriate toward public relations, take the money out of your own pocket. Don't skimp. But squeeze as many services out of the sponsor as possible (administrative, secretarial, and clerical assistance; photocopying; use of tax-exempt status for purchasing postage, materials, and supplies).

PREPARE MAILING LISTS. (See "Mailing Lists—The Usual and Esoteric," page 24.) Study the mailing lists and decide how many press releases, invitations, posters, and catalogs you need. Information listed under "Two Months Before Opening," "Three Weeks Before Opening," and other time frames will help you ascertain who should get what.

WRITE A PRESS RELEASE. (See the section "The Press Release" earlier in this chapter.)

WRITE FREE-LISTING RELEASES. Many publications offer a free-listings section. Special releases should be written for these publications and a listings release should be sent to the attention of each publication's listings editor. Free-listings columns use very few words to announce an event. Therefore, your release should contain the basic who, what, where, and when information. Why and how can be included if you can succinctly explain them in one or two short sentences. Otherwise, the description will not be used. Several free-listings releases might be

necessary. Write a release for each week the event will take place. For example, if the exhibition or performance is for four weeks, write four listings releases and date each release with the date you wish to have the free listing appear. These dates should correspond to the publication's cover-date schedule.

DETERMINE THE CONTENTS OF PRESS KITS AND PROMOTION PACKAGES. (See the sections "Press Kits" and "Other Types of Promotion Packages" earlier in this chapter.) Determine the materials to include in the press kit. Also select the names on your mailing list to which to send press kits and those to which to send promotion packages.

COMPOSE A "PITCH LETTER" AND WRITE COVER NOTES. (See the sections "Pitch Letters" and "Other Types of Promotion Packages" earlier in this chapter.) Compose a pitch letter for appropriate members of the press to accompany a press kit or a promotion package. Accompany the press kit and promotion package with a short note to a select group of people with whom you have been in contact. Remind them of who you are and where you met or how you know them, and tell them that you hope they can attend the exhibition.

PLAN AND DESIGN INVITATIONS, POSTERS, AND CATALOGS. (See the section "Designing Announcements" earlier in this chapter.)

SELECT PHOTOGRAPHS OF YOUR WORK. Choose photos that you want disseminated to the press (see "Slides and Photographs," page 55). Publications require glossy 8-by-10-inch or 5-by-7-inch photographs. If a publication uses both color and black-and-white photographs, send a selection of both types. Many free-listings columns and gallery guides also publish photographs, so include these publications in your photo mailing.

RESOLVE THE ISSUE OF PAID ADVERTISEMENTS. (See the section "Advertisements" earlier in this chapter.) If you are planning to buy advertising space, decide on the publication(s) and obtain all of the relevant information pertaining to closing dates for text and artwork.

PREPARE A MAILING SCHEDULE. Decide who gets what and when. You may use the following guidelines to help establish the exact mailing dates,

but it is important to check with the publications to confirm their closing-date schedules.

FOUR MONTHS BEFORE OPENING

GO TO PRINT. Print photographs and press releases.

MAIL PROMOTION PACKAGES TO MONTHLY PUBLICATIONS THAT HAVE A THREE-MONTH LEAD. Send pitch letters with press kits and other promotion packages to select monthly publications so that they will be able to cover your exhibition or performance *prior to the opening and/or while the exhibition or performance is in progress.* For this type of press coverage, monthly publications usually have a deadline of three months before the cover date, but check with each publication. (Invitations and press releases to critics and staff members of *monthly* publications that *review* work should be sent *three weeks* prior to the opening.)

THREE MONTHS BEFORE OPENING

GO TO PRINT. Print invitations, posters, catalogs, and any other printed matter that you are using.

MAIL PROMOTION PACKAGES TO MONTHLY PUBLICATIONS THAT HAVE A TWO-MONTH LEAD. Send pitch letters with press kits and other promotion packages to select monthly publications so that they will be able to cover your exhibition or performance *prior to the opening and/or while the exhibition or performance is in progress.*

ONE MONTH BEFORE OPENING

SEND PROMOTION PACKAGES TO WEEKLY PUBLICATIONS.

SEND LISTINGS RELEASES TO WEEKLY PUBLICATIONS. Also send photographs to the publications that publish photographs in their listings sections.

THREE WEEKS BEFORE OPENING

SEND PROMOTION PACKAGES TO EVERYONE ELSE ON YOUR LIST. Include critics, curators, art consultants, gallery dealers, collectors, friends, and staff members of monthly, weekly, and daily publications that review shows. If appropriate, send cover notes.

SEND SECOND LISTINGS RELEASES TO WEEKLY PUBLICATIONS.

TWO WEEKS BEFORE OPENING

SEND PROMOTION PACKAGES TO DAILY PUBLICATIONS.

SEND PROMOTION PACKAGES TO RADIO AND TELEVISION STATIONS.

SEND THIRD-LISTINGS RELEASES TO WEEKLY PUBLICATIONS.

ONE WEEK BEFORE OPENING

SEND FOURTH-LISTINGS RELEASES TO WEEKLY PUBLICATIONS.

Press Deadlines

The above schedule is a general guide, and it is very important to check with the various publications regarding their copy deadlines. For example, some weeklies require listings releases to be submitted ten days before an issue is published, while other weeklies have deadlines as much as twenty-one days before publication.

*O*PENINGS

Many artists would rather have open-heart surgery than go to their own openings, or to any openings for that matter, and many guests feel the same way. Most openings are lethal: cold, awkward, and self-conscious. But they don't have to be that way. You worked hard to open. Your opening should be your party, your celebration, and your holiday. Otherwise, why bother?

Do not look at the opening as a means to sell your work or receive press coverage. If it happens, great, but many critics boycott openings, and rightfully so, for with all of the people pressing themselves against the walls (hoping they will be absorbed in the plaster), how can anyone really see the art? And many serious buyers like to spend some quiet time with the work, as well as with the artist and dealer, and an opening is not the time or place to do it. Some openings are planned around a lot of booze to liven things up, and while things can get peppy, often in the high of the night people make buying promises they don't keep.

When the exhibition *11 New Orleans Sculptors in New York* opened at

the Sculpture Center, the eleven New Orleans artists surprised their guest with a creole dinner. It was an excellent opening, and some of the best openings I have attended (including my own) involved the serving of food (other than cheese and crackers). The menus were not elaborate, but something special, which indicated that the artists actually liked being there and liked having you there; that the artists were in control and were "opening" for reasons other than that it was the expected thing to do. In addition, the breaking of bread among strangers relieved a lot of tension.

Choreograph your opening and be involved in the planning as much as possible. Not all dealers are willing to relinquish control and try something new, but push hard. The opening shouldn't be a three-ring circus structured for hard sell with a little goodie (glass of wine) thrown in as a fringe benefit. This is your show, and the opening should be structured accordingly.

CRITICS AND REVIEWS:
THEIR IMPORTANCE AND IRRELEVANCE

"All these years . . . I had assumed that in art, if nowhere else, seeing is believing. Well—how very shortsighted!" wrote author Tom Wolfe. "Not 'seeing is believing' . . . but 'believing is seeing,' for *Modern Art has become completely literary: the paintings and other works exist only to illustrate the text.*"[48]

Pontificating about art is not a new phenomena. The smug and pretentious prose that is published in magazines, newspapers, and catalogs has become a norm in art-world communication.

In 1986, *The New Yorker* published an interview with Ingrid Sischy, who was then the editor of *Artforum*. The interview was conducted by *The New Yorker* staff writer Janet Malcolm. Said Sischy:

> Even now, if I wasn't forced to edit them I probably wouldn't read some of the things we publish. . . . It's always been a problem, this troublesome writing we print. . . . That is probably why I was brought in as editor—because I found much of *Artforum* unreadable myself. . . . An object lesson I keep before me all the time is that of my mother, who picks up *Artforum*, who is com-

pletely brilliant, sophisticated, and complex, who wants to understand—and then *closes* it.[49]

"[Criticism] adopts its own mechanistic modes," wrote art critic Nancy Stapen, "and all too often produces its own sectarian dialect, resulting in the sort of obfuscated, impenetrable verbiage that, as we have seen, even a mother cannot love."[50]

Through layers of verbose ramblings, filled with obscure meanings, symbols, and theories, art is stripped of its own visual language. And although most artists agree that this form of writing is incoherent and repulsive, many artists would not be averse to having their artwork dissected in the press in a similar manner. Even gibberish is viewed as a source of validation!

Although not all critics choose to write in a style of opaque discourse, the emphasis on the importance of being reviewed has grown out of proportion to the intrinsic value of art criticism.

Granted that some artists have gained more "recognition" as a result of their work being praised by the arts press, there is an unfounded perception among artists that having an exhibition reviewed is tantamount to career success.

Critic and curator John Perrault comments:

> I know that artists in general will do almost anything to get a review. I have had artists tell me, "Please write about my show. I don't care if you hate it but write something about it." It's very important for artists to have that show documented in print somehow. Often artists don't think that they exist unless they see their names in print.[51]

The fact of the matter is that an artist can have a substantial and sustaining career with or without reviews.

Artists are not alone in equating reviews with career success. Some dealers, curators, and collectors don't think an artist exists unless the artist's name is in print.

Recognizing that the art world contains a preponderance of insecure individuals who depend on the printed word to form their opinions or convictions about artwork and to decide whether or not you're a good bet and someone to watch in the future, artists should consider

the pursuit of a review a *routine* task using some of the public-relations channels suggested in this chapter. *Pursuing a review is not worthy of obsession.*

My own good breaks came from several different circles: insecure people with power, secure people with heart, and those with both heart and power. Ultimately, I have to take credit for putting this kind of constellation together because dealing with the review system also means putting together a backup system so that *your career can flourish with or without reviews.*

MAKING NEW CONTACTS AND KEEPING IN CONTACT

Making new contacts and keeping in touch are very important aspects of public relations. Establishing new contacts and reviving old contacts can begin with a few first-class stamps.

It is also important to keep your contacts warm and remind people that you exist. For example, at my urging, a client who was literally destitute, out of work for several months, and being evicted from his apartment contacted a music critic at *The New York Times*. Two years before, the critic had written a highly enthusiastic and flattering review about the musician. He reminded the critic of who he was and laid on the line his current dilemma. Consequently, the critic was instrumental in finding the musician work, which not only helped him over a huge financial crisis, but also helped him restore faith in himself, in his work, and in humanity.

Set aside time each week to make new contacts, by using the telephone or sending presentation packages and letters to solicit and generate interest in you and your work. The more contacts you make, the greater the chances that you will find yourself at the right place at the right time.

Do not underestimate the value of this phenomenon. For example, a sculptor who had recently moved to New York from the West Coast asked me to assist her with contacts. I provided her with a list of exhibition spaces that I thought would be interested in her work. The first alternative space she contacted immediately accepted her work, as it precisely fit into the theme of an upcoming show. Both the sculptor and the show received excellent reviews. The sculptor was then invited to participate in a group exhibition at a museum (as well as an-

other alternative-space gallery); a dealer from a well-known gallery saw the museum show and singled out the sculptor and invited her to exhibit at his gallery. This all took place in less than three months!

Once a rhythm is established for a consistent approach to public relations, the job becomes easier and less time-consuming. The letter that once took you hours to compose will become a snap. And if you keep up on your homework (see "Read, Note, File, and Retrieve," page 22), you will never exhaust the list of people, organizations, and agencies to contact.

Keeping in Touch

There are many ways to keep in touch. Press releases and exhibition/performance announcements are two such ways. But there are other vehicles. One sculptor sends a newsletter a few times a year to collectors, people who have expressed interest in his work, and people in the art world whom he knows personally. The newsletter announces upcoming exhibitions and recaps recent activities.

Another artist recycled a postcard featuring a color photograph of a painting, which had been used as an exhibition invitation, to announce a grant she had received from a private foundation. The postcard was sent to collectors, various art-world associates, and dealers with whom she had been in contact.

The use of an internal press release described earlier in this chapter (see page 80) is another effective way of keeping in touch. It can bring tangible and intangible rewards by reminding people that you exist and that your career is moving forward.

The Law of Averages

One of the most important factors about the effectiveness of public relations and marketing is that it is based on the *law of averages*. Regardless of your talents, abilities, and vision as a fine artist, no one will know about you unless you contact many people and do it on a continuing basis. The more contacts you make (and reestablish) and the more opportunities you create to let people know that you and your work exist, the greater the chances that events and situations will occur that accelerate your career development.

As previously mentioned, a presentation package that is based on a brochure generally produces a 6–14 percent response; a slide package averages around a 2 percent response. Much less predictable is the

response rate of a press release that is targeted to generate press coverage. But what is predictable is that if you do not issue a press release, it is unlikely that press coverage will transpire!

Each time you receive a letter of rejection (or of noninterest), initiate a new contact and send out another package. The "in and out" process feeds the law of averages and increases your chances of being at the right place at the right time. It also wards off rejection and puts it in a healthier perspective (also see chapter 11, "Rationalization, Paranoia, Competition, and Rejection").

6

\mathcal{E}xhibition and Sales Opportunities: Using Those That Exist and Creating Your Own

\mathcal{M}ore than ever before, there are many opportunities to exhibit and sell work. This chapter describes various exhibition and sales markets, including national and international resources, available to artists outside of the commercial-gallery system (which is discussed in the chapter entitled "Dealing with Dealers and Psyching Them Out").

\mathcal{A}LTERNATIVE SPACES

During the 1970s the *alternative-space movement* emerged in reaction to the constrictive and rigid structure of commercial galleries and museums. Artists took the initiative to organize and develop their own exhibition spaces, using such places as abandoned and unused factories and indoor and outdoor public spaces that previously had not been considered places to view or experience art. Some alternative spaces acquired a more formal structure, such as artists' cooperatives, and became institutionalized with tax-exempt status.

Alternative spaces mushroomed throughout the United States under such names as the Committee for Visual Arts, the Institute for Art and Urban Resources, and the Kitchen, all in New York City; the Los Angeles Institute of Contemporary Art; the N.A.M.E. Gallery in

Chicago; the Washington Project for the Arts in Washington, D.C.; and the Portland Center for the Visual Arts in Oregon.

The alternative-space system continues to spread, providing general exhibition and performance opportunities, as well as exhibition opportunities for specific artists. For example, there are alternative spaces dedicated to black artists, women artists, black women artists, Hispanic artists, and artists born, raised, or living in specific neighborhoods of cities. There are alternative spaces dedicated to mixed media, photography, performance, sculpture, and so forth.

When the original alternative spaces were established, their goals were simple and direct: to "provide focus for communities, place control of culture in more hands, and question elitist notions of authority and certification."[52] While on the surface the goals of the newer alternative spaces might appear to be in harmony with those of their predecessors, many, unfortunately, have other priorities. Although some spaces are still being run by artists, others are being administered by former artists who have discovered that being an arts administrator or curator is a quicker route to art-world recognition and power.

Consequently, some alternative spaces are being administered and operated with a hidden agenda that is not in the best interests of artists or the communities they were originally intended to serve. An *alternative elite* has arisen, so it should not surprise an artist that the reception he or she receives when contacting an alternative-space gallery could well be reminiscent of the reception encountered at a commercial gallery.

Of course, there are alternative spaces that remain true to the ethic and purpose of what an alternative space is, and generally the alternative-space system has many good attributes.

The biggest and most important difference between an alternative space and a commercial gallery is that the former is non-profit in intent, and therefore is not in business to *sell* art or dependent on selling for its survival. Basically, its survival depends on grants and contributions, which impose another kind of financial pressure. But within the pressure of having to sell what it shows, the alternative space is able to provide artists with exhibition space and moral support, and feature and encourage *experimentation* (a work that can cause cardiac arrest for many dealers). This is not to imply that work is not sold at alternative spaces, for it is, but an artist is not obligated to pay the ungodly com-

missions required by commercial galleries. If an alternative space charges an artist a commission, it is usually in the form of a contribution.

Alternative spaces have many other good points. For example, they offer an artist a gallerylike setting in which to show his or her work. This can help a dealer visualize what the work would look like in his or her gallery. Do not underestimate the value of this opportunity: many dealers have remarkably little imagination. Also, alternative spaces are frequented by the media and critics, providing artists with opportunities for press coverage, which, as discussed in chapter 5, can often be an important factor in career acceleration. And alternative spaces provide artists with a chance to learn the ropes of what exhibiting is all about.

Curators and dealers include alternative spaces in their regular gallery-hopping pilgrimages, for glimpses into *what the future might hold* as well as to scout for new artists. Some of my clients' alternative-space experiences skyrocketed their careers or took them to a new plateau.

Many artists have misconceptions about the value and purpose of an alternative space and regard it as a stepchild of the commercial-gallery system. They think that it should be used only as a last resort. This is not true. While alternative spaces provide valuable introductory experience into the art world and exhibition wherewithal, *it is counterproductive to abandon the alternative-space system once you have been discovered by a gallery.* Balance your career between the two systems. Until a commercial gallery is convinced that your *name alone* has selling power, you will be pressured to turn out more of what you have thus far been able to sell. You might be ready for a new direction, but the dealer won't want to hear about it. Those offering an alternative space do!

Alternative spaces are not closed to artists who are already with commercial galleries. In fact, including more established artists in alternative-space exhibitions adds to the organization's credibility, and for an alternative space whose survival depends on grants and contributions, there is a direct correlation between reputation and financial prosperity.

The names and locations of alternative spaces throughout the United States are listed in the *Art in America Annual Guide to Galleries,*

Museums, Artists and in *The National Association of Artists' Organizations Directory* (see the appendix section "Exhibition, Performance Places and Spaces").

Other Alternative Sites and Spaces

In addition to the traditional types of exhibition spaces in commercial galleries and museums, there are many other kinds of spaces available for artist-initiated exhibitions. Mimi and Red Grooms's *Ruckus Manhattan* exhibition opened in a warehouse in lower Manhattan and ended up at the Marlborough Gallery. Artist Richard Parker turned the windows of his storefront apartment into an exhibition space for his work and received a grant from the New York State Council on the Arts to support the project. Bobsband, a collaborative of artists, convinced New York City's Department of Transportation to let them use the windows of an unused building in midtown Manhattan to exhibit their work and the work of other artists. They started the project with their own money and eventually received financial support from federal and state arts agencies. Banks, barges, restaurants, parks, alleys, rooftops, building facades, and skies are only a sampling of other alternative sites and spaces that artists, dancers, performers, and musicians have used as focal points, props, and backdrops for projects.

Cooperative Galleries

Cooperative galleries are based on artist participation. Artists literally run a cooperative gallery and share in expenses (in the form of a monthly or annual fee) in return for a guaranteed number of one-person shows within a specified period, as well as group exhibitions. Gallery artists make curatorial decisions and select new artists for membership.

Because of its participatory structure, the cooperative system, at its best, offers artists a rare opportunity to take control, organize, and choreograph their own exhibitions and be directly involved in formulating goals, priorities, and future directions of the gallery. At its worst, since a member must accept group decisions, you might find yourself in compromising situations, having to abide with decisions that are in conflict with your own viewpoints. And you might also find yourself

spending more time squabbling and bickering over co-op–related matters than on your artwork!

It is always difficult to know what you are getting yourself into, but before rushing into a cooperative, talk to the members to ascertain whether you are on the same wavelength. Obviously, if you receive an invitation to join a co-op, the majority of members approve of you and your work. You should determine whether your feelings are mutual.

Co-op memberships are limited and correspond to the single-show policy and space availability of the gallery. For example, if the co-op agrees that members should have one-person shows for one month every eighteen months, the membership will be limited to eighteen artists. Or if the gallery has the facilities to feature two artists simultaneously, the membership might be limited to thirty-six artists. Some co-ops have membership waiting lists; others put out calls for new members on an annual basis or when a vacancy occurs. In addition, some co-ops have invitationals and feature the work of artists who are not members.

Some cooperatives do not take sales commissions; others do, but the commissions vary and are far lower than those charged by commercial galleries. If commissions are charged, they are recycled back into the gallery to pay for overhead expenses.

In *On Opening an Art Gallery*, Suzanne K. Vinmans describes with refreshing honesty and humor the evolution, trials, and tribulations of a co-op gallery, as well as the events leading up to its demise. Although problems with a landlord were a contributing factor to the closing of the gallery, most of the difficulties were created by the gallery's artists, many of whom shirked responsibility, suffered from an acute case of stinginess, and were overpowered by negative attitudes. "If I had it all to do again, I would . . . make myself the director from the outset. As the person who did most of the work and made most of the decisions, I should have received that recognition," writes Vinmans. "I would search for more committed artists. . . . A gallery such as ours could have worked if each member was committed to the fullest degree."[53]

If you join a co-op gallery, it is important to *know when it is time to leave*. Since artists are guaranteed a set number of single and group exhibitions within a specific time frame, all too often a co-op serves as a

security blanket for members afraid to venture out into the world and risk the possibility of being rejected.

To subsidize the operating costs of a gallery, many cooperatives sponsor "invitationals." It is a juried procedure, and artists who are selected are also required to pay some sort of fee. Although some artists have had positive experiences participating in cooperative-sponsored invitationals, artist Donna Marxer's ordeal in New York was less than positive:

> Five years ago, needing a show, I got an "invitational" to show in the secondary room of one of the best co-ops around—one that was frequently reviewed and well-located. I also had to undergo rigorous review of my work to be accepted. The cost of that back room was $2,000 for three weeks.
>
> The director and committee were adamant about their standards. They insisted on hanging the show, leaving out a third of my work. They rewrote my perfect news release in their one-paragraph format—fine for someone with nothing to say, but dear reader, that is not me. They gave me a huge out-of-date mailing list that yielded nothing. $4,500 later, I had not made even one sale, had lured no one of importance into the gallery (in spite of promises), and went unreviewed. The only thing I got out of that show was one line on my resumé."[54]

VANITY GALLERIES: ARTISTS BEWARE

Vanity galleries are *for-profit* galleries that require artists to pay an exhibition fee and/or an assortment of other exhibition-related expenses. In addition, many vanity galleries also require a commission on work that is sold. For the most part there are no exhibition standards as long as an artist is willing to pay for an exhibition.

Cooperative galleries are often confused with vanity galleries because in co-ops artists are required to contribute to the galleries' overhead and administration costs through monthly or annual dues or fees. And as previously mentioned, cooperative galleries also sponsor "invitationals" that require artists to pay exhibition fees.

Adding to the confusion, some alternative spaces also require

artists to contribute to exhibition overhead. And, of course, as dis-
cussed in the chapter "Dealing with Dealers and Psyching Them Out,"
some commercial galleries are also requiring artists to contribute to
exhibition expenses.

Although all too often there were some fine lines between the
practices of a vanity gallery and a nonvanity gallery, keep in mind
that, unlike cooperative galleries and other alternative spaces, a vanity
gallery has no exhibition standards, it is not in business for educa-
tional purposes, and it does not have an artist's best interests in mind.

Vanity galleries that are located in large cities are particularly se-
ductive. They appeal to naive, and often desperate, artists who be-
lieve, for example, that having a show in a New York gallery, even if
you have to pay for it, provides the path to fame and fortune. Many
foreign artists also resort to using a vanity gallery in New York to seek
validation in their home countries.

Through advertisements in regional and national art publications,
vanity galleries entice artists with tempting come-ons such as "New
York gallery looking for artists." Artist sourcebooks (see page 119) are
also used by vanity galleries to locate potential prey. For example, the
Agora Gallery in New York contacts artists with a form letter stating
that "we have noticed your work in the *Encyclopedia of Living Artists*
and are very impressed."

For a *Village Voice* article, journalist Lisa Gubernick posed as an artist
and went undercover to learn more about what artists experience
when making the gallery rounds. With a set of borrowed slides, she
contacted numerous galleries in New York City, including the vanities.
At the Westbroadway Gallery, she was offered a show in the gallery
basement, which was called the "Alternative Space Gallery," for $850.
In addition, she described her experience at the Keane Mason Woman
Art Gallery as follows:

> I had a draft contract in my hands within 20 minutes . . . $720
> for 16 feet of wall, a mini-solo they called it. The date . . . was
> contingent upon "how I wanted to spread out my payments," ac-
> cording to the assistant director. In an embarrassingly blatant
> ploy she put red-dot adhesive stickers—the international "sold"
> symbol—on each of the half-dozen slides she deemed suitable
> for my show, all the while emphasizing various corporations' in-
> terest in the gallery. . . . The shows I saw at Woman Art were

hung poorly. Wall labeling was crooked, and the gallery gerry-
mandered with partitions to eke out more space.[55]

Vanity galleries use an assortment of schemes and methods for get-
ting artists to spend vast amounts of money to exhibit. For example, a
gallery in Washington, D.C., charges $95 per month for a one-year
contract that entitles an artist to participation in three group shows
and inclusion in a slide registry. Artwork is *not* insured, so artists must
either carry their own policies in the gallery's plan, for which there is
an *additional monthly fee* of 1½ percent of the declared value of each
work of art. For example, for a piece of work valued at $2,000, insur-
ance would cost $30 extra per month. In addition, the gallery charges
a 50 percent commission if work is sold! So, if a $2,000 piece takes six
months to sell, the artist will have paid $750 in insurance and exhibi-
tion fees and a $1,000 commission to the gallery, and will be left with
a net profit of $250. And on top of paying a monthly gallery fee, in-
surance charges, and a commission, the artist is responsible for round-
trip packing, transportation, and delivery fees, and any installation
costs.

In "Zero Gravity: Diary of a Travelling Artist," the author and artist
Elizabeth Bram describes a phone conversation with the owner of a
vanity gallery in New York:

> He had a smooth voice like a used car salesman. He told me that
> his gallery was near the Soho Guggenheim Museum. He went on
> about how I would get listed in the *New York Gallery Guide* if I
> showed at his gallery. And how he would host an opening com-
> plete with uniformed waitresses. I listened patiently, humoring
> him.
>
> "Tell me about yourself," he said. This was my cue to be flat-
> tered and to excitedly tell him all my dreams and fantasies about
> showing in a gallery near the Soho Guggenheim Museum. He
> would have listened to anything that I wanted to say then about
> my childhood or my schooling or the way that I paint.
>
> "How much are you charging?" I asked, cutting to the chase.[56]

She was told that for a one-thousand-dollar fee she could exhibit
three paintings for a month, along with the work of nine other artists,

and have her work in a computer file for one year. "A quick mathematical accounting told me that the Abney Gallery was collecting $10,000 a month from artists. That would be over $100,000 a year without even selling my paintings."[57]

Once, when a gallery dealer deflated the ego of one of my clients, he trod over to a (now-defunct) vanity gallery, much against my advice, like the guy who discovers his mate has been unfaithful and marches off to a prostitute. He signed up for a show, signed the dotted line on the contract, and wrote a check for several hundred dollars. In addition to the "exhibition fee," he had to pay for all of the publicity, including invitations, announcements, press releases, and postage, and for the wine served at the opening. Although the show did nothing for his career, he felt victorious. He had shown the dealer!

Although exhibiting in a nonvanity New York gallery does not guarantee recognition or financial success, the Herculean strength of the mythology surrounding the importance of exhibiting at a New York gallery enables vanity galleries to flourish. In New York and elsewhere, stay clear of vanity galleries and related schemes that place all of the financial risks on artists. If artists made a concerted effort to boycott vanity galleries, these galleries would disappear.

JURIED EXHIBITIONS

Hundreds of local, regional, national, and international juried exhibitions are held each year. Juried shows can offer artists opportunities for recognition and exposure, as well as cash prizes and awards. If you were so inclined, you could enter a juried exhibition every day of the year.

But there are drawbacks, one of which is the expense involved in entering juried exhibitions. Most shows require entry fees, and these fees continue to increase dramatically.

"What would you think of a theater that charged the performers rather than the audiences?"[58] asked art critic Joan Altabe in an article about juried shows in the *Sarasota Herald-Tribune*. "Crazy, right! Behold the crazy art world. The arrangement described above is one of the ways many exhibit halls support themselves. . . . "[59]

In the article Altabe interviewed various not-for-profit arts organi-

zations who justify charging entry fees because the fees pay for the group's overhead. "We couldn't survive without entry fees,"[60] declared a representative of one of the organizations. Altabe responded by offering a practical and intelligent suggestion: "Charge the audience, not the artists."[61]

The issue of charging fees and other related matters have made juried shows so controversial that the National Artists Equity Association has prepared a positive paper, "Recommended Guidelines for Juried Exhibitions." It states that

> while certain circumstances might necessitate asking the artists who are chosen to share in some of the costs, National Artists Equity suggests that this be done only as a last resort and that the amount to be charged should be published in advance. However, charging fees to *all* prospective artists (entry fees) is considered to be inappropriate and unprofessional.[62]

The National Endowment for the Arts has also had a long-standing position against the charging of fees. A spokesperson for the NEA has stated that "if a show promoter charges fees . . . top caliber artists won't enter the show, and . . . shows requiring entry fees generally don't have good reputations."[63]

However, art critic Joan Altabe's suggestion to charge the audience a fee to attend an exhibition instead of charging artists a fee to participate,[64] brings to mind how convoluted the justification actually is for artists to pay for an organization's overhead.

Sponsors of juried shows that are for-profit and not-for-profit organizations have overhead costs related to juried exhibitions. But because the sponsors experience little resistance from artists to pay entry fees, they have not been forced to develop more creative ways of keeping their organizations and businesses alive. In most instances, in addition to entry fees, sponsors also receive a commission on work that sells during a juried exhibition.

Some juried shows that are sponsored by *for-profit* enterprises use only a small percentage of fees for legitimate expenses, with the bulk of the money going directly into the pockets of the organizers.

For example, one New York gallery sponsors a juried competition

in which artists are required to pay a registration fee of $35 for up to four slides, $5 for each additional slide, a $10 nonrefundable fee for repacking and handling artwork "even if hand-delivered," and a 40 percent commission on all sales!

Another drawback of juried shows is that many of their sponsors do not insure artwork, and many sponsors take little or no precautions to protect the work from theft, vandalism, and loss.

Some juried shows *appear* to be very prestigious because the jury is composed of art-world personalities. But keep in mind that *jurors are paid* to lend their name to exhibitions. The fact that a famous critic, curator, or gallery dealer is on the jury is *absolutely no indication* that the show has been organized with high standards and that it is in the best interest of artists.

I have not seen any overwhelming evidence to support a correlation between juried shows and meaningful and lasting career development. In fact, the biggest illusion about juried shows is that award-winning artists benefit in ways that provide tangible career acceleration. For example, many artists who have won awards in shows that were judged by art-world figures are astonished and disappointed to discover that in most instances a juror's interest in the artist ends after the awards have been given. Although there are a few exceptions, rarely will a juror follow through by providing an artist with some sort of entry into the art world.

The majority of artists who benefit from juried shows are those not particularly concerned with long-range career development. They approach a juried show as a means to an end in gaining respect and recognition in their *local communities*. But for artists who have more ambitious and professional goals, there are many more productive and effective ways in which to use time, energy, and money.

In some arenas the juried show is such a common appendage of the art world that it will take quite a while to change thinking about the relevance of juried exhibitions. If you are convinced that juried shows will help provide a means to your end, use the following guidelines before plunging in.

Before submitting work to a juried exhibition, even if it is sponsored by a museum or reputable institution or organization, do your homework. Make sure the sponsor will provide a contract or contractual letter outlining insurance and transportation responsibilities, fee

structures, submission deadlines, and commission policies. If you pay an entry fee, you should not have to pay a commission on work that is sold, and you should not participate in exhibitions that do not insure work while it is on the sponsor's premises.

The appendix section "Competitions and Juried Exhibitions" includes a list of resources from which you can obtain additional information on juried exhibitions.

ᔑLIDE REGISTRIES

An active slide registry is used by many people: by curators and dealers to select artists for exhibitions, by collectors for purchases and commissions, and by critics, journalists, and historians for research. It makes a lot of sense to participate in the registry system, but not all registries are equally used. Before going through the expense and energy of submitting slides, find out if the registry is really active.

My first encounter with a registry occurred when I was preparing an exhibition at a museum in New York City and spent a lot of time in the curatorial chambers. The curators meticulously went through their registry, on the lookout for artwork that would fit into a theme show they were preparing (eighteen months in advance). When they found something they liked, regardless of whether the artist lived in Manhattan, New York, or Manhattan Beach, California, they invited the artist to participate.

It is very important to *continually update the slides you submit so the registry reflects your most recent work*. A person reviewing the registry will assume that whatever is there represents your current work, but, unless your slides are up-to-date, this might not be the case. For example, one of my clients was invited to participate in a museum exhibition by a curator who had seen her work in a registry. It would have been her first museum show, but she learned that the curator wanted to show only the work that she had seen in the registry. The artist was mortified: a year earlier she had destroyed the entire body of work, and the curator was not interested in her recent work. It was a big letdown, and the artist was depressed for weeks.

Resource materials on slide registries are listed in the appendix under "Public Art" and "Slide Registries."

Museums

Generally speaking, museums are leaving their doors more open to new and emerging artists. Some museums are actually leaving their doors ajar. My first exhibitions were sponsored by museums, contrary to the notion held by many artists that one must be affiliated with a commercial gallery before being considered by a museum. In many instances, what initially led to an exhibition at a museum was a set of slides, a résumé, and a show proposal (see the section "Develop and Circulate a Proposal" in this chapter). Other exhibition invitations came as a result of both long- and short-term professional relationships with museum directors and curators.

My own experience in gaining museum shows is not unlike the steps Patterson Sims outlined when he was associate curator of the Whitney Museum:

> On the basis of slides and exhibition notices the curators will call
> for appointments with individual artists for studio visits. . . .
> Calls from friends, collectors, and gallery owners about the work
> of an artist are another means of introduction. . . . Conversations
> with artists, art writers, and museum personnel will bring an
> artist's name to a curator's attention.[65]

Sims also described how artists are actually invited to exhibit at the Whitney: "Decisions . . . [are] made at curatorial staff meetings. It is up to the individual curators to promote the work of an artist they feel has a fresh style, a sense of quality, and a provocative outline. If a curator can convince others . . . the group will decide to invite an artist to participate."[66]

The unilateral support system that Sims describes is one of the biggest snags in the exhibition process of some museums. It is debatable whether the artist who is presented for consideration on the basis of slides and a studio visit has the same leverage as an artist who was brought to the attention of curators by "friends, collectors, and gallery owners." Many artists believe that the Whitney, for example, is a closed shop to artists not affiliated with well-known commercial galleries. Judging from who *is* invited to participate in the Whitney Biennials,

this is a logical conclusion. On the other hand, one of my clients who had no particular gallery affiliation was invited to participate in a Whitney Biennial. She concluded that she was a "small fish that slipped through the net!"

There are curators who have autonomous power and are able to make their own decisions rather than succumb to peer or dealer pressure. Do not let hearsay discourage you from contacting curators, nor should you be fooled by the myth that only artists connected to prestigious commercial galleries can exhibit in museums.

Curators organize exhibitions, assemble collections, and write catalogs and articles. They are under pressure to put contemporary art into a historical context, discover "new movements," and develop thematic exhibitions, and they cannot rely solely on well-known artists to accomplish their goals. And if they are aggressively pursuing a reputation in the art world, they are on a constant quest to discover artists who will reinforce and support a particular point of view.

Curators select artists whose work thematically falls within the parameters of future exhibitions through the use of slide registries (see page 112). In many instances curators have their own personal registries, which are developed, in part, through artist initiative: artists send letters and presentation packages to introduce these curators to their work.

A young artist who was having a one-person exhibition at a suburban library couldn't understand why a museum would possibly be interested in her work. But I convinced her to include curators in the mailing to announce the show. She sent a cover letter, a color postcard featuring a piece of her work, and a press release to curators nationwide, and was utterly amazed that the mailing elicited a response from curators at the Hirshhorn Museum and the Guggenheim Museum. Both curators requested a set of slides to keep for their files.

Resources for obtaining the names of curators are listed in the appendix sections "General Arts References" and "Mailing Lists."

COLLEGES AND UNIVERSITIES

Colleges and universities are often receptive to sponsoring exhibitions and performances, and their interest is not necessarily limited to alumni, although approaching a college or university of which you

are an alumnus or alumna is a good beginning. Colleges and universities have their own network, and from my experience, once you have an exhibition at one of them, word spreads fast and more invitations follow.

The first step is to send college and university gallery directors a presentation package and cover letter, or a proposal. This process is described in the section "Develop and Circulate a Proposal" in this chapter (see page 130).

Exhibiting at colleges and universities can also offer other rewards. Sometimes, as a result of an exhibition, artwork is purchased for the school's collection, and artists are commissioned to do projects for particular campus sites. In some cases, exhibiting artists are invited to present a lecture about their work, for which they receive a fee and travel expenses.

The names and locations of college and university galleries throughout the United States are listed in the *Art in America Annual Guide to Galleries, Museums, Artists* (see "Exhibition, Performance Places and Spaces" in the appendix).

THE CORPORATE ART MARKET

The corporate art market offers artists many sales and exhibition opportunities. Although some corporations buy art primarily for the purpose of investment, the majority buy art to attain a prestigious image, or even for the far nobler reason of improving employee morale. Although some of the motives behind corporate collecting are basically self-serving, the corporate market has become a very viable arena for many artists to sell and exhibit work.

Generally, corporations steer away from work that is political, overtly sexual, religious, or negatively confrontational. Otherwise, the field is open.

The term *corporate market* encompasses a wide range of institutions, ranging from financial corporations and law offices to hospitals and restaurants.

There are several ways to reach the corporate market: through art consultants and art advisors, through galleries that work with corporations, through architects and interior designers, through real estate developers, and by directly contacting corporations, usually through

staff curators. *The International Directory of Corporate Art Collections* lists hundreds of corporate art collections throughout the United States and abroad. Each listing contains the name of the person responsible for assembling the collection. It also describes the collection and its review procedures and policies. The *Directory* is also available on a computer disk. For additional information, see the appendix section "Corporate Art."

Art Consultants and Art Advisors

Art consultants are agents who sell work to corporations and individuals. If work is sold or commissioned through the efforts of an art consultant, the artist must pay a commission.

Anyone can become an art consultant. Like gallery dealers, art consultants are unregulated. The occupation of art consultant is often confused with *art advisor*, and often these job titles are used erroneously and interchangeably. Some art advisors are members of the Association of Professional Art Advisors, a national organization that has stringent regulations regarding business practices and professional qualifications. It defines an art advisor as one who is

> qualified to provide professional guidance to collectors on the selection, placement, installation, and maintenance of art. The professional art advisor has an understanding of art history, art administration, the art market, educational concepts, contemporary business practices, public relations, and communications.

Orlando art advisor Brenda Bradick Harris of Administrative Arts, Inc., points out that

> our culture has created a modern-day monster called "consulting" which often is used by those who may have good intentions, but who are not fully qualified or trained to advise or consult. Many of these individuals are unaware of the meaning or responsibilities associated with being an art consultant or advisor. These professional designations are often inappropriately used by gallery or artist sales representatives to indicate expertise and imply that the information is provided in the client's best interest. In reality, it is the product with the greatest profit potential, not artistic quality, that may be promoted.[67]

Art advisors do not receive commissions from artists on work sold or for projects commissioned. They are *paid by their clients* (individuals, organizations, and businesses) to provide information, advice, and related services *without any conflict of interest*. This means that, unlike many art consultants, art advisors do not maintain permanent inventories of art, so they are not "pushing" only the work of artists they have on hand. Also, art advisors accept work on consignment only for the purpose of presentation or approval.

Commissions paid to art consultants can be negotiated, but expect to be asked to pay between 40 and 50 percent on work that has already been created. *Under no circumstances* should you pay more than 25 percent of the *artist's fee* for *commissioned projects* obtained through an art consultant. In other words, do not pay a commission on the overhead expenses of the project (see chapter 4, "Pricing Your Work: How Much Is It Worth?").

Art consultant Françoise Yohalem gives excellent advice to artists who are being considered for a commissioned project:

> Never make a model, never make a proposal, unless you are paid for it. This is very important. Artists are too often willing to do a lot of work for nothing on the hopes that maybe something good will come out of it—and that is wrong. It gives the wrong impression to the client. It says that the artist is not professional, that the artist is pathetic and wants the job so badly that [he or she] is willing to do anything. I think the client respects the artist more if the artist says I expect to be paid.[68]

If an art consultant or art advisor requests work on consignment, do not let any work leave your studio *before* an artist/agent contract is signed. If a commissioned project has been arranged by an intermediary, you should use an artist/agent contract *in addition to* the commission contract between yourself and the client. The appendix section "Law" lists publications such as *Legal Guide for the Visual Artist* and *The Artists' Survival Manual* that include artist/agent and commission agreements. For further information on contracts, refer to pages 168–171.

When approaching an art consultant or art advisor, submit a basic presentation package (see chapter 5), including a cover letter and a self-addressed stamped envelope. The names and addresses of art

consultants and art advisors are listed in various publications, including *The International Directory of Corporate Art Collections* and the *Art Marketing Sourcebook*. In addition, the index of the *Art in America Annual Guide to Galleries, Museums, Artists* lists corporate consultants and galleries that work with corporations. For additional information about these resources, see the appendix section "Corporate Art."

Corporate Curators

Generally, corporate curators have the same professional qualifications as museum curators and function in a similar capacity as art advisors, but they are on the staffs of corporations and receive salaries for their services instead of fees. In addition, professional practices of corporate curators are governed by the National Association for Corporate Art Management.

Corporate curators should receive a basic presentation package (see chapter 5), including a cover letter and a self-addressed stamped envelope. Names and addresses of corporate curators are listed in *The International Directory of Corporate Art Collections* (see the appendix section "Corporate Art").

Architects and Interior Designers

Many architectural and interior design firms commission artwork or purchase work in behalf of their clients. Some firms delegate a project manager or project designer to select work and/or maintain an artists' slide registry. In some instances a slide registry is organized by a staff librarian.

Architects and interior designers should receive a basic presentation package (see chapter 5), including a cover letter and a self-addressed stamped envelope.

The names and addresses of architects and interior designers can be obtained in several ways. For example, *The Dodge Report* is a quarterly publication that provides information on every construction project nationwide, including the name of the design firm in charge and whether a budget has been allocated for the purchase or commissioning of artwork. Individual state reports are also available, but the drawback is that even a state report is very expensive.

A less expensive alternative is a publication published by the American Institute of Architects called *Profile*. It profiles architecture and

interior design firms nationwide, and indicates whether the designers are involved in public art or percent-for-art programs (see page 122).

In addition, you can obtain the names and addresses of architects and interior designers in your area by contacting local chapters of the American Institute of Architects (AIA) and the American Society of Interior Designers (ASID), or through the national headquarters of the AIA and ASID.

For additional information regarding *The Dodge Report, Profile,* the American Institute of Architects, and the American Society of Interior Designers, see the appendix sections "Corporate Art" and "Interior Design and Architecture."

You can develop a more personalized list of firms by studying architectural, landscape, and interior design publications to look for designers whose work is aesthetically compatible with your own. The names and addresses of these publications in the United States, Canada, and abroad are listed in the appendix section "Interior Design and Architecture."

Another way of reaching architects and interior designers is to advertise in any of the various sourcebooks published by THE GUILD. These include: *The Architect's Sourcebook, The Designer's Sourcebook,* and *The Sourcebook for Collectors and Galleries.* Each edition contains color photographs of artwork; and the name, address, phone number, and biography of each participating artist. THE GUILD sourcebooks are distributed *free of charge* to those who attend the national conferences of the American Society of Interior Designers and the American Institute of Architects. In addition, the sourcebooks are distributed free of charge to art consultants.

The results of a recent survey conducted by THE GUILD on commissioning provided interesting findings that challenged some popular misconceptions about why artists are selected for projects.[69] These misconceptions include the belief that artists must be well-known, or they must have had prior experience in executing a similar project, or that local artists or artists who submit low-cost project budgets have a better chance of being selected.

A copy of the survey was sent to 161 design professionals who actively use THE GUILD to commission art. Fifty-nine people responded to the survey, including 24 interior designers, 15 architects, 8 art consultants, 3 developers, and 2 art brokers.

Addressing the question "What were the most important factors in selecting the artist"? 43 percent of the respondents said that it was the quality of an artist's portfolio; 16 percent stated that it was the artist's track record with similar projects; 13 percent of the respondents stated it was on the strength of the project proposal; 11 percent stated that it was the personal chemistry with the artist; 10 percent stated that it was an artist's prominence; 4 percent stated that it was an artist's unique style; 2 percent that it was the low cost of proposal; and 1 percent of the respondents said that it was an artist's location.

Not all artists' sourcebooks are as reputable as THE GUILD or used as frequently by art consultants, architects, and interior designers. In the article "Buying Ad Space in Artists' Sourcebooks," published in *Getting the Word Out: The Artist's Guide to Self Promotion*, Carolyn Blakeslee points out that

> there are a slew of sourcebooks on the market now. There are encyclopedias, directories, catalogs, surveys—of contemporary art, New York art, living artists, erotic art, West Coast artists, Florida artists, and so on. Some of the sourcebooks are of questionable quality and value, and a few are downright awful, even some which have been around for a while and are well known.[70]

The article offers good advice to help you determine whether it is worth the effort to advertise in a sourcebook. For example, artists should know what kind of paper the ad will be printed on, at what line-screen ruling the plates will be reproduced, how large the book will be, how many copies of the book will be printed, whether the circulation is audited, how often the book is published, and how many copies of the book are distributed free of charge.[71]

In addition to THE GUILD's sourcebooks, Blakeslee, the former editor-in-chief of *Art Calendar*, recommends the artists' sourcebooks *New American Paintings* published by the Open Studio Press. Artists are selected through a juried procedure. There are no entry fees or publication fees.

Information about *New American Paintings*, THE GUILD's sourcebooks, and *Getting The Word Out: The Artist's Guide to Self Promotion* is listed in the appendix section "Career Management, Business and Marketing."

Publicizing and Generating
Corporate Sales and Commissions

If your work is purchased or commissioned by a corporation, use public-relations tools such as press releases (see page 78) and photographs (see page 55) to generate publicity and new contacts. *Past accomplishments should always be used as a springboard to solicit new clients and projects.*

Issue a press release to announce a corporate commission or sale. Press releases should be sent to collectors, clients, potential collectors and clients, and people in the art world with whom you are in contact, or people in the art world whom you have always wanted to contact.

Send a press release and photograph to *Public Art Review*, a biannual publication that contains the column "Recently Completed Projects." Each announcement contains the artist's name, the title of the artwork, a project description, the year the work was completed, medium, and the name of the sponsor. If a commission or sale involved the *services of an art consultant or art advisor*, send a press release and photograph to *Art Business News*, a monthly publication that announces recent corporate acquisitions and commissions. The address of *Public Art Review* is listed in the appendix section "Public Art," and the address of *Art Business News* is listed in the appendix section "Corporate Art."

A press release issued by an artist announcing the acquisition of three photographs by a Canadian bank led to a feature article in a major New York newspaper. A press release issued by an accounting firm, in behalf of a sculptor, announcing the completion of a commissioned piece was sent to various trade publications read by accountants. An article in one such publication announcing the commission led to a commission for the sculptor from another accounting firm.

THE HEALTH-CARE INDUSTRY

Within the health-care field, many opportunities exist for artists to exhibit and sell work, and create special projects. In the article "Getting Better: Art and Healing," published in *Sculpture* magazine, the author Anne Barclay Morgan pointed out that

As our concern with healing the earth has received widespread attention, there is also a renewed interest in healing ourselves. With health care reform now at the foreground of national debate, health services, alternative medicine and other forms of healing are receiving broader public scrutiny. Directed toward health care facilities, such as hospitals and hospices, the burgeoning field of art and healing is creating venues and modes of interaction for artists, health care givers and patients.[72]

The Society for the Arts in Healthcare (see the appendix "Arts Service Organizations") is a national membership organization that is dedicated to the incorporation of the arts as an appropriate and integral component of health care. Toward this goal, the society is engaged in programs that serve many purposes: to demonstrate the valuable roles the arts can play to enhance the healing process; to advocate the integration of the arts into the planning and operation of health-care facilities; to assist in the professional development and management of arts programming for health-care populations; to provide resources and education to health-care and arts professionals; and to encourage and support research and investigation into the beneficial effects of the arts in health care.

The society's membership includes physicians, nurses, arts administrators, medical students, architects, designers, and artists of all disciplines. It sponsors an annual conference and publishes a membership directory.

PUBLIC ART PROGRAMS

In addition to private and corporate clients, there is a wide range of commission and sales opportunities available to artists through public art programs sponsored by federal, state, and municipal agencies and independent organizations.

There is also a wealth of information available about public art programs. For example: the excellent quarterly magazine *Public Art Review* publishes practical articles about public art programs and provides lists of opportunities in the public art field. *Going Public: A Field Guide to Developments in Art in Public Places*, published by the Arts Extension Service of the University of Massachusetts, provides an

overview of current issues, policies, and processes in the administration and preservation of public art, with an appendix that includes information on two hundred ongoing public art programs. The *Guidebook for Competitions and Commissions*, published by Visual Arts Ontario, provides guidelines on commissioning public art, and discusses the roles of the sponsor and artist. And the *Directory of Percent for Art and Art in Public Places Programs* is available from Mailing List Labels Packages. Entries are organized by state, and within the state the various organizations are identified as a city, county, state, or federal agency. Each entry includes the name and address of each public art program, the name of the contact person, a telephone and fax number, and eligibility requirements. The list is updated on an ongoing basis. In addition, Mailing List Labels Packages provides preprinted, precut postcards with the names and addresses of the sponsoring public art agencies on one side and printed requests for information, application materials, and placement of your name on the agency's mailing list on the other side. Your name and address are also printed on the postcard. Pre-addressed mailing labels of the public art agencies listed in the *Directory* are also available. The *Directory* and other materials are available separately or as a package.

The address of Mailing List Labels Packages as well as other public art resources are listed in the appendix under "Public Art."

Federal Public Art Programs

Through the General Services Administration's (GSA) Percent for Art Program and Art in Architecture Program, the federal government commissions artists to produce works of art for various government projects. Artists are commissioned to produce works of art that are incorporated into the architectural design of new federal buildings. In addition, artwork is commissioned for buildings undergoing repair or renovation, as well as for federal buildings in which artworks were originally planned but never acquired.

Commissioned work includes (but is not limited to) sculpture, tapestries, earthworks, architecturally scaled crafts, photographs, and murals.

One half of one percent of a building's estimated construction cost is reserved for commissioned work. Artists are nominated cooperatively by the GSA, the National Endowment for the Arts (NEA), and the project architect.

The architect is asked to submit an art-in-architecture proposal that specifies the nature and location of the artwork, taking into consideration the building's overall design concept.

The NEA appoints a panel of art professionals who meet at the project site along with the architect and representatives of the GSA and NEA. They review the visual materials (which are submitted through the GSA's slide registry) and nominate three to five artists for each proposed artwork. The NEA forwards the nominations to the administrators of the GSA, who make the final decision.

Municipal, State, and Independent
Public Arts Programs

The precedent of allocating a certain percentage of the cost of new or renovated public buildings for art, as described in the GSA's Percent for Art Program and Art in Architecture Program, has also been legislated by many cities, counties, and states throughout the United States. Canada, too, has similar programs.

The National Endowment for the Arts provides grants to nonprofit organizations so that they can commission artists to create art for public spaces. The Public Art Fund, Inc., sponsors installations in public spaces throughout New York City. The Social and Public Art Resource Center in Venice, California, is a multicultural arts center that produces, exhibits, distributes, and preserves public artwork; it also sponsors murals and workshops. Urban Arts in Boston is a public arts agency that houses a nationwide slide registry of artists in all disciplines.

The names and addresses of municipal and state public art agencies and independent organizations are listed in the appendix section "Public Art."

Public Art Programs for Transportation Systems

Other public art projects have been initiated in conjunction with public transportation providers and airport administrators. For example, in New York City, the Metropolitan Transportation Authority Arts for Transit program commissions artwork for its family of agencies: MTA New York City Transit, MTA Metro-North Commuter Railroad, MTA Long Island Rail Road, and MTA Bridges and Tunnels. Arts for Transit places permanent art throughout its network through its Percent for Art program. It installs photographic work through its Lightbox Project, and brings music to subway stations through its Music Under New

York initiative. The Phoenix Art Commission sponsors the Art in Public Places Program at the Sky Harbor International Airport; Los Angeles has the Art for Rail Transit Program sponsored by the Los Angeles County Transportation Commission. In addition, there is a public art program affiliated with the Metropolitan Atlanta Rapid Transportation Authority in Georgia. The addresses of these and other agencies are listed in the appendix under "Public Art."

MAKING NATIONAL CONNECTIONS

A recent edition of the *Art in America Annual Guide to Galleries, Museums, Artists* lists 4,898 galleries, alternative spaces, museums, university galleries, private dealers, corporate art consultants, and print dealers throughout the United States, from Anniston, Alabama, to Laramie, Wyoming.

The *Annual* lists 530 commercial and not-for-profit galleries in Manhattan, 131 in Chicago, 82 in San Francisco, 43 in Boston, 42 in Atlanta, and 21 in Dallas. Although many consider New York to be the art capital of the world (and also make the erroneous assumption that New York artists are more talented than artists elsewhere), the main reason New York is deserving of its title is the large number of exhibition opportunities that are packed into the small island of Manhattan. However, thousands of exhibition and sales opportunities are available throughout the United States and outside of the United States, resources that are consistently overlooked and neglected by the majority of artists.

As discussed in chapter 1, the main reason these resources are overlooked is that many naive artists believe that their market is limited to their area of residence; or that some sort of universal censorship is imposed, illogically concluding that there is no market *anywhere* for their work if they are unable to find a receptive audience in their hometown or city.

Additionally, many artists fail to make national contacts because they ponder trivial details and dwell on the logistics of transporting work to other cities and working with out-of-town dealers.

It is important to keep in mind that regardless of the varied philosophical or altruistic reasons dealers give to explain their involvement with art, the bottom line is *money*. If someone believes *money can be*

made from your work, geographic considerations become inconsequential.

The *Art in America Annual* can be a helpful tool in locating out-of-town exhibition resources. On a state-by-state, city-by-city basis, it lists the names, addresses, and phone numbers of gallery dealers, alternative spaces, university galleries, and museums. In most cases it provides a short description of the type of art and/or medium of interest, and the names of artists represented or exhibited.

Use the *Annual* to compile a list of galleries nationwide that are interested in your discipline or disciplines (for example, works on paper, sculpture, photography, painting, decorative arts). Some of the descriptions that are provided in the *Annual* are vague or very general. However, if you are using a brochure (see page 58) or other forms of printed matter (see page 63) to contact a gallery, the cost-effectiveness of these presentations eliminates the need to spend a lot of time researching each gallery. On the other hand, if you are using a costly slide package with a self-addressed envelope, researching appropriate galleries is very important.

Publications that are more regional in scope offer more detailed information about exhibition resources. For example, *New York Contemporary Art Galleries: The Complete Annual Guide* lists galleries and alternative spaces in New York City. It describes each gallery's area or areas of interest, the selection process, philosophy, price range, and whether artists are required to contribute exhibition expenses or pay exhibition fees. *The Artists Gallery Guide for Chicago and the Illinois Region* lists exhibition opportunities in Indiana, Missouri, and Wisconsin as well as in Chicago and the rest of Illinois; and the *National Association of Artists' Organizations Directory* lists more than one thousand organizations in the visual, performing, and literary arts, many of which sponsor exhibitions. The names and addresses of the publishers of these resource guides are listed in the appendix section "Exhibition, Performance Places and Spaces."

When an out-of-town gallery expresses interest in representing your work, the most effective way to determine if the gallery is appropriate is to visit it in person. (For guidelines on helping you determine whether a gallery is right for you, see page 159.) Or before making travel plans, if the gallery is on the Internet, visit its Web site and study the artwork created by the featured artists (see chapter 7, "Marketing Art on the Internet and Services to Artists," page 135).

However, if you are unable to travel and/or you are unfamiliar with a gallery's business reputation, contact artists who are already involved with the gallery before committing yourself to a consignment arrangement and/or exhibition. The names of the artists represented by a particular gallery are listed in the *Arts in America Annual*.

Negotiating with out-of-town dealers can be as simple as sending a contract (see page 168) that outlines your requirements and, if necessary, being willing to compromise over certain issues. However, it can also be as complicated as persuading a dealer to use a contract!

You can also make national contacts by writing to out-of-town museums, alternative spaces, public art programs, art consultants, and university galleries and museums.

Developing markets beyond your home city offers many rewards. You should also consider extending your horizons beyond the United States.

*M*AKING INTERNATIONAL CONNECTIONS

If you are interested in exhibiting and selling work abroad or participating in international arts programs, there are several resources that are available:

AN Publications in England has an extensive publishing program aimed at assisting artists with career information. For example, it publishes the *Artists Newsletter*, a monthly publication that lists various opportunities for artists in the United Kingdom, including exhibitions, residencies, and competitions. *Across Europe: The Artist's Personal Guide to Travel and Work* provides information on over twenty European countries, including organizations, funding sources, and periodicals. The *Directory of Exhibition Spaces* lists over 2,100 galleries in the United Kingdom and in Ireland. Each listing describes the exhibition space, the type of work shown, how to apply for exhibition consideration, gallery commissions, and other useful information. *Exhibiting and Selling Abroad* provides information for artists who are interested in exhibiting outside of the United Kingdom. *Investigating Galleries* provides information and strategies to improve an artist's chance of exhibiting in the United Kingdom. AN Publications also publishes books that are geared to artists working in specific disciplines, for example: the *Independent Photography Directory* lists over 250 organizations in the United

Kingdom and the services they provide; and *Making Connections: The Craftsperson's Guide to Europe* lists contacts and organizations in fifteen European countries.

As a result of contacting many of the resources listed in various AN publications, the work of artist Elizabeth Bram of Long Island, New York, was exhibited in five galleries in England and Scotland during a two-year period. Keeping detailed notes about her transatlantic adventures, she composed a journal under the title "Zero Gravity: Diary of a Travelling Artist." She wrote: "Why spend your life feeling rejected by the New York art scene when there are millions of other people on the planet who might enjoy your art work?"[73] The journal was cited earlier in this book when Bram described her experience with a vanity gallery in New York (see page 108).

The artist realized how fortunate she was to have cultivated professional contacts outside of the United States, contacts who did not look to New York for validation of her talents.

If you are intrigued with the idea of exhibiting and selling work abroad, but don't know how to make the contacts or get started, a variety of resources are available. Unfortunately, no single comprehensive reference book lists and describes international galleries, museums, private dealers, corporate consultants, and alternative spaces in detail, but several useful references are available.

The *International Directory of Corporate Art Collections*, published by the International Art Alliance and *ARTnews*, contains information on one thousand corporate art collections, including the collections of Japanese and European corporations.

The Guide Art Press, published by Editions Artpress in Paris, provides detailed descriptions of museums throughout Europe, including those that exhibit the work of contemporary artists. The *Guide* is written in English and in French.

Money for International Exchange in the Arts, published by the American Council for the Arts in cooperation with Arts International, includes information on grants, fellowships, and awards for travel and work abroad. It also includes information on international artists' residencies and programs that support artists' professional development.

The International Directory of Resources for Artisans published by the Crafts Center includes the names and addresses of arts organizations, guilds, foundations, and other resources throughout the world.

In addition, there are many organizations that provide opportunities for artists to work, study and/or exhibit abroad. For example, Arts International sponsors exchange and fellowship programs for artists; and the German Academic Exchange Office (DAAD) (Deutscher Akademicher Austauschdiens) sponsors an Artists in Berlin Program.

By scanning periodicals that review and/or advertise international galleries you can get an idea of the type of work certain galleries exhibit. International periodicals can be found in bookstores and libraries that have extensive art sections. The names of various foreign art periodicals are listed in *The International Directory of the Arts* and *Ulrich's International Periodical Directory*. In addition, *Guide de la Presse Beaux Arts* provides a list of the art press in France.

After compiling a list of museums and galleries, send each contact person a presentation package (see chapter 5), and include a cover letter stating that you are planning a trip to that person's city and would like to arrange an appointment if the person finds your work of interest. If you receive positive responses, make the trip a reality!

The same guidelines for selecting and working with domestic galleries are applicable to galleries in foreign cities (see page 159). The contacts cited in this section and additional resources for making international connections, including funding organizations, artist-in-residence programs, and studio-exchange programs, are listed in the appendix section "International Connections."

CREATING YOUR OWN EXHIBITION OPPORTUNITIES

Even though your presentation packages are circulating in registries, museums, commercial galleries, alternative spaces, and so forth, don't sit around waiting to be asked to exhibit and don't depend on someone to suggest a context in which to exhibit your work. Create your own context and exhibition opportunities.

Theme Shows

Curate your own exhibitions or performances, based on themes that put your work into a context. Theme shows can feature your work exclusively or include the work of other artists. At their best, theme shows increase and enhance art-viewing consciousness, demand the

participation of many of our senses, and help the public as well as the art community understand and learn more about what an artist is communicating and the motivating influences revealed in the work. For example, the group exhibition *Empty Dress: Clothing as Surrogate in Recent Art* featured the work of thirty contemporary artists. It focused "on the use of clothing abstracted from the body as a means of exploring issues of psychological, cultural and sexual identity."[74] The group exhibition *A, E, Eye, O, U, and Sometimes Why* contained two-dimensional pieces that used "a variety of media to express the concerns and reactions to different social, informational, and psychological situations, through the combined use of words and images."[75] The theme show *Top Secret: Inquiries into the Biomirror*[76] featured the work of artist Todd Siler and consisted of a "32-foot, 3-dimensional sketch of a Cerebreactor, drawings and detailed studies which introduce Siler's theories on brain and mind, science and art."[77]

Another asset of theme shows is that it is far more likely you will obtain funding for a theme show with *broad educational value* than for a show called *Recent Paintings*.

DEVELOP AND CIRCULATE A PROPOSAL

A proposal should describe your idea, purpose, intentions, and audience. It should tell why the theme is important, how you plan to develop it, and who will be involved. Supporting materials should include information about the people involved (résumé, slides, etc.) and indicate your space or site requirements. Depending on the intended recipient of the proposal, it could also include a budget and ideas on how the exhibition will be funded.

The proposal should be circulated to museums, colleges, galleries, alternative spaces, cultural organizations, and funding organizations. It could very well be that you will need only one of these groups to complete the project. On the other hand, you might need all of these groups, but for such different reasons as sponsorship, endorsement, administration, facilities, funding, and contributions.

ExhibitsUSA, a national division of the Mid-America Arts Alliance, is a not-for-profit organization that organizes traveling exhibitions. It will consider proposals that are submitted by curators, including artist curators, for group exhibitions.

Once a proposal is accepted, it is listed in an annual catalog that is

circulated to museums, colleges and universities, and cultural centers throughout the United States. Each exhibition that is described in the catalog includes such information as the exhibition fee and what expenses the fee covers, shipping arrangements, availability dates, and the type of security required.

Curators and participating artists in the ExhibitsUSA program receive a fee. The address of ExhibitsUSA is listed in the appendix "Exhibition, Performance Places and Spaces."

A book published by the Smithsonian Institution Traveling Exhibition Service (SITES) called *Good Show! A Practical Guide for Temporary Exhibitions* is an excellent resource for artists interested in curating exhibitions and is also helpful for proposal writing, as it covers the complete range of factors that need to be taken into consideration (e.g., advance planning, preparation, fabrication, illumination, and installation). The book also includes a good bibliography for each of the subjects it covers. For further information see "Exhibition Planning" in the appendix.

ARTIST FEES

Often artists let the excitement of an exhibition opportunity interfere with clear thinking, and overlook various exhibition costs. The most neglected item in budget planning is an artist's *time*—for example, the time spent conceptualizing an exhibition, researching and contacting galleries and museums, and preparing and sending proposals and/or presentation tools. Then there is the time spent preparing, installing, and dismantling the exhibition. The list could go on and on.

Although some alternative and nonprofit galleries pay artists a fee to help offset exhibition expenses, this practice has not been widely adopted, nor is it widely recognized by artists that they have the right to request a fee, particularly a *realistic* fee.

Canada is far ahead of the United States in acknowledging the need for realistic artist exhibition fees. For example, the Canadian arts service organization Canadian Artists' Representation Ontario (CARO) recommends minimum exhibition fees that artists should charge when exhibiting in public or nonprofit museums and galleries. Recommendations take into account a wide variety of exhibiting situations, including single, two-person, three-person, four-person, and group shows; regional, interregional, national, and international

touring and nontouring shows; and juried and nonjuried shows. CARO's recommended fees are published in the *CARFAC Recommended Minimum Exhibition Fee Schedule* (see the appendix section "Exhibition and Performance Planning").

Open-Studio Events

You can generate exhibition and sales opportunities by opening your studio and/or home to the public. However, a successful open-studio event requires careful planning: You must develop an imaginative guest list with many *new* names and have a clear idea of what you want to achieve. Is your main goal exposure, sales, or a combination of both?

Following are guidelines for open studio planning:

DATES. An open studio should be held on a *minimum* of two (not necessarily consecutive) days, preferably including at least one weekend day and one weekday evening.

INVITATIONS AND MAILING LIST. The invitation should include a visual image of your work (see page 88). Invitations should be sent to collectors, potential collectors, contacts within the art world, family, and friends. But most important, *invitations should also be sent to new people.* One way to do this is by telling friends and associates *who admire your work* and are *not* necessarily part of the art world that you want to increase your contacts for the purpose(s) of sales and/or exposure. Ask if they would be willing to write a personal note on the invitation, inviting their friends and associates to attend. If ten people send ten invitations in your behalf, one hundred new contacts will be generated.

USE AN ASSISTANT. All too often, open studios resemble gallery openings, with guests self-consciously glued to the walls. Uncomfortable environments are not conducive to generating sales or exhibiting work; people want to leave as soon as possible. It is important to create a warm and energizing atmosphere. Guests should be introduced to one another. But if you are serving beverages, answering the door, asking people to sign a guest book, and taking care of other activities, you will not have time to meet people in an effective way, introduce guests, talk about your work, or answer questions. Hire a person or ask a friend to help out with all of the various tasks associated with an open studio so that you are free to spend time with people.

PROVIDE PRINTED MATERIALS. Prepare multiple copies of printed materials (as many copies as the number of guests expected), including a résumé (see page 43) or biography (see page 50), an artist statement (see page 51), press clippings (if applicable), and a price list (see page 71). These materials should be placed in a central location.

New York artist Donna Marxer uses the opportunity of holding an open studio by exhibiting each new body of work that she has created at various art colonies. As of 1996, she has had ten open studios. "I do exhibit [in] other places, but the Open Studio is now a keystone in my career. I now have a solid base of collectors who eagerly attend my art parties,"[78] wrote Marxer in her article "Career in the Doldrums? Consider the Open Studio," which was published in *Art Calendar* (see the appendix section "Exhibition and Performance Planning"). In the article she details her planning strategies and other tips for designing an open studio.

Selling from Your Studio

Most artists find the experience of selling work directly to the public gratifying on several levels. The intimacy of a studio and direct contact with an artist can create a very positive environment, and for many people direct contact with an artist is a chief factor in buying art.

But people buy art for many different reasons. Increasing studio sales requires an understanding of basic sales skills particular to selling art, and an understanding of individual buying styles. In her book *How to Sell Art: A Guide for Galleries, Art Dealers, Consultants, and Agents* (see the appendix section "Career Management, Business, and Marketing"), Nina Pratt, a former art market advisor, offers the following advice:

> Learn your own buying style, because it influences your selling style. . . . There are as many different buying styles as there are people. But there are a few main categories that most people fall into . . . [for example,] impulsive versus calculating buyers. . . . There are also people who hate to be told anything . . . as opposed to the ones who want a full biography of the artist; the ones who have to tell you their life stories before they are ready to buy; the apparently timid, docile client with a will of steel; [and] the bargain hunters [who] will ask for a discount at the drop of a hat.

Learning how to distinguish each type comes with time and practice. Until your instincts develop, rely on . . . skillful questions to find out which sort of person you are dealing with.[79]

The questions Nina Pratt recommends include: Does this person buy art? What kind of art? In what price range? Is your work appropriate for this person? Does this person have the authority to buy, or will a spouse have the final say?[80] Pratt points out, however, that "most visitors . . . would be turned off if you boldly grilled them on these subjects. So you must learn to probe delicately but precisely for the information that you need."[81]

7

Marketing Art on the Internet and Services to Artists

In the book *The Arts and the Internet*, the author V. A. Shiva writes about a visual artist who used the Internet as a marketing tool: "Within six months, 15,000 visitors came to view her artwork at her Web site. . . . 'More people have seen my art in the past six months than in the past six years.' She could never had gotten such exposure in the traditional venues of galleries and shows," adds Shiva.[82]

The possibilities for exposure on the Internet are mind-boggling. Web sites offer artists opportunities to have their work seen by gallery dealers, art consultants, collectors, curators, public-art agencies, architects and interior designers, and so forth. But the information that artists want to know about most was not cited in Shiva's anecdote: what are the tangible accomplishments related to art sales or career development that result from thousands of people viewing artwork on Web sites?

The Internet is a very new tool for marketing artwork and it is still too early to draw any precise conclusions regarding its effectiveness on a massive scale. Although when Web sites were first developed for the purpose of establishing on-line galleries, it was hailed as the most promising vehicle for direct sale of artwork between an artist and a collector. Many artists and dealers indulged in the fantasy that collectors would view artwork on the Internet and place an order sight unseen. However, as time passed Web-site sponsors have become more realistic in defining the Internet's effectiveness as a marketing tool.

Through on-line galleries the Internet functions most effectively by providing artists with regional, national, and international opportunities so that interested parties can directly contact artists or dealers to request additional visual materials and background information. And through specific Web sites artists can glean an abundance of valuable information about career opportunities and career-related data.

On-line galleries is a generic term that is used to describe Web sites that feature artists' work. Some on-line galleries are sponsored by dealers or a consortium of art galleries, and requests for information about a particular artist are referred to his or her dealer. However, many on-line galleries were formed only for the purpose of Internet use. They perform "exposure" services and operate more along the lines of an artists' slide registry (see page 112). An additional attribute of this type of on-line gallery is that artists need not own a computer to participate.

Internet registries do not broker art or provide traditional gallery services. Requests for information on a particular artist are directed to the respective artist whose name, address, fax and phone numbers, or E-mail address are provided on the artist's Web page.

As of this writing, sponsors of registry-type on-line galleries are not tracking the effectiveness of the Internet as it impacts artist-clients. Of all the promotional literature that I have screened about registry-type on-line galleries, testimonials from artists touting the results of using a particular Web site are glaringly missing. This is not to suggest that the Internet as a marketing tool for artists is ineffective, but one might conclude that registry-type on-line galleries are prospering well without market surveys or a need for testimonials to validate their products.

Traditional galleries that use the Internet as a marketing adjunct should find it very easy to track the effectiveness of their Web sites. However, galleries are equally evasive about sharing information pertaining to their sales track records resulting from the Internet as they are about sharing other sales information.

From time to time I have heard about a tangible marketing benefit of Internet use by an artist or a dealer. For example, an article *unrelated* to the Internet in *The New York Times Magazine* referred to a dealer selling four paintings as a result of his Internet site;[83] and an artist who used the Web site of the National Association of Fine Artists (now defunct) received gallery representation as a result of a dealer

spotting her work on a Web site. Although some of my clients are using Web sites for the purpose of exposure and making new contacts, they had just begun using the Internet when I was preparing the present edition of this book, and they had not used Web pages for a sufficient amount of time to draw any conclusions or share experiences.

However, referrals to Web sites are being incorporated into brochures (see page 58) and résumés (see page 43). Reference to Web sites can be incorporated into cover letters (see page 53); for example: "if you find my work of interest, I would be pleased to provide further information. Please note that additional images of my work can be viewed on the Internet," and so forth.

One of the most helpful services that the Internet currently offers artists is assistance in researching galleries to determine whether a particular gallery is appropriate for your work. By viewing the Web sites of various galleries and observing a selection of artwork created by artists represented by the respective gallery, you will have a clearer idea if the featured gallery is worth contacting.

The New York Foundation for the Arts conducted a survey[84] in 1995 to determine how artists use computer-based technology in their creative (rather than administrative/secretarial) work; however, a study on the effectiveness of artists and dealers using the Internet for the purpose of marketing and sales has yet to be accomplished. Perhaps in a future edition of this book the results of such a study will be published. In the meantime, this chapter will concentrate on some of the Web sites that offer artists marketing opportunities and informational services related to career development. Web sites, sponsors, and other resources in this chapter are listed in the appendix section "The Internet."

For artists who want more information about the Internet, how it works, and how to prepare material for Web pages, some good explanations are interwoven within the promotional literature of on-line galleries. In particular, OnLineGallery (see page 138) offers good information and explanations.

A comprehensive source of background information about the Internet for artists (that does not promote a particular product) is the book *The Arts and the Internet*, which was referred to at the beginning of this chapter. The author, V. A. Shiva, wrote: "Before I began writing this book, my goal was to write the most readable book without technobabble, to teach you how to use the Internet."[85] Shiva accomplished

his mission, and the book covers a wide range of topics, from creating collaborative art to issues of censorship, security, and copyright. A glossary of terms is also provided. Shiva also pointed out that

> during the course of writing the book, . . . I began to realize that the Internet needed the arts more than the arts needed the Internet. The Internet, after all, is just another tool that artists can use. However, communications tools and technologies, including the Internet, do not ensure true communication.[86]

⁓ EB SITES OF INTEREST TO ARTISTS

The following are a selection of some of the many Web sites that are of particular interest to artists. The address of each site is provided in the appendix section "The Internet." To give you a general idea of the costs involved for using the registry-type of on-line galleries, fee information is provided for some of these sites.

Artist Registry On-Line Galleries

Artists OnLine is a program that was developed by Warner International Communications. There is an initial setup fee of $45.00 and a monthly subscription fee of $24.95. There is also a one-time charge of $5.00 per slide and $2.00 a page for a résumé or biography, articles and reviews, written descriptions, and a commission history. In addition, if artists chose to participate in Silent Auction, which allows viewers to bid on artwork, there is an additional charge of $10.00 per slide.

StudioVisit is part of Sound Data, Inc.'s ArtResources program (also see page 140). It is available to individual artists and through arts organizations. For example, members of the American Craft Association can use the "Studio-Visit" Web site. For $20 a month each featured artist can show a visual image. An artist's name and address, statement, and résumé are also included in the fee.

OnLineGallery charges $35.00 a month for twelve images, and $1.00 a month for each additional image. There is no setup fee. The monthly service charge includes programming up to five thousand words of biographical and promotional information, an individual Web and E-mail address, a cross-referenced listing in the OnLine-

Gallery database, listing in Internet directories, and continuing promotion.

ArtNetWeb offers artists various Internet packages ranging from five Web pages for $299 to sixteen web pages for $499. The fees include a year's placement on two Internet Web sites, image scanning from photographs or slides, short-text input, and résumé formatting.

Art Xpo offers several price packages, including an introductory offer of $39.00 for one full year that entitles artists to place on its Web site two images of their work in three sizes, along with a biography, an artist statement, and a photograph. Artists also receive a supply of business cards printed with their Internet address.

Other registry-type on-line galleries include ArtNet and ArtQuest.

Commercial Galleries with Web Sites

The Art Odyssey Web site is comprised of galleries throughout the United States. Users may view each gallery by name and location or choose to search an individual artist.

Artscope's Web site is divided into sections for galleries, print publishers, individual artists, and curated shows. The Artscope site offers cross-links to Web sites for more than forty galleries.

Contemporary Art Site features galleries in the United States and in Europe. It also offers images and information on selected artists.

Arts Information and Services to Artists

Initiated by the New York Foundation for the Arts, Arts Wire is one of the very first arts-related Web sites. With hundreds of members of arts organizations, arts councils, and individuals, it gives advocacy information. It also serves artists by providing information on grants and employment opportunities. The Artists' Conference section provides opportunities for artists to exchange information and "sound off." The Home Page provides detailed descriptions of the New York Foundation for the Arts' programs and services. It also includes application forms and guidelines for the foundation's fellowship program, and an on-line store from which to order booklets and videos.

Art in Context is a not-for-profit resource for the advancement of fine-art research that provides a free venue for patrons and scholars to locate and discover information about fine art. The site includes selectively reviewed and edited listings and "Reference Pages" for artists,

museums, galleries, and dealers. There are no on-line fees, but if your work is selected for the Web site, you will be charged reasonable processing fees. All images are individually processed by the company.

Sound Data, Inc.'s Web site ArtResources contains six locations devoted to specific themes. Updated monthly, GalleryWalk contains information on galleries worldwide, including artists represented, current shows, future shows, images of artwork, and directions where the gallery is located. MuseumStroll features local and regional museums and provides information on their collections, areas of interest, and current exhibits. It also features items found in museum stores and ordering information. ArtShows provides information on art fairs, festivals, and craft shows worldwide; and ArtSchools lists art schools throughout the world with information on whom to contact for admission inquiries. It also gives course descriptions, biographies of staff members, and images of the campus. ArtNewsstand lists art-magazine publishers and describes each magazine's focus. It also provides a table of contents for each current issue and a brief summary of some of the featured articles. In addition, books and videos that are of interest to artists are listed.

The National Endowment for the Arts (NEA) sponsors several Web sites, including an on-line version of the NEA's program guidelines, and answers to frequently asked questions about the endowment. The International Partnership Office of the NEA offers a comprehensive guide to international arts exchange programs through the site World Arts: A Guide to International Exchange.

ArtsNet provides information on funding resources, including the ArtsNet Development Database to inquire about awards made by state arts councils.

The Arts Deadline List is a monthly digest of competitions, contests, calls for entries, grants, fellowships, jobs, internships, and other career-related information.

For information on resources available in the United Kingdom, the National Arts Guide is the first comprehensive guide to the art galleries of Britain, containing details on over 650 galleries. The Scottish Sculpture Workshop Web site includes a list of sculpture contacts and sculpture organizations in the United Kingdom and the Republic of Ireland.

Other Web sites of interest to artists are Arts Edge, which provides

an alphabetical list of artist-in-education grant opportunities; the Council on Foundations, which maintains an alphabetical list of foundations; the Directory of Grantmakers, which is sponsored by the Foundation Center; the Small Business Association's Web site, which offers information about its programs and tips for starting a business; and Barter.Net, which provides a listing of bartering networks.

8

Dealing with Dealers
and Psyching Them Out

Although this chapter is primarily about gallery dealers, much of the information and advice and most of the perspectives and views are also applicable to people in other arts-related occupations, including art consultants, curators, critics, administrators, collectors, and artists. Some of my impressions and characterizations might seem severe, but it is not my intention to throw all of the blame for the ills and injustices in the art world on dealers, curators, and the like. *Artists must also accept responsibility for the way things are*, mainly because most artists, overtly, covertly, or inadvertently, participate (or try to participate) in the dog-eat-dog system. Few are trying to change it.

If I had my way, I would replace commercial galleries with a system in which artists exhibited work in their studios and sold it directly to the public. But such a system could work only if artists acquired enough self-confidence not to need gallery validations, and if the public, likewise, had the self-confidence necessary to buy work without gallery validation. Since there is a very remote chance that these events will occur in my lifetime, the next best thing for changing the system is to regulate the business practices of galleries nationwide, including policies affecting commissions, discounts, insurance, and payments to artists. For the time being, since the gallery system is still very much intact and is virtually unregulated, the following opinions, advice, and observations are aimed at helping artists acquire more business savvy, more control over their careers, and more control in their relationships with those who are currently running the show.

\mathcal{L}IES, ILLUSIONS, AND BAD ADVICE

Artists are constantly bombarded with erroneous, irresponsible, and unethical advice about the art world and art galleries. While some advice is exchanged through word of mouth, much of it is disseminated through articles in trade publications. Some of these articles are written by well-meaning but naive individuals who are connected to the art world in some capacity; others are written by less-than-well-intentioned art-world figures whose motives are self-serving. For example, in an article from *Art in America*, a dealer assures readers that "a minority of dealers are strictly concerned with commercial success."[87] However, he then condones the greedy practice of awarding dealers a commission on *all* studio sales:

> An artist may on occasion sell a work directly from his studio to a friend or to a collector he has known before his gallery affiliation. It is the artist's ethical obligation to report such transactions to his dealer and to remit a reduced commission, commonly 20 percent, to compensate the dealer for a work he cannot offer under the usual terms of their agreement.[88]

Another dealer insinuates that the fastest track into the art world is to work for a famous artist, and tells *ARTnews* readers that "apprentices have instant entrée. They meet collectors and curators."[89] A political scientist *cum* art collector encourages beginners to exhibit only in "small" places when he writes in *American Artist*, "Begin building your career at smaller local or regional galleries of good repute. It is too bruising to try the larger galleries in major art centers."[90] An arts administrator encourages artists to retreat if they are rejected by galleries, advising, "If your first search is unsuccessful, wait a year or two and try again."[91] And a career consultant to artists states that the reason it is important to dress presentably is "so that you give the impression that you're making money somehow, presumably through your artwork."[92]

Artists also give each other peculiar and bad advice, much of it better suited to the *National Enquirer* than to the "reputable" periodicals that publish it! For example, an artist tells readers of *ARTnews*: "What

works best—for success—is if the artist is handsome or very beauti-ful."[93] In a book profiling contemporary artists, an artist discusses how she uses sex to get ahead: "I've been propositioned a lot: 'I'll give you a show if you sleep with me.' It happens often. Would I do it for a show? Now I would, but when I was younger I wouldn't. I wouldn't because I was a jerk."[94] And another artist tells beginners that "one of the necessary qualities of being an artist . . . is to not expect an awful lot, to be somewhat dense about any thoughts of what you will get out of being an artist."[95]

If you believe everything you read you would conclude that, in or-der to find a gallery and succeed in the art world, you must be beauti-ful or handsome, sleep with dealers, and dress as though you have a lot of money. When beginning your career, you should work as an ap-prentice to a famous artist but have low expectations and exhibit in small, local galleries. You should avoid large cities at all costs. And if you are rejected from galleries, you should retreat and wait a year or two before trying again!

Although in composite form these recommendations sound very silly, many artists, unfortunately, believe the advice to be true.

DEALERS: THEIR BACKGROUNDS AND PERSONALITIES

To compile information for the new book *New York Contemporary Art Galleries: The Complete Annual Guide*, editor Renée Phillips prepared a questionnaire that was sent to galleries and exhibition spaces in all five boroughs of New York City.

The questionnaire addressed specific areas of interest to artists, such as how the gallery selected artists, the gallery's philosophy, and the type of work exhibited. The questionnaire also asked dealers to provide information on their "backgrounds." Although the book con-tains over five hundred listings, from a sample of *379 commercial* gal-leries in Manhattan, 207 of the galleries did not provide "background" information. Since the majority of dealers omitted this information, it is not possible to formulate a typical profile sketch about the back-grounds of dealers in Manhattan. However, one conclusion that can be drawn from Phillips's study is that most dealers in Manhattan are unwilling to share biographical information!

Of the dealers that provided the information, fifty described their background as gallery dealer or as having had gallery experience. Another four dealers provided an even vaguer response of having been "involved in fine art." Thirty-two dealers were artists; fourteen dealers were involved in banking, finance, and business or sales unrelated to art; twelve dealers had studied art history or were art historians; eleven dealers were art collectors; and five dealers were interior designers. Four dealers each were attorneys and art advisors or art consultants. Four dealers had worked in museums, and another four had been involved in the field of music. Three dealers each were curators and art publishers. Three were previously affiliated with nonprofit organizations. Two dealers each had been in fashion, real estate, advertising, magazine or book publishing, and filmmaking. Two dealers had been involved in teaching and education. In addition, there was an architect, a restaurant owner, a television executive, a theater producer, a philosophy major, an artist manager, a book printer, a journalist, a gemologist/press attaché, and an art-display producer.

Allowing for a handful of elderly dealers who most likely exempted themselves from answering the question because they had been dealers for most of their working lives, one can speculate that the reason dealers were unwilling to share details of their backgrounds is that their backgrounds have nothing to do with visual art. They fear that such a discovery will diminish their power and credibility, and even worse, it will cause them to lose the mystique that envelops their occupation: the mystique of possessing a "golden eye," which gives them the right to determine "good" art and "good" artists.

Although a background in fine arts does not insure that a dealer will be effective in art sales and capable of running a gallery, for many dealers who do not have such a background fear of exposure of what they *perceive* to be their "dirty little secret" has become a major factor in the molding of their personalities.

Relating to people who possess a fear-based psyche, whether an artist or a dealer, is very difficult, and the difficulties are manifested in several ways. For example, *arrogant* and *temperamental* are adjectives frequently used to describe both artists and dealers. Was it the arrogance of an artist that forced a dealer to retaliate with the same weapon? Or was it a temperamental dealer who elicited the same response

from an artist? Is it a chicken-and-egg situation or a matter of simultaneous combustion?

Arrogance is a self-defense tactic to disguise insecurities. Some artists and dealers suffer from the same basic insecurities about their past, present, and future. The fear that causes a dealer to conceal biographical information originates in the very same place as the fear that makes it painful for an artist to compile a résumé because he or she lacks an academic background in the fine arts. The fear that causes a dealer to cut gallery expenditures in all of the wrong places is the same fear that causes an artist to be miserly about investing financially in his or her career. The fear of a dealer that he or she will never attain art-world recognition is comparable to the fear of an artist who experiences a panic attack when a fortieth, fiftieth, or sixtieth birthday begins to approach.

Many dealers are frustrated artists who did not have the tenacity, perseverance, and fortitude to stick it out. Consequently, they are jealous of anyone who did. The wrath of some dealers pours forth when they spot weak work or weak personalities. A weak artist reminds them of themselves, and the memories bring little pleasure. Other dealers behave like bulls that see red: they believe all artists are threatening. They do not differentiate.

Because many dealers are unable to produce provocative work, and *showing* provocative work does not gratify their frustrated egos, they compensate by cultivating provocative personalities. Some dealers are so skilled in verbal delivery that they lead others to believe they know what they are talking about. These dealers begin to believe that their reputations give them the right to make outrageous, irresponsible demands and give outrageous, irresponsible advice. These dealers also believe that reputation alone exempts from the requirements of morality or integrity, let alone courtesy.

A painter once came to me for advice about his dealer, with whom he had worked for several years. The dealer gave him single shows on a regular basis, and the artist sold well at all of them. However, the dealer, one of the better known in New York, had been badgering the artist for months to stop doing freelance work for a national magazine. The dealer contended that if the artist continued to work for the magazine he would not be taken seriously as a fine artist. The artist began to question the dealer's judgment only when it infringed on his

financial stability. Until then, he let the dealer's opinions influence and control his life.

In response to his problem, I simply stated that it was none of a dealer's business how an artist made money; the artist looked at me as if this were the biggest revelation of the century!

Another client was told by a dealer who had just finished rejecting him to be careful about showing his work to other artists because they might steal his ideas. The artist didn't know what to do with the back-handed compliment. On the one hand, the work wasn't good enough for the dealer. On the other hand, the ideas were good enough to be stolen. Up until that point the artist had not been paranoid about other artists stealing his ideas, but the dealer successfully instilled a fear: beware of the community of artists!

Dealers take great delight in giving artists advice on how their work can be *improved*. The lecture begins with a critique of the artist's work that quickly transforms into an art history class. And artists listen. They listen in agony, but they listen.

It Takes Two to Tango

Many artists have an "attitude" about dealers and anyone else in the art world who is perceived as an authority figure. In the years that I have worked with artists, I have had to remind clients on several occasions that I am not the enemy!

I am reminded of an artist who called me to make an appointment to discuss her career. She called back a few days later to cancel, saying her slides weren't ready, then quickly changed her mind about the excuse she had offered and lashed into a tirade that ended with: "And who in the hell are you to judge my work? I don't want to be put in a position to be judged."

It took me a while to regain composure, but when I did, I told her that, in my capacity as an artists' consultant, I did not judge work, and even if I did, I hadn't called her, *she had called me* and set up the situation!

Once, at a cocktail party where artists were in the majority, a painter used the opportunity to verbally abuse a dealer he had just met for the first time. At the top of his lungs he held the dealer personally responsible for the hard time he was having selling his work, and he tried, unsuccessfully, to goad his colleagues into joining his

tirade. The scene served no other purpose than to add some excitement to what, up to that point, had been a very dull party. The dealer left in a huff, followed by the artist, who was angry that he had received no support or encouragement from his peers.

On another occasion, a meeting I had with a client and his dealer centered on the artist's career. As long as this was the case, the artist was enthusiastic and amiable. However, when we finished with the subject at hand and drifted on to other topics, the artist began yawning, squirming in his chair, and nervously rapping on the table. When he saw that neither the dealer nor I intended to respond to his body language, he started ranting that he was bored with our conversation. With one conciliatory sentence the dealer placated the artist so easily and skillfully that I realized how familiar and experienced he was with this kind of behavior.

Artists have been known to engage in the shady practice of secretly selling artwork to a dealer's client at a highly discounted rate. Although it does not happen often, it does happen, and once a dealer experiences a broken trust, he or she begins to suspect *all* artists of participating in such schemes.

I recently learned of an artist who had been asked by his dealer to crate and pack a painting that had been sold through the gallery. The artist did not know the name or address of the collector, but in the packing crate the artist left a note saying that if the collector wanted to buy the painting at a substantial discount, he should return the work to the gallery and contact the artist directly. The proposal appealed to the collector, and he informed the dealer that he had changed his mind about buying the painting. When the collector returned the painting to the gallery in the packing crate, he inadvertently included the artist's letter. When the dealer unpacked the crate and found the letter he received quite a shock. And so ended the artist's relationship with the gallery.

Dealers can also be cruel or even sadistic, heaping abuse on artists while the artists masochistically allow it. The following episode illustrates the point loud and clear.

A painter took slides to a dealer. While he was viewing her work, he lit up a cigar. After examining the slides he said that he wasn't interested—her work was "too feminine." He then proceeded to give the artist a lecture on the history of art, all the while dropping cigar ashes on her slides.

The artist watched in excruciating pain, but didn't say a word. When the dealer finished the lecture, the artist collected her slides and left the gallery. But she was so devastated by the symbolism of the ashes on her work that she put herself to bed for three days.

Regardless of whether the dropping of ashes was sadistic or inadvertent carelessness, the question remains, Why didn't the artist say something? For example, "Excuse me, but you are dropping ashes on my slides!"

One wonders: if the dealer had been pressing his foot on her toe, would she have allowed him to continue? When the dealer said that her work was "too feminine," she should have immediately left the gallery (with a curt "Thank you for your time") or stayed to challenge his idiotic statement.

Just as artists tend to forget that, to a great extent, a dealer's livelihood depends on an artist's work, dealers also forget, and they need to be reminded. Reminding them won't necessarily mean that they are going to like your work any more, but it can give you some satisfaction, and put things in perspective, something that the art world desperately needs.

Dealers as Businesspeople

Finding gallery representation is a task that requires patience. In New York, for example, many artists are strung along by galleries for as long as ten years. After several rounds of annual studio visits and more rounds of appointment changes or no-shows, a commitment is finally made—an actual exhibition date is scheduled. But the exaltation of gallery status can quickly dissipate when one discovers exactly what being a gallery artist entails.

Nina Pratt, who for many years served as a New York–based art-market advisor, observes:

> If those considering opening a gallery or entering a related profession were presented with a checklist of qualities and skills necessary for a successful career, the majority of people would have second thoughts about entering the field![96]

Pratt is knowledgeable about the inner workings of gallery operations, and she sheds light on why so many dealers sink or barely keep

their galleries afloat, and live up to neither their own nor artists' expectations. If many of the reasons she addresses sound very familiar, it is because they are the very same reasons that prevent artists from achieving their goals, with or without gallery representation.

Pratt believes the root of the problem is that many dealers believe the myth that art and business do not mix. "Dealers are terrified of being viewed as used-car salesmen. They go to great lengths to disassociate themselves from the 'business' aspects of art."[97] She also points out that many people who open galleries naively assume that an arts-related profession will automatically make them successful. Parallels can be drawn between these dealers and the artists who believe that talent is the only skill necessary to guarantee a constant stream of dealers, curators, and collectors knocking at the door.

Pratt also points out that since a dealer's selling style usually matches his or her personal buying style, he or she frequently hires a staff with a similar selling style. This lack of flexibility can severely cripple sales. "Collectors come with a variety of backgrounds, tastes, and buying power," Pratt says. "They also come with a variety of ways they behave as consumers. A gallery must be able to adapt to the range and differences in consumer habits."[98]

During personal encounters with the public, dealers tend to go to extremes by either not talking at all or taking too much. The cool, nonverbal approach can be perceived as intimidating; overly talkative dealers might not hear what the client is saying. "Important data can be gleaned from listening, including aesthetic learnings, price range, style of buying, and sincerity of interest," Pratt observes.[99]

Citing greed as one of the most self-defeating business practices, and noting dealers' unwillingness to split commissions with other dealers and art consultants, Pratt adds that "dealers should be willing to pass up commissions in order to show clients that they can get them what they want. This can most definitely strengthen a working relationship with collectors, stimulate trust, and encourage future sales. A cooperative spirit between dealers, and between dealers and art consultants, is at an all-time low."[100]

Pratt also faults dealers for their approach to advertising, which is discussed in chapter 5 (see page 90).

"The Attitude"

New York dealer André Emmerich has said that "good dealers don't sell art; they allow people to acquire it."[101] Such a statement sets the tone for the way art is often marketed, an attitude conveyed not only in a gallery's selling style, but by its staff.

In a *New York Times* article the art critic Grace Glueck described some common grievances voiced by the public about galleries.[102] Complaints spanned a range of issues, including the absence of basic civil courtesies and being patronized or treated rudely when purchasing work in the lower end of a gallery's price spectrum.

Dealers, for their part, complained that the public is not knowledgeable about art; they ask too many questions. Dealers further suggested that members of the public do their homework *before* entering a gallery.

The article painted a disheartening picture of the gallery world, primarily in New York City, but the picture is even more disheartening when one realizes how pervasive "the attitude" really is.

Although most dealers are not perceived as used-car salesmen, they often overreact to their fear of being perceived this way by cultivating snobbish airs. However, a haughty attitude coupled with a lack of business acumen often results in a loss of clients and potential clients, and eventually in the loss of their galleries!

Unethical Business Practices

Whether a dealer is ethical depends on his or her moral and financial integrity. A dealer's immoral practices are not always apparent until an artist is already involved in a formal relationship with the dealer. However, some of the ploys used by morally abusive dealers include playing "mind games," making outrageous demands on artists, and dispensing bad advice. Often, artists are willing to accept a dealer's tyrannical or manipulative behavior as long as they don't feel that the dealer is cheating them financially.

THE MARTYR SYNDROME

Frequently, dealers see themselves as martyrs who are taking a big risk simply by selling art for a living. But many of the dealers who had made their way into the art world in recent years require artists to share the financial risks of running a gallery—without sharing the profits. Because they see themselves as martyrs, dealers also rationalize

that it is fair and just to use an *artist's share* of a sale to offset gallery cash-flow problems. Artists are paid when it is convenient—or in some cases they are never paid!

In the second edition of this book, published in 1988, I wrote:

> In the area of finance, there are certain disreputable dealers who are easy to identify, for they blatantly nickel-and-dime artists for every expense that is directly or indirectly related to an exhibition. Up until the time work is placed in a gallery, an artist is financially responsible for the costs of preparing the work for exhibition and transporting the work to a gallery. But once the work is in the gallery, an artist should not have to pay for any costs other than a dealer's commission, and then only if the work is sold!

Tragically, in the 1990s, there would be slim pickings if artists limited themselves only to galleries that pay for all exhibition costs. Data compiled in the book *Artists Gallery Guide for Chicago and the Illinois Region*, published in 1990 by the Chicago Artists Coalition, showed that 38 percent of the galleries polled require artists *either* to split promotion expenses with the gallery or pay the full amount; 22 percent require artists to split opening costs with the gallery or pay the full amount; and 30 percent require artists to split postage costs with the gallery or pay the full amount.

Although the majority of Chicago galleries still pay for most exhibition-related expenses, the statistics are indicative of *a trend outside of New York City* to make artists more responsible for gallery costs. In New York City, the practice of requiring artists to split or fully absorb exhibition expenses is not a trend, it is a *fait accompli!*

GALLERY HANKY-PANKY

Sometimes dealers deduct exhibition expenses and/or client discounts from an artist's share of a sale without forewarning the artist of this policy. And sometimes when work is sold artists are paid based on a price they previously set, when in reality the work sold for a higher amount. In many instances artists are oblivious of the deception.

One artist suspected something fishy after his numerous requests to his dealer for copies of sales invoices pertaining to his work went

unheeded. He concocted a brilliant scheme to determine whether his suspicions were justified. Knowing that his dealer was out of town, he telephoned the gallery assistant to share a secret: he confided his plans to give the dealer a collage to commemorate his first year as a gallery artist. The collage would incorporate copies of sales receipts pertaining to his work, symbolic of hopes for a continuing prosperous relationship. The artist asked the assistant to cooperate by allowing him to photocopy the receipts. The assistant eagerly complied.

The receipts showed that the artist's suspicions were indeed justified. In one instance, a painting for which he had been compensated based on a selling price of five thousand dollars, had actually been sold for ten thousand dollars! The case was settled out of court, and the artist received all of the monies due.

Although the artist was financially compensated for sticking up for his rights, he suffered an emotional blow when he told other gallery artists that he had been cheated and that he planned to take legal recourse. He was chided by some of the artists for "hanging the gallery's dirty laundry in public"; others preferred to look the other way and pretend nothing had happened.

In New York, price manipulation of artwork in galleries was so endemic that in 1988 the city's Department of Consumer Affairs ruled that the prices of artwork in New York galleries must be "conspicuously displayed" for all visitors. Galleries complied, but not without a big fuss. Critic Hilton Kramer wrote a scathing article in *The New York Times* to protest the ruling. His basic point was that galleries are not retail stores and should not be required to display price tags.[103] However, *Times* readers disagreed, and in the following weeks numerous letters to the editor were published contesting Kramer's point of view. One art collector wrote:

> Art galleries are stores. Their proprietors, the art dealers, are merchants. Their primary purpose is to sell art in order to make a profit. They are not houses of worship. They are not museums. They are not schools. They are not eleemosynary institutions. The dealer is not an altruist dedicated to educate and elevate the public. He is a pragmatic businessman. . . . There is no valid reason why this rule should not apply to galleries so that the collector will get the same information as other consumers.[104]

And an artist wrote:

> Mr. Kramer endorses . . . both the "old boy" approach and the "if
> you must ask the price . . ." snob approach: salesmanship by inti-
> macy and intimidation, respectively, which is exactly what the
> New York City Department of Consumer Affairs is trying to
> end. . . . As consumers, we are assured that the amount on
> whatever price tag is meant for everyone. How strange it is that
> the art gallery racket is the singular exception to this forthright
> concept, and how stranger that art dealers should be allowed to
> hide behind that protective screen of esthetics, of all things.[105]

How DEALERS FIND ARTISTS

One of the most annoying and irrational explanations of why the
work of more artists is not exhibited in galleries is the cliché that
"there are too many artists" or "there are not enough galleries for the
number of artists." Such notions reinforce the myth of scarcity which
is discussed in the section on career blocks in chapter 1 (see page 3).

The real reason that the work of more artists is not receiving gallery
exposure is that there are too many dealers who are unwilling to take
a risk on representing artists who do not have an exhibition track
record. There are also too many dealers who know very little about
how to sell art or develop an expanding and broad base of collectors,
and there are too many dealers who do not know how to tap into new
markets and audiences.

On the other hand, many artists without exhibition experience feel
trapped by the popular belief that one must have a track record to be
considered for gallery representation. Although many galleries are
only interested in showing the work of artists with exhibition experi-
ence, if an artist has a track record it logically implies that other gal-
leries were willing to exhibit the artist's work without a track record!

The book *New York Contemporary Art Galleries* includes information
about the selection process of galleries. Out of 471 galleries in the five
boroughs of New York City that show the work of contemporary
artists (excluding membership galleries, rental galleries, print publish-
ers, and vanity galleries), 151 galleries stated that they find artists
through unsolicited slide packages; 125 galleries provided no informa-

tion on their selection process; 91 galleries stated that they select artists through a combination of unsolicited slide packages, referrals, publications, and exhibitions; 56 galleries listed other means of selecting artists; 36 galleries stated that their galleries are closed to new artists; and 12 galleries stated that they select artists only through referrals.

It is interesting to compare these findings to a study done in the late 1970s when *Artworkers News* published the first and only comprehensive survey at that time of New York City galleries that showed contemporary art.[106] The study was based on a questionnaire completed by ninety-nine galleries. Although the main purpose of the study was to investigate the extent to which galleries were excluding artists on sexual or racial grounds,[107] it unearthed some insights into the gallery system of the 1970s. The study indicated that the main way galleries got new artists was through artist referrals *and* referrals from other "art-world figures." The study indicated, however, that artist referrals were the *primary* source.[108]

Referral Systems

Understanding how referral systems operate can sometimes be hazy and difficult to decipher. But a clear example of how the artist referral system works is depicted in the following chain of events. One of my clients, a painter, approached a well-known New York gallery dealer. He set up an appointment, showed his slides, and the dealer responded with the "Come back in two years" routine. Several weeks later, while the painter was working as a waiter, he noticed that a famous artist was sitting at one of the tables. He introduced himself to the celebrity and asked whether the celebrity would come to his studio to see his work. The painter and celebrity exchanged telephone numbers, and within the next few weeks the celebrity paid the artist a visit. The celebrity was impressed with the painter's work, so impressed that he bought a painting and insisted that the painter show his work to a specific gallery dealer, coincidentally the same dealer who had rejected him a few weeks before. The celebrity called the gallery dealer, raved about the artist, and shortly afterward my client returned to the gallery. This time he was greeted with another routine, but one more pleasing to his ear: "Where have you been all my life?"

Relatively few artists are admitted into galleries; assuming that dealers heed mainly the advice of other artists, my contention that

artists are not referring each other to the extent to which they should seems accurate.

On the other hand, although artist referrals do exist, I am skeptical as to whether the gallery dealers who responded to the *Artworkers News* questionnaire were honest about artists being the primary referral source. It sounds good for the record, but compared with artist referrals, referrals from other art-world figures offer more mileage. For example: Curator tells dealer that critic wrote an excellent review about artist. Dealer checks out artist and invites artist into gallery. Dealer tells curator that artist is now part of gallery. Curator tells museum colleagues that artist is part of gallery and has backing of critic. Curator invites artist to exhibit at museum. Curator asks critic to write introduction to exhibition catalog in which artist is included. Dealer tells clients that artist has been well reviewed and is exhibiting at museums. Clients buy.

There are other variations on the same theme, including curator/dealer/critic conspiracies, which involve each buying the work of an unknown artist for very little money. Press coverage and exhibition exposure begin, and within a short period of time the dealer, curator, and critic have substantially increased their investment.

Throughout the book *The Art Biz: The Covert World of Collectors, Dealers, Auction Houses, Museums and Critics*, Alice Goldfarb Marquis describes the many entangled, self-serving relationships among art-world figures, pointing out that

> the marketplace in stocks and bonds operates under stringent regulations against insider trading and conflicts of interest and insists on considerable openness about buyers, sellers, and prices. Despite occasional lapses, trading is constantly monitored; violators of the rules could end up being frog-marched down the center of Wall Street in handcuffs. By contrast, the art marketplace tolerates—indeed fosters—a sleazy, robber-baron style of capitalism not seen on Wall Street since the Great Depression. . . . If they were dealing in securities rather than one of humankind's noblest endeavors—art—the perpetrators of such egregious conflicts would be in jail.[109]

New York art dealer Richard Lerner acknowledged the importance of the art-world-figure referral system when he discussed his criteria

for inviting new artists into his gallery. He described his selection process, which sounds more like a shampoo-judging contest, in this way:

> For the benefit of the people that are already in the gallery, it's imperative, if I add names, I add names that already have some luster . . . I mean peer approval . . . who are recognized curatorially, critically as having importance in the mainstream of American art.[110]

One can ponder at great length over the reasons why a dealer initiates a business relationship with an artist. But there could be as many reasons as there are dealers, and in the end it is a pointless task. A much more productive use of time and energy should be spent contacting dealers to let them know that you exist.

Artists who want to gain broad exposure and/or derive a healthy part-time or full-time income from gallery exhibitions and sales *must be represented by many dealers*. Relying on one dealer for your livelihood is not practical for many reasons. For example, your dealer might die, go into bankruptcy, or go out of business for other reasons. And unless a dealer understands the importance of expanding his or her client base and, most importantly, *is willing to engage in an expansion*, the gallery's narrowly focused market will soon become saturated, and sales activity will come to a screeching halt.

INSUFFICIENT TRAINING OF DEALERS

The section "Insufficient Training of Fine Artists" in chapter 1 (see page 8) discusses the problem of art schools not preparing students for real life. The same problem of unpreparedness holds true for dealers, most of whom jump into the field without a clue of how to run a gallery, how to sell art, and how to work with artists in order to achieve a mutually satisfying relationship.

Being an art dealer requires no particular qualifications. *Anyone* can become a dealer, and it seems apparent that *anyone* and *everyone* have become art dealers as witnessed by a general lack of good business skills, good business standards, and good business attitudes in the dealer's community at large. Also prevalent are a general lack of sensitivity toward artists and a lack of basic knowledge about art.

One of the biggest attractions for becoming an art dealer is that the *immediate* payback is formidable. The instant respect, awe, and power gained by dealers are probably unparalleled in any other occupation. On the other hand, obtaining a reputation as a dealer who *actually sells* art is a completely separate matter.

However, positive changes are being made to prepare future art dealers for the gallery world. Degrees in arts administration are now being offered at colleges and universities throughout the United States and abroad, and many of the programs are specifically structured for people who want to become art dealers.

The goals expressed by Columbia College Chicago regarding its graduate program, The Arts, Entertainment and Media Management, are certainly refreshing compared to the reality of how galleries are currently being run:

> Successful arts management is critical to the continued vitality of modern cultural institutions, creative enterprises, and arts organizations. If the public is to benefit, skilled arts managers must facilitate the work of artists. To achieve this end, capable managers combine aesthetic sensibilities and business acumen. Their financial, legal and organizational decisions help make it possible for artists to realize their vision and to share it with the public. In short, talented arts managers are partners in a collaborative process.[111]

Courses offered at Columbia College Chicago include Decision Making: Visual Arts Management, Software for Arts Management, The Artist in a Climate of Change, and Arts Entrepreneurship. Golden Gate University in San Francisco offers both M.A. and M.B.A. degrees in arts administration as well as a certificate in arts administration. Courses include Marketing and Public Relations in Arts Administration, Gallery Management, Contemporary Arts Issues, and Legal Aspects of Arts Administration. New York University in New York City offers a specific degree in Visual Arts Administration. Courses include Marketing the Visual Arts, Law and the Visual Arts, Corporate Art Collecting, Exhibition Design, The Artist's Career, and Visual Arts Markets.

Additional information about colleges and universities that offer

degrees in arts administration can be found in the *Guide to Arts Admin-istration Training and Research* (see appendix section "Employment Op-portunities") published by the Association of Arts Administration Educators.

Hopefully, in the near future the *majority* of individuals joining the ranks of art dealers will possess the necessary skills and knowledge that can lead to successful careers and make the gallery experience much more pleasurable and professional for artists, the public, and other members of the art world.

Selecting Galleries

The most common advice given to artists about selecting galleries is to start small and avoid big cities. The advice is not based on any great truism or profound knowledge; it is simply the way things have been done. However, there is no guarantee that if you start with a small, obscure gallery you will end up in a large, high-profile gallery, just as there is no certainty that if you start big you will auto-matically be turned away. Since neither of the formulas is guaranteed to work, *approach all galleries that meet your criteria.* Keep all of your op-tions open and do not let supposedly pragmatic advice narrow the possibilities.

Criteria for Selecting Galleries

Deciding whether the gallery is right means paying attention to big and little details. Obviously, respecting the work of gallery artists is an important consideration, but do not limit your selection to those gal-leries featuring work that is similar to your own. Although it seems like a logical criterion by which to select a gallery, logic does not often prevail in the art world, and a dealer might respond by saying, "We have someone doing that already!" Select galleries with whose artists you *share an affinity.*

The physical properties of a space, including size, ceiling height, and light quality, are another important consideration. Envision your work in the gallery space. Would it be exhibited to its best advantage? Does the gallery have a cluttered or spacious feeling?

Another important factor to consider is a gallery's price range. A

gallery should offer you pricing *breadth*. Even though your work might currently be priced in a lower range, you want to be able to gradually increase your prices. Therefore, you need a gallery that sells work in a flexible price range. Many galleries have a price ceiling based on what they think their constituency will spend on art.

Let Your Fingers Do the Walking, and Wear a Disguise

The *Art in America Annual Guide to Galleries, Museums, Artists* is a helpful tool for locating galleries throughout the United States. Other publications offer more detailed information on a regional basis, including *Artists Gallery Guide for Chicago and the Illinois Region* and *New York Contemporary Art Galleries: The Complete Annual Guide*. The names and addresses of the publishers of these resource guides are listed in the appendix section "Exhibition, Performance Places and Spaces."

Use the *Annual* and/or regional publications to compile a list of galleries corresponding to the various descriptions that apply to your work (e.g., works on paper, sculpture, photography, painting, decorative arts).

For galleries in your area follow up by visiting each gallery to ascertain whether it is right for you. Consider this to be an "exploratory" visit—not the time to approach a dealer about your work. On the contrary, *disguise yourself as a collector*. You can glean much more valuable information about the gallery if the dealer thinks you are there to buy! By asking the right questions, you can learn quite a lot about the gallery's profile, including its price range, the career level of artists represented, and whether the dealer and/or his sales force is effective.

On the basis of your experiences during personal gallery visits, eliminate from your list the galleries that are no longer of interest and concentrate on approaching those that have made an impression.

For artists interested in exploring galleries in New York, the Art Information Center provides a consultation service that involves screening slides and preparing a list of suggested galleries. The center will see artists by appointment or in certain cases review slides by mail. The address of the Art Information Center is listed in the appendix section "Arts Service Organizations." Guidelines for contacting out-of-town galleries are described in "Making National Connections" (see page 125) and "Making International Connections" (see page 127).

What a Gallery Can Do

A gallery has the *potential* to provide artists with many important amenities that are valuable in the present as well as the future. The optimum services to artists can include selling work through single and group exhibitions and on consignment; generating publicity; establishing new contacts and providing entrée into various network systems; developing and expanding markets in all parts of the world; arranging to have work placed in collections; arranging exhibitions in museums and other galleries; and providing financial security in the form of cash advances and/or retainers.

The minimum gallery services can include selling work on consignment (without an exhibition), providing general gallery experience, and adding résumé credits.

Naively, artists either (1) believe that once they are accepted into a gallery, the optimum services will automatically be provided, or (2) enter a gallery relationship without any expectations, thus missing the amenities that a gallery could provide. Keep in mind that dealers in big galleries do not provide any more or fewer amenities than dealers in small galleries. *It really depends on the dealer.*

There are various reasons why some dealers are more supportive than others. In some instances, it is because a dealer is so busy promoting one particular artist that other gallery artists are treated like second-class citizens. Often it is a case of downright laziness. For example, an artist was told by his dealer that he had been nominated for *Who's Who in American Art,* but the dealer had let the deadline pass for providing the required biographical data. In addition, for more than two months she had been "sitting on" sixty-five written inquiries that had resulted from the artist's work being published in a magazine.

Since there are no guidebooks available that evaluate dealers by strengths or weaknesses, the best way to track down this information is to talk to artists who are with a gallery or artists who have left one.

FEAR OF LEAVING A GALLERY

Artists have many excuses for staying with galleries even though the relationship with a dealer might be unproductive or even painful. Many artists believe that it is better to have a gallery with a poor performance record than no gallery at all.

Feelings of financial and/or emotional dependency on a dealer are prevalent among artists who have a difficult time terminating a relationship with a gallery, regardless of whether it is a well-established gallery or it is much less prestigious. The fear of leaving a gallery can be even more intense if an artist has a relationship *only* with *one* gallery.

Regardless of how lazy, contentious, unfair, or ethically dubious a dealer might be, many artists will stay with the dealer through hell and high water because of an underlying fear of *never again* being able to find another gallery. Irrational as the fear might be, it prevents artists from establishing better relationships with other dealers.

Some artists who have achieved success in the art world want to believe that once you are on top you are entitled to stay on top, as if to expect a cosmic IOU slip that is valid for the rest of their lives. And even though a dealer's interest in an artist has waned to a point where an artist is treated with disdain, the artist will remain with the gallery because of false pride. Some artists who have experienced success early in their careers have a particularly difficult time at a midlife junction, because they contend that they have passed the point where they should have to initiate new contacts; they see it as degrading or they fear that other people will perceive it as degrading. They are either unaware or refuse to acknowledge the fact that maintaining career recognition and success is a maintenance job, sometimes for the rest of your working life. Very few successful artists are given the good fortune of being able to coast.

Don't be afraid to leave a gallery if you find that it is no longer serving your best interests. Give a dealer a chance to respond to your needs or requirements, but if he or she is unresponsive, leave.

Presenting Yourself and Your Work

Dealers are so whimsical: I mean, who knows who is going to like what? I just tell people that I know it's a humiliating, horrible process. I don't approve of it at all, the way artists have to trundle around with their wares. I hate being in a gallery when an artist is in there showing slides. It makes me sick to my stomach—I mean, whoever the artist is. But the fact remains, that's how it works and I'm not going to be able to change it single-

handedly. If artists get upset about it, maybe they will do something about it.[112]

Most artists can probably identify with the circumstances and feelings described here by author and critic Lucy Lippard. But showing your work to a dealer doesn't have to be a painful, gut-wrenching experience. Doing everything possible to put yourself on the offensive will make the process easier.

The first step is to understand that many dealers play games. *Just realizing that games are being played will give you an edge*, making it less likely that the games will be played at your expense. Having an edge can give you the self-confidence and perception necessary to respond with precision, candor, wit, or whatever the circumstances call for. Compare this power with the many times you have walked out of a gallery thinking of all the brilliant retorts you wished you had said while you were there. Keep in mind that one reason why dealers appear to be in control, even when they are hostile, is that they have a lot of experience talking to artists. Dealers have much more contact with artists than artists have with dealers. The more face-to-face encounters you have with dealers, the more quickly you will be able to psych them out, and the more rapidly your tongue will untwist. Practice makes perfect!

How you contact a gallery can also put you on the offensive. You can walk in cold, lukewarm, warm, or hot. Walking in cold means that you are literally coming off the streets without setting up an appointment or bothering to inquire whether the dealer has regular viewing hours. Chances are you will be interrupting one of the numerous tasks and appointments that consume a dealer's day. Walking in cold leaves you vulnerable to many uncertainties, except the fact that you will receive a cold reception.

Walking in lukewarm means that you have sent a presentation package (see chapter 3) or you have set up an appointment in advance. If you mail a package, follow up with a telephone call two weeks later. Keep calling until you get a reaction. Dealers complain that they are pestered with phone calls, but phone calls are the only way to circumvent procrastination and vagueness. As long as the package remains unopened, you are losing valuable time; the package could be in the process of review elsewhere. One of the advantages of

using a brochure in lieu of slides (see page 58) is that you do not have to wait for it to be returned to contact other people.

Walking in warm means that you have been personally referred by an artist or art-world figure. In other words, someone is allowing you to use his or her name. You still might have a hard time getting an appointment, but be persistent. Persistence is not making one telephone call and giving up.

Walking in hot means that a person who is well respected by a dealer has taken the initiative to personally contact the dealer in your behalf.

Don't Show Your Work to Subordinates

Do not show your work to a gallery subordinate (e.g., receptionist, secretary, gallery assistant, assistant manager) for the purpose of eliciting an opinion regarding whether your work is suitable or appropriate for the gallery. Although there are exceptions, subordinates rarely have any power to influence a dealer's decision, and you should not put them in a position to interpret their boss's tastes. Too many artists make the mistake of allowing their work to be judged by gallery underlings. Subordinates are capable of giving compliments, but your ego is in sad shape if you need to hang on to the opinion of each and every staff member who happens to be hanging out at the gallery. Everyone on the staff, except the dealer, is basically an apprentice. Always get the final word straight from the horse's mouth!

Additionally, do not let subordinates discourage you from seeing a dealer. There are always a million excuses why an appointment is impossible. For example, "Mr. Smith is much too busy; he's going to Europe." "He's just returned from Europe." "He's preparing an opening." Don't assume that this overprotectiveness of the boss is necessarily maternalistic or paternalistic. On the contrary, it can be one of the many tactics used by people who feel powerless to usurp what they don't have. In some cases, subordinates want to see your work so *they* can reject it. In other cases, subordinates derive pleasure simply from informing an artist that a dealer is unavailable. Of course, not all subordinates are involved in these power games, and there are those who are sincerely interested in seeing your work. But keep in mind that subordinates are not in a position to make the decision as to whether your work will be accepted by the gallery. Their enthusiasm or discouragement is opinion, not gospel.

There are ways to penetrate the protective shields that surround a dealer. Name-dropping can work. Demonstrating a good sense of humor can also be effective. And then there is basic honesty, letting the person know that *you know* that he or she is playing a power game and why. Honesty is a very effective tool in disarming someone.

Don't Send a Substitute

Even if a friend, mate, spouse, or relative is trying to be supportive and offers to take your work around to galleries, turn the offer down. Do not send a substitute; it is unprofessional and it weakens your position. A dealer wants to know, and has every right to know, with whom he or she is dealing. Likewise, an artist has the same rights and should have the same concerns. If a dealer delegates the responsibility to see an artist's work to a subordinate, an artist will not feel that he or she is being taken seriously. And if an artist is unwilling to confront a dealer, the dealer could conclude that the artist is not serious about exhibiting at the gallery.

Agents

The use of agents is an accepted practice and has sometimes proved to be effective for marketing and selling art that is *commercially used*. For example, photographers, illustrators, and fashion and graphic designers use agents ("reps") to establish contacts, obtain commissions, and sell their products.

In such cases, the artist pays a commission to a rep, but not to anyone else. For an agent to make a decent living, he or she must represent several artists simultaneously. The nature of the commercial art business makes this feasible. A rep may work with many publishers, whose business requires and needs many artists, with different styles and different areas of expertise. Thus, a rep can handle many artists without anyone being neglected (although I am sure some commercial artists would argue with me on this point).

However, in the field of fine arts the use of agents is complicated. Dealers do not like to split commissions, and usually if an agent is involved it means the dealer will receive less money on a sale. And if a commission is paid to an agent from an artist's share of a sale, ultimately the artist pays more money in commissions than he or she receives for the sale of the work. For example, if a dealer's commission is 50 percent, and an agent's commission is 20 percent of the artist's

share, for a painting priced at $5,000 the dealer receives $2,500, the agent receives $500, and the artist receives $2,000!

Over the last several years, a new type of agent has emerged, one who bypasses galleries and sells work directly to museums, corporations, and individuals. Many of the new agents are former gallery owners who found that it was more cost-effective to represent artists without high gallery overhead costs, and to use their contacts and networks in a new way. Essentially, an agent who works this way goes directly to the client, and two commissions are not involved. Unlike an art consultant, this type of agent represents a limited number of artists, and is likely to be interested only in artists with proven track records.

Some artists are using managers. Although a manager functions as an agent, he or she works with only one artist, and is paid a salary or fee in lieu of commission.

In chapter 11 (see page 199), I describe an artist's fantasy of finding the perfect agent. It is important to learn to *manage your own career* because the odds are too low that you will find the fantasy agent, or even one who works well with dealers and splits commissions with them; who takes on emerging artists; who is an effective businessperson; and who works with a small number of artists, giving each of them tender loving care and individual attention.

Studio Visits

Believe it or not, dealers dread studio visits as much as artists dread having them visit. Both parties are nervous and uncomfortable. Dealers are uneasy because they do not like to be put on the spot on an artist's turf. They feel more comfortable rejecting an artist or being vague in their own territory. Dealers also feel anxious about the reception they will receive. They fear that an artist will use the studio visit to give the dealer a taste of the same medicine the artist received in the gallery!

Artists are nervous about the judgment that a studio visit implies. They are anxious about being rejected, or they feel hostile, thus validating a dealer's worst fears that the studio visit will be used as an opportunity to "get even."

One dealer told me that she had to prepare herself mentally weeks in advance of a studio visit. "They are always a nightmare. Artists are so arrogant and hostile." I asked her how she coped with such situations. "I am indecisive and unresponsive. This drives them crazy!"

You have the power to set things up so that the studio visit accomplishes something positive. In some instances, you also must take some of the responsibility if the visit turns out to be unsatisfactory. A successful studio visit should not depend on whether the dealer offers you an exhibition. Many of my clients have been able to score excellent referrals through studio visits. Although the dealers didn't believe that the work was right for their galleries, they were impressed enough to contact other dealers or curators in the artists' behalf, or offered to let artists use their names to set up appointments (enabling them to "walk in warm").

When you host a studio visit, be yourself and don't turn your life upside down. A curator who had spent a concentrated month visiting artists' studios observed that artists who lived and worked in the same space often made a conscious effort to create an atmosphere that suggested their lives were devoid of other living entities. Although the curator saw relics and signs that indicated that the premises were inhabited by dogs, cats, babies, children, and other adults, the studios were conspicuously cleared of all of these other forms of life. She felt very uneasy, as if the artists had a special life-style reserved for curators. She sensed that the artists viewed her as subhuman. The strange atmosphere actually diverted her attention away from the art. She couldn't give the artists or their work her undivided concentration.

Even though you might not yet have had a gracious or civilized gallery experience, treat a dealer the way you would want to be treated when you enter his or her domain.

As soon as the studio visit begins, *take control* by defusing tension. Tell the dealer that you understand this is only a preliminary visit and you do not expect a commitment.

Sometimes circumstances are beyond your control. The worst studio visit I ever had involved a well-known art critic who came to look at my work for the purpose of writing an article in a national news magazine. The meeting was going well, but just as he began to select photographs to accompany the article, our meeting was interrupted by an emotionally unstable artist acquaintance who had decided to pay me a visit. Before I had a chance to make introductions, the artist lashed into a series of incoherent insults, *impersonally* directed at anyone who had happened to be in the room.

While the art critic quickly packed up his gear, I tried to make apologies. The critic was unresponsive. He had assumed that the

artist's insults were directed at him because he was a critic. He departed and I never heard from him again, although I wrote a letter of apology. I was guilty by association.

At first my anger was directed at the artist, but the more I thought about it, the more I realized that the critic and artist had much in common: they were both devoid of clarity and powers of reason.

I lost the article, but I also lost my awe of the critic. This was an important gain.

ARTIST-GALLERY AGREEMENTS

Beware of dealers who won't use contracts. Requesting someone to enter into a formal agreement does not imply that you are distrustful. It merely attests to the fact that being human lends itself to being misunderstood and misinterpreted. Contracts can help compensate for human frailties. Another important reason for using contracts is that it will save you a lot of time and energy in having to reinvent the wheel each time a situation arises that needs some sort of clarification.

Also beware of contracts prepared by dealers. Just because a contract is *ready*, don't assume that its contents are necessarily in your best interests. This brings to mind a contract recently proposed by a New York gallery to an artist living in the Midwest. The contract tied up the artist for three years, requiring him to pay the dealer a 50 percent commission on work sold through the gallery and a 30 percent commission on all work sold *through other galleries*. The contract did not state whether the 30 percent commission should come from the artist's proceeds of a sale or a third party, but either arrangement would have a devastating impact. It would either paralyze the artist from working with other dealers, or it would leave the artist with only 20 percent of the retail price of artwork sold.

Prior to the artist's establishing a relationship with the New York gallery, his work had been exhibited at museums and prestigious institutions throughout the United States and abroad. He was a National Endowment for the Arts fellowship recipient, and a university professor. But his perception of the importance of having a New York gallery threw his reasoning abilities out of whack, and he signed the contract!

Over the years, most of the dealer-originated contracts that I have

screened have not been at all in the best interests of the artists. For the most part they have been narrow in scope and have not taken into account the very realistic scenarios that can develop in an artist/gallery relationship. A contract is a *symbol* that a transaction is being handled in a "professional" manner. What the contract contains is the heart of the matter.

All negotiated points (as well as unnegotiated points) *must* be put into writing. The section "Law" in the appendix lists resources for obtaining legal advice and *sample* contracts for various situations that involve artists and dealers. I emphasize *sample* because the contracts should be used as *guidelines*. No two artists or their situations are 100 percent similar, and contracts should reflect these distinctions accordingly.

Consignment and Consignment/Exhibition Agreements

A consignment agreement and a consignment/exhibition agreement are the most common type of contracts between an artist and a dealer. Many artists mistake a consignment *sheet* for a contract. A consignment sheet should be *attached* to a consignment agreement or consignment/exhibition agreement; it provides an inventory of the work in a dealer's possession and states the retail value of each piece. A consignment *agreement* should cover basic issues, including the length of time the contract is in effect, whether a dealer is limited to selling your work within a specific geographic region, where in the gallery your work will be displayed, the range of sales commissions to be awarded a dealer under *various circumstances*, transportation and packaging responsibilities of the artist and dealer, financial arrangements for rentals and installment sales, artist payment due schedules, and gallery discount policies.

In addition, a consignment agreement should protect an artist against the assignment or transfer of the contract, and address the very important issues of moral rights, arbitration, copyright, and insurance.

A consignment/exhibition agreement should cover all of the issues just raised, but it should also outline the exhibition-related responsibilities of an artist and dealer. Does the gallery pay for advertising, catalogs, posters, announcements, postage for announcements, press releases, postage for press releases, special installations, photography sessions, opening parties, and private screenings? Or are all or some of

these costs split between the artist and gallery—or fully absorbed by the artist?

Artist Sales Contract

An artist sales contract is an agreement between an artist and a collector. Although dealers do not sign this contract, the fact that an artist requires a sales contract as a condition of sale can be a provision in a consignment agreement, consignment/exhibition agreement, or artist/agent contract (see page 117).

Some dealers are vehemently opposed to the use of an artist sales contract because they are naive and are unilaterally opposed to all artist-related contracts. Other dealers are opposed to the contract because it states the price actually paid for the work. If a dealer is involved in hanky-panky, the last thing he or she wants an artist to know is the work's real selling price. Probably the most common reason some dealers are opposed to the use of the contract is they fear that if an artist knows the name and address of a collector, the artist will try to sell more work to the collector without the dealer's involvement. You can placate some dealers by assuring them that you would much rather be in your studio creating work than going behind their backs trying to sell work. Making an effort to address a dealer's fear often resolves the situation.

From an artist's point of view, a sales contract or artist transfer sales agreement (see below) is very practical. Not only does it provide you with a record of who owns your work at any given time, but it reminds collectors that they cannot alter or reproduce your work without your permission. The contract also states that the artist must be consulted if restoration becomes necessary. And if the work is transferred to a new owner, the sales contract is also transferred.

ARTIST TRANSFER SALES AGREEMENT

An artist transfer sales agreement includes all of the provisions of an artist sales contract, but it goes one step further: it requires the collector to pay the artist a percentage of the increase in the value of a work *each* time it is transferred. The amount of the percentage can vary.

In California, which is the only state that has enacted a resale royalties act, artists are entitled to a *5 percent* royalty on the gross sale price when work is resold in California or by a California resident.

This ruling applies to any work created after January 1, 1977, that is sold for more than $1,000 and more than the seller's original price. The California act applies only to paintings, sculpture, and drawings, and the artist must be either a United States citizen or a two-year resident of California at the time of resale.

Some artists are using *7 percent*, which was the amount required in the Resale Royalties Act that was proposed but defeated in New York State. Others are using *15 percent*, an amount suggested in what is known as the Projansky Agreement, drafted several years ago by New York attorney Robert Projansky.

In recent years, the United States Congress commissioned the Registrar of Copyrights at the Library of Congress to conduct a study on the feasibility of enacting national resale royalties legislation and establishing a collection agency or agencies to monitor its enforcement. In an article about the Library of Congress study, La Jolla, California, arts attorney Peter H. Karlen discussed the pros and cons of resale royalties:

> There are practical and theoretical reasons for resale royalties. The typical visual artist is one of the most underpaid individuals in our society. The commissions that artists pay to dealers and other agents are terribly high, and sales of artworks are often at extreme discounts. Why shouldn't a consumer of artwork have to pay a royalty based upon each new "consumption" of the work, in the same way that purchasers of books pay the author (via the publisher) upon each new purchase.
>
> Nonetheless, unless the attitudes of dealers and collectors change so that they fully understand artists' residual rights in their works and the theory behind resale royalties, enacting a national resale royalty law is only likely to create a new expensive bureaucracy. It will be much to do about nothing simply because the costs of collecting resale royalties from recalcitrant dealers and collectors may exceed the royalties.[113]

In the meantime, since there is no bureaucracy monitoring or collecting royalties for visual artists, an artist transfer sales agreement is a document based on trust, not law. Each artist makes his or her own personal decision on whether or not to use this contract.

Checking Up on Dealers

Before committing to a consignment and/or exhibition relationship with a dealer, request a contract. If a dealer is unwilling to use a contract, do not get involved. If a dealer provides you with a contract that he or she has prepared, compare it with one of the sample contracts referred to in the appendix section "Law." If necessary, amend the dealer's contract to include any important provisions that are missing.

If you have successfully negotiated a contract but are unfamiliar with a gallery's business reputation, talk to other artists represented by the gallery. If you do not know the names and whereabouts of other gallery artists, ask the dealer. *It is about time that artists began requesting references*! If you are still unable to get a clear picture of a gallery's business reputation, contact a local chapter of the Better Business Bureau. Ask whether complaints have been registered against the gallery. You should inquire about the gallery's reputation from both an artist's and a client's point of view.

Dealing with Dealers: In Summary

Over the years, I have met with thousands of artists, often serving as a coach to help them iron out gallery-related problems. And over the years I have had at least one client in approximately 90 percent of the galleries in New York City that exhibit contemporary work. These experiences have provided me with an unusually broad perspective on what has gone on behind the scenes at many galleries since the late 1970s and what is going on today. I have been privy to intimate information about how artists are treated and mistreated, who is suing whom and why, the names of the dealers who do not pay artists or do not pay on time, and other maladies.

I still cringe when I hear or learn about some of the unintelligent remarks and value judgments made by dealers, or the outrageous rudeness they display. Those rare occasions when an artist praises a dealer for being fair and wise give me hope that perhaps things are changing for the better.

More often, though, I have trouble responding when I am asked to name dealers I respect *both* as businesspeople and as human beings. In New York, which has more than five hundred commercial galleries, the dealers on my list could be counted on one hand!

Although for many reasons I consider the gallery system in New York to be the most decadent, New York is certainly not the only place that attracts art dealers with questionable moral and business ethics. Many artists around the country have trying and cumbersome relationships with dealers.

If artists do not learn to *cultivate their own market* and become less dependent on galleries for sales and exposure, they will find themselves paying commissions in the neighborhood of 75 percent and up, just to support dealers in the style to which they are accustomed! But it is also highly likely that if you total the amount of money a dealer currently receives for the sale of work and the amount of money some artists are now required to spend for exhibition-related expenses, the day of the 75 percent commission might have already arrived!

It is important that artists develop an autonomous posture and make their own career decisions rather than wasting time waiting for something to happen. The chances are remote that you will find the perfect agent or be introduced to galleries through an art-world-figure referral system, and the so-called artist referral system is virtually nonexistent, because most artists are too paranoid and competitive to refer each other.

You *can* find a gallery without being referred and without an agent. But do not rely on representation by *one* gallery to provide the exposure or livelihood you are seeking. Build a network of many galleries located throughout the United States and the world. Building such a network requires time and patience. But it can be done.

9

The Mysterious World
of Grants: Fact and Fiction

He who hesitates watches someone else
get the grant he might have gotten.
—*Jane C. Hartwig, Former Deputy Director,
Alicia Patterson Foundation*

Who gets grants and why? The *real* answers to these questions can be provided by jurors who select grant recipients. All other answers are speculative and have more to do with hearsay than reality. When I asked members of various grants panels about their selection criteria, their answers were simple and direct: they liked the artist's work or they liked the project under consideration and thought that the artist was capable of undertaking the work. When I probed further, the answers were predictably numerous, varied, and subjective, and boiled down to "taste buds."

Artists who are apprehensive and skeptical about applying for grants have many misconceptions about who receives them. Skeptical artists deem themselves ineligible for various reasons, such as being too old or young, lacking sufficient or impressive exhibition or performance credits, or lacking the right academic background. They believe that the kind of work they are doing isn't considered "in" or that they lack the right connections, which implies that juries are rigged!

It is perfectly conceivable and probable that some artists have been denied grants by some foundations because of some or all of the above-mentioned factors. However, on the basis of my own experiences as a grant recipient and juror, as well as the experiences of my clients (the majority of whom would not measure up to the tough stereotype that many artists have of "the perfect grant-winning specimen"), I am convinced that, for the most part, grant selection is a de-

mocratic process—meaning that everyone has a *real* chance. Many artists believe that because they have applied for the same grant year after year without success, it is a waste to continue to apply. Images are conjured up of a jury sitting around a table moaning, "Oh, no, not him again!" Or conversely, there are artists who believe that one must apply for the same grant at least three or four times before it will be awarded: "It's her fourth application, let's give her a break!" But contrary to the notion that jurists remember who applied for a grant each year, most panels have new members each time they convene. Each time you apply you have a fresh chance.

Since grant selection in the arts is based on taste, and like taste buds, the grants world is mysterious, whimsical, and fickle, you should not depend on or view grants as the only means of providing the opportunity to do what you really want. Grants should be looked upon as "cream" to help alleviate financial pressures, provide time and new opportunities to develop your career, and add another entry to your list of endorsements.

Projects and ideas should not be tossed aside if funding agencies or foundations reject your application(s). Remember, the selection criteria are subjective and *ultimately you must be the judge* of whether your work and ideas have merit. A grant is not the deciding factor.

Also remember that juries are composed of human beings, and humans are not always right. In fact, we have quite a track record of not recognizing talent (until someone dies) and of putting some questionably talented people on a pedestal.

The grants world might seem mysterious, but hundreds of artists each year who take time and energy to investigate grant possibilities and complete well-thought-out applications are reaping the benefits.

BIG GRANTS AND LITTLE GRANTS

Grants come in many different shapes, sizes, and forms. There are grants for visual and performing artists with broad-based purposes and specific project grants for well-defined purposes. For example, there are grants for artists who are women, artists who are mothers, artists with a particular ethnic or religious background; grants for artists born in certain regions, states, and cities; grants for artists involved with conceptual art or traditional art; grants for travel; grants

for formal study; grants for independent study; grants for apprenticeship; and grants for teaching.

From year to year grant agencies and foundations open and fold, cut budgets, increase budgets, change their funding interests and priorities, emphasize one arts discipline over another or one socioeconomic group over another. It is important to keep abreast of these changes. A grant that is not applicable to your current situation and interests could be suitable in the future.

Even when budgets are being cut, don't hesitate to submit grant applications. A case in point: In the 1980s, while federal arts budgets were being slashed, I received a large matching grant from the National Endowment for the Arts. I was not optimistic that I would receive a grant when I submitted the application. Not only was I surprised that I received the grant, I was also surprised that I was awarded every penny that I requested. However, it was pointed out to me by a person familiar with the inner workings of the NEA that when government arts funding is cut, people are reluctant to submit grant applications. Thus, the competition is reduced. In many instances, people have a better chance of receiving a grant when the financial climate is restrained.

Unfortunately, as of this writing, the National Endowment for the Arts has eliminated its fellowship program for visual artists. Although the NEA, the National Endowment for the Humanities, and state arts councils are known for awarding fellowships in the performing- and visual-arts fields, many other grants are available. Because they are less well known, often fewer people apply for them. Good sources of information on grants that are specifically geared to artists include *Money for Visual Artists*, *Money for Film and Video Artists: A Comprehensive Resource Guide*, and *Money for Performing Artists*. In addition, *Art Calendar* (see appendix section "Periodicals"), which is published eleven times a year, provides a listing of grants and fellowships available to artists and writers and to nonprofit arts organizations. It also includes a listing of scholarship, residencies, and artist colonies. *An Artist's Resource Book* by Jennifer Parker describes more than 300 national and international grants, awards, fellowships, and residency programs for artists. *The Directory of Financial Aid for Women* identifies 1,200 financial resources for women, including scholarships, fellowships, and grants. The *Guide to Canadian Art Grants* lists more than 600 art-granting programs throughout Canada for Canadian artists in all disciplines. Addi-

tional resources for information on grants are listed in the appendix sections "Grants and Funding Resources" and "Art Colonies and Artist-in-Residence Programs."

Art Colonies and
Artist-in-Residence Programs

Acceptance in an art colony, also known as a retreat or artist-in-residence program, is a form of a grant, since the sponsoring organization subsidizes the artists it selects.

Such retreats are scattered throughout the United States and the world. They offer an artist the opportunity to work on a project for a specific amount of time, free from life's daily burdens, responsibilities and distractions.

Subsidization can be as comprehensive as payment of transportation expenses, room and board, and a monthly stipend. Or it can be limited to partial payment of room and board, with the artist required to pay a small fee.

Some colonies, such as the American Academy in Rome and the Bellagio Study Center in Italy, sponsored by the Rockefeller Foundation, offer luxurious creature comforts. Other colonies offer a summer-camp ambience and are based on a communal structure.

There are colonies that specialize in one particular arts discipline as well as those that include visual and performing artists and writers.

Artist-in-residence programs can include teaching opportunities (described in the next chapter) as well as international exchanges. Many excellent resources are available that list and describe art colonies and artist-in-residence programs. For example, *Artists Communities*, compiled by the Alliance of Artists Communities, provides information on residence opportunities in the United States for visual and performing artists and writers. In addition, it includes a special section that lists artists' communities, art agencies, and key contacts that support international artist exchanges. *Artists and Writers Colonies: Retreats, Residencies and Respites for the Creative Mind*, by Gail Bowler, describes nearly two hundred residencies, retreats, and fellowships. It is indexed by state and disciplines. *Go Wild: Creative Opportunities for Artists in Out-of-Doors*, by Bonnie Fournier, is revised annually, and it describes national park residencies for visual and performing artists and writers. *Money for International Exchange in the Arts*, by Jane Gullong, Noreen Tomassi, and Anna Rubin, provides information on

international artists' residency programs. Additional resource lists and information about art colonies, artist-in-residence programs, and exchange programs are in the appendix sections "Art Colonies and Artist-in-Residence Programs" and "International Connections."

Nonprofit and Umbrella Organizations

There are more grants available to nonprofit art organizations than to individual artists, and the dollar value of the grants available is substantially higher. For this reason, when I was working as an artist I turned myself into a nonprofit, tax-exempt organization. The tax-exempt status also allowed individuals to receive tax breaks on any contributions and donations they made to my projects.

Although there were many advantages to being a nonprofit, tax-exempt organization, there were also disadvantages. For example, while my organization was in operation, I found myself spending a disproportionate amount of time completing the various forms and reports that were required by federal and state agencies. Another drawback was having to contend with a board of directors, which diminished, to a certain extent, the autonomy that I had enjoyed while working on my own. I also spent a lot of time meeting with board members and sustaining their enthusiasm for fund-raising.

Carefully evaluate your situation before taking steps to form a nonprofit organization. For further information about forming a nonprofit organization and working with a board of directors see the appendix section "Nonprofit Organizations."

If you personally do not wish to go nonprofit, there is an option available that allows you to bypass the tax-exemption route: use the services of an *umbrella organization*. Umbrella organizations are nonprofit, tax-exempt groups that let you apply for a grant under their auspices. If a grant is awarded, the umbrella organization receives the award and in turn pays you.

Umbrella services can vary from a minimum of signing a grant application to bookkeeping; managerial advice; preparation of annual, federal, and state reports; assistance with publicity and promotion; and fund-raising. In return for these services, a percentage of any grant that is awarded to an artist or a group of artists goes to the umbrella organization.

Umbrella organizations do not take all artists under their wings.

They consider the nature of an artist's project and the impact it will have on the community. Umbrella groups rely on grants to pay their overhead and salaries, and their ability to receive grants depends largely on the success of the projects they sponsor.

The best way to learn about umbrella organizations in your area is to contact your local state arts council.

INCREASING YOUR CHANCES
OF BEING FUNDED

Preapplication Research

Before completing a grant application, learn as much as possible about the funding organization. Your homework should include learning about eligibility requirements, funding priorities, the long-term goals of the organization, and the maximum and minimum amount of the grant. Jane C. Hartwig, former deputy director of the Alicia Patterson Foundation, emphasizes the importance of homework: "The fact that you have done your homework, even at the earliest stage, is impressive, and appreciated by the foundation. It will also save you time, money, and possibly grief."[114]

When you receive your application instructions and the background information about the agency or foundation, the kind of language used will give you a strong indication of the types of art and arts projects that are funded. For example, if you are told that the purpose of a grant is "to foster a high standard in the study of form, color, drawing, painting, design, and technique as expressed in modes showing a patent affinity with the classical tradition of Western culture,"[115] it is very clear what the foundation giving the grant is looking for. If your work or project involves anything other than "the classical tradition of Western culture," it is a waste of time to apply to this foundation.

Submitting Visual Materials

Grant applications in visual arts usually require that slides or photographs of the artist's work accompany a written application. Although some funding agencies request to see the actual work once an

artist passes a semifinal stage, most organizations make their final se-
lections on the basis of slides or photographs.

Too often artists place great importance on a written application
and give too little attention to the photographic material. Both are im-
portant for completely different reasons. Here are some guidelines to
follow in submitting visual materials. In addition, review the section
"Slides and Photographs" in chapter 3.

(1) All photographic material should be of *top quality*: clear and
crisp, with good lighting and tone.

(2) Submit photographs of your most *recent* work. Funding agen-
cies do not want to see a retrospective of your last ten years.
They want a strong, clear indication of your current interests
and directions.

(3) Select photographs or slides that represent the *best* of your re-
cent work. *You decide what is best.* If you are indecisive about
what to submit, consult with someone whose taste you respect.

(4) Even if the funding agency does not require photographic ma-
terials to be labeled, *label* each and every slide or photograph
with your name and the title, medium, date, and dimensions
of the work. Also include a directional indication showing the
top of the work. This information could decide whether your
work is rejected or enters the next stage of judging. Pho-
tographs or slides should seduce the judges, but if they are con-
fused and can't "read" what is going on, they will not take the
time to look up your application in hopes of clarification.

A final pointer about slide presentations: since most funding agen-
cies actually project slides on a screen, it is very *important* to project
your slides on a large screen *before* you submit a grant application. If
your slides are being projected for the first time, you might be shocked
to discover the results. Recently, I borrowed slides from various artists
for a lecture that I was giving at a museum. I selected the slides from
slide sheets and then reviewed them with a hand viewer. However, I
made the mistake of not projecting the slides on a screen before the
presentation. When projected, half of the slides were so dark that I
had the entire audience squinting.

Completing Applications

When you first encounter a grant application, it can seem like Egyptian hieroglyphics. Mastering grant applications *is* like learning a new language, and the more experience you have, the easier it becomes.

In addition to carefully following instructions, the best posture to take when filling out an application is to *put yourself in the shoes of a jurist*. In other words, you want to read applications that are legible and clear and that come quickly to the point. You do not want to have to reread an application in order to understand it clearly. Applications should hold the judge's attention.

I am often called upon to review *unsuccessful* grant applications. These applications tend to have in common one or all of the following mistakes:

(1) They reflect a negative tone, implying that the artist has a chip in his or her shoulder (e.g., "The world owes me a grant").

(2) The description of the grant purpose and/or project talks over the heads of the readers, rambles on with artsy language, and goes off on irrelevant tangents.

(3) Funds are requested for inappropriate or "off-the-wall" purposes, basically insulting the intelligence of the judges.

Recently I was one of eight jury members who met to select a public art project. The proposal I liked best was very imaginative and had a wonderful sense of scale. It would have been relatively easy to install, maintenance free, and able to withstand inclement weather. It was also the least costly of all of the proposals submitted.

However, the project did not win because the artist antagonized the jury! Leaving most of the application questions unanswered, except for a project description, the artist wrote (in barely legible longhand) one arrogant sentence implying that the drawings that accompanied the application would make the sculpture's design and meaning clear to all but the dumbest of viewers.

Although most jurors agreed that this project was the most appealing, they also concurred, based on the attitude expressed in the application, that the artist would probably be difficult to work with during the planning and installation stages. Whether or not that would have been true is open to speculation, but the fact of the matter is that the

way in which the artist completed the application prevented her from receiving the commission.

Proposals and Budgets

Some agencies that award grants require a written proposal and a budget.

In the book *Supporting Yourself as an Artist* by Deborah A. Hoover, a former executive director of the Council for the Arts at the Massachusetts Institute of Technology, the author covers the topics of proposal writing and budget preparation in a very clear and thorough manner. The book also includes sample proposals and budgets and provides good information on other related subjects, such as how to interpret letters of rejection.

Hoover urges artists to "be direct; express yourself in writing as you would in speech. Keep your sentences short. Put statements in a positive and persuasive form."[116]

Hoover's book is an excellent resource for advice and information about proposal writing and budget preparation. It is listed in the appendix section "Grants and Funding Resources."

JUDGING PROCEDURES

Most funding agencies use the first round of judging to sort through applications to make sure that artists have complied with all of the instructions, rules, and regulations. Consider this the "negative" stage of judging, as the agency is on the lookout for applicants who do not follow instructions. This hunt has no deeper purpose than to make the judges' work easier by reducing the number of applications to be considered.

Each funding agency has its own procedures for reviewing grant applications. After eliminating the applications that do not qualify, some agencies then review the artists' creative achievements by such steps as looking at slides and videotapes, listening to audio tapes, and reading manuscripts. After the judges have narrowed down the selection of artists for the final stages of judging, they review written applications. Other agencies that require written proposals and budgets review the application and support material simultaneously.

"Say the Secret Word and Win One Hundred Dollars"

Probably as a result of the many tests one is subjected to in school, artists approach a grant application as an aptitude or IQ test. It is felt that ultimately the application is trying to trick you with double meanings. The fact is that there are definitely "wrong" answers, such as those I have described from the unsuccessful grant applications, but there is no one "right" answer.

For example, many grant applications request information on *educational background* and *salary*. Those artists who believe their formal education is inadequate, in terms of the "right" academic credentials, erroneously believe that they will have virtually no chance of being funded. Artists also worry that if their salaries are above poverty level they will be ineligible for a grant. Although there are grants available that are specifically designed to assist impoverished artists, if this criterion is not stated in a foundation's application guidelines, one can safely assume that the grant is awarded on the basis of merit or merit combined with moderate financial needs. Such situations might include, for example, artists who are on a tight budget and lack the funds to be able to take a leave of absence from a job or reduce the number of hours of employment to devote time to their artwork.

Although there are grants available that are specifically designed to assist impoverished or low-income artists, this requirement is specified in a foundation's statement of purpose. If it is not stated, one can safely assume that the grant is awarded on the basis of merit and not financial need.

Another part of the "secret word" syndrome is how much money to ask for. Arriving at a funding-request figure is not like competing in a jelly-bean-counting contest—you don't have to guess down to the exact penny how much you think the foundation will give you.

Some foundations give a set amount of money (e.g., twenty grants of five thousand dollars each). Other foundations state a maximum amount but say that smaller grants—the amount of which will be left to the discretion of the jury—will also be given. In recent years, the discretion of the jury resulted in awarding one of my clients *almost double* the amount of the grant that she requested!

Letters of Recommendation

When foundations request that an applicant include a letter or letters of recommendation, it means that they are asking for testimony from

other people that your work is good and/or that your project has merits and is relevant and important. I often encounter blank expressions when I ask applicants whom they are going to use as a reference. They believe there is not one person available to help. Of course, it is impressive if you are recommended by an art-world superstar. However, if such a person is not part of your network, do not let this become a stumbling block. Jane C. Hartwig puts it this way:

> You certainly shouldn't shy away from using someone well known in your field if that person happens to know you and your work and has indicated a willingness to write a letter in your behalf. Just don't think that you haven't a chance if you don't know any luminaries. Happily, it really doesn't matter.[117]

In summary, if you were on a grant panel, what would impress you more? An insipid but well-meaning letter of recommendation from a celebrity or a perceptive and analytical letter from someone you have never heard of?

There is a range of possibilities of obtaining letters of recommendation: for example, the curator or director of a museum or nonprofit gallery, a critic, a member of the academic art community, an art historian, another artist, or the director of a nonprofit arts organization.

Less effective sources of letters of recommendation are from those people in positions that could be interpreted as a conflict of interest. For example, gallery directors and collectors have a vested interest in awards that artists receive. Such recognition can contribute to a rise in the monetary value of artwork and heighten an artist's standing in the art world. Since gallery dealers and collectors can directly and indirectly benefit from an artist's achievements, letters of recommendation pumping up an artist's virtues from either source are much less impressive than those letters written by people in much more objective positions.

Remember, the worst thing that can happen is that the person you ask to write the recommendation will say no. Although this happens, it doesn't happen that often, because most everyone has been in the position of asking for help.

An Untraditional Grantsmanship Route

The traditional way to apply for grants is to rely on a foundation to announce the availability of a grant and submit an application. However, there is an untraditional route, which I have personally used with very successful results.

Corporate Detective Work

I obtained corporate sponsors for many exhibitions and projects by taking the initiative and contacting companies, regardless of whether they were in "the grants business." I first located corporations that either provided services or manufactured goods and materials that had some relationship to my project or exhibition. I began my detective work at the library using *Standard & Poor's Rating Guide*, a massive directory that lists American corporations, cross-referenced according to product and/or service.

In one instance, I was planning an exhibition of sculpture in which aluminum would be used extensively. Through *Standard & Poor's* I came up with a list of major aluminum companies, their addresses, and the names of key officers and public- or corporate-relations directors.

I sent a letter to each public- or corporate-relations director, with a copy to each key officer; I indicated on each original letter that company officers were also receiving the letter.

The letter detailed the purpose of the exhibition, told where it was being held, and included a description and a budget. I also included a sentence or two about what the company would receive in turn for its sponsorship, namely, public-relations benefits. *Within six weeks* I landed a sponsor.

Value of Sending Copies

Sending copies of the sponsorship request to key corporate officers is very important. It increases the chances that the letter will really be given careful consideration and it decreases the chances that a sponsorship decision will be blocked by one person. For example, if only the public-relations director receives a letter and that person, for one reason or another, is unmoved, the request dies a quick death. By submitting the request to many officers, you increase the chances that you will find an ally with clout!

\mathcal{Y}ES, YOU CAN FIGHT CITY HALL

For four consecutive years I applied for a grant from a state arts coun-
cil for three different projects. Each year I was rejected. After the
fourth rejection, I launched my own investigation and learned that
one staff member was blocking my application, but for reasons that
were so petty I could attribute them only to a "personality conflict."
Venting my frustration, I wrote to the director of the arts council, de-
tailing the four-year history of grant applications, documenting all the
hours spent on applications, answering questions, meetings, appoint-
ments, interviews, letters of recommendation, and more letters of rec-
ommendation. But most important, I reiterated the merits of the
project that I wanted funded. I also named the staff member who had
been giving me such a hard time and sent a copy of my diatribe to that
person. About three weeks later I received a letter from the arts coun-
cil stating that it had reversed its decision—the project would be
funded.

10

\mathcal{G}enerating Income:
Alternatives to Driving a Cab

\mathcal{B}eing able to support yourself as an artist, and maintain a high-quality life through finances generated from your work, can and does happen all the time. But rarely does it happen overnight, and realistically, until your career gets rolling, it is necessary to earn a living through other means. This chapter covers the assets and drawbacks of conventional jobs, and it discusses some job opportunities and ways of generating income within the fine-arts field. It also provides ideas for minimizing business expenses and saving money.

\mathcal{A}SSETS AND DRAWBACKS OF CONVENTIONAL JOBS

To solve the problem of supporting yourself as an artist you must take into account your financial and emotional needs and your physical capabilities. Whether the options suggested in this chapter are appealing or you prefer traditional forms of employment that offer more financial security depends on your personality, temperament, and energy level. What works for one artist doesn't necessarily work for another. But the *common goal* is to generate income that simultaneously allows you to maintain a good standard of creature comforts, a good state of mind and health, energy for your own projects, and energy to develop your career. Each of these criteria is equally important. One should not be sacrificed or compromised for another.

However, in the name of art and the "myth of the artist," compromises and sacrifices are constantly made. Contrary to the teachings of the myth, you are entitled to what you want, and there are ways to get it.

Before jumping into employment, assess carefully and *honestly* what you are looking for and why. Does the job provide a *real means to an end*, or is the job likely to annihilate your end? For example, two of my clients took jobs with arts service organizations. Both jobs provided the artists with sufficient income as well as opportunities to meet people related to their profession and expand contacts and networks. One job involved low-pressure, routine duties. Although the artist was not mentally stimulated, she had energy to sculpt and develop her career because her responsibilities were minimal. The other job was full of responsibilities. It was demanding and stimulating. Although the artist found the work fulfilling, at the end of the day she was drained and did not have the energy for her artwork.

If you want to work within the arts, there are some good resources available. *Art Job*, published by the Western States Art Federation, is a biweekly newsletter that lists employment opportunities in the visual and performing arts, literature, education, and arts administration. *The College Art Association's* newsletter *CAA Careers* lists arts-related jobs, mainly in museums, colleges, and universities. *Artsearch*, published by the Theatre Communications Group, is a national employment bulletin for the performing arts. It includes art and art-related positions in education, production, and management. *National Arts Placement* is published eight times a year by the National Art Education Association and lists positions in arts councils, colleges, museums, schools, and universities. *Jobs in Arts and Media Management: What They Are and How to Get One* by Stephen Langley and James Abruzzo is a guide to the job market in the entertainment industry. *Museum Jobs from A–Z: What They Are, How to Prepare, and Where to Find Them* by G. W. Bates, describes over sixty museum positions. It includes information about eligibility requirements, where to find jobs, and various employment opportunities. In the book *The Off-the-Beaten-Path Job Book: You CAN Make a Living AND Have a Life!* the author Sandra Gurvis focuses on "unusual and enjoyable work and where to find it."[118] Eighty-five jobs are described and organized by areas of interest, including artistic talents. Gurvis writes:

An American beginning a career in the nineties will likely work in more than ten jobs with at least five employers. He or she may steer clear of the long work weeks and demanding "fast track" careers that eat up time and energy. Flexible hours and being able to work at home may be more desirable than a huge pay-check.[119]

Gurvis's book and other employment resources named in this section are listed in the appendix section "Employment Opportunities."

\mathcal{U}SING YOUR TALENTS TO GENERATE INCOME

Teaching: A Boon or a Trojan Horse?

Teaching is attractive to artists for several reasons: it offers financial security as well as the fringe benefits of health insurance, life insurance, sick leave, vacation pay, and long vacations. In addition, it is a highly respected occupation.

Because of these attractions, the competition to teach is horrendous—so horrendous that, unless one is a superstar, getting a job usually necessitates returning to school for more degrees. On the other hand, even if your qualifications are superlative, there is no job guarantee. There are more qualified artists than teaching positions available in colleges and universities and within school systems.

The scarcity of jobs is not the only drawback. When you are an artist and a teacher, you wear two hats. If teaching consisted only of lecturing, critiquing, and advising students, it would be relatively simple. However, teaching means a lot more. It means extracurricular involvement with faculty politics and yielding to the special demands and priorities of academia. Theoretically, these roles should be compatible and supportive, but often they are not.

Artists who teach *and* want to develop their careers must contend simultaneously with the occupational hazards of both professions. The situation is particularly complex because many of the demands and priorities of the art world and academic world are in conflict. Often, artists involved in the academic world face peer pressure based on how much they know about the past rather than what they are doing

in the present. Sometimes artists are forced to change their methods of teaching and/or style of work to conform to current academic trends and ideology. Getting tenure often becomes the most important goal in life. Academia also puts demands on teachers to publish articles, essays, and books about art history and art criticism. An artist may have little time for his or her personal work.

On the other hand, some teaching opportunities are available that allow artists autonomy and flexibility. These opportunities exist both within and outside academic compounds. Some of these opportunities are described on the following pages.

Apprenticeships

Serving as an apprentice to another artist is a viable means of earning a living for a certain period of time. But keep in mind that contrary to the myth, working for a *famous* artist is not a prerequisite to achieving success in the art world. However, serving as an apprentice to an experienced artist can be helpful to less-experienced artists. It can provide an opportunity to learn more about the business of art and see firsthand what being an artist is all about.

An apprenticeship experience can be particularly advantageous if the apprenticeship is with an artist who is surefooted and emotionally secure. Insecure artists might not be generous in sharing career information or their contacts. Insecure people also tend to have difficult personalities. Before accepting an apprenticeship position, ask your potential employer for the names and phone numbers of previous apprentices. You have every right to request references.

Whether you are seeking an apprenticeship position or are seeking an apprentice, additional information about apprenticeships is listed in the appendix section "Apprentices and Interns" and on pages 41–42 of chapter 2.

Artist-in-Residence Programs

There are various forms of artist-in-residence programs. Some have the fundamental purpose of providing artists with opportunities to live in an environment in which they may work unimpeded by life's daily worries (see page 177). Other artist-in-residence programs pay artists to teach on a temporary, part-time, or full-time basis in school systems and communities throughout the United States.

Among the national programs is the Arts in Education Program of the National Endowment for the Arts, which, through state agencies, places visual and performing artists and writers in educational settings to work and demonstrate artistic disciplines. Hospital Audiences, Inc., brings visual and performing artists to individuals confined in institutions such as mental health facilities, senior citizens' homes, drug rehabilitation facilities, and correctional centers.

For information regarding artist-in-residence programs on the local level, contact local and state arts councils. In addition, in the book *The Fine Artist's Guide to Marketing and Self-Promotion*, the author Julius Vitali provides a complete chapter on the subject of artists-in-education. The chapter describes in detail the inner workings of these programs, including information on application procedures and the credentials necessary to compete. Information about organizations and resources on artist-in-residence programs can be found in the appendix section "Art Colonies and Artist-in-Residence Programs."

Lectures and Workshops

Lectures, slide presentations, demonstrations, and workshops are excellent means of generating income. They also offer exposure and serve as good public-relations vehicles.

Colleges, universities, social-service agencies, and civic, cultural, and educational organizations often hire artists for "guest appearances." For example, the On-Call Faculty Program, Inc., arranges guest appearances for academics and professionals at colleges and universities. The organization also places its affiliates in short-course or semester-course teaching programs.

You can base presentations on your own work alone or also discuss the work of other contemporary artists, art history, and art criticism. Subjects and themes of arts-related presentations are unlimited.

The financial rewards of public appearances can be considerable if you repeat your performance several times. For example, when I receive an out-of-town invitation to conduct career workshops for artists, I use the opportunity to create more opportunities by contacting other educational or cultural institutions in the same region. What starts out as a one-shot engagement ends up as a lecture tour. This generates more revenue and exposure, and since the institutions

involved split my travel expenses (apart from the fees I am paid), they all save money.

Setting Up Artist-in-Residence Positions, Lectures, and Workshops

The best way to approach an organization or institution about sponsoring an artist-in-residence position, public appearance, or workshop is to provide a concrete proposal that describes the purpose of your idea or program, why it is relevant, and what the audience will gain. If you are applying for an artist-in-residence position, include a proposal, even if the application does not require one. A proposal for a lecture workshop should not be limited to a title. It should elaborate on the contents of your presentation, including the purpose, relevance, and benefit to the audience.

The value of preparing a proposal in advance is that you avoid having to rely on the institution or organization to figure out a way to use your talents. This could take months.

The other value of preparing a proposal is that it can be used to generate residencies, public appearances, and workshops independent of organizations and institutions that sponsor such programs. In other words, you can initiate contacts yourself.

Send proposals to schools, colleges, universities, social-service agencies, and educational and cultural organizations. Corporations are also receptive to sponsoring lectures and workshops, and many organize educational and cultural programs specifically for their employees.

Advice and information about organizing and publicizing public appearances can be found in the book *How to Develop & Promote Successful Seminars & Workshops: The Definitive Guide to Creating and Marketing Seminars, Workshops, Classes, and Conferences* by Howard L. Shenson (see the appendix section "Employment Opportunities").

Generating Income Through the Printed Image

Mail art, book art, rubber-stamp art, Xerox art, computer-generated art, and postcard art are art forms created by artists exploring the tools and resources of mass communication and the electronic age. Not only do these art forms respond to the aesthetic sensibilities of mass communication, they *are* mass communication and are mass-produced.

Thus, they are art forms with nonexclusive price tags and have the potential to broaden the art-buying market.

A market and marketing vehicles for these art forms have developed over the last twenty years. This can be attributed to the efforts of Printed Matter, which was founded in New York City in 1976. This retail store and gallery also offers a mail-order service. It exhibits and sells a vast range of artists' books and other types of artist-created printed materials. Although Printed Matter is considered the largest distributor of artists' books worldwide, artists' books are also sold through retail stores, galleries, and distribution outlets throughout the United States. Their names and addresses are listed in the excellent publication *The Book Arts Directory.* The *Directory* also includes information for papermakers, calligraphers, paper decorators, printmakers, book designers, fine printers and publishers, traditional bookbinders, and makers of artist books.

The addresses of Printed Matter, *The Book Arts Directory*, and other artists' book resources are listed in the appendix section "Artists' Books."

PRINTMAKING

Creating lithographs, etchings, woodblock prints, and serigraphs offers artists opportunities to generate income and exposure. Painter Toby Judith Klayman, the author of *The Artists' Survival Manual*, writes:

> The idea of "multiples"—of having many prints of the same image—fascinated me. I liked the possibility of having my work in many places: whereas a one-of-a-kind work can only be in one place at any one time, a print can be in several places simultaneously. It's possible to be selling a print in your studio and have twenty galleries around the country selling them at the same time as well. . . . Since multiples also tend to be priced lower than one-of-a-kind works, more people can not only see your work, but *buy* it as well. There's a "democracy" of pricing possible with prints that appeals to me.[120]

There is a large demand for works on paper, and sales do not necessarily depend on working with art dealers. You can be your own publisher and do your own marketing or go through a print publisher

and/or print distributor. The names of print publishers and distributors can be found in the publications *Printworld Directory of Contemporary Prints and Prices* and *Art Marketing Sourcebook*. These publications as well as other resources on printmaking and marketing prints are listed in the appendix section "Prints and Printmaking."

Other Ways of Generating Income from Fine-Art Skills
Using talents and skills acquired in the fine arts, some artists generate income by working in applied-arts fields, such as graphic design, fashion illustration, book and book cover design, scenic design, and fabric design.

One very imaginative way of generating income using fine-art skills was achieved by the East Hampton, New York, artist Eleanor Allen Leaver. Leaver has established a network of real estate companies that commission her to create pen-and-ink drawings of homes that have been purchased and sold by their clients. Once a sales transaction has been completed, the artist's drawing is presented as a gift to the real estate agents' clients. It is interesting to note that the artist began this particular freelance business in 1996 when she was seventy-six years old.

I have sold numerous prints through my studio, just on the basis of distributing a press release. In one instance I was involved with a silkscreen series consisting of five prints based on one theme. Press releases announcing the series and availability details were sent to arts-related publications and museum shops. Except for the prints that I retained for myself, the entire series sold. Marketing involved neither paid advertising nor a middleperson.

There are many potential markets for artists' work. If you limit yourself to one-of-a-kind objects, your market is one-of-a-kind buyers, those who consider exclusivity and scarcity important and are willing and able to pay for it. However, there are many others who appreciate and want to buy art and are not concerned with these issues.

USING YOUR "OTHER" CAREER TO GENERATE INCOME

Wearing two hats can be used to an artist's advantage if one utilizes and transfers the resources and contacts of a second career into the

fine arts. Such was the opportunity created by Molly Heron, a New York artist, who parlayed a series of timely events and a freelance position into a one-person exhibition located in prime space on the ground floor of a choice midtown Manhattan office building.

Heron was hired as a freelance book designer at HarperCollins which, coincidentally, was the publisher of *The Writing Life* by Annie Dillard, a book that she had recently read, savored, and reread.

Six months after she obtained the freelance position, Heron attended an exhibition at the HarperCollins Gallery, located in an open and attractive bilevel space. Impressed with the physical attributes of the gallery and its opportune location, she made inquiries regarding how the space could be acquired for an exhibition. She learned through the gallery curator that all exhibitions in the space *had to be related to a HarperCollins book.*

Eureka! Before the lightbulbs in Heron's head had a chance to dim, she developed an exhibition proposal. Within four weeks she submitted the proposal and a set of slides to the HarperCollins curator, and soon afterwards she received an invitation to install a solo exhibition in the gallery later in the year.

Heron's proposal was based on the inspiration she had received from *The Writing Life.* The book had infused her with a new energy force, and she felt compelled to interpret Dillard's metaphors and observations visually. In the proposal she wrote:

> Annie Dillard's *The Writing Life* describes the elusive process of creation in a way that is a strong invitation to try to feel the edge and see if it's possible to have the sun hit you. With her metaphors conjuring up strong visual images, this book inspires me to take color to hand and dance around the mystery with marks on paper. To wonder, to wonder if the dance will take me to the dawn. Will it take me to the abyss?[121]

Heron selected twenty of Dillard's phrases to interpret. Using the medium of collage, she incorporated candy wrappers, paper cups, handmade paper, paper doilies, lace, and other fabrics in combination with a variety of paint, crayons, pencils, and ink. "Combining these materials and building the picture in layers reflected the creative

process of making a whole piece out of parts while working in stages," said Heron.[122]

> A phrase like, "The life of the spirit requires less and less"[123] is so provocative that I made several pieces based on Ms. Dillard's insight. At times it was a completely new and mysterious idea and then it would remind me of something that I have known all my life.
>
> Perhaps the most central of Dillard's metaphors are about climbing. Working in the dark, going to the dangerous edge, searching for the opening into the mystery, finding the moment when everything is in place and you are overwhelmed by clarity. I found myself responding with central images of portals as passageways to that mystery and circles as symbols of continuity and connection. The circle allows you to go out into the bright light and also to return. Then you begin the journey again.[124]

Entitled *Impressions on Annie Dillard's* The Writing Life: *Works on Paper by Molly Heron*, the exhibition was organized with the discerning eye and grace of a major museum event. Each collage was displayed with the respective Dillard text that had been the source of Heron's inspiration, and the title of each collage was found within the accompanying prose.

Exhibition visitors were given a nine-page package of information, including a press release, artist's statement, excerpts from the Dillard book, and Molly Heron's and Annie Dillard's biographies.

Molly Heron sold five pieces of work while the exhibition was installed. And as soon as the show closed, she handled the ending as a new beginning and wasted no time in taking the next step. She revised the original proposal and, along with a one-page cover letter, a set of slides, and promotion materials from her HarperCollins show, she began making contacts.

Her new initiatives resulted in exhibition invitations from a university museum, a nonprofit gallery, and a commercial gallery. She also received requests to present lectures and workshops.

In addition, a curator of a branch gallery of the Whitney Museum of American Art informed Heron that, due to the branch museum's policy of only sponsoring group shows, she was unable to offer her a

solo exhibition, but that she was so impressed with Heron's work, she had contacted another cultural institution in the artist's behalf.

In part, Molly Heron's adventures and her success can be attributed to the cosmic phenomenon of being at the right place at the right time. But most of the credit belongs to the artist, who through very earthly pursuits took the initiative to utilize in her fine-arts career the resources and contacts of the publishing world.

11

Rationalization, Paranoia, Competition, and Rejection

RATIONALIZATION

If you want to avoid fulfilling your potential as an artist, it is easy to find an excuse. When excuses linger unresolved too long they become rationalizations. Webster defines the word *rationalize* as "to attribute [one's actions] to rational and creditable motives without analysis of true and especially unconscious motives," and "to provide plausible but untrue reasons for conduct."

Rationalization in one form or another is common to the human species, and sometimes it can be used constructively. However, when rationalization is used to evade fulfilling one's potential, it is being used to disguise a lack of self-confidence and/or fear of rejection.

The most common kinds of rationalizations practiced by artists are rationalizations to *avoid the work process* and rationalizations to *avoid getting work out of the studio and into the public domain*, the marketplace.

Avoiding Work

"I'll get going once I find a work space" and "I'll get going when I have the right working environment" are rationalizations I hear most often from artists who want to postpone or avoid knuckling down. Artists who engage in this form of rationalization do little or nothing, financially or motivationally, in order to attain their goal of finding a suitable work space.

There are many variations on the theme: One artist tells me he can't begin work until he can afford stationery embossed with his studio address. He believes that no one will take him seriously until he has a business letterhead. Another artist, who has spent the last four years traveling, tells me she needs more life experience in order to paint. Another artist tells me that he is waiting for technology to invent the right material that he needs for sculpture. Chances are that when the letterhead, life experience, and new technology are attained, the artists will quickly find another excuse to avoid confronting their work. As psychotherapist and artist Bruce M. Holly puts it:

> For some of us, the risk of choosing and failing in life and in art is a loss of self-esteem which outweighs the potential satisfaction of success so completely that we are locked into immobility by fear. It is this that causes creative death far more frequently than heart disease. There is a quiet courage demanded of all of us with each breath we take. In art, this courage is manifested each time we choose to move toward a new creation.[125]

For the artist who chronically finds an excuse to avoid work, the consequences of rationalization are not limited to getting nothing accomplished. Guilt sets in because you are not doing what you think you want to be doing and because you are practicing self-deceit. Animosities and tensions develop internally and toward others, whom you blame for your circumstances. Jealousy and contempt rear their miserable heads, directed toward any artists (and nonartists as well) who have managed to put their lives together in such a way that they are accomplishing, or are really trying to accomplish, their goals.

With so much negativity festering, no wonder work is impossible. The distance between what you want to achieve and what you are actually achieving grows wider. And if you try to work you find each product of self-expression tainted and influenced by your anger and hostility. Creativity is used to vent frustration and addresses nothing else.

Avoiding Public Exposure

Some artists have no problem working but begin the rationalization process when it comes time for their work to leave the studio and enter the marketplace. To insure yourself against experiencing any form

of rejection, you begin to rationalize: your work isn't ready, you don't have enough work to show, you don't fit into the latest trend, you're working for your own pleasure and do not want to derive money from art, and no one will understand your work anyway—it's too deep!

One of the more popular rationalizations is the *perpetual search for the perfect agent*. Once this person is found, he or she will take your work to the marketplace. This person, you tell yourself, will shield you from criticism and rejection; schlepp your slides from gallery to museum; bargain, negotiate, and establish your market value; arrange exhibitions; write letters; attend cocktail parties; and make important connections. In addition, the agent will have excellent press contacts and your work will be regularly featured in leading publications, with critics fighting among themselves for the opportunity to review your shows. And of course, this agent will fill out grant applications on your behalf and will be very successful in convincing foundations to subsidize your career. And when cash flow is a problem, the agent will tide you over with generous advances. When your ego needs stroking, the agent will always be on call. All you have to do is stay in your ivory tower and work.

I estimate that the majority of artists who contact me for assistance have the notion in the backs of their minds that I will fulfill this fantasy and provide the buffer zone they are seeking. Apart from my belief that within the visual-arts field this fairy godperson is practically nonexistent, I strongly believe that artists are their own best representatives.

Meanwhile, the search for the perfect agent, the supposed saint of all saints, continues while the artist's work accumulates in the studio, to be seen only by four walls.

Rationalization can become a style of life—an art unto itself. Artists who use rationalization as a style of living tend to associate with other artists who are skilled at the same game, supporting and reinforcing each other, pontificating in unison that "life is hell," and that it's everyone else's fault. It's less lonely going nowhere fast in a group than by yourself.

Paranoia

Rationalization has a twin: paranoia. Webster defines *paranoia* as a "tendency on the part of an individual or group toward excessive or irrational suspiciousness and distrustfulness of others."

Sometimes the twins are inseparable and it is difficult to know where rationalization ends and paranoia begins. Sometimes rationalization is the aggressor and paranoia takes over, and other times paranoia prevails on its own. But the twins always meet again at the same junction, called *insecurity*.

For example, a painter tells me she dislikes showing her work to dealers because when she invites them to her studio she believes that her invitation is interpreted as a sexual proposition. I asked whether she had encountered this kind of experience. "No," she replied, "but I know what they are all thinking." Consequently, dealers are not invited for studio visits. Thus, she eliminates any possibility of being rejected or hearing that her work isn't good enough. Another artist, who was part of a group that I was assisting with public relations for an upcoming exhibition, told me that he did not want press coverage in certain newspapers and on television out of fear that the "wrong kind of people" would come to the show. I could never figure out who the "wrong kind of people" might be—street gangs, muggers? Nor could the artist shed light on the subject when I asked for an explanation. But in his mind there was a special group of people who were not meant to view or buy art.

The belief that there *is* a special group of people who are not meant to view or buy art is common among artists. It translates into the "creating art for friends" syndrome, a principle that, on the surface, sounds very virtuous, but all too often means that anyone who likes your work is worth knowing, and anyone who doesn't isn't. It is a tidy black-and-white package: a handpicked audience that you create for the purpose of lessening the possibility that you will be rejected and increasing your sense of security and self-esteem.

I don't mean to understate or underrate the importance of support and compliments, but there are many dangers in being paranoid about new audiences. In addition to propagating elitist notions about art, it also creates incestuous attitudes and incestuous results. To continually create only what you know will please your peanut gallery

impedes your creative growth and limits your creativity. The fear of new audiences also applies to artists who are afraid to leave their galleries or expand into new local, regional, national, and international territories.

One area where paranoia runs rampant is within the so-called community of artists. Artists are often fearful of ideas being stolen, competition, and losing the status quo. By this reasoning every artist is a potential enemy.

An artist who served as an apprentice for two years to a well-known sculptor was preparing a grant application and needed three letters of recommendation. He felt comfortable asking his former employer for a letter because on numerous occasions the sculptor had praised his talents. Yet the sculptor turned him down, saying that on principle he does not give artists letters of recommendation.

Reading between the lines, it is likely that the younger artist posed a threat to the sculptor's status. The sculptor felt that there was no more room at the top, and just to ensure that no one else would inch his or her way up, he thwarted every opportunity that might give someone else upward mobility.

A painter who had recently moved to New York and was eager to begin making gallery contacts told me that she had a good friend who was with an established New York gallery where she would like to exhibit. I suggested that she ask her friend for a personal introduction. "I already did," she glumly replied. "But she said that *she* would be heartbroken if the dealer didn't like my work."

In this example, the artist tried to disguise her own insecurities with a protective gesture. She would not allow herself to be put in a position where her "taste" would be questioned, and/or she saw her friend as a potential threat to her status in the gallery—a realistic enough threat to warrant cutting her friend out of a network.

I once asked a sculptor who was sharing a studio with other artists whether her colleagues were supportive and helped each other with contacts. "Oh, no," she replied, "just the opposite. Whenever one of the artists has a dealer or curator over for a studio visit, the day before the appointment she asks us to cover up our work with sheets." Then she added, "I don't blame her. If I were in her position I would do the same."

In this example there is little room to read between the lines. It is a

blatant example of paranoid behavior. Oddly enough, her studio mates complied with the outrageous request because they deeply identified with and understood the artist's fear.

Paranoia also manifests itself in the hoarding and concealment of information. I have seen artists smother in their bosoms any tidbit of information or leads that they believed would be a *weapon in the hands of other artists*. A dancer told me that she holds back information from colleagues about scheduled auditions. A sculptor complained that his best friend entered a competition whose theme was very relevant to his own work; when he learned of the opportunity only after the deadline closed, his friend nonchalantly said, "Oh, I thought I mentioned it to you." A photographer suspiciously asked me how many other photographers I had advised to approach a certain gallery.

Overreacting to Competition

Some of the examples cited above might sound familiar—so familiar and ordinary that you most likely never thought to consider them examples of rationalization and paranoid behavior. This is part of the problem. In the art world, illogical and unsubstantiated fears and scapegoating have become the norm.

One of the basic reasons why rationalization and paranoia are condoned in the art world is overreaction to competition. Everyone tells us how competitive the art world is, how competitive being an artist is. We hear it from critics, curators, dealers, educators, our parents, and other artists. We enter contests and juried shows; vie for the interest of dealers, collectors, patrons, and critics; fight for grants, teaching jobs, and commissions. We write manifestos to be more profound than others.

Competition is an occupational hazard in every profession; it is not exclusive to the art world. But all too often in the art world we have let rivalry assume the predominant role in how we relate to one another. Although for some artists the mere thought of being judged is so overwhelming that they won't even allow themselves to compete, others plunge into the match but let a dog-eat-dog mentality pilot their trip. These are artists who backstab, hoard information, and exercise selective memories.

Some artists try to deal with competition by establishing elitist values, adamantly contending that only a select few were meant to understand their work. Trying to win the interest of a select audience makes competition seem less threatening. Other artists have concocted a myth that dealers, curators, and collectors are incapable of simultaneous appreciation of or interest in more than a few artists. Such artists cultivate a brutal "It's me or you" attitude.

The main reason competition has become so fierce is that many artists really believe only a limited number of artists *can* achieve success. Although it might be true that only a limited number of artists do achieve success, the *potential number* of artists who can succeed *is not limited*. Achieving success has nothing to do with "beating out the competition" through deception, lies, manipulation, and viciousness. Artists who succeed have beaten out the competition through exercising powers of perseverance and discipline, and by cultivating good marketing skills.

Until competition in the art world is recognized for what it really is, rationalization and paranoia will continue to be used by many artists as tools of the trade. They are odious, unproductive, and self-defeating props that are dangerous to your health, career, and the present and future of the art world.

There is no need to expound on why it is unhealthy to live a life predicated on fear, lies, and excuses and what it can do to us physically and mentally. Some artists are at least consistent, allowing self-destruction and self-deceit to govern all facets of their existence. But other artists have a double standard: honesty, intellect, courage, discipline, and integrity are their ruling principles, except when it comes to their art and careers!

Those who let rationalization and paranoia rule their careers in order to avoid rejection, assuage insecurity, and fend off competition must face the fact that their careers can come to a screeching halt, limp along in agonizing frustration, or be limited in every possible sense. Their work suffers (reflecting lies, excuses, and fears) and their network of friends and contacts degenerates to the lowest common denominator, as they stop at nothing to eliminate what is perceived as a possible threat.

Dealing with Rejection

An artist described her experience with rejection in this way: "I, like most young artists, romanticized the idea of 'being an artist' and in so doing anticipated a degree of rejection, but had I known the degree of rejection that would be in store . . . I might have chosen to become a doctor instead. Frankly, I don't get it."[126]

There are many reasons why an artist's work is rejected. Artists are constantly turned down from galleries, museums, alternative spaces, juried shows, and teaching jobs. A bad review is a form of rejection; so is not being reviewed.

Some artists are rejected for reasons for which they are *ultimately responsible*, and for these artists rejection can be an asset. It might be the only indication an artist has that his or her career is being mismanaged.

Artists who are responsible for rejection include those who make no effort to improve their chances by taking the initiative or creating career opportunities. Examples of such artists have been described throughout this book: those who haphazardly enter the marketplace, those who prepare poor presentations, and those who can't abandon "the myth of the artist."

Some artists rely on moods to enter the marketplace. A burst of energy tells them it is time to make contacts and take action, and for a week or two, or perhaps a month, they are sincerely dedicated to showing their work around. But the goal is instant gratification, and if expectations are not rewarded, they retreat. Depending on the artist, it can take months—sometimes years—for anything constructive to happen.

Artists who are controlled by moods further encourage self-defeat by drawing the conclusion that rejection is an absolute: once they are rejected, a museum's or gallery's doors are always closed. Consequently, these artists will not return with a new body of work.

But there are many instances in which artists are not responsible for rejection. These instances are caused by subjective forces, including "taste buds," trends, norms, and other people's priorities. These forces can be illogical and arbitrary, and are, by nature, unfair.

I once had a grant application rejected. The grant's panel had

confused me with another artist whose name was similar. That artist had previously received a grant from the same foundation, but had misused the funds. It was only by accident, and many months later, that I learned what had happened.

This was luxurious rejection: I could not take it personally or hold myself responsible, and I was able to learn the *real* reason. It is rare, though, that artists know the real reasons why they are rejected. Consequently, they think they are untalented and that their ideas are without merit.

The side effects of rejection are more horrendous than the actual rejection. For this reason, once you have ascertained that you are no longer responsible for the situation, it is important to build up an immunity against being affected by rejection.

Artist Billy Curmano described his immunity system in *Artworkers News*: "One day, while reflecting on . . . accumulated rejections, I composed an equally impersonal rejection rejection and have begun systematically sending it to everyone in my file. . . . Striking back immediately becomes a ritual to look forward to."[127] Here is the letter Mr. Curmano composed:

> Hello:
>
> IT HAS COME TO OUR ATTENTION that you sent a letter of rejection concerning BILLY CURMANO (hereinafter the "Artist") or his work dated _____ to the Artist.
>
> BE IT KNOWN TO ALL, that the said MR. CURMANO no longer accepts rejection in any form.
>
> KNOW YE THAT, this document, as of the day and year first written, shall serve as an official rejection rejection.
>
> IN WITNESS WHEREOF, Artist and Counsel have set their hands and seals as of the date above first written.[128]

Mr. Curmano provided space for his signature as well as his counsel's and ended his rejection rejection notice with: "We are sorry for the use of a form letter, but the volume of rejections received makes a personal response impossible."[129]

One starting point for developing an immunity to rejection is to look at rejection in terms of its counterpart—acceptance, or what is commonly referred to as *success*. Rejection and success are analogous

for various reasons. What artists define as rejection and success are usually borrowed from other people's opinions, values, and priorities. Artists who measure success and rejection in terms of what society thinks have the most difficult time coping with both phenomena.

Both success and rejection are capable of producing an identity crisis. Some artists who attain success find themselves stripped of goals, direction, and a sense of purpose. The same holds true for artists who are rejected.

Stagnation is a by-product of success and rejection. Artists who are rejected can be diverted and blocked in their creativity. Artists who attain success can lose momentum and vision.

It *is* possible for artists to be unscathed by rejection or success, and continue with new goals, directions, and explorations, irrespective of other people's aesthetic judgments.

The sooner you lose an obsession with rejection, the sooner your real potential develops, and the better equipped you will be to handle success.

If you accept the premise that the reasons for rejection are not truths or axioms, analyze rejection under a microscope. Reduce it to its lowest common denominator. Who is rejecting you? What does the person or entity mean relative to your existence? Is this entity blocking your energy, self-confidence, and achievements? Are you so vulnerably perched that other people's opinions can topple you?

When you can have a good laugh over the significance you had once placed on the answers to these questions, you will be able to respond to rejection the same way you respond to any other form of junk mail.

Building Immunities to Rejection

Keep in mind that generally it takes fifty slide packages of the same body of work to generate one positive response (see page 58). A number less than fifty does not even begin to approach an effective market penetration level that justifies any sense of defeat or rejection.

Each time you receive a letter of rejection, initiate a new contact, send out another presentation package, or pick up the phone. Replace feelings of rejection with a sense of anticipation. This process increases the odds of acceptance and keeps your psyche in good shape.

Stop putting all of your eggs in one basket. Submitting one grant application a year or seeing one gallery every six months is only a gesture; strong, affirmative results do not come from gestures. Create opportunities for things to happen. Think big and broad. Make inroads in many directions. *What you want are lots of baskets filled with lots of eggs.*

Appendix of Resources

The following list of contacts and resources includes the addresses of organizations and agencies and the details of publications cited in this book. It also includes other resources pertaining to specific topics. This list is a beginning and by no means covers the infinite number of resources and amount of information available to artists. But it is a good starting point from which to develop a library of materials and contacts to launch (or relaunch) and sustain your career.

During the time the Appendix of Resources was being compiled for this new edition, the American Council for the Arts (ACA) merged with the National Association of Local Arts Agencies, forming a new organization entitled Americans for the Arts, which is now based in Washington, D.C.

At the time of this writing, Americans for the Arts planned to operate a small office at the former headquarters of the American Council for the Arts (1 East 53rd Street, New York, NY 10022-4201). In question is whether ACA's publications program and/or information services will be continued by the new organization.

For the purpose of compiling this appendix, when ACA publications are cited, I have provided the address of Americans for the Arts in Washington, D.C. Until a decision is made regarding the future of the ACA's publishing program and information services, inquiries might be referred to the New York office.

ACCOUNTING/BOOKKEEPING
Publications

The Art of Deduction: Income Taxation for Performing, Visual and Literary Artists by Kim Marios. Bay Area Lawyers for the Arts, Fort Mason Center, Building C, Room 255, San Francisco, CA 94123, revised 1985.

The Artist in Business: Basic Business Practices by Craig Dreezen. Arts Extension Service, Division of Continuing Education, University of Massachusetts, Amherst, MA 01003, 1988. See "Practicing Business Basics."

ArtistHelp: The Artist's Guide to Work-Related Human and Social Services, compiled by the Research Center for Arts and Culture, Columbia University. Neal-Schuman Publishers, 23 Leonard Street, New York, NY 10013, 1990. Identifies agencies offering financial and other human services to artists, with addresses, phone numbers, contacts, and cost information.

Artists' Bookkeeping Book. Chicago Artists' Coalition, 11 East Hubbard Street, 7th Floor, Chicago, IL 60611, revised 1994. Explains legal tax deductions for artists and record keeping procedures. Also includes 10 pages of sample journals illustrating effective record keeping.

Artists' Taxes Hands-On Guide: An Alternative to Hobby Taxes by Jo Hanson. Zortext Press, 201 Buchanan Street, San Francisco, CA 94102, 1987.

The Artist's Tax Workbook by Carla Messman. Lyons and Burford, 31 West 21st Street, New York, NY 10010, revised annually. A step-by-step guide for preparing tax returns, focusing on special tax situations artists are likely to encounter. It also includes information on record keeping, IRS reporting requirements, sale of business equipment, and home studio deductions.

ArtNetwork Yellow Pages. ArtNetwork, P.O. Box 1268, Penn Valley, CA 95946, 1995. A directory that includes the names of accountants that specialize in the arts.

Business Entities for Artists Fact Sheet by Mark Quail. Available from Artists' Legal Advice Services and Canadian Artists' Representation Ontario (CARO), 440-40L Richmond Street West, Toronto, Ontario M5V 3A8, Canada, 1991. Summarizes information for Canadian artists on sole proprietorships and corporations, with tax perspectives, registration and legal liability.

The Business of Art, edited by Lee Caplin. Englewood Cliffs, N.J.: Prentice-Hall, revised 1989. See "Understanding Everyday Finances" by Robert T. Higashi and "Preparing for Taxes and Other Atrocities" by Ira M. Lowe and Paul A. Mahon.

Do-It-Yourself Quick Fix Tax Kit by Barbara A. Sloan. AKAS II, P.O. Box 734, Scottsdale, AZ 85252-0734, updated on a yearly basis. Presented in two parts: The *General Tax Guide* enumerates the various types of taxes affecting artists who sell their artwork; and *Schedule C Kit* is for visual artists who are sole proprietors of their art business.

Fear of Filing: A Beginners Guide to Tax Preparation and Record Keeping for Artists, Performers, Writers and Freelance Professionals by Theodore W. Striggles and Barbara Sieck Taylor. Volunteer Lawyers for the Arts, 1 East 53rd Street, New York, NY 10022-4201, revised 1985.

Legal Guide for the Visual Artist by Tad Crawford. New York: Allworth Press, revised
 1995. See "Income Taxation," "Income Taxation II," "The Hobby Loss Chal-
 lenge," "The Artist's Estate," and "The Artist as Collector."
National Directory of Volunteer Accounting Programs. Accountants for the Public Inter-
 est, 1625 I Street, NW, Washington, DC 20006. Provides information on whom
 to contact for free accounting services.
A Practical Business and Tax Guide for the Craftsperson by Fred Bair and James Norris.
 Publishing Horizons, P.O. Box 02190, Columbus, OH 43202-9990, revised 1986.
Recordkeeping Kit by Barbara A. Sloan. AKAS II, P.O. Box 734, Scottsdale, AZ 85252-
 0734, 1996. Includes bookkeeping basics for artist's business and personal
 records, with suggested alternatives to formal bookkeeping and accounting, and
 completed sample record-keeping forms.
The Tax Workbook for Artists and Others by Susan Harvey Dawson. ArtBusiness, Inc.,
 223 North St. Asaph Street, Alexandria, VA 22314. Revised annually.
Taxation Information for Canadian Visual Artists. CARFAC, B1-100 Gloucester Street,
 Ottawa, Ontario K2P 0A4, Canada, revised 1988. Includes information on record
 keeping, income taxes, and import and export taxes. Tax updates are also included.

Software

QuickBooks. Recommended software program for accounting and bookkeeping. Avail-
 able in software section of computer stores for IBM compatibles and Macintoshes.

National Organizations

Artists for Tax Equity, c/o Graphic Artists' Guild, 90 John Street, Suite 403, New
 York, NY 10038-3202.

Organizations by State

CALIFORNIA
Business Volunteers for the Arts/East Bay, 1404 Franklin Street, Suite 713, Oak-
 land, CA 94612.

CONNECTICUT
Business Volunteers for the Arts, c/o Arts Council of Greater New Haven, 70
 Audubon Street, New Haven, CT 06510.

DISTRICT OF COLUMBIA
Business Volunteers for the Arts, Cultural Alliance of Greater DC, 410 8th Street,
 NW, #600, Washington, DC 20004.

FLORIDA
ArtServe, 1350 East Sunrise Boulevard, Suite 100, Fort Lauderdale, FL 33304.
Business Volunteers for the Arts/Miami, Suite 2500, Museum Tower, 150 West
 Flagler Street, Miami, FL 33130.

GEORGIA
Business Volunteers for the Arts, P.O. Box 1740, Atlanta, GA 30301.
Georgia Volunteer Accountants for the Arts, One CNN Center, 1395 South Tower, Atlanta, GA 30303.

ILLINOIS
Business Volunteers for the Arts, 800 South Wells Street, Chicago, IL 60607.

MISSOURI
St. Louis Volunteer Lawyers and Accountants for the Arts, 3540 Washington, 2nd Floor, St. Louis, MO 63103.

OHIO
Volunteer Lawyers and Accountants for the Arts Program, c/o Cleveland Bar Association, 113 St. Clair Avenue NE, #225, Cleveland, OH 44114-1253.

PENNSYLVANIA
Community Accountants, University City Science Center, 3508 Market Street, #135, Philadelphia, PA 19104. Offers free services to qualified artists.

TEXAS
Austin Legal and Accounting Assistance, P.O. Box 2577, Austin, TX 78768.
Business Volunteers for the Arts, 1331 Lamar, #550, Houston, TX 77010.
Business Volunteers for the Arts of Fort Worth and Tarrant County, 1 Tandy Center, Suite 150, Fort Worth, TX 76102.
Texas Accountants and Lawyers for the Arts, 1540 Sul Ross, Houston, TX 77006.

WASHINGTON
Business Volunteers for the Arts, 1301 5th Avenue, #2400, Seattle, WA 98101.

APPRENTICES AND INTERNS
Publications

Apprentice Alliance Directory. Apprentice Alliance, 318 South A Street, Santa Rosa, CA 95401, revised annually. Lists master artists in all disciplines that use apprentices in the San Francisco Bay Area and Sonoma County.

Internship Opportunities at the Smithsonian Institution. Office of Museum Studies, Smithsonian Institution, Arts & Industries Building, Room 2235, Washington, DC 20560, revised 1996. Lists internship projects at the Smithsonian Institution in New York and Washington, D.C.

Internships and Fellowships. Visitor Information and Associates Center, Smithsonian Institution, Washington, DC 20560, 1994. Describes internships and fellowship opportunities available within the Smithsonian Institution.

Internships and Job Opportunities in New York City and Washington, D.C. The Graduate
Group, P.O. Box 370351, West Hartford, CT 06117-0351, revised annually.
Internships in Federal Government. The Graduate Group, P.O. Box 370351, West Hart-
ford, CT 06117-0351, revised annually.
Internships in State Government. The Graduate Group, P.O. Box 370351, West Hart-
ford, CT 06117-0351, revised annually.
Internships Leading to Careers. The Graduate Group, P.O. Box 370351, West Hartford,
CT 06117-0351, revised annually.
National Directory of Arts Internships, edited by Warren Christensen and Diane Rob-
inson. National Network of Artist Placement, 935 West Avenue 37, Los An-
geles, CA 90065, updated regularly. Lists hundreds of internship opportunities in
the arts.
New Internships. The Graduate Group, P.O. Box 370351, West Hartford, CT 06117-
0351, revised annually.

Organizations

Apprentice Alliance, 318 South A Street, Santa Rosa, CA 95401. Brings together
apprentices and masters in all disciplines.
Arts Apprenticeship Program, New York City Department of Cultural Affairs, 330
West 42nd Street, 14th Floor, New York, NY 10036.
Great Lakes College Association, Ohio Wesleyan University, Delaware, OH 43105.
Great Lakes College Association Program in New York, 305 West 29th Street, New
York, NY 10001.
National Network for Artist Placement, 935 West Avenue 37, Los Angeles, CA
90065.

ART COLONIES
AND ARTIST-IN-RESIDENCE PROGRAMS
Publications

About Creative Time Spaces: An International Sourcebook by Charlotte Plotsky. P.O. Box
30854, Palm Beach Gardens, FL 33420, revised 1996. Lists and describes artists'
communities, retreats, residences, and workspaces throughout the world.
Art Colonies/Artist-in-Residence Programs, compiled by Caroll Michels. Available from
Caroll Michels, 19 Springwood Lane, East Hampton, NY 11937-1169. Includes
the names, addresses, phone numbers, contact person, and descriptions of over
one hundred national and international artist-in-residence programs and
artists' colonies for visual and performing artists and writers. Updated annually.
Artists and Writers Colonies: Retreats, Residencies and Respites for the Creative Mind by Gail
Bowler. Blue Heron Publishing, Inc., 24450 Northwest Hansen Road, Hillsboro,

OR 97124, 1995. Describes nearly two hundred residencies, retreats, and fellowships. Indexed by state and disciplines. Includes information on eligibility requirements, application deadlines, and services.

Artists' Colonies & Retreats. Chicago Artists' Coalition, 11 East Hubbard Street, 7th Floor, Chicago, IL 60611, regularly revised.

Artists Communities by the Alliance of Artists Communities. New York: Allworth Press, 1996. A complete guide to residence opportunities in the United States for visual and performing artists and writers. Includes information on facilities, admission deadlines, eligibility requirements, and the selection process.

An Artist's Resource Book by Jennifer Parker. Go Far Press, 9333 Kirkside Road, Los Angeles, CA 90035, revised 1997. Includes a listing of residency programs and facilities for visual artists.

Artists with Class. Cultural Conspiracy, Inc., 66 Jenkins Road, Burnt Hills, NY 12027, published quarterly. A newsletter devoted to artists involved in arts-in-education and other arts-residency teaching programs.

Artists' Workspace Guide. New York City Department of Cultural Affairs, 2 Columbus Circle, New York, NY 10019, 1988. Includes studio space available in conjunction with artist-in-residence programs in the New York City area.

ArtNetwork Yellow Pages. ArtNetwork, P.O. Box 1268, Penn Valley, CA 95946, 1995. A resource directory that includes artist's residencies.

Directory of Writers' Residency Programs, compiled by Andy Robinson. P.O. Box 3015, Tucson, AZ 85702. Lists thirty-four North American retreat centers for writers and artists, with a comparison of costs and benefits.

The Fine Artist's Guide to Marketing and Self-Promotion by Julius Vitali. New York: Allworth Press, 1996. Provides good background information about teaching-residency opportunities in the arts. See the chapter "Artists-in-Education."

Go Wild: Creative Opportunities for Artists in Out-of-Doors by Bonnie Fournier. Lowertown Lofts Artists Cooperative, P.O. Box 65552, St. Paul, MN 55165-0552, revised annually. Describes national-park residencies for visual and performing artists and writers. Includes information on the history of each program, the selection process, special tips for applying, contact names, deadlines, stipends (if applicable) and services artists receive, and other information. A special hot line has been established to update residency information: (612) 290-9421.

Money for Film and Video Artists: A Comprehensive Research Guide, compiled by Douglas Oxenhorn. New York: Allworth Press, revised 1993. Includes information on artists' colonies.

Money for International Exchange in the Arts by Jane Gullong, Noreen Tomassi, and Anna Rubin. American Council for the Arts in cooperation with Arts International, 1992. Available from Arts International, Institute of International Education, 809 United Nations Plaza, New York, NY 10017. Includes information on international artists' residency programs.

Money for Performing Artists, edited by Suzanne Niemeyer. New York: American Council for the Arts, revised 1993. Available from Americans for the Arts (formerly American Council for the Arts and National Assembly of Local Arts Agen-

cies), 1000 Vermont Avenue, NW, 12th Floor, Washington, DC 20005. Includes
information on artists' colonies.

Money for Visual Artists, compiled by the American Council for the Arts. New York:
Allworth Press, revised 1993. Includes information on artists' colonies.

The Visual Arts Handbook. Visual Arts Ontario, 429 Wellington Street West, 2nd
Floor, Toronto, Ontario M5V 1E7, Canada, revised 1991. A comprehensive
guide to resources for artists, including art colonies.

Visual Arts Residencies: Sponsor Organizations. Mid Atlantic Arts Foundation, 22 Light
Street, Suite 300, Baltimore, MD 21202. Describes organizations that sponsor vi-
sual artists' residencies in the mid-Atlantic region. Lists the name, address,
phone number, and contact person for each sponsoring organization.

Organizations

Alliance of Artists' Communities, 210 SE 50th Avenue, Portland, OR 97215. A na-
tional service organization that supports the field of artists' communities and
residency programs.

Arts Partners Arts-in-Education Program, New York City Department of Cultural
Affairs, 2 Columbus Circle, New York, NY 10019. Works with arts organizations
to enhance the curriculum of New York City public schools. Provides access to
professional artists through artist residencies, performances, and workshops.

Florida Division of Cultural Affairs, The Capitol, Tallahassee, FL 32399-0250. Places
professional artists in Florida schools. Also sponsors a visiting-artist residency
program that places artists in community colleges.

Hospital Audiences, Inc., 220 West 42nd Street, New York, NY 10036.

New York Foundation for the Arts, Artists in Residence Program, 155 Avenue of
the Americas, 14th Floor, New York, NY 10013. Awards matching grants to or-
ganizations and schools to support artists' residencies.

Partners of the Americas, 1424 K Street, NW, Washington, DC 20005. Sponsors
artist-in-residence programs in Latin America and Caribbean countries.

Studio in a School Association, 594 Broadway, Suite 502, New York, NY 10012.
Places professional visual artists in New York City's public schools.

Young Audiences, Inc., 115 East 92nd Street, New York, NY 10128. National orga-
nization that offers opportunities for artists in all disciplines to work in school
systems throughout the United States.

Also see "Grants and Funding Resources," "International Connections," and "The Internet."

ARTISTS' BOOKS
Publications

The Book Arts Classified. Page Two, Inc., P.O. Box 77167, Washington, DC 20013-
7167, 1996. Lists opportunities and information of interest to book artists. Pub-
lished bimonthly.

The Book Arts Directory. Page Two, Inc., P.O. Box 77167, Washington, DC 20013-7167, 1996. An excellent resource for artists working in the book-arts field. Also includes information for papermakers, calligraphers, paper decorators, printmakers, book designers, fine printers and publishers, traditional bookbinders, and artist bookmakers. Lists dealers, galleries, guilds, museums, organizations, libraries, schools, and suppliers related to book arts.

Umbrella. Umbrella Associates, P.O. Box 3640, Santa Monica, CA 90408. Digest of current trends in artists' books, artists' publications, and mail art. Published three to four times a year.

Organizations

Book Arts Network, Washington University, Campus Box 1031, One Brookings Drive, St. Louis, MO 63130-4899. Sponsors workshops and seminars.

Center for Book Arts, Inc., 626 Broadway, New York, NY 10012. Nonprofit educational and exhibition facility. Offers classes and production facilities for artists' books. Also provides workspace, a slide registry, and internships. Publishes a quarterly newsletter, *Koobstra*.

Center for Book & Paper Arts, Columbia College, 218 South Wabash, 7th Floor, Chicago, IL 60604-2316. An archive and registry of artists' books. Also sponsors exhibitions and workshops. Offers a master's program in book and paper arts.

Houston Artists Bookworks, 915 Richmond Avenue, Houston, TX 77006. Offers workshops and sponsors an exhibition space.

Minnesota Center for Book Arts, 24 North Third Street, Minneapolis, MN 55401. Offers studio space and workshops and classes in papermaking, bookbinding, and letterpress.

Pacific Center for Book Arts, P.O. Box 424431, San Francisco, CA 94142-4431. Offers exhibitions, workshops, and lectures. Publishes a quarterly journal and a newsletter.

Printed Matter, 77 Wooster Street, New York, NY 10012. Largest nonprofit distributor and retailer of artists books. Also sponsors exhibitions.

Also see "Printmaking."

ARTISTS' HOUSING AND STUDIO/PERFORMANCE SPACE
Publications

About Creative Time Spaces: An International Sourcebook by Charlotte Plotsky, P.O. Box 30854, Palm Beach Gardens, FL 33420, revised 1996. Includes descriptions of work spaces for artists available throughout the world.

The Artists' Studio and Housing Handbook by Dino Tsantis. Canadian Artists' Representation Ontario (CARO), 440-40L Richmond Street West, Toronto, Ontario M5V 3A8, Canada, 1985. A guide to the rights and obligations of artists leasing studio space under a commercial lease in Canada.

Artists' Workspace Guide. New York City Department of Cultural Affairs, 2 Columbus Circle, New York, NY 10019, 1988. Lists work-space and artist-in-residence programs. Includes nonprofit spaces and commercial work spaces available to the arts community.

Creating Space: A Real Estate Development Guide for Artists by Cheryl Kartes. New York: American Council for the Arts in conjunction with Artspace Projects, Inc., and the Bay Area Partnership, 1992. Available from Americans for the Arts, 1000 Vermont Avenue, NW, 12th Floor, Washington, DC 20005. A comprehensive guide that shows artists how they can develop their own spaces for living and working. Includes techniques for assessing a studio/housing project, identifying resources, and organizing tenants. Also provides information on financing strategies, legal structures, design issues, and management.

The Inspector Cometh by Richard Reineccius. ArtHouse, Fort Mason Center, Building C, Room 255, San Francisco, CA 94123, 1993. Written to assist in the acquisition and development of exhibition and performance space in San Francisco. Includes information on the city's code and permit regulations, general considerations for locating space, and technical data on design and renovation.

Live/Work: Form and Function by Jennifer Spangler. ArtHouse, Fort Mason Center, Building C, Room 255, San Francisco, CA 94123, revised 1990.

The 100 Best Small Arts Towns in America: Where to Discover Creative Communities, Fresh Air, and Affordable Housing by John Villani. John Muir Publications, P.O. Box 613, Santa Fe, NM 87504, revised 1996. An annotated list of communities that are particularly artist-friendly.

Space Conversion Guidebook. ArtHouse, Fort Mason Center, Building C, Room 255, San Francisco, CA 94123, 1996. A nuts-and-bolts resource guide that provides information about converting military bases for peacetime use by artists and arts organizations. Outlines the steps in the base conversion process and provides a framework for groups to evaluate whether they are equipped to purchase space on former base property.

Will It Make Theatre: Find, Renovate, and Finance the Non-Traditional Performance Space, by Eldon Elder. New York: American Council for the Arts in cooperation with A.R.T./NY, 1993. Available from Americans for the Arts, 1000 Vermont Avenue, NW, 12th Floor, Washington, DC 20005. Discusses how to create a performance facility in a building designed for another purpose. Also covers upgrading space, determining priorities for renovations, understanding building and fire codes, and sharing space with other organizations.

Organizations

ArtHouse, Fort Mason Center, Building C, Room 255, San Francisco, CA 94123. Nonprofit organization created to address the problem of live-work space for artists. Provides a listing of available space on a twenty-four-hour basis.

Artspace Projects, Inc., 250 Third Avenue North, #400, Minneapolis, MN 55401.

Assists artists in finding or developing affordable studio and performance space in vacant and underutilized buildings.

Essex and Phoenix Mills, 24 Mill Street, Patterson, NJ 07501. A government housing program that provides 70 percent of its space to professional artists, both individuals and families. Priority placement is given to those applicants who have lost their housing or those who spend 50 percent or more of their income on rent or those living in substandard housing.

Fort Point Arts Community, Inc., 300 Summer Street, Boston, MA 02210. An advocacy organization that helps Boston-area artists obtain studio space.

Institute for Contemporary Art, 46-01 21st Street, Long Island City, NY 11101. Through a national program and international program, provides visual artists with free, nonliving studio space for one year at the P.S. 1 Museum in Long Island City and the Clocktower Gallery in Manhattan.

Maria Walsh Sharpe Art Foundation, 711 North Tejon Street, #B, Colorado Springs, CO 80903. Provides free studio space in New York City to visual artists. Artists throughout the United States are eligible to apply for work space.

ARTS LEGISLATION AND ARTISTS' ADVOCACY
Publications

Artfax. Artists for a Better Image (ArtFBI), P.O. Box 2769, Silver Spring, MD 20915. A newsletter devoted to art and advocacy information. Published ten times a year.

Artistic Freedom Under Attack. People for the American Way, 2000 M Street, NW, Washington, DC 20036, 1995. Documents challenges to artistic freedom across the United States.

Videotapes

TV Bloopers and Practical Jokes: Media Representations of Artists. Artists for a Better Image (ArtFBI), P.O. Box 2769, Silver Spring, MD 20915. A videotape presentation extracted from popular television shows about artist stereotyping.

Organizations

Americans for the Arts (formerly American Council for the Arts and the National Assembly of Local Arts Agencies), 1000 Vermont Avenue, NW, 12th Floor, Washington, DC 20005. National organization that provides information on legislative issues and government policies affecting the arts. Also promotes the development of the arts by strengthening the role of local arts agencies.

Artists for a Better Image (ArtFBI), P.O. Box 2769, Silver Spring, MD 20915. A national information-gathering and advocacy organization that collects and monitors examples of stereotypical portrayals of artists in literature and the media in order to promote a more realistic image of the artist in society. Offers workshops, lectures, a newsletter, and educational programs.

Artsave, People for the American Way, 2000 M Street, NW, Suite 400, Washington, DC 20036. Assists artists and arts organizations in defending themselves against censorship challenges. Provides legal counsel, mobilizes national and local coalitions, mounts letter-writing campaigns, and designs media strategies to build public support for the arts.

Graphic Artists Guild, 90 John Street, Suite 403, New York, NY 10038-3202. National membership organization with local chapters throughout the United States. Advances the rights and interests of artists through legislative reform.

National Artists Equity Association, P.O. Box 28068, Central Station, Washington, DC 20038. National organization with local chapters. Involved at federal, state, and local levels. Concerned with legislative issues affecting artists economically and socially.

National Association of Artists' Organizations, 918 F Street, NW, Washington, DC 20004. A membership organization made up of organizations and individual artists. Provides information on legislative issues and governmental policies affecting artists and arts organizations.

National Campaign for Freedom of Expression, 918 F Street, NW, Washington, DC 20004. Coalition of artists, artists' organizations, and other individuals working together to protect the First Amendment and freedom of expression. Chapters are located throughout the United States.

Oregon Advocates for the Arts, 707 13th Street, SE, Suite 275, Salem, OR 97301. Statewide arts lobby and public-information organization that has successfully advocated the enactment of several significant pieces of legislation and a law governing consignment sales.

ARTS SERVICE ORGANIZATIONS
Publications

Access: A Guide to the Visual Arts in Washington State, edited by Claudia Bach. Allied Arts of Seattle, 105 South Main Street, Seattle, WA 98104, 1989.

The Artist's Resource Handbook by Daniel Grant. New York: Allworth Press, revised 1996. Includes a list of arts service organizations nationwide.

ArtNetwork Yellow Pages. ArtNetwork, P.O. Box 1268, Penn Valley, CA 95946, 1995. Lists various arts services organizations.

Asian American Arts Organizations in New York. Asian American Artists Network, P.O. Box 879, Canal Street Station, New York, NY 10013-0864, 1990.

Directory of Arts Organizations. ARTS Inc., 315 W. 9th Street, Los Angeles, CA 90015, 1995. A comprehensive listing of arts organizations in Los Angeles County.

Directory of Hispanic Arts Organizations. Association of Hispanic Artists, 173 East 116th Street, New York, NY 10029, revised 1996. Lists organizations involved with dance, literature, media, music, theater, and visual arts.

Directory of Minority Arts Organizations, edited by Carol Ann Huston. Division of Civil Rights, National Endowment for the Arts, 1100 Pennsylvania Avenue, NW,

Washington, DC 20506, updated 1997. Lists art centers, galleries, performing groups, presenting groups, and local and national arts service organizations with leadership and constituencies that are predominantly Asian-American, black, Hispanic, Native American, or multiracial.

Directory of the Arts. Canadian Conference of the Arts, 189 Laurier Avenue East, Ottawa, Ontario K1N 6P1, Canada, revised 1996. A complete listing of Canadian cultural departments and agencies, national arts associations, arts councils, and cultural agencies.

Fine Art Resources: A Guide to New York Metropolitan Area, New Jersey and Long Island Organizations. Manhattan Arts International, 200 East 72nd Street, Suite 26L, New York, NY 10021, 1996. A listing of nonprofit organizations, alternative spaces, advocacy groups, legal and business associations, cooperative galleries, workshops, schools, museums, and other institutions that offer a range of services to fine artists.

Manitoba Visual Artists Index. CARFAC Manitoba, 221-100 Arthur Street, Winnipeg, Manitoba R3B 1H3, Canada, 1992. Includes a list of arts service organizations in Manitoba.

National Association of Artists' Organizations Directory. National Association of Artists' Organizations, 918 F Street, NW, Washington, DC 20004, revised 1997. Describes alternative spaces and arts service organizations. Each entry includes a description of programs, disciplines, exhibition and/or performance spaces, proposal procedures, and the name of the contact person.

National Directory of Multicultural Arts Organizations, edited by Johanna L. Misey. National Assembly of State Arts Agencies, 1010 Vermont Avenue, NW, Suite 920, Washington, DC 20005, 1990. Contains more than 1,200 entries; includes listings for service organizations.

The National Resource Guide for the Placement of Artists, edited by Cheryl Slean. National Network for Artist Placement, 935 West Avenue 37, Los Angeles, CA 90065, revised regularly. An annotated guide to arts organizations that provide support to artists.

Organizing Artists, edited by Lane Relyea. National Association of Artists' Organizations, 918 F Street, NW, Washington, DC 20004, 1990. A critical examination of the evolution of artists' organizations and the artist-space movement, tracing the history of artist activism in the United States from 1905 to 1990.

The Visual Arts Handbook. Visual Arts Ontario, 329 Wellington Street West, Toronto, Ontario M5V 1E7, Canada, revised 1991. A comprehensive guide to resources for artists and to artists' associations.

National Organizations

American Craft Council, 72 Spring Street, 6th Floor, New York, NY 10012. National organization that sponsors exhibitions, seminars, workshops, and international exchange and communications programs. Publishes *American Craft*.

Art and Science Collaborations, Inc., P.O. Box 040496, Staten Island, NY 10304-0009.

Artists for a Better Image (ArtFBI), P.O. Box 2769, Silver Spring, MD 20915. A national information-gathering and advocacy organization that collects and monitors examples of stereotypical portrayals of artists in literature and the media in order to promote a more realistic image of the artist in society. Offers workshops, lectures, and educational programs.

Arts Extension Service, Division of Continuing Education, University of Massachusetts, Amherst, MA 01300. Serves as a catalyst for better management of the arts in communities through continuing education for artists and the arts organizations. Sponsors programs in arts management, business development, fundraising, advocacy leadership, and marketing. Publishes and distributes books, guides, and pamphlets.

Asian American Arts Alliance, Inc., 74 Varick Street, Suite 302, New York, NY 10013. Sponsors exhibitions, publications, and programs for Asian-American artists.

Asian American Arts Centre, 26 Bowery, 3rd Floor, New York, NY 10013. Promotes the preservation and creative vitality of Asian-American cultural identity through the arts. Sponsors research projects, exhibitions, performances, educational programs, an Asian-American-artist historical archive, and an artist-in-residence program.

Association of Hispanic Arts, Inc., 173 East 116th Street, New York, NY 10029. Offers a variety of services geared toward professional Hispanic artists and arts organizations.

Association of Independent Video and Filmmakers, Inc., 304 Hudson Street, 6th Floor, New York, NY 10013. Provides creative and professional opportunities for independent video makers and filmmakers.

ATLATL, P.O. Box 63090, Phoenix, AZ 85067-4090. A national nonprofit organization dedicated to the preservation, promotion, and development of contemporary and traditional Native American arts. Provides a Native American resource and distribution clearinghouse. Offers employment referrals, reference and referral information, and publishes *Native Arts Update*.

Canadian Crafts Council, 189 Laurier Avenue East, Ottawa, Ontario K1N 6P1, Canada. Provides information and services to artists.

CARFAC National, B1-100 Gloucester Street, Ottawa, Ontario K2P 0A4, Canada. A national advocacy organization for Canadian artists.

Coast to Coast National Women Artists of Color, P.O. Box 310961, Jamaica, NY 11431. National membership organization dedicated to supporting women artists of color. Maintains a slide registry, mailing lists, and database information. Publishes a newsletter.

En Foco, 32 East Kingsbridge Road, Bronx, NY 10468. National organization devoted to photographers of color. Publishes *Critical Mass*.

Friends of Fiber Art International, P.O. Box 468, Western Springs, IL 60558. Sponsors annual programs and a fiber-art registry and publishes a quarterly newsletter.

Graphic Artists Guild, 90 John Street, Suite 403, New York, NY 10038-3202. National membership organization with local chapters throughout the United States. Advances the rights and interests of artists through legislative reform and organizes networking activities, including job-referral services. Publishes the newsletter *Guild News*.

International Sculpture Center, 1050 17th Street, NW, Suite 250, Washington, DC 20036. Nonprofit service organization for professional sculptors. Offers health and studio insurance, provides a computerized data bank, and organizes international and national exhibitions. Publishes *Sculpture*.

Intuit: The Center for Intuitive and Outsider Art, 1926 North Halsted Street, Chicago, IL 60614. Established to recognize the work of artists who demonstrate little influence from the mainstream art world and who are motivated by a unique personal vision. Sponsors exhibitions, lectures, and public programs. Publishes *In'tuit*, a quarterly newsletter.

Museum Reference Center, Smithsonian Institution Libraries, Office of Museum Studies, Arts and Industries Building, Room 2235, 900 Jefferson Drive, SW, Washington, DC 20560. Provides technical assistance, workshops, conferences, and information on museums and visual arts. Sponsors an internship program and publishes booklists and guides.

National Artists Equity Association, P.O. Box 28068, Central Station, Washington, DC 20038. National organization with local chapters throughout the United States. Benefits include group medical insurance, studio and work insurance, promotion of arts-related legislation, model contracts, and publications.

National Association of Artists' Organizations (NAAO), 918 F Street, NW, Washington, DC 20004. Composed of organizations and individuals that sponsor the production and presentation of contemporary artists' work and/or artists' services.

National Center on Arts and the Aging, 409 Third Street, SW, 2nd Floor, Washington, DC 20024. Serves as a clearinghouse on public and private arts and aging agencies. Provides reference materials and technical assistance. Sponsors conferences, workshops, and exhibitions. Maintains an artists' registry. Publishes *Collage* and books on arts and the aging.

National Conference of Artists, Gallery Row, 409 7th Street, NW, Washington, DC 20004. The oldest national organization for African-American artists in the United States. Devoted to the preservation, promotion, and development of the work of African-American artists through its various services, publications, and programs.

Photographic Resource Center, 602 Commonwealth Avenue, Boston, MA 02215. A membership organization providing a range of programs and services for photographers, journalists, critics, curators, students, and other individuals and organizations interested in photography.

Society for the Arts in Healthcare, 45 Lyme Road, Suite 304, Hanover, NH 03755. A national membership organization that is dedicated to the incorporation of the arts as an appropriate and integral component of health care. Members include physicians, nurses, medical students, arts administrators, architects, designers,

and artists in all disciplines. Publishes a newsletter and membership directory and sponsors an annual conference.

Women's Caucus for Art, P.O. Box 2646, New York, NY 10009. National organization with regional chapters throughout the United States. Represents the professional and economic concerns of women artists, art historians, educators, writers, and museum professionals. Sponsors conferences and exhibitions and publishes a newsletter.

Regional Organizations

Arts Midwest, 528 Hennepin Avenue, Suite 310, Minneapolis, MN 55403. Regional arts organization serving Illinois, Indiana, Iowa, Michigan, Minnesota, North Dakota, Ohio, South Dakota, and Wisconsin. Provides services, publications, workshops, exhibitions, and grants.

Canadian Artists' Representation Ontario (CARO), 440-40L Richmond Street West, Toronto, Ontario M5V 3A8, Canada. Association of professional visual artists in Ontario working to improve the financial and professional status of artists.

CARFAC Manitoba, 221-100 Arthur Street, Winnipeg, Manitoba R3B 1H3, Canada. An artists' advocacy organization that provides career-related services and publications.

Consortium for Pacific Arts and Cultures, 2141C Atherton Road, Honolulu, HI 96822. Helps state arts agencies in the Pacific Basin develop multistate and international programs. Sponsors workshops, residencies, and educational programs.

Mid-America Arts Alliance, 912 Baltimore Avenue, #700, Kansas City, MO 64105. Provides recognition and opportunities for artists, performers, and arts institutions in Arkansas, Kansas, Missouri, Nebraska, Oklahoma, and Texas. Sponsors exhibitions, performances, workshops, residencies, grants, and other services.

Mid Atlantic Arts Foundation, 22 Light Street, Suite 300, Baltimore, MD 21202. Serves artists and arts organizations in Delaware, the District of Columbia, Maryland, New Jersey, New York, Pennsylvania, Virginia, and West Virginia. Sponsors performances, fellowships, and residencies, and provides other services.

New England Foundation for the Arts, 330 Congress Street, 6th Floor, Boston, MA 02210. Serves artists and arts organizations in Connecticut, Maine, Massachusetts, New Hampshire, Rhode Island, and Vermont. Sponsors exhibitions, performances, workshops, residencies, and publications and provides other services.

Ontario Crafts Council, 35 McCaul Street, Toronto, Ontario M5T 1V1, Canada. Provides information and assistance to artists through seminars, conferences, publications, and exhibitions.

Resources and Counseling for the Arts, 308 Prince Street, Suite 270, Saint Paul, MN 55101-1437. Provides business-related information, advice, and technical assistance to artists in Minnesota and surrounding states through workshops, consultations, publications, and other support services.

Southern Arts Federation, 181-14th Street, NE, Suite 400, Atlanta, GA 30309. Serves artists and arts organizations in Alabama, Florida, Georgia, Kentucky, Louisiana, Mississippi, North Carolina, South Carolina, and Tennessee.

Visual Arts Ontario, 439 Wellington Street West, Toronto, Ontario M5V 1E7, Canada. A resource center with books, reports, periodicals, and catalogs. Sponsors artists' business seminars. Services also include group insurance plans, slide registry, color xerography center, international art programs, and art placement programs.

Western States Arts Foundation, 1453 Champa Street, Suite 220, Denver, CO 80202. Serves artists and arts organizations in Alaska, Arizona, California, Colorado, Hawaii, Idaho, Montana, Nevada, New Mexico, Oregon, Utah, Washington, and Wyoming. Sponsors exhibitions, performances, and publications and provides other services.

Other Organizations

Art Information Center, 55 Mercer Street, New York, NY 10013. Provides information to artists interested in exhibiting in New York. Catalogs information on contemporary artists that exhibit in New York galleries. Also sponsors a slide file for artists unaffiliated with New York galleries.

Artists Foundation, 8 Park Plaza, Boston, MA 02116. A statewide nonprofit organization devoted to enhancing the careers of individual artists and the position of artists in society. Sponsors exhibitions and performances and provides other services.

Arts for Greater Rochester, 335 East Main Street, Rochester, NY 14604. A coalition of arts organizations, artists, businesses, and county government. Provides support services to individual artists, including promotion, consultations, management workshops, volunteer legal assistance, group health insurance, and a slide registry.

Artswatch, 2337 Frankfort Avenue, Louisville, KY 40206. Sponsors exhibitions, performances, workshops, educational programs, and residencies.

Boston Visual Artists Union, P.O. Box 399, Newtonville, MA 02160. Service organization that supports artists' work through exhibitions, a slide registry, a resource center, a newsletter, and special programs.

The Center for Contemporary Arts of Santa Fe, P.O. Box 148, Santa Fe, NM 87501. Sponsors exhibitions, performances, workshops, residencies, publications, educational programs, and studios and provides other services.

The Center for Photography at Woodstock, 59 Tinker Street, Woodstock, NY 12498. Sponsors exhibitions, fellowships, lectures/workshops, and publications for photographers, video artists, and filmmakers.

Center on Contemporary Art, 65 Cedar Street, Seattle, WA 98121. Sponsors exhibitions, performances, publications, educational programs, and residencies.

Chicago Artists' Coalition, 11 East Hubbard Street, 7th Floor, Chicago, IL 60611. An artist-run service organization for visual artists that offers members a slide reg-

istry, lectures, job referral services, and workshops. Publishes *Chicago Artists' News* and other resources.

Chicano Humanities and Arts Council, Inc., P.O. Box 2512, Denver, CO 80201. Provides technical assistance on proposals and promotion and offers workshops on the business of art and on marketing techniques.

Contemporary Arts Center, 900 Camp Street, New Orleans, LA 70130. Mailing address: P.O. Box 30498, New Orleans, LA 70190. Sponsors exhibitions, performances, publications, workshops, educational programs, and grants and provides other services.

Cultural Alliance of Greater Washington, 410 8th Street, NW, Suite 600, Washington, DC 20004. Membership organization that sponsors workshops and seminars. Provides health insurance for members. Publishes *Art Washington Newsletter*.

The Delaware Center for the Contemporary Arts, 103 East 16th Street, Wilmington, DE 19801. Sponsors exhibitions, publications, workshops, educational programs, residencies, and studio space.

Detroit Artists Market, 300 Stroh's River Place, Suite 1650, Detroit, MI 48207. Promotes and assists Detroit metropolitan-area artists. Sponsors exhibitions, publications, and educational programs.

Diverse Works, Inc., 1117 East Freeway, Houston, TX 77002. Sponsors exhibitions, performances, publications, and workshops.

Florida Center for Contemporary Art, P.O. Box 75184, Tampa, FL 33065. Primarily represents emerging artists in Florida. Services include a slide registry, legal referrals, studio space, and networking information.

Individual Artists of Oklahoma, P.O. Box 60824, Oklahoma City, OK 73146. Sponsors exhibitions, performances, publications, and workshops.

Maryland Art Place, 218 West Saratoga Street, Baltimore, MD 21201. Sponsors exhibitions, performances, publications, workshops, educational programs, and residencies.

Nexus Contemporary Art Center, 535 Means Street, Atlanta, GA 30318. Sponsors exhibitions, performances, publications, workshops, residencies, educational programs, grants, and studios and provides other services.

New Organization for the Visual Arts (NOVA), 4614 Prospect Avenue, Suite 212, Cleveland, OH 44103. Artists' membership organization. Provides art marketing program to corporations; sponsors exhibitions, lectures, and workshops.

New York Foundation for the Arts, 155 Avenue of the Americas, 14th Floor, New York, NY 10013-1507. Supports the development of individual professional artists, their projects, and their organizations. Publishes *FYI*, a quarterly publication. Provides grants and services, and sponsors the Visual Artist Information Hotline, a toll-free information and referral service for visual artists nationwide: (800)232-2789 (also see appendix page 271).

Oklahoma Visual Arts Coalition, 5224 Classen Boulevard, Oklahoma City, OK 73118. Sponsors publications, workshops, and educational programs, and awards grants to Oklahoma artists.

Organization of Independent Artists, 19 Hudson Street, Suite 402, New York, NY 10013. Provides artists with exhibition opportunities throughout New York City, sponsors artist-curated shows, maintains a slide registry for members, and publishes *OIA Newsletter*.

Painted Bride Art Center, 230 Vine Street, Philadelphia, PA 19106. Sponsors exhibitions, performances, publications, and workshops.

Pro Arts, 461 9th Street, Oakland, CA 94607. Nonprofit membership organization serving artists of all disciplines in the Bay Area. Offers technical assistance, consultations, service library, seminars, workshops, artist-in-residence programs, and exhibitions.

Real Art Ways (RAW), 56 Arbor Street, Hartford, CT 06106. Sponsors exhibitions, performances, publications, educational programs, residencies, and grants and provides other services.

1708 East Main, P.O. Box 12520, Richmond, VA 23241. Sponsors exhibitions, performances, publications, and workshops.

Surface Design Association, P.O. Box 20799, Oakland CA 94620-0799. Professional organization of artists involved in surface design, including textiles, weavings, quilts, and other forms of fiber art.

Texas Fine Arts Association, 3809-B West 35th Street, Austin, TX 78703. Membership organization for Texas artists. Provides statewide and national art exhibits, information, and referrals.

Urban Institute for Contemporary Arts, 88 Monroe, NW, Grand Rapids, MI 49503. Sponsors exhibitions, performances, publications, workshops, educational programs, and residencies.

Visual Studies Workshop, 31 Prince Street, Rochester, NY 14607. Provides services, including educational and publishing programs, exhibitions, residencies, and grants, for artists working in photography, artists' books, video, and independent film.

Washington Project for the Arts (WPA), c/o Corcoran Gallery of Art, 17th Street and New York Avenue, NW, Washington, DC 20006. Sponsors exhibitions, performances, publications, and residencies.

Wisconsin Painters and Sculptors, Inc., 1112 Smith Street, Green Bay, WI 54302. Sponsors exhibitions, performances, publications, workshops, and educational programs. Publishes *Art in Wisconsin*.

Women and Their Work, 1710 Lavaca Street, Austin, TX 78703. Sponsors exhibitions, performances, workshops, educational programs, and publications.

Women's Art Registry of Minnesota, 2402 University Avenue West, St. Paul, MN 55114-1701. Membership organization serving women visual artists in Minnesota. Maintains a slide registry and administers a mentor program that matches emerging women artists with more-established women artists for a period of one year.

ARTWORK CARE AND MAINTENANCE
Publications

The Care of Photographs by Siegfried Rempel. Lyons and Burford, 31 West 21st Street, New York, NY 10010, 1988. Includes information on proper storage techniques and criteria for preparing museum-quality matting and framing.

Caring for Your Art by Jill Snyder. New York: Allworth Press, revised 1996. Covers the best methods to store, handle, mount, frame, display, document and inventory, photograph, pack, transport, insure, and secure art. Also discusses proper environmental controls to enhance longevity of work.

Conservation Concerns: A Guide for Collectors and Curators, edited by Konstanze Bachmann. Washington, DC: Smithsonian Institution Press, 1992. Available from the American Association of Museums, 1225 I Street, NW, Suite 200, Washington, DC 20005. Focuses on proper storage techniques and environmental control.

Curatorial Care of Works of Art on Paper by Anne F. Clapp. Lyons and Burford, 31 West 21st Street, New York, NY 10010, revised 1991. Includes advice on conservation techniques and describes the effect of light, acid, and temperature on works on paper.

Guide to Maintenance of Outdoor Sculpture. American Institute of Conservation, 1717 K Street, NW, #301, Washington, DC 20006, 1992.

Matting and Hinging of Works of Art on Paper by Merrily A. Smith. The Consultant Press/The Photographic Arts Center, Limited, 163 Amsterdam Avenue, New York, NY 10023, 1989. Describes mounting and matting techniques used at the Library of Congress.

Permanence and Care of Color Photographs: Traditional and Digital Color Prints, Color Negatives, Slides and Motion Pictures by Henry Wilhelm. Preservation Publishing Company, 733 Broad Street, Grinnell, IA 50112, 1993.

Videotapes

Basic Art Handling. Gallery Association of New York State, P.O. Box 345, Hamilton, NY 13346, 1988. Demonstrates the best methods for handling artworks in all disciplines.

Also see "Exhibition and Performance Planning."

CAREER MANAGEMENT, BUSINESS, AND MARKETING
Publications

Annotated Bibliography for the Professional Visual Artist by Sarah Yates. Canadian Artists' Representation Ontario (CARO), 440-40L Richmond Street West, Toronto, Ontario M5V 3A8, Canada, 1989. Lists and describes books available on various career-related topics for visual artists.

The Architect's Sourcebook. THE GUILD, 931 East Main Street, #106, Madison, WI 53703-2955. A resource directory that contains the names, addresses, phone

numbers, and photographs of the work of American fine-arts and craft artists, as well as biographical information. Distributed free of charge to attendees of the American Society of Interior Designers' and the American Institute of Architects' national conferences. Also distributed free of charge to art consultants. Published annually.

The Art Biz: The Covert World of Collectors, Dealers, Auction Houses, Museums, and Critics by Alice Goldfarb Marquis. Chicago: Contemporary Books, Inc., 1991.

The Art Business Encyclopedia by Leonard D. DuBoff. New York: Allworth Press and the American Council for the Arts, revised 1994. Explains the most significant legal and business terms from national and international art worlds. Also includes discussions on the innovative use of computers and related technology, artist-gallery relationships, artists' rights, national and international law affecting art, and new developments in art consumer protection.

Art Business News. 19 Old Kings Highway South, Darien, CT 06820. Published monthly.

Art Calendar, P.O. Box 199, Upper Fairmount, MD 21867-0199. Comprehensive listing of opportunities for artists, including exhibitions, grants, art colonies, alternative spaces, and slide registries. Also features articles on all facets of marketing advice. Eleven issues per year.

An Art Calendar Guide: Building a Good Portfolio. Art Calendar, P.O. Box 199, Upper Fairmount, MD 21867-0199, 1997.

The Art Calendar 1997–1998 Annual Resource Directory. Art Calendar, P.O. Box 199, Upper Fairmount, MD 21867-0199, 1997. Includes a listing of artists' organizations and alternative spaces, college and university galleries, corporate collections, residencies and artists colonies, grants, art consultants, internships, and more.

Art Marketing Handbook: Marketing Art in the Nineties by Calvin Goodman. Los Angeles: Gee Tee Bee, Inc., 1991.

Art Marketing 101: A Handbook for the Fine Artist by Constance Smith. ArtNetwork, P.O. Box 1268, Penn Valley, CA 95946, 1997.

Art Marketing Sourcebook. ArtNetwork, P.O. Box 1268, Penn Valley, CA 95946, regularly revised. Contains over two thousand listings of galleries, art consultants, art publishers, etc.

The Art of Self Promotion, Creative Marketing Management, P.O. Box 23, Hoboken, NJ 07030, published quarterly.

The Artist in Business: Basic Business Practices by Craig Dreesen. Arts Extension Service, Division of Continuing Education, University of Massachusetts, Amherst, MA 01003, 1988. Includes information on record keeping, legal issues, grants, commissions, and competitions.

The Artist's and Graphic Designer's Market. Cincinnati: Writer's Digest Books, revised annually.

The Artist's Guide to New Markets: Opportunities to Show and Sell Art Beyond Galleries by Peggy Hadden. New York: Allworth Press, 1998.

The Artist's Resource Handbook by Daniel Grant. New York: Allworth Press, revised 1997. Guide to career assistance for artists on a wide range of topics.

The Artist's Survival Manual: A Complete Guide to Marketing Your Work by Toby Judith Klayman, with Cobbett Steinberg. New York: Charles Scribner's Sons, revised 1987.

Artists' Yellow Pages. Chicago Artists' Coalition, 11 East Hubbard Street, 7th Floor, Chicago, IL 60611, 1996. A listing of materials, services and supplies for visual artists.

ArtNetwork Yellow Pages. ArtNetwork, P.O. Box 1268, Penn Valley, CA 95946, 1995. Directory of arts organizations, art councils, critics, magazines, reference books and publications, residencies, grants, accountants, and lawyers for-the-arts. Over 3,000 listings.

ARTnewsletter: The International Biweekly Report on the Art Market. ARTnews, 48 West 38th Street, New York, NY 10018.

Artsource Quarterly. ArtNetwork, P.O. Box 1268, Penn Valley, CA 95946. A newsletter that contains marketing tips for artists. Published quarterly.

Artworld Hotline. ArtNetwork, P.O. Box 1268, Penn Valley, CA 95946. A newsletter that contains marketing tips and opportunities. Includes information on galleries, art consultants, art publishers, residencies, and percent-for-art programs. Published monthly.

BizBits Newsletter. AKAS II, P.O. Box 734, Scottsdale, AZ 85252-0734. Includes information and suggestions for running a business as an artist, such as the availability of money resources, pricing of artwork, use of a computer, and estate planning guidelines. Published quarterly.

Business Entities for Artists Fact Sheet by Mark Quail. Available from Artists' Legal Advice Services and Canadian Artists' Representation Ontario (CARO), 440-40L Richmond Street West, Toronto, Ontario M5V 3A8, Canada, 1989. Summarizes information on sole proprietorships and corporations, with information on tax perspectives, registration, and legal liability.

The Business of Art, edited by Lee Caplin. Englewood Cliffs, N.J.: Prentice-Hall, revised 1989. See "An Artist's Way of Life" by James Rosenquist, "Practical Planning" by Bruce Beasely, "Setting Up Business" by Harvey Horowitz, and "Preparing Your Portfolio" by Kate Keller and Mali Olatunji.

The Business of Being an Artist by Daniel Grant. New York: Allworth Press, revised 1996.

CARNET. Copublished by Canadian Artists' Representation Ontario, CARFAC National and CARFAC Manitoba. Available through CARFAC Manitoba, 221-100 Arthur Street, Winnipeg, Manitoba R33 1H3; CARO, 440-40L Richmond Street West, Toronto, Ontario M5V 3A8, Canada; and CARFAC National, B1-100 Gloucester Street, Ottawa, Ontario K2P 0A4, Canada. A bilingual (English and French) magazine featuring articles on professional development, opportunities, and programs for artists. Published quarterly.

Craft as a Business by Wendy Rosen. The Rosen Group, 3000 Chestnut Avenue, Suite 304, Baltimore, MD 21211, 1994.

Craft Equipment Exchange Newsletter, P.O. Box 358, Sebastopol, CA 95473. A national newsletter for selling used equipment, overstocked or unused supplies, and display materials. Published six times a year.

The Crafts Report: The Business Journal for the Crafts Industry, P.O. Box 1992, Wilmington, DE 19899. Published monthly.

Developing a Client List by Nina Pratt. Available from Nina Pratt, 116 Pinehurst Avenue, New York, NY 10033, 1994. Provides information on networking techniques for selling art.

The Designer's Sourcebook. THE GUILD, 931 East Main Street #106, Madison WI 53703-2955. A resource directory that contains the names, addresses, phone numbers, and photographs of the work of American fine-arts and craft artists, as well as biographical information. Distributed free of charge to attendees of the American Society of Interior Designers' and the American Institute of Architects' national conferences. Also distributed free of charge to art consultants. Published annually.

The Entrepreneurial Artist by Zella Jackson and Judy Cunningham. The Consultant Press/The Photographic Arts Center, Limited, 163 Amsterdam Avenue, New York, NY 10023, 1991.

Film and Video Budgets by Michael Wiese. Michael Wiese Productions, 4354 Canyon Boulevard, Suite 234, Studio City, CA 91604, 1995. A guide to developing budgets for many types of films and videos.

Film and Video Financing by Michael Wiese. Michael Wiese Productions, 4354 Canyon Boulevard, Suite 234, Studio City, CA 91604, 1991. Creative strategies for financing feature films and video projects.

Finding Art Buyers for Your Art: Quick, Easy and Economical Marketing for Artists by Nina Pratt. Nina Pratt, 116 Pinehurst Avenue, New York, NY 10033, 1994. This condensed version of *How to Find Art Buyers* (see below) contains information that is particularly useful to artists. *How to Find Art Buyers* is primarily geared for art dealers.

The Fine Artist's Guide to Marketing and Self-Promotion by Julius Vitali. New York: Allworth Press, 1996. Covers various topics related to marketing and publicity. Includes chapters on other career-related issues.

Getting the Word Out: An Artist's Guide to Self Promotion, edited by Carolyn Blakeslee. Art Calendar Publishing, Inc., P.O. Box 199, Upper Fairmount, MD 21867-0199, 1995. Contains selected articles from the monthly publication *Art Calendar* on a wide variety of career-related topics.

Hand Papermaking Newsletter. P.O. Box 77027, Washington, DC 20013-7027. Lists information and opportunities of interest to hand-papermaking artists, including exhibits, competitions, conferences, and workshops. Published four times a year.

How to Find Art Buyers by Nina Pratt. Available from Nina Pratt, 116 Pinehurst Avenue, New York, NY 10033, 1992. Although geared for art dealers, it is also useful to artists. Covers such topics as advertising, mailers, public relations, exhibitions, art fairs, catalogs.

How to Sell Art: A Guide for Galleries, Art Dealers, Consultants, and Artist's Agents by Nina Pratt. Available from Nina Pratt, 116 Pinehurst Avenue, New York, NY 10033, 1992. Although geared for art dealers, artists will find this book an excellent tool for selling art from their studio.

How to Start and Succeed as an Artist (formerly *On Becoming an Artist*) by Daniel Grant. New York: Allworth Press, revised 1997.

Information for Artists edited by Sarah Yates. CARO, 440-40L Richmond Street West, Toronto, Ontario M5V 3A8, Canada, revised 1990. Outlines a variety of alternative venues for exhibitions, sale of work, and information on basic business practices and legislation affecting artists.

Making a Living as an Artist, edited by Carolyn Blakeslee and Drew Steis. Art Calendar, P.O. Box 199, Upper Fairmount, MD 21867-0199, 1993. Contains selected articles from the monthly publication *Art Calendar* on a wide variety of career-related topics.

Making Marketing Manageable: A Painless & Practical Guide to Self-Promotion by Elise Benun. Available from Creative Marketing & Management, P.O. Box 23, Hoboken, NJ 07030, 1995.

Marketing the Fine Arts by Marcia Layton. The Consultant Press/The Photographic Arts Center, Limited, 163 Amsterdam Avenue, New York, NY 10023, 1992.

The National Resource Guide for the Placement of Artists, edited by Cheryl Slean. National Network for Artist Placement, 935 West Avenue 37, Los Angeles, CA 90065, revised regularly. An annotated guide to organizations and publications of interest to artists. Covers legal assistance, contract information, publications, job banks, funding, and arts organizations that provide support to artists.

New American Paintings. The Open Studio Press, 66 Central Street, Wellesley, MA 02181. A series of artists' sourcebooks published several times a year. Artists are selected by a juried procedure. No entry fees or publication fees are charged.

Options. Pardus, Inc., 28 Moya Loop, Santa Fe, NM 87505. A straightforward monthly newsletter that lists opportunities for artists, including exhibitions and competitions. Each issue contains seventy-five to one hundred listings. Does not include art fairs, outdoor shows, or vanity galleries.

Perfect Portfolio. Visual Arts Ontario, 439 Wellington Street West, 2nd Floor, Toronto M5V 1E7, Canada, 1995. Includes information on effective presentations including slides and photographing two-dimensional artwork.

The Photographer's Guide to Marketing and Self-Promotion by Maria Piscopo. New York: Allworth Press, revised 1995.

Photographer's Market. Cincinnati: Writer's Digest Books, revised annually.

Plugging In: A Resource Guide for Media Artists. Media Alliance, WNET/Thirteen, 356 W. 58th Street, New York, NY 10019, 1996. Includes information on media service groups in New York State, equipment access, funding, national festivals, and distributors.

Poor Dancer's Almanac: Managing Life and Work in the Performing Arts, edited by David R. White, Lise Friedman, and Tia Tibbits Levenson. National Network for Artist Placement, 935 West Avenue 37, Los Angeles, CA 90065, revised regularly.

Profitable Crafts Marketing: A Complete Guide to Successful Selling by Brian T. Jefferson. Madrona Publishers, P.O. Box 22667, Seattle, WA 98122, 1986.

The Secret Life of Money: How Money Can Be Food for the Soul by Tad Crawford. New York: Allworth Press, revised 1996.

Self-Management Workbook for Visual Artists. Canadian Artists' Representation Ontario (CARO), 440-40L Richmond Street West, Toronto, Ontario M5V 3A8, Canada, 1993. Contains various CARO publications including *CARO Fact Sheets, Copyright for Visual Artists, Artist/Dealer Checklist, Artist/Exhibition Contract, Preparing for Your Tax Return, Guidelines for Professional Standards in the Organization of Juried Exhibitions,* and the *CARFAC Recommended Minimum Exhibition Fee Schedule.* Published in English and French.

The Selling of Art by Zella Jackson. The Consultant Press/The Photographic Arts Center, Limited, 163 Amsterdam Avenue, New York, NY 10023, 1992.

The Selling of Art with a Higher Mind: No More Art Sharks by Barbara Scott. Inchor, 2021 California Avenue, #5, Santa Monica, CA 90433, 1990. Discusses the application of spiritual principles and values to selling art.

The Sourcebook for Collectors & Galleries. THE GUILD, 931 East Main Street, #106, Madison, WI 53703-2955; State Street, Madison, WI 53703. A resource directory that contains the names, addresses, phone numbers, and photographs of the work of American fine-arts and craft artists, as well as biographical information. Distributed free of charge to attendees of the American Society of Interior Designers' and the American Institute of Architects' national conferences. Also distributed free of charge to art consultants. Published annually.

Success Now! For Artists: The Fine Arts Monthly Guide to Success and Independence. Manhattan Arts International, 200 East 72nd Street, Suite 26-L, New York, NY 10021.

Supporting Yourself as an Artist: A Practical Guide by Deborah A. Hoover. New York: Oxford University Press, revised 1989.

Survival Skills. Visual Artists Ontario, 439 Wellington Street West, 2nd Floor, Toronto, Ontario M5V 1E7, Canada, 1994. A synopsis of Artists' Business Seminars. Includes information on marketing, portfolio presentations, and other career-related material.

The Whole Work Catalog: Options for More Rewarding Work. The New Careers Center, P.O. Box 339, Boulder, CO 80306, regularly updated. Describes career-related books on a variety of topics, including career planning and working from home.

"Zero Gravity: Diary of a Travelling Artist" by Elizabeth Bram. Available from Elizabeth Bram, 4 Prospect Street, Baldwin, NY 11510, 1995. A detailed account of the adventures and impressions of an American artist, who, through her own initiatives, organized a traveling exhibition of her work in Europe, Canada, and the United States.

Charts, Audiotapes, and Videotapes

Art Charts by Sue Viders. Color Q, Inc., The Art Education Division, 2710 Dryden Road, Dayton, OH 45439, 1992. Ten charts with hundreds of promotional ideas for marketing artwork.

Artistry: The Business of Art. Craven Home Videos, P.O. Box 4012, Hollywood, CA 90078. An eleven-part series on various topics including art law, art galleries,

artist's agents, the art critic, art in public places, fine-art printing, art marketing, framing/shipping, art publishing, the graphic artist, and cartooning. Available as a complete set or individually.

Perfect Portfolio. Visual Arts Ontario, 439 Wellington Street West, 2nd Floor, Toronto M5V 1E7, Canada, 1995. Five art professionals discuss the fundamentals of portfolio presentation. Also covers the subjects of artists' expectations and geographic isolation.

Six Steps to Success, narrated by Sue Viders and Steve Doherty. Color Q, Inc., The Art Education Division, 2710 Dryden Road, Dayton, OH 45439, 1995. One-hour audiotape about marketing art. Accompanied with a printed outline.

Organizations

Caroll Michels, career coach and artist's advocate, 19 Springwood Lane, East Hampton, NY 11937-1169. Author of *How to Survive and Prosper as an Artist.* Assists artists throughout the United States and abroad with career development through phone and in-person consultations. Also offers resource lists.

Career Transition for Dancers, 1727 Broadway, 2nd Floor, New York, NY 10019-5284.

National Network for Artist Placement, 935 West Avenue 37, Los Angeles, CA 90065. Nonprofit organization dedicated to bringing career counseling, employment services, and survival skills to visual and performing artists.

Resources and Counseling for the Arts, 308 Prince Street, St. Paul, MN 55101-1437. Runs ongoing workshops related to artist career management and provides other services.

Visual Artist Information Hotline. (800) 232-2789. A toll-free information service for visual artists sponsored by the New York Foundation for the Arts. Provides visual artists nationwide with information on various career-related topics, including grants, art law, health insurance, emergency funding, health and safety issues, etc. The hotline staff is available between 2 P.M. and 5 P.M., Monday through Friday.

Also see "International Connections," "The Internet," "Organizing Paperwork," "Periodicals," and "Press Relations and Publicity."

COMPETITIONS AND JURIED EXHIBITIONS
Publications

Art Calendar. P.O. Box 199, Upper Fairmount, MD 21867-0199. Includes a comprehensive listing of juried exhibitions and competitions. Published eleven times a year.

The Business of Being an Artist by Daniel Grant. New York: Allworth Press, revised 1996. See book's index entry, "Jurying Art Shows."

Guidebook for Competitions and Commissions. Visual Arts Ontario, 439 Wellington Street West, Toronto, Ontario M5V 1E7, Canada, 1991.

Guidelines for Professional Standards in the Organization of Juried Exhibitions. CARO/CARFAC, revised 1988. Available from Canadian Artists' Representation Ontario, 440-40L Richmond Street West, Toronto, Ontario M5V 3A8, Canada.

Juried Art Exhibitions: Ethical Guidelines and Practical Applications. Chicago Artists' Coalition, 11 East Hubbard Street, 7th Floor, Chicago, IL 60611, 1995.

Options. Pardus, Inc., 28 Moya Loop, Santa Fe, NM 87505. A straightforward monthly newsletter that lists opportunities for artists, including exhibitions and competitions. Each issue contains seventy-five to one hundred listings. Published monthly.

Recommended Guidelines for Juried Exhibitions. National Artists Equity Association, P.O. Box 28068, Central Station, Washington, DC 20038, 1991.

Also see "Public Art."

CORPORATE ART
Publications

The Architect's Sourcebook. THE GUILD, 931 East Main Street, #106, Madison, WI 53703-2955. A resource directory that contains the names, addresses, phone numbers, and photographs of the work of American fine-arts and craft artists, as well as biographical information. Distributed free of charge to attendees of the American Society of Interior Designers' and the American Institute of Architects' national conferences. Also distributed free of charge to art consultants. Published annually.

Art in America Annual Guide to Galleries, Museums, Artists. Published annually. See "Corporate Consultants" in index.

Art Consultants List by Caroll Michels. Available from Caroll Michels, 19 Springwood Lane, East Hampton, NY 11937-1169, updated several times a year. An annotated list of art consultants and art advisors. Includes names, addresses, telephone and fax numbers, and information about art disciplines and markets of interest.

Art Marketing Sourcebook. ArtNetwork, P.O. Box 1268, Penn Valley, CA 95946, updated every two years. Contains the names and addresses of art consultants.

Art Representatives, Consultants & Dealers. Chicago Artists' Coalition, 11 East Hubbard Street, 7th Floor, Chicago, IL 60611, regularly updated. List of artists' agents, art consultants, and gallery dealers.

Business Art News. 19 Old Kings Highway South, Darien, CT 06820. Lists the names of corporations that have purchased art and commissioned art projects. Each listing also includes the name of the artist; if applicable, the name of the art consultant or advisor involved; and a short project description. Published monthly.

The Business of Art, edited by Lee Caplin. Englewood Cliffs, N.J.: Prentice-Hall, revised 1989. See "Art Advisory Services—The Age of the Art Advisor" by Jeffrey Deitch and "Art Collections in Corporations" by Mary Lanier.

Corporate Art Consulting by Susan Abbott. New York: Allworth Press, revised 1996. Although written for those who want to enter or expand the art-consulting business, it provides advice and tips for artists interested in corporate sales.

The Designer's Sourcebook. THE GUILD, 931 East Main Street, #106, Madison, WI 53703-2955. A resource directory that contains the names, addresses, phone numbers, and photographs of the work of American fine-arts and craft artists, as well as biographical information. Distributed free of charge to attendees of the American Society of Interior Designers' and the American Institute of Architects' national conferences. Also distributed free of charge to art consultants. Published annually.

The Dodge Report. McGraw-Hill, 1221 Avenue of the Americas, New York, NY 10020, revised on a regular basis. Computerized printouts of construction projects.

International Directory of Corporate Art Collections. Published by *ARTnews* and the International Art Alliance, revised on a regular basis. Available from the International Art Alliance, P.O. Box 1608, Largo, FL 34649. Lists hundreds of corporate art collections throughout the United States and abroad, with addresses, key personnel, and description of interests.

Profile. American Institute of Architects, 1735 New York Avenue, NW, Washington, DC 20006, revised biannually.

The Sourcebook for Collectors & Galleries. THE GUILD, 931 East Main Street, #106, Madison, WI 53703-2955; State Street, Madison, WI 53703. A resource directory that contains the names, addresses, phone numbers, and photographs of the work of American fine-arts and craft artists, as well as biographical information. Distributed free of charge to attendees of the American Society of Interior Designers' and the American Institute of Architects' national conferences. Also distributed free of charge to art consultants. Published annually.

Computer Software

International Directory of Corporate Art Collections. Published by *ARTnews* and the International Art Alliance, revised on a regular basis. Available from the International Art Alliance, P.O. Box 1608, Largo, FL 34649. A listing of hundreds of corporate art collections throughout the United States and abroad, with addresses, key personnel, and description of interests. Available in two 3½-inch diskettes in DOS or Windows.

Organizations

American Institute of Architects, 1735 New York Avenue, NW, Washington, DC 20006.
American Society of Interior Designers, 1430 Broadway, New York, NY 10018.

Also see "Interior Design and Architecture."

DISABLED ARTISTS
Publications

Art Information Update. Resources for Artists with Disabilities, 77 Seventh Avenue, Suite #PhH, New York, NY 10011-6644. A free newsletter that lists exhibitions, grants, professional opportunities, reviews, publications, and slide registries. Feature articles are also included.

Expressions. Serendipity Press, P.O. Box 16294, St. Paul, MN 55116-0294. A magazine compiled by disabled persons. Includes feature articles on disabled artists. Published twice yearly.

Resources for Illinois Artists Overcoming Disabilities by William Harroff. Chicago Artists' Coalition, 11 East Hubbard Street, 7th Floor, Chicago, IL 60611, regularly updated.

Audiotapes

Crafts Report. Jewish Guild for the Blind, Cassette Library, 15 West 65th Street, New York, NY 10023. A newsletter in cassette form. Published monthly.

Organizations

Artists Unlimited, 158 Thompson Street, Seattle, WA 98109.

Arts Carousel/Arts with the Handicapped Foundation, 1262 Don Mills Road, Toronto, Ontario M5S 2S8, Canada.

Association of Handicapped Artists, 5150 Broadway, Depew, NY 14043. Information clearinghouse for artists who paint with their mouths or feet. Conducts workshops and organizes exhibitions.

Deaf Artists of America, 302 North Goodman, Suite 205, Rochester, NY 14607-1149. Nonprofit arts service organization for deaf artists.

Disabled Artists' Network, P.O. Box 20781, New York, NY 10025. Support group for disabled professional visual artists. Publishes a newsletter.

National Endowment for the Arts, Office for Accessibility, 1100 Pennsylvania Avenue, NW, Washington, DC 20506.

National Exhibits by Blind Artists, Associated Services, 919 Walnut Street, Philadelphia, PA 19107.

National Institute of Art and Disabilities, 551 23rd Street, Richmond, CA 94804.

Resources for Artists with Disabilities, 77 Seventh Avenue, Suite PhH, New York, NY 10011-6644. Promotes public awareness of professional visual artists with physical disabilities. Sponsors exhibitions and a slide registry and publishes a newsletter.

Very Special Arts, 1300 Connecticut Avenue, Suite 700, Washington, DC 20036. Sponsors several programs, including the Very Special Arts Institute, in which artists with disabilities are selected as Yamagata Fellows, the fellowship program named in honor of Hiro Yamagata, to exchange information and exhibit work.

EMPLOYMENT OPPORTUNITIES
Publications

Artists with Class. Cultural Conspiracy, Inc., 66 Jenkins Road, Burnt Hills, NY 12027. A newsletter devoted to artists involved in Arts in Education and other arts-residency teaching programs. Published quarterly.

Artjob. Western States Arts Federation, 1453 Champa Street, Suite 220, Denver, CO 80202. Biweekly newsletter listing available employment in visual and performing arts, literature, education, and arts administration.

ArtSearch. Theatre Communications Group, 355 Lexington Avenue, New York, NY 10017. Published biweekly, this is a national employment-service bulletin for people in the performing arts and performing artists that lists jobs in arts and arts-related education, production, and management.

Artwork: Opportunities in Arts Administration. Resources and Counseling for the Arts, 308 Prince Street, Suite 270, St. Paul, MN 55101-1437, 1993.

AVISO. American Association of Museums, 1575 I Street, NW, Washington, DC 20005. Lists museum-related positions. Published monthly.

CAA Careers. College Art Association, 275 7th Avenue, New York, NY 10001. A newsletter that lists jobs in higher education and museums, including international listings. Published six times a year.

Careers by Design: A Headhunter's Secrets for Success and Survival in Graphic Design by Roz Goldfarb. New York: Allworth Press and the American Council for the Arts, 1993.

Careers in Museums: A Variety of Vocations. Resource report, available from the American Association of Museums, 1575 I Street, NW, Washington, DC 20005, 1994.

Careers in the Visual Arts. National Art Education Association, 1916 Association Drive, Reston, VA 22091-1590, 1993.

Current Jobs in Art. Plymouth Publishing, P.O. Box 40550, 5136 MacArthur Boulevard, NW, Washington, DC 20016. A national listing of employment opportunities for new and early career art graduates. Published monthly.

Finding a Job in Elementary and Secondary Art Education. National Art Education Association, 1916 Association Drive, Reston, VA 22091-1590, 1985. Covers each step of the job-hunting process, including interviewing, preparing a résumé, arranging a portfolio, and getting certified.

Finding a Job in Higher Education in Art Education. National Art Education Association, 1916 Association Drive, Reston, VA 22091-1590, 1986. Leads the reader through the methods of job search in higher education. Also discusses how to prepare for interviews.

The Fine Artist's Guide to Marketing and Self-Promotion by Julius Vitali. New York: Allworth Press, 1996. Provides good background information about teaching-residency opportunities in the arts. See the chapter "Artists-in-Education."

Guide to Arts Administration Training and Research 1995-97, edited by Dan J. Martin. San Francisco: Association of Arts Administration Educators, revised 1995. Available from Americans for the Arts, 1000 Vermont Avenue, NW, 12th Floor, Washington,

DC 20005. Describes graduate degree programs in arts management in the United States and abroad.

How to Develop and Promote Successful Seminars and Workshops: The Definitive Guide to Creating and Marketing Seminars, Workshops, Classes, and Conferences by Howard L. Shenson. New York: John Wiley and Sons, Inc., 1990.

Jobs in Arts and Media Management: What They Are and How to Get One by Stephen Langley and James Abruzzo. New York: American Council for the Arts, revised 1990. Available from Americans for the Arts, 1000 Vermont Avenue, NW, 12th Floor, Washington, DC 20005.

Museum Jobs from A-Z: What They Are, How to Prepare, and Where to Find Them by G. W. Bates. Switzerland, Fla.: Batax Museum Publishing, 1994. Available from the American Association of Museums, 1575 I Street, NW, Washington, DC 20005. Describes over sixty museum positions. Includes information about education, training and experience, personal characteristics, where to find jobs, and opportunities for employment and promotion.

The National Resource Guide for the Placement of Artists, edited by Cheryl Slean. National Network for Artist Placement, 935 West Avenue 37, Los Angeles, CA 90065, revised regularly. Lists arts organizations that provide support to artists, including national job banks.

The Off-The-Beaten-Path Job Book: You Can Make a Living and Have a Life! by Sandra Gurvis. New York: Citadel Press, 1995.

Part-Time Careers: For Anyone Who Wants More than Just a Job—But Less than a 40-Hour Week! by Joyce Hadley. Hawthorne, NJ: Career Press, 1993.

Teaching as a Career. National Art Education Association, 1916 Association Drive, Reston, VA 22091-1590, undated.

What Color Is Your Parachute? A Practical Manual for Job Hunters and Career Changers by Richard Nelson Bolles. Berkeley, Calif.: Ten Speed Press, revised regularly.

The Whole Work Catalog: Options for Rewarding Work. The New Careers Center, P.O. Box 339, Boulder, CO 80306, regularly updated. Describes career-related books on a variety of topics, including alternative careers and new work options.

Work With Passion: How To Do What You Love for a Living by Nancy Anderson. Copublished New York: Carroll & Graf Publishers, Inc., and Mill Valley, Calif.: Whatever Publishing, Inc., revised 1987.

Organizations

Arts-in-Education Program, Education Access Division, National Endowment for the Arts, 1100 Pennsylvania Avenue, NW, Washington, DC 20506.

Chicago Artists' Coalition, Job Referral Service, 11 East Hubbard Street, 7th Floor, Chicago, IL 60611. A computerized employment service offered free of charge to Chicago Artists' Coalition members.

Hospital Audiences, Inc., 220 West 42nd Street, New York, NY 10036.

National Guild of Community Schools of the Arts, P.O. Box 8018, Englewood, NJ

07631. Membership organization that provides employment referrals to members in visual-arts education.

National Network for Artist Placement, 935 West Avenue 37, Los Angeles, CA 90065. Nonprofit organization dedicated to bringing career counseling, employment services, and survival skills to visual and performing artists.

The On-Call Faculty Program, Inc., 3655 Darbyshire Drive, Hillard, OH 43026-2534. Arranges guest appearances for academics and professionals at colleges and universities. Also arranges for affiliates to teach short or semester courses.

Prison Arts Project, William James Association, 303 Potrero, #12B, Santa Cruz, CA 95060. Open to visual and performing artists interested in conducting workshops in California correctional facilities.

Also see "Apprentices and Interns," "Art Colonies and Artist-in-Residence Programs," and "The Internet."

ESTATE PLANNING
Publications

Estate Planning for Artists by Ruth Waters, Marcee Yager, and Paul Barulich. Women's Caucus for Art, 1992. Available from Ruth J. Waters, 1870 Ralston Avenue, Belmont, CA 94002.

Estate Planning Reference Pamphlet: Future Safe, The Present Is the Future. The Alliance for the Arts, 330 West 42nd Street, Suite 1702, New York, NY 10036, 1992.

Estate Planning for Visual Artists by Liz Wylie. Canadian Artists' Representation Ontario (CARO), 440-40L Richmond Street West, Toronto, Ontario M5V 3A8, Canada, 1994. Advises artists on how to plan their estates and prepare a will.

Legal Guide for the Visual Artist by Tad Crawford. Allworth Press, 10 East 23rd Street, Suite 400, New York, NY 10010, revised 1995. See chapter "The Artist's Estate."

Report: The Estate Project for Artists with AIDS. Alliance for the Arts, 330 West 42nd Street, Suite 1701, New York, NY 10036, 1992.

Organizations

Alliance for the Arts, 330 West 42nd Street, Suite 1701, New York, NY 10036. Sponsors the Estate Project for Artists with AIDS.

Art in Perpetuity, 324 Bowery, New York, NY 10012. Places artwork from artists' estates.

Artist Legacy Project, Volunteers Lawyers for the Arts, 1 East 53rd Street, New York, NY 10022. Provides free and specialized estate planning and related legal services to artists.

Leslie-Lohman Gay Art Foundation, 127 Prince Street, New York, NY 10012. Represents estates of lesbian and gay artists.

New York City Health and Hospitals Corporation, Public Art Program, City Hall, 3rd
Floor, New York, NY 10007. Acquires art for hospitals from artists' estates.

EXHIBITION, PERFORMANCE PLACES AND SPACES
Publications

Access: A Guide to the Visual Arts in Washington State, edited by Claudia Bach. Allied
Arts of Seattle, 105 South Main, Suite 201, Seattle, WA 98104, 1989. Lists com-
mercial galleries, college and university galleries, nonprofit and alternative
spaces, and museums. Also includes percent-for-art agencies.

American Craft Guide to Craft Galleries and Shops USA. American Craft Council, 72
Spring Street, New York, NY 10012, revised regularly.

Art in America Annual Guide to Galleries, Museums, Artists. *Art in America*, 575 Broad-
way, New York, NY 10012. Alphabetical listing of American museums, galleries,
private dealers, and alternative spaces arranged by state and city. Each entry in-
cludes the address, phone number, business hours, names of key staff members,
a short description of type of art shown, and artists represented. Published
annually each August.

Art Marketing Sourcebook. ArtNetwork, P.O. Box 1268, Penn Valley, CA 95946, regu-
larly revised. Contains more than two thousand listings of galleries, art consul-
tants, and art publishers.

Art Now Gallery Guide. P.O. Box 5541, Clifton, NJ 08809-0401. A national publica-
tion with up-to-date information on exhibitions in galleries and museums. Spe-
cial geographic editions are also available for New York City, Boston/New
England, Philadelphia, the Southwest, Chicago/Midwest, the Southeast, Cali-
fornia, Europe, and Latin America. Published eleven times a year.

The Artist's and Graphic Designer's Market. Cincinnati: Writer's Digest Books, revised
annually.

Artists' Gallery Guide for Chicago and the Illinois Region. Chicago Artists' Coalition, 11
East Hubbard Street, 7th Floor, Chicago, IL 60611, revised 1996. A comprehen-
sive and well-organized guide to commercial and alternative galleries, muse-
ums, university galleries, and arts organizations in Chicago, north central and
south central Illinois, southeast Wisconsin, St. Louis, and northwest Indiana.

The Artists' Guide to Philadelphia by Amy Orr. The Artists' Guide, P.O. Box 8755,
Philadelphia, PA 19101, revised 1990.

Commercial Galley Issue. Visual Arts Ontario. 439 Wellington Street West, 2nd Floor,
Toronto, Ontario M5V 1E7, Canada, revised regularly. A comprehensive listing
of all commercial galleries in Ontario. Includes pointers about approaching a
gallery and contracts.

Exhibit: Basic Guide to Gallery and Exhibition Spaces in Minnesota by the Minnesota
State Arts Board and Resources and Counseling for the Arts, 1994. Available
from Resources and Counseling for the Arts, 308 Prince Street, Suite 270, St.
Paul, MN 55101-1437.

Guide to Traveling Exhibition Organizers, edited by Shirley Reiff Howarth. Largo, Fla.:

The Humanities Exchange, Inc., 1992. Available from the American Association of Museums, 1575 I Street, NW, Washington, DC 20005. Lists more than eighty organizations that offer traveling exhibitions to museums, art centers, libraries, and other spaces.

Information for Artists. Canadian Artists' Representation Ontario (CARO), 440-40L Richmond Street West, Toronto, Ontario M5V 3A8, Canada, revised 1990. Lists a variety of alternative venues for exhibition and sale of work.

International Directory of the Arts. New Providence, N.J.: K. G. Saur, revised biennially. Two-volume guide to museums, universities, associations, dealers, galleries, publishers, and others involved in the arts in Europe, the United States, Canada, South America, Asia, and Australia.

Manitoba Visual Artists Index. CARFAC Manitoba, 221-100 Arthur Street, Winnipeg, Manitoba R3B 1H3, Canada, 1992. Includes a list of exhibition spaces in Manitoba.

National Association of Artists' Organizations Directory. National Association of Artists' Organizations, 918 F Street, NW, Washington, DC 20004, revised 1997. Describes alternative spaces and arts service organizations. Each entry includes a description of programs, disciplines, exhibition and/or performance spaces, proposal procedures, and the name of the contact person.

The National Resource Guide for the Placement of Artists, edited by Cheryl Slean. National Network for Artist Placement, 935 West Avenue 37, Los Angeles, CA 90065, revised regularly. An annotated guide to arts organizations, including those that provide exhibition and performing space.

Organizing Artists, edited by Lane Relyea. National Association of Artists' Organizations, 918 F Street NW, Washington, DC 20004, 1990. A critical examination of the evolution of artists' organizations and the artist-space movement, tracing the history of artist activism in the United States from 1905 to 1990.

New York Contemporary Art Galleries: The Complete Annual Guide by Renée Phillips. Manhattan Arts International, 200 East 72nd Street, Suite 26L, New York, NY 10021, revised 1997. Lists commercial art galleries and alternative spaces in New York City. Provides names, addresses, phone numbers, and contact persons. Also provides background information, when available, on each gallery, including the selection process, philosophy, and demographic profiles of gallery artists.

The Photograph Collector's Resource Directory, edited by Peter Hastings Falk. The Consultant Press/The Photographic Arts Center, Limited, 163 Amsterdam Avenue, New York, NY 10023, revised 1992. More than seventeen hundred listings of galleries, museums, and dealers in the United States, Canada, and Europe.

The Photographer's Complete Guide to Exhibitions and Sales Spaces by Peter Hastings Falk. The Consultant Press/The Photographic Arts Center, Limited, 163 Amsterdam Avenue, New York, NY 10023, revised 1992.

Photographer's Market. Cincinnati: Writer's Digest Books, revised annually.

Photography in New York International. Photography New York, Inc., 64 West 89th Street, New York, NY 10024. A comprehensive guide to photography galleries in New York City. Also includes national and international listings. Published bimonthly.

The Visual Arts Handbook. Visual Arts Ontario, 439 Wellington Street West, 2nd Floor, Toronto, Ontario M5V 1E7, Canada, revised 1991. A comprehensive guide to resources for artists, including galleries and exhibition space.

Organizations

Exhibits U.S.A., MidAmerica Arts Alliance, Suite 700, 912 Baltimore Avenue, Kansas City, MO 64105. Organizes an exhibits that travel to small and midsized museums, university galleries, and community art centers throughout the United States. Also provides various exhibition-related services.

Also see "International Connections."

EXHIBITION AND PERFORMANCE PLANNING
Publications

The Art of Showing Art by James K. Reeve. Tulsa, Okla.: Council Oak Books, revised 1992. Available from the American Association of Museums, 1575 I Street, NW, Washington, DC 20005. Includes guidelines for protecting and displaying paintings, sculpture, and photographs, and information on display concepts, storage, records, and appraisals.

Art on the Move: A Directory of Fine Art Shippers, Packers and Warehouses. Gallery Association of New York, P.O. Box 345, Hamilton, NY 13346-0346, 1988.

The Artist's Guide to Successfully Exhibiting at Convention Shows and Other Fine Art Fairs, Art Calendar, P.O. Box 199, Upper Fairmount, MD 21867, 1997.

CARFAC Recommended Minimum Exhibition Fee Schedule. CARFAC, B1-100 Gloucester Street, Ottawa, Ontario K2P 0A4, Canada, revised annually. A bilingual official exhibition-fee schedule outlining the amounts of money that visual artists receive in Canada.

Good Show! A Practical Guide for Temporary Exhibitions by Lothar P. Witteborg. Smithsonian Institution Traveling Exhibition Service, Washington, D.C., revised 1991. Available from the American Association of Museums, 1575 I Street, NW, Washington, DC 20005. An excellent how-to manual for developing temporary exhibitions.

On Your Own. Visual Arts Ontario, 439 Wellington Street West, 2nd Floor, Toronto M5V 1E7, Canada, 1995. A step-by-step analysis of how to mount your own exhibition. Includes sample budgets, time-lines, sample press releases, and other information.

Performing on Tour: How to Take Your Show on the Road by Rena Shagan. New York: American Council for the Arts, 1994. Available from Americans for the Arts, 1000 Vermont Avenue, NW, 12th Floor, Washington, DC 20005. A complete manual for planning and executing out-of-town engagements for soloists and companies in all the performing arts.

Presenting Performances, by Thomas Wolf. New York: American Council for the Arts in cooperation with Association of Performing Arts Presenters, revised 1991. Available from Americans for the Arts, 1000 Vermont Avenue, NW, 12th Floor, Washington, DC 20005. Covers the topics of acquiring space, handling promotion, dealing with unions, and dependable technical assistance.

Way to Go: Crating Artwork for Travel by Stephen A. Horne. Gallery Association of New York, Box 345, Hamilton, NY 13346-0345, 1985. Provides information on how to crate two- and three-dimensional work.

Videos

On Your Own. Visual Arts Ontario, 439 Wellington Street West, 2nd Floor, Toronto M5V 1E7, Canada, 1995. Artists share experiences and offer practical advice on how to mount your own exhibition.

Also see "Artwork Care and Maintenance."

GALLERY RELATIONS
Publications

An Art Calendar Guide: Choosing a Gallery . . . Or Getting a Gallery to Choose You. Art Calendar, P.O. Box 199, Upper Fairmount, MD 21867-0199, 1997.

The Artist's Survival Manual: A Complete Guide to Marketing Your Work by Toby Judith Klayman, with Cobbett Steinberg. New York: Charles Scribner's Sons, revised 1987. See "Preparing to Negotiate with Dealers" and "Questions to Ask Your Gallery."

The Business of Art, edited by Lee Caplin. Englewood Cliffs, N.J.: Prentice-Hall, revised 1989. See "Selling Under Contract" by Tennyson Schad and "The Integrity of the Artist, Dealer, and Gallery" by Tibor de Nagy.

"Inside the Art Scene: Dealing with Art World Attitude and Power Tactics" by Shannon Wilkinson. *Art Calendar*, P.O. Box 199, Upper Fairmount, MD 21867-0199, October 1996.

The Right of Public Presentation: A Guide to Exhibition Rights. Canadian Conference of the Arts, 189 Laurier Avenue East, Ottawa, Ontario K1N 6P1, Canada, 1990. Includes an overview of exhibition rights guidelines, sample forms and contracts, and a list of options for typical situations.

GENERAL ARTS REFERENCES
Publications

American Art Directory. New Providence, N.J.: R. R. Bowker. Published triennially. A directory of arts organizations, art schools, museums, periodicals, scholarships, and fellowships.

International Directory of the Arts. New Providence, N.J.: K. G. Saur, revised bienni-
ally. Two-volume guide to museums, universities, associations, dealers, gal-
leries, publishers, and others involved in the arts in Europe, the United States,
Canada, South America, Asia, and Australia.

Museums of the World. New Providence, N.J.: K. G. Saur, revised regularly. Provides
information about more than 24,000 museums throughout the world. Orga-
nized by country and city.

Official Museum Directory. New Providence, N.J.: R. R. Bowker, in cooperation with
the American Association of Museums, regularly revised. Profiles more than
7,300 museums and institutions.

GRANTS AND FUNDING RESOURCES
Publications

ArtNetwork Yellow Pages. ArtNetwork, P.O. Box 1268, Penn Valley, CA 95946, 1995.
A resource directory that includes artist's residencies and grants.

An Artist's Resource Book by Jennifer Parker. Go Far Press, 9333 Kirkside Road, Los
Angeles, CA 90035, revised 1997. Describes over three hundred national and
international grants, awards, fellowships, residency programs, and facilities for
visual artists.

The Business of Art, edited by Lee Caplin. Englewood Cliffs, N.J.: Prentice-Hall, re-
vised 1989. See "Financial Resources for Artists."

Directory of Computer and High Technology Grants by Richard M. Eckstein, publisher.
Available from Research Grant Guides, P.O. Box 1214, Loxahatchee, FL 33470-
1214, regularly revised. Lists more than six hundred funding sources.

Directory of Financial Aids for Women. Reference Service Press, 1100 Industrial Road,
Suite 9, San Carlos, CA 94070, updated regularly. Identifies twelve hundred
scholarships, fellowships, grants, awards, loans, and internships, designed pri-
marily or exclusively for women.

Directory of Grants in the Humanities. The Onyx Press, 4041 North Central, Suite 700,
Phoenix, AZ 85012-3397, revised regularly. More than four thousand listings of
grants for humanities or art projects.

The Fine Artist's Guide to Marketing and Self-Promotion by Julius Vitali. New York: All-
worth Press, 1996. Includes information on how to find corporate support,
grants, and other funding.

Foundation Grants to Individuals. The Foundation Center, 79 Fifth Avenue, New
York, NY 10003, revised regularly. Lists scholarships, educational loans, fel-
lowships, residencies, internships, awards, and prizes available to individuals
from private foundations. Also includes information on how to approach
foundations.

Funding for Artists. Chicago Artists' Coalition, 11 East Hubbard Street, 7th Floor,
Chicago, IL 60611, revised regularly. A list of funding resources for artists.

Fundraising: The Artist's Guide to Planning and Financing Work, edited by Susan Jones.
AN Publications, P.O. Box 23, Sunderland SR4 6DG, England, 1994.

Getting Funded: A Complete Guide to Proposal Writing by Mary Stewart Hall. Continuing Education Publications, Portland State University, P.O. Box 1491, Portland, OR 97207, regularly revised.

Getting the Word Out: An Artist's Guide to Self Promotion, edited by Carolyn Blakeslee. Art Calendar Publishing, Inc., P.O. Box 199, Upper Fairmount, MD 21867-0199, 1995. See "Competing for Grants Effectively."

Grant Proposals That Have Succeeded by Virginia White. Plenum Press, 233 Spring Street, New York, NY 10012, 1983.

Grants: Basic Guide to Grants for Minnesota Artists by the Minnesota State Arts Board and Resources and Counseling for the Arts, 1996. Available from Resources and Counseling for the Arts, 308 Prince Street, Suite 270, St. Paul, MN 55101-1437.

Grants and Awards Available to American Writers. PEN American Center, 568 Broadway, New York, NY 10012, revised 1996. Lists American and international grant programs for writers. Includes deadlines, guidelines, and summaries of application procedures.

Grants to Artists. Ottawa: The Canada Council, revised every two years. Available from CARFAC, B1-100 Gloucester Street, Ottawa, Ontario K2P 0A4, Canada.

Guide to Canadian Arts Grants. Toronto: Canada Grants Service, 1993. Available from Canadian Artists' Representation Ontario (CARO), 440-40L Richmond Street West, Toronto, Ontario M5V 3A8, Canada. Lists more than six hundred art-granting programs and awards throughout Canada for artists in every discipline.

Money for Film and Video Artists: A Comprehensive Resource Guide, researched by Douglas Oxenhorn. New York: American Council for the Arts, revised 1993. Available from Americans for the Arts, 1000 Vermont Avenue, NW, 12th Floor, Washington, DC 20005. Provides information on fellowships, grants, awards, low-cost facilities, emergency assistance programs, and technical-assistance and support services.

Money for Performing Artists, edited by Suzanne Niemeyer. New York: American Council for the Arts, 1991. Available from Americans for the Arts, 1000 Vermont Avenue, NW, 12th Floor, Washington, DC 20005. Primarily for musicians, choreographers, dancers, actors, and writers and composers working in the performing arts field. Lists awards, grants, fellowships, competitions, auditions, workshops, and artists' colonies, and emergency and technical-assistance programs.

Money for Visual Artists, researched by Douglas Oxenhorn. New York: Allworth Press and American Council for the Arts, revised 1993. Includes grants, fellowships, awards, artist colonies, emergency and technical assistance, and support services.

Money to Work: Grants for Visual Artists. Art Resources International, 5813 Nevada Avenue, NW, Washington, DC 20015, revised 1992. Provides information on fellowships and grants for visual artists working in the United States.

National Endowment for the Arts: A New Look. Communications Office, The National Endowment for the Arts, 1100 Pennsylvania Avenue, NW, Washington, DC 20506, revised regularly. A guide to programs of the National Endowment for the Arts.

The National Guide to Funding in Arts and Culture. The Foundation Center, 79 Fifth

Avenue, New York, NY 10003, 1996. Lists thousands of grants for arts and cultural programs from independent, corporate, and community foundations.

The National Resource Guide for the Placement of Artists, edited by Cheryl Slean. National Network for Artist Placement, 935 West Avenue 37, Los Angeles, CA 90065, revised regularly. Lists arts organizations including those providing funding, that provide support to artists.

Shaking the Money Tree: How to Get Grants and Donations for Film & Video by Morris Warshawski. Michael Wiese Productions, 4354 Laurel Canyon Boulevard, Suite 234, Studio City, CA 91604, 1994.

Standard & Poor's Rating Guide. New York: Standard & Poor's Corporation, revised annually.

Supporting Yourself as an Artist by Deborah A. Hoover. New York: Oxford University Press, revised 1989.

Organizations

Associated Grantmakers of Massachusetts, 294 Washington Street, #840, Boston, MA 02108. Offers services and resources for fund-raising.

The Foundation Center, 79 Fifth Avenue, New York, NY 10003. A national service organization that provides information on foundation funding. Services include disseminating information on foundations and publishing reference books on foundations and foundation grants.

The Foundation Center, 50 Hurtz Plaza, #150, Atlanta, GA 03030-2914.

The Foundation Center, Kent H. Smith Library, 1442 Hanna Building, 1422 Euclid Avenue, Cleveland, OH 44115.

The Foundation Center, 312 Sutter Street, San Francisco, CA 94108.

The Foundation Center, 1001 Connecticut Avenue, NW, Suite 938, Washington, DC 20036.

The Grantsmanship Center, P.O. Box 17220, Los Angeles, CA 90017.

National Endowment for the Arts, 1100 Pennsylvania Avenue, NW, Washington, DC 20506.

National Endowment for the Humanities, 1100 Pennsylvania Avenue, NW, Washington, DC 20506.

Also see "Art Colonies and Artist-in-Residence Programs," "International Connections," and "The Internet."

HEALTH HAZARDS
Publications

Acrylic Polymer Emulsion Paint Data File. The Ralph Mayer Center for Artists' Techniques, 303 Old College, University of Delaware, Newark, DE 19716.

ACTS Facts. 181 Thompson Street, #23, New York, NY 10012-2586. A newsletter that focuses on health hazards for artists, published by the organization Arts, Crafts and Theater Safety. Published monthly.

Art Hazards News. Center for Safety in the Arts, P.O. Box 310, New York, NY 10023. Published quarterly.

Artist Beware: The Hazards in Working with All Art and Craft Materials and the Precautions Every Artist and Photographer Should Take by Michael McCann. Lyons and Burford, 31 West 21st Street, New York, NY 10010, revised 1992.

The Artist's Complete Health and Safety Guide by Monona Rossol. New York: Allworth Press, revised 1994. A guide to using potentially toxic materials safely and ethically. Designed to help artists and teachers comply with applicable health and safety laws, including American and Canadian right-to-know laws and the U.S. Art Materials Labeling Act.

The Artist's Resource Handbook by Daniel Grant. New York: Allworth Press, 1994. See chapter "Health and Safety in the Arts."

Health Hazards for Photographers by Siegfried and Wolfgang Rempel. Lyons and Burford, 31 West 21st Street, New York, NY 10010, 1992. A reference guide to the safe use of all chemicals used in black-and-white and color photography.

Health Hazards Manual for Artists by Michael McCann. Lyons and Burford, 31 West 21st Street, New York, NY 10010, revised 1994. Details harmful effects caused by art materials and outlines procedures that can make working with these materials safer.

Overexposure: Health Hazards in Photography by Susan D. Shaw and Monona Rossol. New York: Allworth Press, revised 1991.

Pigment Data File. The Ralph Mayer Center for Artists' Techniques, 303 Old College, University of Delaware, Newark, DE 19716.

The Safer Arts. Health and Welfare Canada, 1988. Available from CARFAC, B1-100 Gloucester Street, Ottawa, Ontario K2P 0A4, Canada. Includes major hazards in the arts and crafts field in the home or studio.

Studio Safety Checklist by P. Durr. CARFAC, B1-100 Gloucester Street, Ottawa, Ontario K2P 0A4, Canada, 1985. Contains a checklist on health hazards, information notes, and safety rules and an extensive list of additional resources.

Ventilation: A Practical Guide by Nancy Clark, Thomas Cutter, and Jean-Ann McGrane. Lyons and Burford, 31 West 21st Street, New York, NY 10010, 1988. Presents methods of properly ventilating a workshop or studio.

Organizations

Artists Health Project, The Artists Foundation, 8 Park Plaza, Boston, MA 02116. A program that informs artists about hazardous art materials and alternatives for safe use.

Arts and Crafts Materials Institute, Inc., 100 Boylston Street, Boston, MA 02116. Certifies 90 percent of all art materials sold in the United States. Provides information on hazardous art products and publishes a newsletter.

Arts, Crafts and Theater Safety (ACTS), 181 Thompson Street, #23, New York, NY 10012-2586. A not-for-profit organization that provides health and safety services to the arts on a national and international basis. Provides copies of educational

and technical materials and refers callers to doctors, health services, and other resources. Publishes the newsletter *ACTS Facts*.

Center for Safety in the Arts, P.O. Box 310, New York, NY 10023. Publishes the newsletter *Art Hazards News*. The center's extensive resource library is housed at the School of Health Sciences, Hunter College, 425 E. 25th Street, New York, NY 10010.

International Arts-Medicine Association, 3600 Market Street, Philadelphia, PA 19104.

INSURANCE AND MEDICAL PLANS
Publications

ArtistHelp: The Artist's Guide to Work-Related Human and Social Services, compiled by the Research Center for Arts and Culture, Columbia University. Neal-Schuman Publishers, 23 Leonard Street, New York, NY 10013, 1990. Identifies agencies offering health and human services to artists; provides addresses, phone numbers, names of contacts, and cost information.

The Business of Art edited by Lee Caplin. Englewood Cliffs, N.J.: Prentice-Hall, revised 1989. See "Insuring Artwork and the Artist" by Huntington T. Block.

Caring for Your Art by Jill Snyder. New York: Allworth Press, revised 1996. Provides information on insuring art in the studio, home, or gallery; while in transit; and when on display.

Health Insurance: A Guide for Artists, Consultants, Entrepreneurs, and Other Self-Employed by Leonore Janecek. New York: Allworth Press and the American Council for the Arts, 1993. Available from Americans for the Arts, 1000 Vermont Avenue, NW, Washington, DC 20005, 1993. Explains how to select and use insurance plans; discusses health-insurance options, including short-term insurance, and dental, disability, and life insurance.

Insurance by Hamish Buchanan. Canadian Artists' Representation Ontario (CARO), 440-40L Richmond Street West, Toronto, Ontario M5V 3A8, Canada, 1985. A basic introduction to insurance for artists, including studio and artwork insurance, with examples of rates.

Organizations

American Craft Association, 21 South Eltings Corner Road, Highland, NY 12528. Offers group health, dental, and life insurance to members. Also offers property and casualty insurance that covers artwork, studio, tools, work at other sites, and work in transit. Membership organization open to craft artists throughout the United States.

American Federation of Musicians, 1501 Broadway, Suite 600, New York, NY 10036. Offers health insurance to members.

American Institute of Graphic Arts, 164 Fifth Avenue, New York, NY 10010. Offers group health insurance to members.

American Print Alliance, 302 Larkspur Turn, Peachtree City, GA 30269. Offers fine-art insurance.

American Society of Artists, P.O. Box 1326, Palatine, IL 60078. Offers comprehensive medical and dental plans and life insurance to members.

Artist Trust, 1402 Third Avenue, Suite 404, Seattle, WA 98101.

Artists Talk on Art, P.O. Box 1149, New York, NY 10013-0866. Offers health insurance to members.

Association and Society Insurance, P.O. Box 2510, Rockville, MD 20852-0510. Offers Craftsman Protection Plan, an "all risk" fine-art studio coverage.

Association of Independent Video and Filmmakers, 304 Hudson Street, 6th Floor, New York, NY 10013. Offers members health insurance and production and liability insurance.

Boston Visual Artists Union, P.O. Box 399, Newtonville, MA 02160. Offers health insurance to members.

Chicago Artists' Coalition, 11 East Hubbard Street, 7th Floor, Chicago, IL 60611. Membership organization that offers studio insurance and group medical insurance to artists living in Arizona, Iowa, Illinois, Indiana, Minnesota, Missouri, and Wisconsin.

College Art Association of America, 275 Seventh Avenue, New York, NY 10001. Offers members group health insurance, disability, liability, and life insurance.

Connell Howe Insurors, Inc., P.O. Box 1840, Branson, MO 65616. Offers a crafter package policy that covers general liability, products and completed operations liability, fire liability, medical payments, and the value of contents while work is on display.

Co-op America, 1612 K Street, NW, Suite 600, Washington, DC 20006. Membership organization open to self-employed individuals. Offers health insurance to members.

Cultural Alliance of Greater Washington, 410 8th Street, NW, Suite 600, Washington, DC 20004. Offers members health and dental insurance.

Deaf Artists of America, Inc., 302 North Goodman Street, Suite #205, Rochester, NY 14607-1149. Offers members a health insurance plan.

Empire State Crafts Alliance, 320 Montgomery Street, Syracuse, NY 13202.

Flather Perkins Inc., 888 17th Street, NW, Suite #508, Washington, DC 20006. Insures fine art and crafts on premises, in transit, and in shows.

Graphic Artists Guild, 90 John Street, Suite 903, New York, NY 10038-3202. Offers members basic hospital and medical benefits, major medical, term life, and disability-income insurance. Also offers artwork insurance.

Huntington T. Block, 1120 20th Street, NW, Washington, DC 20036. Offers individual artists studio insurance and a business-package insurance.

International Sculpture Center, 1050 17th Street, NW, Suite 250, Washington, DC 20036. Offers members group health insurance and "all risk" fine-art studio coverage and coverage while work is in transit.

Lenore Janecek and Associates, Ltd., 4433 West Touhy Avenue, Suite 405, Chicago, IL 60646. Insures visual and performing artists and writers in the Chicago area.

Specialized insurance services include health, life, dental, disability, and retirement programs.

National Artists Equity Association, P.O. Box 28068, Central Station, Washington, DC 20038. Offers group health and fine-art insurance to members.

National Association of Fine Artists, P.O. Box 4189, Fort Lauderdale, FL 33338. Offers health, life, disability, and dental insurance to members. Also offers "all risk" studio insurance.

National Small Business United, 1156 15th Street, NW, Suite 1100, Washington, DC 20005.

National Association for the Self-Employed, P.O. Box 6120667, Dallas, TX 75261-9968.

National Sculpture Society, 1177 Avenue of the Americas, New York, NY 10036. Offers major medical, dental, and disability insurance to members.

National Writers Union, 113 University Place, 6th Floor, New York, NY 10003.

New York Artists Equity Association, Inc., 498 Broome Street, New York, NY 10013. Offers group health insurance to members.

PEN American Center, 568 Broadway, New York, NY 10012. Offers medical insurance at group rates to members.

Society of Illustrators, 128 East 63rd Street, New York, NY 10021. Offers disability, health, and accidental-death insurance to members.

Small Business Service Bureau, P.O. Box 15014, Worcester, MA 01615-0014. Membership organization open to self-employed individuals. Offers health insurance to members.

Support Services Alliance, P.O. Box 130, Schoharie, NY 12157. Membership organization open to self-employed individuals. Offers health insurance to members.

Texas Fine Arts Association, 3809-B West 35th Street, Austin, TX 78703. Medical and dental insurance are offered to members.

Trinder & Norwood Inc., 106 Corporate Park Drive, White Plains, NY 10604-3301. Offers a fine-arts insurance program covering art while it is being created, while it is in transit, or while it is on exhibition.

Women's Caucus for Art, P.O. Box 2646, New York, NY 10009. Membership organization open to women and men who are artists, and others involved in the visual-arts field. Offers health, life, and disability insurance to members. Also offers fine-arts insurance.

Also see "Pension Plans."

INTERIOR DESIGN AND ARCHITECTURE
Publications

Architectural Digest, 6300 Wilshire Boulevard, Suite 1100, Los Angeles, CA 90036.

Architectural Record, 1221 Avenue of the Americas, New York, NY 10020.

Architecturereach (formerly *Progressive Architecture*), 400 Main Street, Suite 202, Stamford, CT 06901.

Better Homes and Gardens, 1716 Locust Street, Des Moines, IA 50309-3023.

Canadian Architect, Southam Business Information, 1450 Don Mills Road, Don Mills, Ontario M3D 2X7, Canada.

Contract Design, 1515 Broadway, New York, NY 10036.

Decor, 330 North 4th Street, St. Louis, MO 63102-2729.

Elle Decor, 1633 Broadway, New York, NY 10019.

The Architect's Sourcebook. THE GUILD, 931 East Main Street, #106, Madison, WI 53703-2955. A resource directory that contains the names, addresses, phone numbers, and photographs of the work of American fine-arts and craft artists, as well as biographical information. Distributed free of charge to attendees of the American Society of Interior Designers' and the American Institute of Architects' national conferences. Also distributed free of charge to art consultants. Published annually.

The Designer's Sourcebook. THE GUILD, 931 East Main Street, #106, Madison, WI 53703-2955. A resource directory that contains the names, addresses, phone numbers, and photographs of the work of American fine-arts and craft artists, as well as biographical information. Distributed free of charge to attendees of the American Society of Interior Designers' and the American Institute of Architects' national conferences. Also distributed free of charge to art consultants. Published annually.

House and Garden, 342 Madison Avenue, New York, NY 10017.

House Beautiful, 1700 Broadway, 37th Floor, New York, NY 10019.

Interior Design, 245 West 17th Street, New York, NY 10011.

Interiors, 1 Astor Plaza, New York, NY 10036.

Landscape Architecture, 4401 Connecticut Avenue, NW, 5th Floor, Washington, DC 20008.

Marie Claire, 250 W. 55th Street, New York, NY 10019-0599.

Metropolis, 177 East 87th Street, New York, NY 10128.

Metropolitan Home, 1633 Broadway, New York, NY 10019.

The Sourcebook for Collectors & Galleries. THE GUILD, 931 East Main Street, #106, Madison, WI 53703-2955; State Street, Madison, WI 53703. A resource directory that contains the names, address, phone numbers, and photographs of the work of American fine-arts and craft artists, as well as biographical information. Distributed free of charge to attendees of the American Society of Interior Designers' and the American Institute of Architects' national conferences. Also distributed free of charge to art consultants. Published annually.

Southern Accents, 2100 Lakeshore Drive, Birmingham, AL 35209-6721.

Sunset, 80 Willow road, Menlo Park, CA 94025.

Organizations

American Institute of Architects, 1735 New York Avenue, NW, Washington, DC 20006.

American Society of Interior Designers, 1430 Broadway, New York, NY 10018.

Also see "Corporate Art."

INTERNATIONAL CONNECTIONS
Publications

Across Europe: The Artist's Personal Guide to Travel and Work, edited by David Butler. AN Publications, Freepost, P.O. Box 23, Sunderland SR4 6DG, England, 1992. Provides information on over twenty European countries, with information on organizations, funding, magazines, and agencies.

Across the Street Around the World: A Handbook for Cultural Exchange by Jennifer Williams. London: British American Arts Association, 1996. Available from Arts International, Institute of International Education, 809 United Nations Plaza, New York, NY 10017. A handbook for those starting out in the field of cultural exchange. Chapters include information on planning, fund-raising, and international contacts.

Art & Auction International Directory. Art & Auction, 440 Park Avenue South, New York, NY 10016, published annually. Includes the names, addresses, and phone numbers of art galleries in Europe, Canada, and the United States.

Art Diary: The World's Art Directory. Milan, Italy: Giancarlo Politi Editore, published annually. Available c/o Flash Art, 799 Broadway, New York, NY 10003 and in many bookstores that specialize in arts-related publications. Covers Europe, South America, the United States, and Japan and lists artists, galleries, museums, critics, organizations, agencies, and magazines.

Artists Communities by the Alliance of Artists Communities. New York: Allworth Press, 1996. A complete guide to residency opportunities in the United States for visual and performing artists and writers. Features a special section that lists artists' communities, art agencies, and key contacts that support international artist exchanges.

Artists Newsletter. AN Publications, P.O. Box 23, Sunderland SR4 6DG, England. Comprehensive listings of awards, commissions, open exhibitions, residencies, competitions, and other opportunities for artists in the United Kingdom. Published monthly.

Artworld Europe. International Art Alliance, P.O. Box 1608, Largo, FL 34649. Bimonthly newsletter regarding art- and gallery-related news in Europe.

Asia Pacific Arts Directory. London: Visiting Arts in association with UNESCO, 1996. Available from Visiting Arts, 11 Portland Place, London W1N 4EJ, England. A three-volume guide to the arts in the Asia Pacific region. Each country is accorded its own chapter, which includes an introduction with general background information. The directory also lists cultural agencies, arts venues, and resource centers.

Cultural Organizations in Southeast Asia by Jennifer Lindsay. Sydney: Australia Council, 1994. Available from Arts International, Institute of International Education, 809 United Nations Plaza, New York, NY 10017. A guide for artists, performers, and cultural workers interested in Southeast Asia that describes cultural programs in Vietnam, the Philippines, Thailand, Malaysia, Singapore, Brunei, and Indonesia.

Directory of Exhibition Spaces, edited by Janet Ross. AN Publications, P.O. Box 23, Sunderland SR4 6DG, England, regularly revised. A comprehensive listing of

over 2,100 galleries in the United Kingdom and Ireland. Includes such information as when and how to apply, the type of work shown, space, facilities, and gallery commissions.

Directory of Sources for International Traveling Exhibitions. Washington, DC.: International Council of Museums, regularly revised. Available from International Art Alliance, P.O. Box 1608, Largo, FL 34649. Lists more than two hundred organizations in thirty-five countries that organize traveling exhibitions. Each entry includes name, address, name of contact person, and telephone number.

Exhibiting and Selling Abroad by Judith Staines. AN Publications, P.O. Box 23, Sunderland SR4 6DG, England, 1995. Provides information for artists in the United Kingdom who wish to establish international connections. Includes information on commissions, competitions, exporting work, insurance, and pricing.

Financial Aid for Research, Study, Travel and Other Activities Abroad by Gail A. Schlachter and R. David Weber. Reference Service Press, 1100 Industrial Road, Suite 9, San Carlos, CA 94070, updated regularly. Each financial-aid program listing includes the program, title, name of sponsoring organization, address, phone number, purpose, eligibility, amount of financial support, duration, special features, limitations, number of awards, and deadline dates.

The Guide Art Press: Modern and Contemporary Art in Europe by Paul Ardenne and Ami Barak. Editions Art Press, 8 rue François Villon, Paris 75015, France, 1994. A bilingual guide in English and in French that describes one thousand museums, art centers, and foundations throughout Europe.

Guide de La Presse Beaux-Arts by Etienne Caveyrac. Editions Sermadiras, 11 rue Arsène-Houssaye, Paris 75008, France, 1984. Lists names and addresses of newspapers and magazines in France.

Guide of Host Facilities for Artists on Short-Term Stay in the World. Arts International, Institute of International Education, 809 United Nations Plaza, New York, NY 10017, 1995. This bilingual guide, written in English and in French, presents information on short-term residencies throughout the world that are available to visual and performing artists and writers.

Guide to Funding for International and Foreign Programs. The Foundation Center, 79 Fifth Avenue, New York, NY 10003, 1996. Designed to help those seeking grants from U.S. corporations and foundations for international and foreign projects. Contains over 622 grantmakers.

Independent Photography Directory, edited by Michael Hallett and Barry Lane. AN Publications, Freepost, P.O. Box 23, Sunderland SR1 1BR, England, regularly revised. Lists over 250 organizations in the United Kingdom and the services they provide of interest to independent photographers.

International Directory of Corporate Art Collections. New York: ARTnews. Published in cooperation with the International Art Alliance. Updated on a regular basis. Available from the International Arts Alliance, P.O. Box 1608, Largo, FL 34649, and ARTnews, 48 West 38th Street, New York, NY 10018. Contains information on hundreds of corporate art collections, including those in Japan and in Europe. Also available on diskettes in DOS and Windows.

International Directory of Resources for Artisans. The Crafts Center, 1001 Connecticut Avenue, NW, Washington, DC 20036, revised biennially. Includes the names and addresses of arts organizations, guilds, agencies, foundations, schools, and suppliers arranged by region of the world.

International Directory of the Arts. New Providence, NJ: K. G. Saur, revised biennially. Two-volume guide to museums, universities, associations, dealers, galleries, publishers, and others involved in the arts in Europe, the United States, Canada, South America, Asia, and Australia.

Investigating Galleries by Debbie Duffin. AN Publications, P.O. Box 23, Sunderland SR4 6DG, England, 1995. Includes information and strategies to improve an artist's chance of exhibiting in the United Kingdom and minimize the risk of rejection. Covers approaching galleries, presenting work, sales commissions, promotion, and documentation.

Money for International Exchange in the Arts by Jane Gullong, Noreen Tomassi, and Anna Rubin. New York: American Council for the Arts, published in cooperation with Arts International, 1992. Available from Arts International, Institute for International Education, 809 United Nations Plaza, New York, NY 10017. Includes information on grants, fellowships, and awards for travel and work abroad; support and technical assistance for touring and international exchange; international artists' residencies; and programs that support artists' professional development.

Money Matters: The Artist's Financial Guide by Richard Murphy, Sarah Deeks, and Sally Nolan. AN Publications, P.O. Box 23, Sunderland SR4 6DG, England, updated 1995. A guide for self-employed artists working in the United Kingdom. Covers pricing work, working abroad, dealing with grants and sponsorships, and keeping records.

More Bread and Circuses: Who Does What for the Arts in Europe. London: Informal European Theater Meeting and the Arts Council of England, London, 1994. Available from Arts International, Institute of International Education, 809 United Nations Plaza, New York, NY 10017. Describes special programs and funding opportunities available from the European Commission, the Council of Europe, UNESCO, and European foundations and corporations.

Organizing Your Exhibition by Debbie Duffin. AN Publications, P.O. Box 23, Sunderland SR4 6DG, England, 1994. A guide to preparing an exhibition in the United Kingdom. Includes information on locating exhibition space, budgets, promotion, insurance, transportation, and selling.

Performing Arts Yearbook for Europe, edited by Rod Fisher and Martin Huber. London: Arts Publishing International Limited, revised 1994. Available from Americans for the Arts, 1000 Vermont Avenue, NW, 12th Floor, Washington, DC 20005. Lists more than fourteen thousand organizations in fifty countries, including ministries of culture, funding agencies, national organizations, networks, resource centers, arts center, promoters, agents, festivals, and publications.

Selling by Judith Staines. AN Publications, P.O. Box 23, Sunderland SR4 6DG, En-

gland, 1995. Examines the ins and outs of selling artwork in the United Kingdom; covers marketing, prices, commissions, legal issues, and contracts.

The Visual Arts Handbook. Visual Arts Ontario, 329 Wellington Street West, Toronto, Ontario M5V 1E7, Canada, revised 1991. A comprehensive guide to resources for artists; lists artists' associations, galleries, exhibition spaces, art colonies, and funding sources.

World Crafts Council Directory/Europe. World Crafts Council, Secretariat, Rheinstrasse 23, D-60325 Frankfurt am Main, Germany, published annually. Covers twenty-five countries with information on and addresses of government agencies concerned with crafts, institutions, schools, galleries, craft events, trade fairs and publications.

"Zero Gravity: Diary of a Travelling Artist" by Elizabeth Bram. Available from Elizabeth Bram, 4 Prospect Street, Baldwin, NY 11510, 1995. A detailed account of the adventures and impressions of an American artist who took the initiative to explore exhibition opportunities abroad and in the United States and Canada.

Software

International Directory of Corporate Art Collections. New York: ARTnews. Published in cooperation with the International Art Alliance. Updated on a regular basis. Available from the International Art Alliance, P.O. Box 1608, Largo, FL 34649, and ARTnews, 48 West 38th Street, New York, NY 10018. Contains information on hundreds of corporate art collections, including those in Japan and in Europe. Also available on diskettes in DOS and Windows.

Organizations

American Academy in Rome, 7 East 60th Street, New York, NY 10021.

American Council on Germany, 14 East 60th Street, New York, NY 10022. Awards professional fellowships annually to promising young Germans and Americans in a wide variety of fields, including the arts.

The American Scandinavian Foundation, 725 Park Avenue, New York, NY 10021. Awards fellowships and grants to professionals and scholars born in the United States or Scandinavian countries, including those in the creative and performing arts.

AN Publications, P.O. Box 23, Sunderland SR4 6DG, England. A valuable resource of information for artists interested in establishing contacts in the United Kingdom and in Europe. Offers information services and publications, many of which are described in the "Publications" section of "International Connections."

ArtNetwork, P.O. Box 1268, Penn Valley, CA 95946. Sells a mailing list of foreign galleries.

Arts Exchange, Massachusetts Cultural Council, 120 Boylston Street, Boston, MA 02116. Funds international tours, exhibitions, and residencies.

Arts International, Institute of International Education, 809 United Nations Plaza, New York, NY 10017. Operates exchange and fellowships programs for individual artists and arts managers; arranges conferences on international cultural exchange; and publishes information on international arts activities, ranging from discussions of critical issues to practical data on touring and sources of support.

Bellagio Study Center, Rockefeller Foundation, 420 Fifth Avenue, New York, NY 10018.

German Academic Exchange Office (DAAD), Artists in Berlin Program, 950 Third Avenue, 19th Floor, New York, NY 10022. Selects young sculptors, painters, writers, composers, and filmmakers to spend twelve months in Berlin as artists-in-residence.

Partners of the Americas, 1424 K Street, NW, Washington, DC 20005. Arranges cultural-exchange programs between the United States, Latin America, and Caribbean nations, including residencies and exhibitions.

Res Artis, The International Association of Residential Art Centres and Networks, Kunstlerhaus Bethanien, Mariannenplatz 2, 10997 Berlin, Germany.

Also see "General Arts References," "Grants and Funding Resources," "Law," and "Public Art."

THE INTERNET
Publications

Arts and the Internet: A Guide to the Revolution by V. A. Shiva. New York: Allworth Press, 1996. A guide to opportunities on the Internet for artists and arts organizations. Explores avenues for selling, exhibiting, promoting, and creating artwork in cyberspace. Covers a wide variety of subjects, from virtual art openings to legal issues.

The Business of Being an Artist by Daniel Grant. New York: Allworth Press, revised 1996. See "Selling Art Through Descriptions and Photographs."

"Draw Collectors into Your (World Wide) Web" by Tamra Heathershaw-Hart, *The Crafts Report*, October 1995.

The HTML Sourcebook by Ian Graham. Somerset, NJ: John Wiley & Sons, Inc., revised 1996. For anyone who wants to learn HyperText Markup Language (HTML) or to understand how the Internet works. HTML is used to create Web pages, and to get photos or slides of your work scanned into the computer.

The Internet Publicity Guide: How to Maximize Your Marketing and Promotion in Cyberspace by V. A. Shiva. New York: Allworth Press, 1997.

The Internet Research Guide: A Concise, Friendly, and Practical Handbook for Anyone Researching in the Wide World of Cyberspace by Timothy K. Maloy. New York: Allworth Press, 1996.

Internet World. Box 713, Mount Morris, IL 61054. Monthly publication.

The Internet Yellow Pages by Harley Hahn and Rich Stout. Berkeley, Cal.: Osborne/ McGraw-Hill, revised 1996.

The Net. Imagine Publishing Inc., 150 North Hill Drive, Brisbane, CA 94105. Published monthly.

NetGuide. CMP Media, Inc., 600 Community Drive, Manhasset, NY 11030. Published monthly.

The Photographer's Internet Handbook by Joe Farace. New York: Allworth Press, 1997.

Zen and the Art of the Internet: Parents' and Educators' Guide by Brendan P. Kehoe. Englewood Cliffs, N.J.: Prentice-Hall, revised 1996.

Web Sites

American Craft Association (http://www.ftgi.com), 21 South Eltings Corner Road, Highland, NY 12528. Part of ArtResources' "StudioVisits" Web site. Features artwork and information about individual craft artists.

Art in Context (http://www.artincontext.com), P.O. Box 336, New York, NY 10003. A nonprofit resource for fine-art research. Provides a free venue for patrons and scholars to locate and discover information about fine art. Open to artists, museums, galleries and dealers. There are no on-line fees, but if artwork is selected, a processing fee is charged.

Art Odyssey (http://www.artodyssey.com), BizNexus, 8 West 3rd Street, Suite 400, Winston-Salem, NC 27101. On-line service for galleries throughout the United States.

Art Xpo (www.artxpo.com), P.O. Box 8245, Emeryville, CA 94662. Registry-type gallery Web site open to individual artists.

Artists OnLine (http://www.onlineart.com), 4322 North Beltline Road, Suite B-207, Irving, TX 75038. Registry-type gallery Web site open to individual artists.

The Arts Deadline List (http://custwww.xensei.com/adl/). A monthly digest of competitions, grants, fellowships, jobs, internships, and other career-related opportunities.

Arts Edge (http://artsedge.kennedycenter.org/sc/fn-index.html). An alphabetical list of artist-in-education grant opportunities.

ArtFBI (http://www.tmn.com/Community/jgates/artfbi.html). Web site for Artists for a Better Image (ArtFBI), a nonprofit organization founded to study stereotypes of artists in the media.

ArtNet (http://www.artnet.com), ArtNet Worldwide, 145 East 57th Street, New York, NY 10022. Registry-type gallery Web site open to individual artists.

ArtNetWeb (http://www.awa.com), VRE, Inc., 426 Broome Street, New York, NY 10013. Registry-type gallery Web site open to individual artists.

ArtQuest Direct Listing Service (http://www.artquest.com), P.O. Box 50291, St. Louis, MO 63105. Registry-type gallery Web site open to individual artists.

arts.community (http://arts.endow.gov/). A monthly Web site magazine sponsored by the National Endowment for the Arts.

Artscope (http://www.artscope.com). A Web site for commercial galleries.

ArtsNet (http://artsnet.heinz.cmu.edu/DevelopmentResources/). Provides information on funding resources, including a database to inquire about awards made by state arts councils.

Artsource (http://www/uky.edu/Artsource/general.html). A directory of art-related Web sites.

Artsource (http://arth.concordia.ca/AHRC/). A directory of art- and art-history-related Web sites sponsored by Concordia University.

Arts Wire (http://www/artswire.org/). One of the first art-related Web sites, initiated by the New York Foundation for the Arts. Open to individual subscribers for a monthly fee. Provides information on grant deadlines and employment opportunities. The Artists' Conference section is for the exchange of ideas and information.

Barter.Net (http://www.bigyellow.com). A Web site that provides a listing of bartering networks.

Contemporary Art Site (http://www.tractor.com). Web sites for galleries in the United States and in Europe. Also offers images and information on selected artists.

Council on Foundations (http://www.cof.org/). Maintains an alphabetical list of foundations.

CultureNet (http://www.ffa.ucalgary.ca/). A Canadian culture guide and forum.

Directory of Grantmakers on the Internet (http://fdncenter.org/grantmaker/contents.html). Sponsored by the Foundation Center.

Internet ArtResources (http://artresources.com), Sound Data, Inc., 2601 Elliott Avenue, Suite 3148, Seattle, WA 98121. Maintains six Web locations devoted to specific segments of the arts community.

National Arts Guide (http:www.national-arts guide.co.uk/uk/hk/home.html). First comprehensive guide to the art galleries of Britain. Contains information on 680 galleries.

National Endowment for the Arts. (http://arts.endow.gov/NEAText/Guide/Contents_ Guide.html). An on-line version of the National Endowment for the Arts' program guidelines. Also includes the answers to frequently asked questions about the endowment.

OnLine Gallery (http://www.OnLineGallery.com), Internet Marketing Corporation, P.O. Box 280, Chalfont, PA 18914-0280. Registry-type gallery Web site open to individual artists.

Scottish Sculpture Workshop (://www/ssynth/co/uk/grampian/ssw/). Includes a list of sculpture contacts and sculpture organizations in the United Kingdom and the Republic of Ireland.

Small Business Association (http://www.sbaonline.sba.gov). Offers information about its programs and tips for starting a business.

Very Special Arts (http://www/vsarts.org.) An international organization that sponsors many arts-related programs for people with disabilities. Also sponsors the Very Special Arts Institute in which artists with disabilities are selected as Yamagata Fellows to exchange information and exhibit work.

World Arts: A Guide to International Exchange (http://arts.endow.gov/Resource/WorldArts/Contents.html). Sponsored by the International Partnership Office

nership Office of the National Endowment for the Arts. A comprehensive guide to international arts-exchange programs.

LAW

Publications

Art, Artifact & Architecture Law by Jessica L. Darraby. Clark Boardman Callaghan, 155 Pfingsten Road, Deerfield, IL 60015-4998, 1995. Discusses policies and laws concerning the creation, display, production, distribution, and preservation of visual arts.

The Art Business Encyclopedia by Leonard D. DuBoff. New York: Allworth Press and the American Council for the Arts, revised 1994. Explains the most significant legal and business terms from national and international art worlds. Also includes discussions on the innovative use of computers and related technology, artist-gallery relationships, artists' rights, national and international law affecting art, and new developments in art consumer protection.

The Art Law Primer by Linda F. Pinkerton and John T. Guardalabene. Lyons and Burford, 31 West 21st Street, New York, NY 10010, 1988. Briefs visual artists on the major legal issues that affect their work and business. Includes sections on copyrights, contracts, leases, and artist/dealer relationships.

Art Law: Rights and Liabilities of Creators and Collectors by Franklin Feldman and Stephen E. Weil. Boston: Little, Brown and Company, 1988.

The Artist in Business: Basic Business Practices by Craig Dreesen. Arts Extension Service, Division of Continuing Education, University of Massachusetts, Amherst, MA 01003, 1988. Includes information on legal issues.

ArtistHelp: The Artist's Guide to Work-Related Human and Social Services compiled by the Research Center for Arts and Culture, Columbia University. Neal-Schuman Publishers, 23 Leonard Street, New York, NY 10013, 1990. Identifies agencies offering legal and other services to artists with addresses, phone numbers, names of contacts, and cost information.

Artist-Public Gallery Exhibition Contract. CARFAC, B1-100 Gloucester Street, Ottawa, Ontario K2P 0A4, Canada, 1977. Four-page sample contract for use between visual artists and local, regional, national, and international galleries.

An Artist's Guide to Small Claims Court. Volunteer Lawyers for the Arts, 1 East 53rd Street, 6th Floor, New York, NY 10022-4201, revised 1994. A step-by-step guide for preparing a case in New York City's small claims court.

The Artists' Survival Manual: A Complete Guide to Marketing Your Work by Toby Klayman, with Cobbett Steinberg. New York: Charles Scribner's Sons, revised 1987. See sample contracts in appendix section.

ArtNetwork Yellow Pages, ArtNetwork, P.O. Box 1268, Penn Valley, CA 95946, 1995. A directory of information on arts organizations, including lawyers for the arts.

Business and Legal Forms for Fine Artists by Tad Crawford. New York: Allworth Press, 1990. Includes sample contracts and instructions for a variety of situations, as well as a kit of tear-out contracts.

Business and Legal Forms for Photographers, by Tad Crawford. New York: Allworth Press, 1991. Includes sample contracts and instructions for a variety of situations, as well as a kit of tear-out contracts.

Business Entities for Artists Fact Sheet by Mark Quail. Artists' Legal Advice Services and Canadian Artists' Representation Ontario, 1991. Available from Canadian Artists' Representation Ontario (CARO), 440-40L Richmond Street West, Toronto, Ontario M5V 3A8, Canada. Summarizes information on sole proprietorships and corporations, with tax perspectives, registration, and legal liability.

Canadian Copyright Law by Lesley Ellen Harris. Toronto: McGraw-Hill Ryerson Limited, 1992. Written for visual and performing artists and writers, it includes information on current copyright laws in Canada.

Commission Contracts. AN Publications, P.O. Box 23, Sunderland SR4 6DG, England, 1995. Provides information to artists who are commissioned to do artwork in the United Kingdom. Contract forms are included.

Contracts for Artists. Available from Caroll Michels, 19 Springwood Lane, East Hampton, NY 11937-1169. The following contracts are available individually or as a set: Artist-Agent Agreement, Artist-Gallery Consignment Agreement, Commission Agreement, Artist's Sales Agreement, Artist's Sales Agreement with Installment Provisions, Artist's Reserved Rights Transfer and Sales Agreement, and Artist's Reserved Rights Transfer and Sales Agreement with Installment Provisions.

Copyright Collective Fact Sheet. Ottawa: CARFAC Copyright Collective, Inc., 1993. Available from Canadian Artists' Representation Ontario (CARO), 440-40L Richmond Street West, Toronto, Ontario M5V 3A8, Canada. A bilingual brochure that contains basic copyright information and an outline of activities and benefits of the CARFAC Copyright Collective, Inc.

Copyright for the Canadian Visual Artist by P. Walsh. CARFAC, B1-100 Gloucester Street, Ottawa, Ontario K2P 0A4, Canada, 1981. Contains background information on all aspects of copyright for visual artists.

Copyright Information Kit. Copyright Office, Library of Congress, Washington, DC 20559. When ordering, specify that copyright is for a visual art.

Exhibition Right: Interior Contract and Description. CARFAC and Canadian Artists Representation Ontario, 1988. Available from CARFAC, B1-100 Gloucester Street, Ottawa, Ontario K2P 0A4, Canada. A short description of exhibition rights with a sample bill of sale.

A Guide to Licensing Artwork by Marilyn Moore. Kent Press, P.O. Box 1169, Stamford, CT 06904-1169, 1996.

Illinois Fine Art Consignment Act & Sample Contract. Chicago Artists' Coalition, 11 East Hubbard Street, 7th Floor, Chicago, IL 60611.

Introduction to Contracts. AN Publications, P.O. Box 23, Sunderland SR4 6DG, England, 1995. Provides artists working in the United Kingdom with the ammunition they need to negotiate, deal with disputes, and enter into a contractual agreement. Also includes information on finding an attorney.

Journal of Law and the Arts. A joint publication of the Columbia University School of
Law and Volunteer Lawyers for the Arts. Available from Volunteer Lawyers for
the Arts, 1 East 53rd Street, 6th Floor, New York, NY 10022-4201. Published
quarterly.

The Law (in Plain English) for Craftspeople by Leonard D. DuBoff. Interweave Press,
201 E. 4th Street, Loveland, CO 80537, revised 1993.

The Law (in Plain English) for Photographers by Leonard D. DuBoff. New York: All-
worth Press, revised 1995.

Legal Guide for the Visual Artist by Tad Crawford. New York: Allworth Press, revised
1995. Covers copyright and moral rights; sale of art by artist, gallery, or agent;
sale of reproduction rights, including assignment confirmations, licensing, and
book contracts; taxation, hobby-loss challenges and the IRS; studios and leases;
and estate planning. Model contracts are also included.

Legal-Wise: Self-Help Legal Forms for Everyone by Carl W. Battle. New York: Allworth
Press, 1991. An excellent guide for artists and nonartists. Covers procedures and
forms for solving career-related and noncareer issues, including how to legally
change your name and apply for patents, trademarks, and copyright. It also dis-
cusses real estate agreements, living wills, bankruptcy, and how to handle an
IRS audit.

Licensing Art and Design by Caryn R. Leland. New York: Allworth Press, revised 1995.
A comprehensive and helpful guide to the mechanics of licensing images for use
on apparel, ceramics, posters, stationery, and many other products.

Minimum Artist-Dealer Agreement. National Artist Equity Association, P.O. Box
28068, Washington, DC 20038. Sample contract available to National Artist
Equity members that contains very *basic* terms of an artist–gallery dealer
relationship.

Model Agreements for Visual Artists: A Guide to Contracts in the Visual Arts by Paul
Sanderson. Canadian Artists' Representation Ontario (CARO), 440-40L Rich-
mond Street West, Toronto, Ontario M5V 3A8, Canada, 1982. An introduction
to Canadian art law and professional business practices. Includes twenty-three
model contracts and checklists, each accompanied by a commentary clarifying
particular provisions.

Moral Rights in Copyright by Mark Burnham. Canadian Artists' Representation On-
tario (CARO), 440-40L Richmond Street West, Toronto, Ontario M5V 3A8,
Canada, 1982.

The NAA Public Exhibition Contract. AN Publications, P.O. Box 23, Sunderland SR4
6DG, England, 1995. Commissioned by the National Artists' Association in the
United Kingdom, this contract covers the legal arrangements surrounding the
showing of work in public galleries and exhibition spaces.

The National Resource Guide for the Placement of Artists, edited by Cheryl Slean. Na-
tional Network for Artist Placement, 935 West Avenue 37, Los Angeles, CA
90065, revised regularly. An annotated guide to organizations lending support
to artists, including those offering legal advice.

Public Commissions Contract for Artists. CARFAC, B1-100 Gloucester Street, Ottawa, Ontario K2P 0A4, Canada, 1977. Three-page sample contract for visual artists involved in public commissions with federal, provincial, or municipal governments in Canada.

Retransmission Rights Fact Sheet by Marian Hebb. Canadian Artists' Representation Ontario (CARO), 440-40L Richmond Street West, Toronto, Ontario M5V 3A8, Canada, 1990. Contains information on retransmission royalties, copyright collectives, copyright ownership, and effects of new copyright legislation.

The Rights of Authors, Artists, and Other Creative People. Carbondale, Ill.: Southern Illinois University Press in cooperation with the American Civil Liberties Union, revised 1992. Available from Volunteer Lawyers for the Arts, 1 East 53rd Street, New York, NY 10022-4201. Explains how authors and visual artists can protect themselves and their works under the present law. Discusses contracts between writers and artists and their agents, collaborators, publishers, and galleries.

Selling Contracts. AN Publications, P.O. Box 23, Sunderland SR4 6DG, England, 1995. A contract that covers selling artwork to private buyers and galleries in the United Kingdom.

Trademarks and the Arts by William M. Borchard. New York: Columbia University School of Law, 1989. Includes instructions on obtaining and retaining trademarks, information on protecting artistic elements as trademarks, and advice on shaping merchandising licensing agreements.

The Visual Artist's Business and Legal Guide by Gregory Victoroff. Englewood Cliffs, N.J.: Prentice-Hall, 1995. Available from Volunteer Lawyers for the Arts, 1 East 53rd Street, 6th Floor, New York, NY 10022-4201. Offers business and legal information about such matters as selling, promoting, copyrights, licensing, privacy, art destruction, fraud, fund-raising, and grants. Also includes artists' contracts with comments by lawyers on negotiable clauses.

VLA Guide to Copyright for the Performing Arts. Volunteer Lawyers for the Arts, 1 East 53rd Street, 6th Floor, New York, NY 10022-4201, revised 1993.

VLA Guide to Copyright for Visual Artists. Volunteer Lawyers for the Arts, 1 East 53rd Street, 6th Floor, New York, NY 10022-4201, revised 1989.

VLA Membership Directory. Volunteer Lawyers for the Arts, 1 East 53rd Street, 6th Floor, New York, NY 10022-4201, regularly updated. Lists the names and addresses of New York State lawyers who are members of Volunteer Lawyers for the Arts.

VLA National Directory. Volunteer Lawyers for the Arts, 1 East 53rd Street, 6th Floor, New York, NY 10022-4201, regularly updated. Describes Volunteer Lawyers for the Arts programs throughout the United States and Canada.

Software and Audiotapes

Business and Legal Forms for Fine Artists by Tad Crawford. New York: Allworth Press, 1990. Available on a computer disk.

Business and Legal Forms for Photographers by Tad Crawford. New York: Allworth Press, 1991. Available on a computer disk.

Protecting Your Rights and Increasing Your Income: A Guide for Authors, Graphic Designers, Illustrators, and Photographers by Tad Crawford. New York: Allworth Press, 1991. Audiotape covering the basics of copyright law, how to handle contracts and negotiations, how to transfer limited rights, royalties, cancellation fees, and advances. Aimed at artists who sell reproduction rights and often work on assignment.

National Organizations

Visual Artists and Galleries Association (VAGA), 1 Rockefeller Plaza, Suite 2626, New York, NY 10020. Membership organization that reviews cases and helps artists determine whether they need professional legal assistance; in such instances the organization provides attorney referrals.

Organizations by State

ARIZONA

Lawyers for the Arts, c/o Sam Sutton, Cahill, Sutton and Thomas, 2141 East Highland Avenue, #155, Phoenix, AZ 85016.

CALIFORNIA

Beverly Hills Bar Association, Barristers Committee for the Arts, 300 South Beverly Drive, #201, Beverly Hills, CA 90212. Serves artists in Los Angeles County.

California Lawyers for the Arts, 247 4th Street, Suite 110, Oakland, CA 94607. Serves artists in California. Also handles requests from artists outside of California.

California Lawyers for the Arts, Building C, Room 255, Fort Mason Center, San Francisco, CA 94123. Serves artists in California. Also handles requests from artists outside of California.

California Lawyers for the Arts, 1641 18th Street, Santa Monica, CA 90404. Serves artists in California. Also handles requests from artists outside of California.

San Diego Lawyers for the Arts, 1205 Prospect Street, Suite 400, La Jolla, CA 92037. Serves artists in San Diego County.

COLORADO

Colorado Lawyers for the Arts, 200 Grant Street, Suite 303E, Denver, CO 80203. Serves artists in Colorado.

CONNECTICUT

Connecticut Volunteer Lawyers for the Arts, Connecticut Commission on the Arts, 755 Main Street, Hartford, CT 06103. Serves artists in Connecticut.

DISTRICT OF COLUMBIA

District of Columbia Lawyers Committee for the Arts, Volunteer Lawyers for the Arts, 918 16th Street, NW, Suite 400, Washington, DC 20006. Serves artists in Washington, DC, northern Virginia, and Maryland.

Washington Area Lawyers for the Arts, 410 8th Street, NW, Suite 601, Washington, DC 20004. Serves artists in Washington, DC, northern Virginia, Delaware, and parts of Maryland.

FLORIDA

Volunteer Lawyers for the Arts/Florida, ArtServe, Inc., 1350 East Sunrise Boulevard, Suite 100, Fort Lauderdale, FL 33304. Serves artists in Florida.

GEORGIA

Atlanta Lawyers for the Arts, 152 Nassau Street, Atlanta, GA 30303. Serves artists in Georgia.

Georgia Volunteer Lawyers for the Arts, Bureau of Cultural Affairs, City Hall, East 5th Floor, 675 Ponce de Leon Avenue, NE, Atlanta, GA 30308-1807. Serves artists in Georgia.

ILLINOIS

Lawyers for the Creative Arts, 213 West Institute Place, Suite 411, Chicago, IL 60610-3125. Serves artists in Illinois.

KANSAS

Mid-America Arts Resources (formerly Kansas Register of Volunteers for the Arts), c/o Susan J. Whitfield-Lungren, Esq., P.O. Box 363, Lindsborg, KS 67456. Serves artists in Kansas, Nebraska, and Oklahoma.

KENTUCKY

Lexington Arts and Cultural Council, Artsplace, 161 North Mill Street, Lexington, KY 40507. Serves artists in Lexington-Fayette County.

LOUISIANA

Louisiana Volunteer Lawyers for the Arts, c/o Arts Council of New Orleans, 821 Gravier Street, Suite 600, New Orleans, LA 70112. Serves artists in Louisiana.

MAINE

Maine Volunteer Lawyers and Accountants for the Arts, 43 Pleasant Street, South Portland, ME 04106. Serves artists in Maine.

MARYLAND

Maryland Lawyers for the Arts, 218 West Sarasota, Baltimore, MD 21201. Serves artists in Maryland.

MASSACHUSETTS

Volunteer Lawyers for the Arts of Massachusetts, Office of Cultural Affairs, Boston City Hall, Room 716, Boston, MA 02201. Serves artists in Massachusetts.

MINNESOTA

Resources and Counseling for the Arts, Art Law Referral Service, 308 Prince Street, Suite 270, St. Paul, MN 55101-1437. A joint effort of Resources & Counseling for the Arts and the Art and Entertainment Law Committee of the Minnesota State Bar Association. Serves artists in Minnesota, western Wisconsin, Iowa, North Dakota, and South Dakota.

MISSOURI

Kansas City Attorneys for the Arts, c/o Dale Werz, Marshall Suite 2-310, 500 East 52nd Street, Kansas City, MO 64110.

St. Louis Volunteer Lawyers and Accountants for the Arts, 3540 Washington, St. Louis, MO 63103. Serves artists in Missouri and southwestern Illinois.

MONTANA

Montana Volunteer Lawyers for the Arts, c/o Joan Jonkel, Esq., P.O. Box 8687, Missoula, MT 59807. Serves artists in western Montana.

NEW HAMPSHIRE

Lawyers for the Arts/New Hampshire, New Hampshire Business Committee for the Arts, One Granite Place, Concord, NH 03301. Serves artists in New Hampshire.

NEW YORK

Volunteer Lawyers for the Arts, 1 East 53rd Street, New York, NY 10022-4201. Among its many services, it operates an art law hotline ([212]319-2910) for artists and arts organizations that need quick answers to arts-related legal questions.

Albany/Schenectady League of Arts, Inc., 19 Clinton Avenue, Albany, NY 12207. Serves artists in the counties of Albany, Columbia, Fulton, Greene, Montgomery, Rensselaer, Saratoga, Schenectady, Schoharie, Warren, and Washington.

NORTH CAROLINA

North Carolina Volunteer Lawyers for the Arts, Inc., P.O. Box 26513, Raleigh, NC 27611-6513. Serves artists in North Carolina.

OHIO

Volunteer Lawyers and Accountants for the Arts Program, c/o Cleveland Bar Association, 113 St. Clair Avenue NE, Cleveland, OH 44114-1253.

Toledo Volunteer Lawyers for the Arts, Suite 1523, 608 Madison Avenue, Suite 1523, Toledo, OH 43604. Serves artists in northwest Ohio.

OREGON

Northwest Lawyers and Artists, Inc., Suite 330, 520 SW Yamhill Avenue, Portland, OR 97204. Serves artists in Oregon and southwest Washington.

PENNSYLVANIA

Philadelphia Volunteer Lawyers for the Arts, 251 South 18th Street, Philadelphia, PA 19103. Serves artists in Pennsylvania, Delaware, and New Jersey.

RHODE ISLAND

Ocean State Lawyers for the Arts, P.O. Box 19, Saunderstown, RI 02874. Serves artists in Rhode Island and southeastern New England.

SOUTH DAKOTA

South Dakota Arts Council, 800 Governors Drive, Pierre, SD 57501. Serves artists in South Dakota.

South Dakota Arts Council, 230 South Philips Avenue, Suite 204, Sioux Falls, SD 57102. Serves artists in South Dakota.

TENNESSEE

Tennessee Arts Commission, 404 James Robertson Parkway, Suite 160, Nashville, TN 37243-0780.

TEXAS

Artists Legal and Accounting Assistance/Austin, P.O. Box 2577, Austin, TX 78768. Serves artists in Austin and neighboring counties.

Texas Accountants and Lawyers for the Arts/Dallas, 2917 Swiss Avenue, Dallas, TX 75240. Serves artists in northern Texas.

Texas Accountants and Lawyers for the Arts, 1540 Sul Ross, Houston, TX 77006. Serves artists in Texas.

UTAH

Utah Lawyers for the Arts, Suite 1600, P.O. Box 652, Salt Lake City, UT 84110-0652. Serves artists in Utah.

Canadian Organizations

Artists Legal Advice Services, 183 Bath Street, 1st Floor, Toronto, Ontario M5T 2R7, Canada. Serves artists in Ontario.

Artists Legal Advice Services, Canadian Artists' Representation Ontario (CARO), B1-100 Gloucester Street, Ottawa, Ontario K2P 0A4, Canada. Serves artists in Ontario.

CARFAC Copyright Collective, Canadian Artists' Representation Ontario (CARO), B1-100 Gloucester Street, Ottawa, Ontario K2P 0A4, Canada. Represents artists in the administration and protection of copyrights and exhibition fees.

APPENDIX OF RESOURCES
267

MAILING LISTS
Organizations

Art in America, 575 Broadway, New York, NY 10012. Makes available on disk the
names and addresses of all entries listed in the *Art in America Annual Guide to Gal-
leries, Museums, Artists,* including museums, galleries, private dealers, art consul-
tants, university galleries, and publishers.

ArtNetwork, P.O. Box 1268, Penn Valley, CA 95946. Offers arts-related mailing lists
that include the addresses of art publications, corporations that collect art, art
critics, architects, galleries, and arts organizations.

Arts Extension Service, Division of Continuing Education, University of Massachu-
setts, Goddell Building, Amherst, MA 01003. Provides mailing lists that include
the names and addresses of individual artists, by discipline, in visual and per-
forming arts, and of arts councils, craft organizations, lawyers, and other profes-
sions who serve the arts.

Arts Information Exchange, Mid Atlantic Arts Foundation, 11 East Chase Street,
#2A, Baltimore, MD 21202. Sells computerized lists of arts-related organizations
and individuals in the mid-Atlantic region.

Best Mailing Lists, 888 South Craycroft Road, Tucson, AZ 85711. Sells lists in hun-
dreds of categories, including medical doctors (by specialty), lawyers, and the
names and addresses of America's most wealthy people.

Mailing Lists Labels Packages, P.O. Box 1114, Weston, CT 06883. Offers *The Percent
for Art/Public Places Programs Mailing List* which includes pre-addressed mailing
labels and postcards to request information for city, state and national public art
programs.

Caroll Michels, career coach and artist advocate, 19 Springwood Lane, East Hamp-
ton, NY 11937-1169. Offers various arts-related mailing lists including the
names and addresses of museum and independent curators, art consultants,
New York City critics, national and regional arts press and consumer press, and
New York City press. Updated on an ongoing basis.

NONPROFIT ORGANIZATIONS
Publications

Financial Management Strategies for Arts Organizations by Frederick J. Turk and Robert
P. Gallo. New York: American Council for the Arts, 1986. Available from Amer-
icans for the Arts, 1000 Vermont Avenue, NW, 12th Floor, Washington, DC 20005.

Getting Organized: A Not-for-Profit Manual. New York: Lawyers Alliance of New York,
1994. Available from Volunteer Lawyers for the Arts, 1 East 53rd Street, 6th
Floor, New York, NY 10022-4201. A comprehensive handbook, including a de-
tailed discussion of New York State not-for-profit law. Explains step-by-step
procedures for forming a not-for-profit corporation.

How to Apply for Recognition of Exemption for an Organization. Published by the Internal
Revenue Service. Contact your local IRS for a copy.

How to Form a Non-Profit Corporation by Anthony Mancuso. Berkeley, CA: Nolo Press, revised 1994. Available from Volunteer Lawyers for the Arts, 1 East 53rd Street, 6th Floor, New York, NY 10022-4201.

Something Ventured: Something Gained: A Business Development Guide for Nonprofit Organizations by Laura Landy. New York: American Council for the Arts, 1989. Available from Americans for the Arts, 1000 Vermont Avenue, NW, 12th Floor, Washington, DC 20005.

This Way Up: Legal and Business Essentials for Nonprofits. Volunteer Lawyers for the Arts, 1 East 53rd Street, 6th Floor, New York, NY 10022-4201, 1988.

To Be or Not to Be: An Artist's Guide to Not-for-Profit Incorporation. Volunteer Lawyers for the Arts, 1 East 53rd Street, 6th Floor, New York, NY 10022-4201, revised 1986. Explains the pros and cons of not-for-profit corporate status, legal responsibilities and requirements, and alternatives to incorporation.

ORGANIZING PAPERWORK
Publications

An Art Inventory System (for Computer Haters) by Nina Pratt. Available from Nina Pratt, 116 Pinehurst Avenue, New York, NY 10033, 1992. Specially prepared for artists who cannot or will not use a computer. Provides guidelines for keeping track of your work, where it is located, who bought it, and how much is still owed.

Business and Legal Forms for Fine Artists by Tad Crawford. New York: Allworth Press, 1990. Includes sample contracts and instructions for a variety of situations, as well as a kit of tear-out contracts.

Business and Legal Forms for Photographers by Tad Crawford. New York: Allworth Press, 1991. Includes sample contracts and instructions for a variety of situations, as well as a kit of tear-out contracts.

Conquering the Paper Pile-Up: Moving Those Mountains of Paper Out of Your Life by Stephanie Culp. Cincinnati: Writer's Digest Books, 1990

The Organization Map by Pam McClellan. Cincinnati: Betterway Books, 1993. See chapter "The Office."

Computer Software Programs

A.R.T. Systems, Ltd., 17 West 17th Street, Suite 603, New York, NY 10011. Distributes *Gallery*, a Windows software package.

The Art Manager, Venrite Programming, 12443 Beech Fork Lane, Athens, AL 35611. Provides database management for artwork and exhibitions, tracking studio expenses, forms, automated bookkeeping functions, and more.

Artstacks, 57 Marguerite Avenue, Mill Valley, CA 94941. Designed exclusively for the Macintosh. Also ArtStacks/New York, 419 Third Avenue, #5A, New York, NY 10016.

ArtWatch, Sound Data, Inc., 2601 Elliott Avenue, Suite 3148, Seattle, WA 98121. Provides art-management software.

Business and Legal Forms for Fine Artists by Tad Crawford. New York: Allworth Press, 1990. Available on computer disk.

Business and Legal Forms for Photographers by Tad Crawford. New York: Allworth Press, 1991. Available on computer disk.

Art & Craft Organizer, Faben Inc., P.O. Box 3133, Sarasota, FL 34230. A PC computer program that tracks business expenses, sales tax, and inventories. Also includes a database for establishing a mailing list.

Gallery Systems, Inc., 2255 Broadway, New York, NY 10024. Provides art-management software that is used by artists.

PENSION PLANS AND SAVINGS AND LOANS PROGRAMS
Publications

The Artist's Tax Workbook by Carla Messman. Lyons and Burford, 31 West 21st Street, New York, NY 10010, revised annually. See "Retirement Plans."

Health Insurance: A Guide for Artists, Consultants, Entrepreneurs, and Other Self-Employed by Leonore Janecek. New York: Allworth Press and Americans for the Arts, 1000 Vermont Avenue, NW, Washington, DC 20005, 1993. Available from American Council for the Arts, 1 East 53rd Street, New York, NY 10022-4201. See chapter "Saving for Retirement."

Individual Retirement Arrangements (IRAs). IRS publication 590. Washington, D.C.: Internal Revenue Service, revised annually. Contact your local Internal Revenue office.

Self-Employed Retirement Plans. IRS publication 560. Washington, D.C.: Internal Revenue Service, revised annually. Contact your local Internal Revenue Service.

Organizations

The Artists Community Federal Credit Union, 155 Avenue of the Americas, 14th Floor, New York, NY 10013-1507. A federally insured credit union providing savings accounts and loans, and services to assist artists in establishing a credit rating.

Chicago Artists' Coalition, 11 East Hubbard Street, 7th Floor, Chicago, IL 60611. Offers members credit-union services, including savings accounts, loans, and IRAs.

Small Business Loan Programs. Contact your local Small Business Administration. Provides a limited number of loans and loan guarantees to independently owned and operated profit-making small businesses, including culture-related businesses (teaching studios; performing-arts schools; retail music or art-and-crafts shops). Loans may be used to purchase real estate, buildings, machinery, equipment, and inventory, as well as to cover construction or expansion costs.

Also see "Insurance and Medical Plans."

PERIODICALS

Afterimage, Visual Studies Workshop, 31 Prince Street, Rochester, NY 14607. For photographers and independent filmmakers and video artists. Published monthly except July through September.

Agenda, Visual Arts Ontario, 329 Wellington Street West, Toronto, Ontario M5V 1E7, Canada. Published quarterly.

American Artist, 1515 Broadway, New York, NY 10036. Published monthly.

American Ceramics, 9 East 45th Street, #603, New York, NY 10017. Published quarterly.

American Craft, American Craft Council, 72 Spring Street, New York, NY 10012-4019. Articles on all aspects of crafts and information on grants, marketing, and exhibitions. Published bimonthly.

Art and Auction, 440 Park Avenue South, New York, NY 10016. Published monthly.

Art Calendar, P.O. Box 199, Upper Fairmount, MD 21867-0199. Comprehensive listing of opportunities for artists nationwide, including exhibitions, grants and awards, residencies, slide registries, public-art programs, and employment openings. Eleven issues per year.

Art in America, 575 Broadway, New York, NY 10012. Published monthly.

Art New England: A Resource for Visual Artists, 425 Washington Street, Brighton, MA 02135. Focuses on artists in New England. Published ten times a year.

Art Papers, P.O. Box 77348, Atlanta, GA 30357. Focuses on artists living in the Southeast. Published bimonthly.

Art Washington, Cultural Alliance of Greater Washington, 140 8th Street, NW, Suite 600, Washington, DC 20004. Published monthly.

Artforum, 65 Bleecker Street, New York, NY 10012. Published monthly.

The Artists' Magazine, 1507 Dana Avenue, Cincinnati, OH 45207. Published monthly.

ARTnews, 48 West 38th Street, New York, NY 10018. Published monthly.

Artweek, 2149 Paragon Drive, Suite 100, San Jose, CA 95131. Regional focus: the Northwest, the Southwest, Alaska, and Hawaii. Includes information on competitions, exhibitions, and festivals for visual and performance artists. Forty-four issues, published weekly, September through May; biweekly, June through August.

Association of Hispanic Arts News, Association of Hispanic Arts, 173 East 116th Street, New York, NY 10029. Published nine times a year.

Boston Visual Artists Union News, P.O. Box 399, Newtonville, MA 02160. Focuses on art news, events, and opportunities in the Boston area. Published monthly.

CARNET, copublished by Canadian Artists' Representation Ontario, CARFAC National and CARFAC Manitoba. Available through CARFAC Manitoba, 221-100 Arthur Street, Winnipeg, Manitoba R3B 1H3, Canada; CARO, 440-40L Richmond Street West, Toronto, Ontario M5V 3A8, Canada; and CARFAC National, B1-100 Gloucester Street, Ottawa, Ontario K2P 0A4, Canada. A bilingual mag-

azine featuring articles on professional development and opportunities and programs for artists. Published quarterly.

Ceramics Monthly, Professional Publications, Inc., P.O. Box 12788, Columbus, OH 43212-0788. Published monthly.

Chicago Artists' News, Chicago Artists' Coalition, 11 East Hubbard Street, 7th Floor, Chicago, IL 60611. Includes information on local exhibition opportunities and national art issues. Published monthly.

The Crafts Report: The Business Journal for the Crafts Industry, P.O. Box 1992, Wilmington, DE 19899. Published monthly.

Critical Angles: The Newsletter of the Center for Arts Criticism, Center for Arts Criticism, 2822 Lyndale Avenue South, Minneapolis, MN 55408. Published quarterly.

Critical Mass, En Foco, 32 East Kingsbridge Road, Bronx, NY 10468. Devoted to photographers of color, it lists grant, exhibition, and job and internship opportunities throughout the United States. Published four times a year.

Dialogue: Art in the Midwest, P.O. Box 2572, Columbus, OH 43216-2572. Lists exhibitions and competitions in Illinois, Indiana, Kentucky, and Ohio. Published bimonthly.

Fiberarts, 50 College Street, Asheville, NC 28801. Published bimonthly, with summer issue for the months of May through August.

FYI, New York Foundation for the Arts, 155 Avenue of the Americas, New York, NY 10013-1507. Provides information of interest to artists and arts organizations in New York City and New York State. Published quarterly.

Glass Magazine, Urban Glass, 647 Fulton Street, Brooklyn, NY 11217. Published quarterly.

Graphic Artists Guild Newsletter, 90 John Street, Suite 403, New York, NY 10038-3202. Focuses on graphic-arts news throughout the country and features legal and financial advice, book reviews, and conference reports. Published monthly.

The Independent, Association of Independent Video & Filmmakers, 304 Hudson Street, 6th Floor, New York, 10013. Serves independent videomakers and filmmakers and lists professional opportunities. Published ten times a year.

Maquette, International Sculpture Center, 1050 17th Street, NW, Washington, DC 20036. Lists national and international opportunities for sculptors. Published ten times a year.

The National Resource Guide for the Placement of Artists, edited by Cheryl Slean, National Network for Artist Placement, 935 West Avenue 37, Los Angeles, CA 90065, revised regularly. Lists over one thousand trade publications of interest to artists.

New Art Examiner, 314 West Institute Place, Chicago, IL 60610. Published monthly except July and August.

Options, Pardus, Inc., 28 Moya Loop, Santa Fe, NM 87505. A straightforward monthly newsletter that lists opportunities for artists, including exhibitions and competitions. Each issue includes seventy-five to one hundred listings. It does not include art fairs, outdoor shows, or vanity galleries. Published monthly.

The Photo Review Newsletter, The Photo Review, 301 Hill Avenue, Suite 107, Lang-
horne, PA 19047. Includes exhibition lists in the mid-Atlantic region, including
New York, Philadelphia, Pittsburgh, Baltimore, and Washington, D.C. Also lists
exhibition opportunities nationwide and abroad. Published eight times a year.

The Photo Review Journal, The Photo Review, 301 Hill Avenue, Suite 107, Langhorne,
PA 19047. Contains exhibition reviews, essays, interviews, portfolios, and book
reviews. Published quarterly.

Photography in New York International, 64 W. 89th Street, #3F, New York, NY 10025.
Lists photography exhibitions in New York City and national and international
exhibitions. Also publishes news items and articles about photography. Pub-
lished bimonthly.

Professional Craft Journal, P.O. Box 1585, Palo Alto, CA 94302. Features news, com-
mentaries, and opinions by and for the American craft community. Published
quarterly.

Sculpture, International Sculpture Center, 1050 17th Street, NW, Suite 250, Wash-
ington, DC 20036. Published bimonthly.

Shuttle, Spindle and Dyepot, Handweavers Guild of America, 3327 Duluth Highway,
#201, Duluth, MN 30136-3373. International magazine of the Handweavers
Guild of America. For weavers, spinners, and dyers. Contains technical and
historical articles as well as marketing and business information. Published
quarterly.

Southwest Art, P.O. Box 640535, Houston, TX 77056-8535. Lists opportunities for
artists living in the Southwest. Published monthly.

Surface Design, Surface Design Association, P.O. Box 20799, Oakland, CA 94620-
0799. Quarterly publication of a professional organization of artists involved in
surface design, textiles, weavings, quilts, and other forms of fiber art.

Westart, P.O. Box 6868, Auburn, CA 95604. Provides an overview of the West Coast
arts community. Published bimonthly.

Wildlife Art News, Box 16246, St. Louis Park, MN 55416-0246. The largest journal
on wildlife art. Published seven times a year, including an annual yearbook.

Women Artists News Book Review (formerly *Women Artist News*), Midmarch Arts Press,
300 Riverside Drive, New York, NY 10025-5329. Reviews books and exhibition
catalogs on women artists and writers. Published annually.

Also see "Career Management, Business, and Marketing" and "Press Relations and Publicity."

PHOTOGRAPHING ARTWORK
Publications

How to Photograph Paintings by Nat Bukar. ECB Publishing, P.O. Box 630224, Little
Neck, NY 11363, undated.

How to Photograph Your Art by Malcolm Lubliner. Pomegranate Press, 210 Classic
Court, Rohnert Park, CA 94929, 1997.

How to Photograph Your Artwork by Kim Brown. Canyonwinds, 28 North Rim Road, Ransom Canyon, TX 79366, 1996.

Perfect Portfolio. Visual Arts Ontario, 439 Wellington Street West, 2nd Floor, Toronto M5V 1E7, Canada, 1995. Includes information on how to photograph two-dimensional artwork.

Photographing Your Artwork. Chicago Artists' Coalition, 11 East Hubbard Street, 7th Floor, Chicago, IL 60611, undated.

Photographing Your Artwork: A Step-by-Step Guide to Taking High-Quality Slides at an Affordable Price by Russell Hart. Cincinnati: North Light Books, 1987. Provides examples of the results of various types of lighting and camera angles; discusses photographing challenging artwork, including three-dimensional pieces, miniatures, and installations; also discusses masking and cleaning slides.

Videotapes

How to Photograph Your Art Using Natural Light. Idaho Commission on the Arts, P.O. Box 83720, Boise, ID 93720-0008, 1995. An instructional video on photographing visual art for artists needing quality images of their work. Also includes information on how to create 35mm slides.

Perfect Portfolio. Visual Arts Ontario, 439 Wellington Street West, 2nd Floor, Toronto M5V 1E7, Canada, 1995. Includes information on how to photograph two-dimensional artwork.

Organizations

Citizens Photo, P.O. Box 15068, Portland, OR 97293-5058.

PRESS RELATIONS AND PUBLICITY
Publications

Bacon's Radio/TV Cable Directory. Chicago: Bacon's Information, Inc., revised regularly. Includes the names, addresses, phone and fax numbers, and profiles of all United States radio and television stations and four hundred cable stations, as well as hosts and producers.

Developing The Press Packet. Media Distribution Co-op, 1745 Louisiana Street, Lawrence, KS 66044. Provides information on compiling a press packet, including a press release, photographs, and follow-through. Includes sample forms and a bibliography of public-relations directories.

Editor and Publishers Annual Directory of Syndicate Services Issue. Editor and Publisher Company, 11 West 19th Street, New York, NY 10011-4324. Lists syndicates serving newspapers in the United States and abroad with news and feature articles.

Encyclopedia of Associations, edited by Katherine Gruber. Detroit: Gale Research Company, revised regularly. Indexed by title and subject. Each entry includes address, purpose, programs, and publications.

Fine Art Publicity: The Complete Guide for Galleries and Artists by Susan Abbott and Barbara Webb. New York: Allworth Press, revised 1996. Explains how to organize effective public-relations plans. Includes sample forms, letters, and press releases.

The Fine Artist's Guide to Marketing and Self-Promotion by Julius Vitali. New York: Allworth Press, 1996.

Getting the Word Out: An Artist's Guide to Self Promotion, edited by Carolyn Blakeslee. Art Calendar Publishing, Inc., P.O. Box 199, Upper Fairmount, MD 21867-0199, 1995. See "Getting into Print" and "Personal Appearances."

Internal Publications Directory. New Providence, N.J.: Reed Elsevier, revised regularly. Provides detailed information on internal and external house organs of over thirty-five hundred United States and Canadian companies, government agencies, clubs, and other groups.

Marketing Made Easier: Guide to Free Product Publicity. Todd Publications, P.O. Box 635, West Nyack, NY 10960, 1994. Lists over one thousand magazines, newsletters, and trade publications that accept press releases. Indexed by subject.

Media Personnel Directory. Detroit: Gale Research Company, regularly updated. Lists editors, publishers, columnists, correspondents, and bureau chiefs of more than seven hundred magazines and periodicals in the United States.

Metro California Media. Public Relations Plus, Inc., P.O. Box 1197, New Milford, CT 06776, revised semiannually. Comprehensive list of press contacts in California, including newspapers, magazines, broadcast and cable television, radio networks and programs, syndicated writers, and news bureaus.

The National Resource Guide for the Placement of Artists, edited by Cheryl Slean. National Network for Artist Placement, 935 West Avenue 37, Los Angeles, CA 90065, revised regularly. Lists over one thousand trade publications of interest to artists.

New York Publicity Outlet. Public Relations Plus, Inc., P.O. Box 1197, New Milford, CT 06776, revised semiannually. A comprehensive list of press contacts in the New York metropolitan area, including those in Long Island; Putnam, Rockland and Westchester counties; northern New Jersey; and southwestern Connecticut. Includes newspapers, magazines, broadcast and cable television, radio networks and programs, syndicated writers, and news bureaus.

Professional's Guide to Publicity by Richard Winer. Public Relations Publishing Company, Inc., 437 Madison Avenue, New York, NY 10022, updated periodically.

The Publicity Handbook: How to Maximize Publicity for Products, Services and Organizations by David R. Yale. NTC Business Books, 4255 West Touhy, Lincolnwood, IL 60646, 1991.

Six Steps to Free Publicity by Marcia Yudkin. New York: Penguin Books USA, 1994. Provides excellent tips and information.

Talk Show Selects, edited by Mitchell P. Davis. Broadcast Interview Source, 2233 Wisconsin Avenue, NW, Washington, DC 20007, 1996. Profiles more than seven hundred radio and television talk shows in the United States. Each listing contains the name of the producer, host, or programming executive responsible for deciding what gets on the air. Addresses and fax and phone numbers are also provided.

Ulrich's International Periodical Directory. New Providence, N.J.: R. R. Bowker, revised annually. Includes the names, addresses, and descriptions of periodicals published throughout the world.

Writer's Market. Cincinnati: Writer's Digest Books. Published annually.

Software

America's Largest Newspapers. Computer disk available in IBM-compatible or Macintosh formats. Abalone Press, 14 Hickory Avenue, Tacoma Park, MD 20912. One hundred fifty of the largest newspapers in the United States with addresses, phone numbers, and names of various editors.

PR Profitcenter. AD-lib Publications, 5 1/2 West Adams, Fairfield, IA 52556. A computer database that contains the names and addresses of over four thousand magazine editors, thirty-nine hundred newspaper editors, and thirty-five hundred talk show producers.

Also see "The Internet," "Mailing Lists," and "Periodicals."

PRICING

Publications

The Artists' Survival Manual: A Complete Guide to Marketing Your Work by Toby Judith Klayman, with Cobbett Steinberg. New York: Charles Scribner's Sons, revised 1987. See chapter "Getting Ready: Pricing Your Work."

Graphic Artists Guild Handbook: Pricing and Ethical Guidelines. Graphic Artists Guild, 90 John Street, Suite 403, New York, NY 10038-3202. Revised biannually.

How to Sell Art: A Guide for Galleries, Dealers, Consultants and Artists' Agents by Nina Pratt, 1992. Available from Nina Pratt, 116 Pinehurst Avenue, New York, NY 10033. See index in the book under "Price."

InformArt: The Limited Edition Print Price Journal, 1727 East Second Street, Casper, WY 82601. Published bimonthly. Publishes information about market values of limited-edition prints, including the names of artists, title of print, and high and low selling prices.

Pricing Photography: The Complete Guide to Assignment & Stock Prices by Michal Heron and David MacTavish. New York: Allworth Press, 1993. Although geared for commercial photographers, this book will be very helpful to fine artists for establishing fees when photographs of your artwork are used in such media as newspapers, magazines, annual reports, books, posters, and calendars.

Also see "International Connections."

PRINTS AND PRINTMAKING
Publications

Art Marketing Sourcebook. ArtNetwork, P.O. Box 1268, Penn Valley, CA 95946, revised regularly. Includes a list of art publishers.

The Book Arts Directory. Page Two, Inc., P.O. Box 77167, Washington, DC 20013-7167, 1996. An excellent resource for artists working in the book-arts field, it also includes information for printmakers.

Contemporary Impressions. The American Print Alliance, 302 Larkspur Turn, Peachtree City, GA 30269. Includes articles, reviews, and interviews related to printmaking. Published twice a year.

Guide to Print Workshops in Canada and the United States. The American Print Alliance, 302 Larkspur Turn, Peachtree City, GA 30269, updated every two years. Lists more than five hundred places to make prints, paperworks, and artists' books.

InformArt: The Limited Edition Print Price Journal. Westtown Publishing Company, Inc., 1727 East Second Street, Casper, WY 82601. Publishes information about the market value of limited-edition prints, including the names of artists, titles of prints, and high and low selling prices. Published bimonthly.

On Paper: The Journal of Prints, Drawings and Photography (formerly *Print Collectors Newsletter*). Fanning Publishing Company, 39 East 78th Street, New York, NY 10021. Covers information on prints, photographs, works on paper, and artists' books. Published bimonthly.

PRINTthoughts, Mel Hunter Graphics, Box 1530 Route 7, Ferrisburgh, VT 05456. A quarterly newsletter devoted to printmaking. Contains articles and discussions on various forms of printmaking.

The Printworld Directory of Contemporary Prints and Prices, edited by Selma Smith. P.O. Box 1957, West Chester, PA 19380. Published annually.

Producing and Marketing Prints: The Artist's Complete Guide to Publishing and Selling Reproductions by Sue Viders. Color Q, Inc., The Art Education Division of Color Q, Inc., 2710 Dryden Road, Dayton, OH 45439, 1996. Provides step-by-step information on marketing photo off-set lithographs, including worksheets, checklists, and a discussion on how to estimate expenses and predict profits.

Publishing Your Art as Cards and Posters by Harold Davis. The Consultant Press/Photographic Arts Center, Limited, 163 Amsterdam Avenue, New York, NY 10023, 1990.

Audiotapes

Hints on Prints, narrated by Sue Viders. Color Q, Inc., The Art Education Division of Color Q, Inc., 2710 Dryden Road, Dayton, OH 45439, 1996. One-hour tape about entering the print market. Accompanied by a resource booklet.

Organizations

American Print Alliance, 302 Larkspur Turn, Peachtree City, GA 30269. Nonprofit alliance of artists' organizations involved in printmaking. Offers fine-art insur-

ance to members. Publishes *Contemporary Impressions* and *Guide to Print Workshops*.

Northwest Print Council, 2005 SE Hawthorne, Portland, OR 97214. Juried membership organization for printmakers throughout the Northwest United States and Canada. Sponsors a newsletter and other programs.

Also see "Artists' Books."

PUBLIC ART
Publications

Art in Other Places by William Cleveland. New York: Praeger Publishers, 1992. Features accounts of artists working in the community, addressing social ills, or bringing creative solutions to everyday environments. Topics include projects that focus on the elderly, prisons, people with disabilities, hospitals, and youth at risk.

Art in Public: What, Why and How, edited by Susan Jones. AN Publications, P.O. Box 23, Sunderland SR4 6DG, England, 1993. A guide to public art in the United Kingdom. Includes policies, proposals and presentations, an extensive bibliography, and contacts.

The Business of Art, edited by Lee Caplin. Englewood Cliffs, N.J.: Prentice-Hall, revised 1989. See "Financial Resources for Artists—Art in Public Places" by Patricia Fuller.

Competitions. P.O. Box 20445, Louisville, KY 40250. Quarterly magazine devoted to articles on public art, architecture, and landscape-architecture competitions in the United States and abroad.

Competitions Hotline. P.O. Box 20445, Louisville, KY 40250. Quarterly newsletter that lists public-art, architecture, and landscape-architecture competitions in the United States and abroad.

Directory of Percent for Art and Art in Public Places Programs. Mailing List Labels Packages, P.O. Box 1114, Weston, CT 06883. A list of city, county, state, and federal public-art programs and private nonprofit agencies. The directory also includes preaddressed mailing labels and postcards for requesting information about each program.

Going Public: A Field Guide to Developers in Art in Public Places by Jeffrey J. Cruikshank and Pam Korza. Arts Extension Service, Division of Continuing Education, 604 Goodell Building, University of Massachusetts, Amherst, MA 01003, 1992. Provides an overview of current issues, policies, and processes in the administration or preservation of public art.

Guidebook for Competitions and Commissions. Visual Arts Ontario, 439 Wellington Street West, Toronto, Ontario M5V 1E7, Canada, 1991. A guide to the process of commissioning art. Discusses methods for commissioning art, contexts and constraints, the role of the sponsor, and the role of the artist.

Public Art: A Directory of Programs in the United States. Americans for the Arts (formerly the National Assembly of Local Arts Agencies), 1000 Vermont Avenue, NW, 12th

Floor, Washington, DC 20005, revised 1997. Lists public art programs through-
out the country.

Public Art Commissions. Chicago Artists' Coalition, 11 East Hubbard Street, 7th Floor,
Chicago, IL 60611.

Public Art Commissions. North Carolina Arts Council, Department of Cultural Re-
sources, Raleigh, NC 28502. A list of public-art commissions that are open to all
artists in the United States.

Public Art Proposals. International Sculpture Center, 1050 17th Street, NW, #250,
Washington, DC 20036, 1992. Presents over two hundred contemporary art
installations.

Public Art Review. Forecast Public Artworks, 2324 University West, Suite 102, St.
Paul, MN 55114. A magazine that provides a wealth of practical information on
public-art programs. Also lists opportunities in public art and competitions. Pub-
lished twice a year.

Organizations

Art in the Urban Landscape, Capp Street Project, 525 Second Street, San Francisco,
CA 94107. A program that commissions artists to create semipermanent art in-
stallations in the San Francisco area.

Chicago Public Art Group, 1255 South Wabash Avenue, Chicago, IL 60605. Main-
tains a public-art slide registry.

Project for Public Spaces, Inc., 153 Waverly Place, New York, NY 10014. Specializes
in public-space planning, design, and management; assists city agencies, com-
munity groups, private developers, and planners in selecting and placing art in
public spaces. Maintains a slide registry and offers workshops and conferences
on public-space planning.

Public Art Fund, 1 East 53rd Street, New York, NY 10022. Promotes the integration
of art into the urban landscape, sponsors art installations in public spaces through-
out New York City, and provides educational and informational services.

Social and Public Art Resource Center (SPARC), 685 Venice Boulevard, Venice, CA
90291. A multicultural arts center that produces, exhibits, distributes, and pre-
serves public artwork. Sponsors exhibitions, workshops, and mural production.

UrbanArts, P.O. Box 1658, Boston, MA 02205. A public arts agency that accepts
contracts to place art in public places. Houses a nationwide slide registry of
artists in all disciplines.

Zero Percent for Art Program, c/o A. Herman, 455 North Park Street, 6th Floor,
Madison, WI 53706. An archive of public-art projects that have been imple-
mented by artists without public funding.

National Public-Art Programs

(*Open to out-of-state residents; + slide registry)

Note: Entries are alphabetized first by state, then by city, and then by name of the
sponsoring agency.

*+Percent for Art Program and Art in Architecture Program, General Services Admin-
istration, Public Buildings Service, 19th & F Streets, NW, Washington, DC 20005.

Municipal and State Public-Art Programs

ALASKA

*+Percent for Art Program, Alaska State Council on the Arts, 411 West 4th Avenue,
Suite 1E, Anchorage, AK 99501-2343.

Percent for Art Program, Municipality of Anchorage, Anchorage Museum of His-
tory and Art, 121 West Seventh Avenue, Anchorage, AK 99501.

Public Art Program, Homer Council on the Arts, 374 Bartlett Street, Homer, AK 99603.

ARIZONA

Art in Public Places, Arts and Humanities Commission, City of Casa Grande, 300
East 4th Street, Casa Grande, AZ 85222.

*Percent for Art Program, Arts Commission, City of Chandler, 250 North Arizona
Avenue, Chandler, AZ 85224.

*Percent for Arts Program, Glendale Arts Commission, 5850 West Glendale Av-
enue, Glendale, AZ 85301.

*Percent for Art Program, Peoria Arts Commission, City Manager's Office, 8401
West Monroe Street, Peoria, AZ 85345.

+Public Art/Design Program, Arizona Commission on the Arts, 417 West Roosevelt
Street, Phoenix, AZ 85003.

*+Percent for Art Program, Phoenix Arts Commission, 200 West Washington
Street, 10th Floor, Phoenix, AZ 85003.

*+Art in Public Places Program, City of Scottsdale, Scottsdale Cultural Council,
7380 East Second Street, Scottsdale, AZ 85251.

*+Art in Public Places Program and Education in the Arts Program, Sedona Depart-
ment of Arts and Culture, P.O. Box 30002, Sedona, AZ 86339.

*Art in Public Places Program, Oscar Yram Community Center, 3020 East Tacoma
Street, Sierra Vista, AZ 85635.

*+Art in Public Places Program, Cultural Arts Program, Tempe Arts Commission,
City of Tempe, Library Building, 3500 South Rural Road, Tempe, AZ 85282.

*+Public Art Program, Tucson/Pima Arts Council, 240 North Stone Avenue, Tuc-
son, AZ 85701-1212.

*Crawford County Art Association, 104 N. 13th Street, Van Buren, AZ 72956.

ARKANSAS

*Public Art Program, Arkansas Arts Council, 323 Center Street, 1500 Tower Build-
ing, Little Rock, AR 72201.

CALIFORNIA

*Art in Public Places Program, Civic Arts Department, City of Antioch, P.O. Box
5007, Antioch, CA 94531-5007.

*Percent for Art Program, City of Beverly Hills, 444 North Rexford Drive, Beverly Hills, CA 90210.

*+Art in Public Places Program, City of Brea, One Civic Center Circle, Brea, CA 92621.

*Art in Public Places Program, Parks and Recreation Department, City of Burbank, 275 East Olive Avenue, Burbank, CA 91502.

*+Art in Public Places Program, Arts Office, City of Carlsbad, 1200 Carlsbad Village, Carlsbad, CA 92008.

*Public Art Program, Chico Arts Commission, City of Chico, P.O. Box 3420, Chico, CA 95927-3420.

*Art in Public Places Program, Redevelopment Agency, City of Concord, 1950 Parkside Drive, Concord, CA 94519.

*Art in Public Places Program, South Coast Metro Alliance, 600 Anton Boulevard, Suite 120, Costa Mesa, CA 92626.

*Art in Public Places Program, Del Norte Association for Cultural Awareness, P.O. Box 1480, Crescent City, CA 95531.

Public Art Program, Fine Arts Commission, City of Cupertino, City Hall, 10300 Torre Avenue, Cupertino, CA 95014-3255.

*Art in Public Places Program, Parks and Community Services Department, City of Davis, 23 Russell Boulevard, Davis, CA 95616.

*+Public Art Partnership Panel, Community Services Department, City of Escondido, 201 North Broadway, Escondido, CA 92025.

*+Art in Public Places Program, Humboldt Arts Council, 214 "E" Street, Eureka, CA 95501.

*Percent for Art Program, Civic Arts Division, City of Fairfield, 1000 Webster Street, Fairfield, CA 94533.

*Public Art Program, City of Fremont, P.O. Box 5006, Fremont, CA 94537.

*Public Art Program, Fresno Arts Council, City of Fresno, 2425 Fresno Street, Room 102, Fresno, CA 93721.

*Art in Public Places Program, Cultural Affairs Division, City of Irvine, P.O. Box 19575, Irvine, CA 92713.

*+Art in Public Places Program, Laguna Beach Arts Commission, 505 Forest Avenue, Laguna Beach, CA 92651.

*Art in Public Places Program, Lake County Arts Council, 325 Main Street, Lakeport, CA 95453.

*Public Art Program, Public Corporation for the Arts, 100 West Broadway, Suite 360, Long Beach, CA 90802.

+Metro Art, P.O. Box 194, Los Angeles, CA 90053.

*Percent for Art Program, Cultural Affairs Department, City of Los Angeles, 433 South Spring Street, 10th Floor, Los Angeles, CA 90013.

*Percent for Art Program, Los Angeles Community Redevelopment Agency, 354 South Spring Street, Suite 800, Los Angeles, CA 90013-12158.

Art in Public Places Program, Sierra County Arts Council, P.O. Box 1049, Loyalton, CA 96118.

*Art in Public Places Program, Madera County Arts Council, Inc., 315 West Olive Avenue, Madera, CA 93637.

*Art in Public Places Program, City of Manhattan Beach, 1400 Highland Avenue, Manhattan Beach, CA 90266.

*+Public Art Program, Yuba Sutter Regional Arts Council, P.O. Box 468, Marysville, CA 95901.

*Art in Public Places Program, Community Development Department, City of Moorpark, 799 Moorpark Avenue, Moorpark, CA 93021.

*+Art in Public Places Program, Visual Arts Committee, City of Mountain View Planning Department, 500 Castro Street, Mountain View, CA 94041.

Percent for Art Program, Nevada County Arts Council, 5401 Spring Street, Suite 104, Nevada City, CA 95959.

*Percent for Art Program, Alameda County Art Commission, P.O. Box 29004, Oakland, CA 94604.

*Public Art Program, City of Oakland, 505 14th Street, Suite 715, Oakland, CA 94612.

*+Art in Public Places Program, Community Development Department, City of Oxnard-Carnegie Museum, 305 West Third Street, Oxnard, CA 93030.

*+Art in Public Places Program, City of Palm Beach, 73-510 Fred Waring Drive, Palm Desert, CA 92260.

*+Percent for Art Program, Arts Commission, City of Palm Springs, P.O. Box 2743, Palm Springs, CA 92262-2743.

*Art in Public Places Program, City of Palo Alto, 1313 Newell Road, Palo Alto, CA 94303.

*Art in Public Places Program, Community Development, City of Paramount, 16400 Colorado Avenue, Paramount, CA 90723.

*+Art in Public Places Program, Cultural Planning Division, City of Pasadena, 175 North Garfield Avenue, Pasadena, CA 91109-1704.

*+Public Art Program, Civic Arts Commission, City of Pleasanton, 200 Old Bernal Avenue, Pleasanton, CA 94566.

*Public Art and Design Program, California Arts Council, 1300 I Street, Suite 930, Sacramento, CA 95814.

*Art in Public Places Program, Sacramento Housing and Redevelopment Agency, c/o Sacramento Metropolitan Arts Commission, 800 10th Street, Suite 1, Sacramento, CA 98514.

*Art in Public Places Program, Sacramento Metropolitan Arts Commission, 800 10th Street, Suite 1, Sacramento, CA 95814.

Art in Public Places Program, Calaveras County Arts Council, P.O. Box 250, San Andreas, CA 95249.

*+Art in Public Places Program, Commission for Arts and Culture, City of San Diego, Executive Complex, 1010 2nd Avenue, Suite 555, San Diego, CA 92101-4904.

*+Art in Public Places Program, San Francisco Arts Commission, 25 Van Ness, Suite 240, San Francisco, CA 94102.

*Percent for Art Program, San Francisco Redevelopment Agency, 770 Golden Gate Avenue, San Francisco, CA 94102.

*Art in Public Places Program, Office of Cultural Affairs, City of San Jose, 291 South Market Street, San Jose, CA 95113.

*+Art in Public Places Committee, San Luis Obispo County Arts Council, P.O. Box 1710, San Luis Obispo, CA 93406.

*Art in Public Places Program, Santa Barbara County Arts Commission, P.O. Box 2369, Santa Barbara, CA 93120.

*Public Art Program, Arts Commission, City of Santa Cruz, 323 Church Street, Santa Cruz, CA 95062.

*Percent for Art Program, Parks Department, Santa Cruz County Arts Commission, 9000 Soquel Avenue, Santa Cruz, CA 95062.

*+Percent for Arts Program, Cultural Arts Division, City of Santa Monica, 1685 Main Street, Room 106, Santa Monica, CA 90401.

*Public Art Program, Headlands Center for the Arts, 944 Fort Barry, Sausalito, CA 94965.

*Public Art Program, Stockton Arts Commission, City of Stockton, 425 North El Dorado, Stockton, CA 95202.

Public Art Program, Arts and Youth Services Division, City of Sunnyvale, P.O. Box 3707, Sunnyvale, CA 94088-3707.

*Percent for Arts Program, City of Thousand Oaks, City Hall, City Manager's Office, 2100 Thousand Oaks Boulevard, Thousand Oaks, CA 91362.

*Public Art Program, Office of Cultural Affairs, City of Ventura, P.O. Box 99, Ventura, CA 93002-0099.

*Public Art Program, Bedford Gallery, City of Walnut Creek, 1601 Civic Drive, Walnut Creek, CA 94596.

COLORADO

*Public Art Program, Arvada Center for the Arts and Humanities, 6901 Wadsworth Boulevard, Arvada, CO 80003.

*Public Art Program, City of Arvada, 8101 Ralston Road, Arvada, CO 80001-8101.

*Percent for Art Program, Art in Public Places Commission, 13655 East Alameda Avenue, Aurora, CO 80012.

+Art in Public Art Program, Colorado Council on the Arts and Humanities, 750 Pennsylvania Street, Denver, CO 80203.

*+Public Art Program, City of Denver, Mayor's Office of Culture and Film, 280 14th Street, Denver, CO 80202.

*Percent for Art Program, Denver Urban Renewal Authority, 1555 California Street, Suite 200, Denver, CO 80202.

*Art in Public Places Committee, Longmont Council for the Arts, City of Longmont, 375 Kimbark Street, Longmont, CO 80501.

*Art in Public Places Program, Visual Arts Commission of the City of Loveland, c/o Loveland Museum and Gallery, 503 North Lincoln, Loveland, CO 80537.

*Art in Public Places Program, Town of Vail, 75 South Frontage Road, Vail, CO 81657.

CONNECTICUT

*+Percent for Art Program, Connecticut Commission on the Arts, 755 Main Street, One Financial Plaza, Hartford, CT 06103.

Public Art Program, Commission on the Arts and Cultural Activities, City of Middletown, P.O. Box 1300, Middletown, CT 06457.

DELAWARE

*Wilmington Arts Commission, City-County Building, 800 North French Street, 9th Floor, Wilmington, DE 19801.

DISTRICT OF COLUMBIA

*Art in Public Places Program, District of Columbia Commission on the Arts and Humanities, 410 Eighth Street, NW, Fifth Floor, Washington, DC 20004.

FLORIDA

*Public Art and Design Program, Cultural Affairs Division, Broward County Office of Cultural Arts, 100 South Andrews Avenue, Fort Lauderdale, FL 33301.

*Art in Public Places Board, Lee County, Department of Community Services, Lee County Alliance for the Arts, 10091-A McGregor Boulevard, Fort Myers, FL 33919.

*Art in Public Places Program, Department of Culture and Nature, City of Gainesville, P.O. Box 490, Station 30, Gainesville, FL 32602.

*+Art in Public Places Program, Cultural Affairs Council, Metropolitan Dade County, 111 Northwest First Street, Suite 610, Miami, FL 33218.

*Percent for Art Program, Orlando Public Art Board, City of Orlando, 400 South Orange Avenue, Orlando, FL 32806.

Public Art Programs, Arts Council of Northwest Florida, P.O. Box 731, Pensacola, FL 32594-0731.

*Public Art Committee, City of Sarasota, Planning and Development Department, P.O. Box 1058, Sarasota, FL 34230.

*Art in Public Places Program, Sarasota County, P.O. Box 8, Sarasota, FL 34230-0008.

*Public Art Commission, Arts Advisory Committee, City of St. Petersburg, 175 5th Street North, St. Petersburg, FL 33701.

Percent for Art Program, Brevard Cultural Alliance, 2725 Saint Johns Street, Building C-2, Satellite Beach, FL 32940.

*Art in State Buildings, Division of Cultural Affairs, Florida Arts Council, The Capitol, Tallahassee, FL 32399-0250.

*+Public Art Program, City of Tampa, 1420 North Tampa Street, Tampa, FL 33602.

*+Public Art Program, Community Action and Planning Agency, Hillsborough County, 601 East Kennedy Boulevard, 28th Floor, Tampa, FL 33602.

*Percent for Art Program, Art in Public Places Committee, City of West Palm Beach, P.O. Box 3366, West Palm Beach, FL 33402.

*Art in Public Places Program, Palm Beach County Cultural Council, 1555 Palm Beach Lakes Boulevard, Suite 1414, West Palm Beach, FL 33401-2371.

GEORGIA

*+Percent for Arts Program, Bureau of Cultural Affairs, City of Atlanta, City Hall East, 5th Floor, 675 Ponce de Leon Avenue, NE, Atlanta, GA 30308.

*Percent for Art Program and Contract for Services, Fulton County Arts Council, 141 Prior Street, Southwest, Suite 2030, Atlanta, GA 30303.

*Public Art Collection, Leisure Services Department, Clarke County, P.O. Box 1868, Athens, GA 30603.

GUAM

*Percent for Art Program, Insular Arts Council of Guam, P.O. Box 2950, Agana, GU 96910.

HAWAII

*+Art in City Buildings Program, Mayor's Office of Culture and Arts, City of Hono- lulu, City Hall, Room 404, Honolulu, HI 96813.

*+Art in Public Places Program, Foundation for Culture and the Arts, State of Hawaii, 44 Merchant Street, Honolulu, HI 96813.

IDAHO

*Public Art Program, Arts Commission, City of Boise, P.O. Box 1015, Boise, ID 83701-1015.

ILLINOIS

*Percent for Art Program, Art Commission, City of Aurora, 44 East Downer Place, Aurora, IL 60507.

*+Chicago Public Art Group, 1255 South Wabash Avenue, Chicago, IL 60605.

*+Public Art Program, Department of Cultural Affairs, City of Chicago, 78 East Washington Street, Chicago, IL 60602.

*+Percent for Art Program, Evanston Arts Council, 927 Noyes Center, Evanston, IL 60201.

Public Art Program, Peoria Area Arts and Sciences Council, 1125 West Lake Av- enue, Peoria, IL 61614.

*+Percent for Art Program, Capitol Development Board, State of Illinois, 401 South Spring Street, 3rd Floor, Springfield, IL 62706.

INDIANA

*Public Art Program, Dearborn Highland Arts Council, P.O. Box 41, Lawrenceburg, IN 47025.

IOWA

+Art in State Buildings Program, Department of Cultural Affairs, Iowa Arts Council, 600 East Locust Street, Des Moines, IA 50319-0290.

KANSAS

*+Percent for Art Program, Public Art Advisory Board, City of Wichita, 2601 North Arkansas, Wichita, KS 67204.

LOUISIANA

*+Percent for Art Program, Arts Council of New Orleans, 821 Gravier Street, Suite 600, New Orleans, LA 70112.

*+Public Art Program, Shreveport Regional Arts Council, 800 Snow Street, Shreveport, LA 71101.

MAINE

*+Percent for Art Program, Maine Commission on the Arts, 55 Capitol Street, State House, Station 25, Augusta, ME 04333.

MARYLAND

*+Percent for Art Program, Civic Design Commission, City of Baltimore, Abell Wolman Municipal Building, Room 9, Baltimore, MD 21202.

*+Art in Public Places Program, Maryland State Arts Council, 601 North Howard Street, Baltimore, MD 21201.

*Art in Public Places Program, Office of Special Projects, Department of Business and Economic Development, State of Maryland, 300 West Preston Street, Suite 400, Baltimore, MD 21201.

*Art in Public Places Program, City of Rockville, Glenview Mansion, 603 Edmonston Drive, Rockville, MD 20851.

MASSACHUSETTS

*Boston Public Art Program, City of Boston, Boston City Hall, Room 716, Boston, MA 02201.

*+Urban Arts, 140 Clarendon Street, Boston, MA 02116.

*+Percent for Arts Program, Cambridge Art Council, 57 Inman Street, Cambridge, MA 02139.

MICHIGAN

Art in Public Places Program, Cultural Arts Division, 24350 Southfield Road, Southfield, MI 48075.

MINNESOTA

*Public Art Program, Arts Commission, City of Duluth, 322 City Hall Duluth, MN 55802-1196.

Public Art Program, Arts Commission, City of Minneapolis, City Hall, Room 200, 350 South Fifth Street, Minneapolis, MN 55415-1385.

*+Public Art Program, City of St. Paul, Minnesota Building, Suite 828, 46 East Fourth Street, St. Paul, MN 55101.

*+Percent for Art Program, Minnesota State Arts Board, Park Square Court, 400 Sibley Street, Suite 200, St. Paul, MN 55101-1928.

MISSOURI

*+Percent for Art Program, Kansas City Municipal Arts Commission, City Architect's Office, City Hall, 17th Floor, 414 East 12th Street, Kansas City, MO 64106.

*Public Art Program, Allied Arts Council, 118 South 8th Street, St. Joseph, MO 64501-2231.

*Public Art Program, Regional Arts Commission, 3540 Washington Avenue, Second Floor, St. Louis, MO 63103.

MONTANA

*Percent for Art Program, State of Montana, Montana Arts Council, 316 North Park Avenue, Helena, MT 59620.

*Public Art Program, Missoula Public Art Committee, City of Missoula, P.O. Box 8687, Missoula, MT 59807.

NEBRASKA

*Public Art Program, Lincoln Arts Council, 920 "O" Street, Lincoln, NE 68508.

*Percent for Art Program, Nebraska Arts Council, 1313 Farnam-on-the-Mall, Omaha, NE 68102-1873.

NEVADA

*+Art in Public Places Program, City of Las Vegas Arts Commission, 749 Veterans Memorial Drive, Las Vegas, NV 89101.

*Art in Public Places Program, Nevada State Council for the Arts, 329 Flint Street, Reno, NV 89501.

NEW HAMPSHIRE

*+Percent for Art Program, New Hampshire State Council on the Arts, 40 North Main Street, Concord, NH 03301.

NEW JERSEY

*+Arts Inclusion Program, Cape May County Cultural and Heritage Commission, DN101, Library Office Building, Cape May Court House, Cape May, NJ 08210-3050.

*Percent for Art Program, Office of Cultural and Heritage Affairs, Atlantic County, 40 Farragut Avenue, Mays Landing, NJ 08330.

*+Arts Inclusion Program, New Jersey State Council on the Arts, 20 West State Street, CN-306, Trenton, NJ 08625-0306.

NEW MEXICO

*+Percent for Art Program, Mayor's Office, City of Albuquerque, P.O. Box 1293, CIP/OMB, Albuquerque, NM 87103.

*+Art in Public Places Board, County of Los Alamos County, P.O. Box 30, Los Alamos, NM 87544.

*+Percent for Art Program, Santa Fe Arts Commission, City of Santa Fe, P.O. Box 909, Santa Fe, NM 87504-0909.

*+Percent for Art Program, New Mexico Arts Division, 228 East Palace Avenue, Santa Fe, NM 87501.

NEW YORK

*+Percent for Art Program, Buffalo Arts Commission, 920 City Hall, Buffalo, NY 14202.

*+Percent for Art Program, Department of Cultural Affairs, City of New York, 330 West 42nd Street, 14th Floor, New York, NY 10036.

*+Public Art Program, Health and Hospitals Corporation, City of New York, City Hall, Third Floor, New York, NY 10007.

*Public Art Fund, 1 East 53rd Street, New York, NY 10022.

*+Percent for Art Program, Art in Public Places Committee, The Arts Council of Rockland County, 7 Perlman Drive, Spring Valley, NY 10977.

NORTH CAROLINA

*+Public Art Commission, Charlotte-Meckenburg Arts and Sciences Council, 227 West Trade Street, Suite 250, Charlotte, NC 28202.

*Public Art Program, Arts Commission, City of Raleigh, P.O. Box 590, Raleigh, NC 27602.

OHIO

*+Committee for Public Art, 1220 West 6th Street, Suite 300, Cleveland, OH 44113.

*Art in Public Places Program, Ohio Arts Council, 727 East Main Street, Columbus, OH 43205-1796.

*+Percent for Art Program, Ohio Arts Council, 727 East Main Street, Columbus, OH 43205-1796.

*+Public Art Program, City of Dayton, P.O. Box 22, Dayton, OH 45401.

*Public Art Program, Arts Council, City of Dublin, 129 South High Street, Dublin, OH 43107.

*+Art in Public Places Program, Arts Commission of Greater Toledo, 2201 Ottawa Parkway, Toledo, OH 43606.

OKLAHOMA

*Percent for Art Program, Parks and Recreation Department, Oklahoma City Arts Commission, 420 West Main Street, Suite 210, Oklahoma City, OK 73102.

*+Percent for Art Program, Arts Commission, City of Tulsa, 2210 South Main Street, Tulsa, OK 74114.

OREGON
Percent for Art Program, Beaverton Arts Commission, P.O. Box 4755, Beaverton, OR 97076.
*Percent for Art Program, Holt Center for the Performing Arts, City of Eugene, One Eugene Center, Eugene, OR 97401.
*Percent for Art Program, Regional Arts and Culture Council, 309 SW 6th Avenue, Suite 100, Portland, OR 97204.
*+Percent for Art Program, Oregon Arts Commission, 775 Summer Street, NE, Salem, OR 97310.

PENNSYLVANIA
*Public Art Program, Abington Art Center, 515 Meetinghouse Road, Jenkintown, PA 19046.
*+Percent for Art Program, Office of Arts and Culture, City of Philadelphia, 1600 Arch Street, Philadelphia, PA 19103.
*Public Art Program, Fairmount Park Art Association, 1616 Walnut Street, Suite 2012, Philadelphia, PA 19103.
*+Percent for Art Program, Fine Arts Program, Redevelopment Authority of Philadelphia, 1234 Market Street, 8th Floor, Philadelphia, PA 19107.
*Percent for Art Program, Department of City Planning, City of Pittsburgh, 200 Ross Street, Pittsburgh, PA 15219.

RHODE ISLAND
+Art in Public Places Program, Rhode Island State Council on the Arts, 95 Cedar Street, Suite 103, Providence, RI 02903-1034.

SOUTH CAROLINA
*+Art in Public Places Program, South Carolina Arts Commission, 1800 Gervais Street, Columbia, SC 29201.

SOUTH DAKOTA
*Art in Public Places Program, South Dakota Arts Council, 800 Governors Drive, Pierre, SD 57501.

TENNESSEE
*+Association for Visual Artists, Masonry Works in Public, 744 McCallie Avenue, Suite 321, Chattanooga, TN 37403.
*+Public Art Program, Arts Council of Greater Knoxville, P.O. Box 2506, Knoxville, TN 37901.
*Public Art Program, Memphis Arts Council, 2714 Union Avenue Extended, Memphis, TN 38112.

*+Public Art Program, Metro Nashville Arts Commission, 209 10th Avenue South, Suite 416, Nashville, TN 37203-4101.

+Public Art Program, Tennessee Arts Commission, 404 James Robertson Parkway, Suite 160, Nashville, TN 37243-0780.

TEXAS

*+Art in Public Places Program, City of Austin, Parks & Recreation Department, P.O. Box 1088, Austin, TX 78767.

*Art in Public Places, Texas Commission on the Arts, P.O. Box 13406, Austin, TX 78711.

*+Percent for Art Program, City of Corpus Christi, P.O. Box 9277, Corpus Christi, TX 78469-9277.

*+Percent for Art Program, Parks and Recreation Department, City of Corpus Christi, P.O. Box 9277, Corpus Christi, TX 78469-9277.

*+Art in Public Places Program, Municipal Arts Commission, Multicultural Center, 1581 North Chaparral Street, Corpus Christi, TX 78401.

*+Percent for Art Program, Office of Cultural Affairs, Majestic Theatre, Suite 500, 1925 Elm Street, Dallas, TX 75201.

*+Public Art and Urban Design Program, Cultural Arts Council, City of Houston, 3201 Allen Parkway, Houston, TX 77019.

*+Public Art Program, Houston Municipal Art Commission, Office of the Mayor, 2999 South Wayside, Houston, TX 77023.

*+Percent for Art Program, Department of Arts and Cultural Affairs, City of San Antonio, 222 East Houston, Suite 500, San Antonio, TX 78205.

UTAH

*Percent for Art Program, Salt Lake Art Design Board, Salt Lake City Arts Council and Board, 54 Finch Lane, Salt Lake City, UT 84102.

*+Design Arts Program, Utah Arts Council, 617 East South Temple, Salt Lake City, UT 84102.

VERMONT

*+Art in State Buildings, Vermont Council on the Arts, 136 State Street, Montpelier, VT 05633-6001.

VIRGINIA

*Public Arts Initiative, Alexandria Commission on the Arts, 1108 Jefferson Street, Alexandria, VA 22314-3999.

*Public Art Program, Arlington Arts Center, Maury School, 3550 Wilson Boulevard, Arlington, VA 22201.

*+Public Art Program, Public Art Committee, Chesapeake Fine Arts Commission, P.O. Box 15225, Chesapeake, VA 23328.

*Public Art Program, Department of Community Development, City of Richmond, 900 East Broad Street, Richmond, VA 23219.

WASHINGTON

*Public Art Program, Auburn Arts Commission, 25 West Main Street, Auburn, WA 98001.

*Art in Public Places Program, Bainbridge Island Arts and Humanities Council, 261 Madison Avenue South, Bainbridge Island, WA 98110.

*Percent for Art Program, Bellevue Arts Commission, P.O. Box 90012, Bellevue, WA 98009.

*Public Art Program, Watcom Museum, 121 Prospect Street, Bellingham, WA 98225.

*Percent for Art Program, Edmonds Art Commission, 700 Main Street, Edmonds, WA 98020.

*Municipal Arts Program, Everett Cultural Commission, 1507 Wall Street, Everett, WA 98201.

Public Art Program, Arts Commission, City of Issaquah, City Hall, 135 East Sunset Way, Issaquah, WA 98027.

*Art in Public Places Program, Kent Arts Commission, Kent Parks and Recreation Department, 220 4th Avenue South, Kent, WA 98032-5895.

*+Percent for Art Program, Arts Commission, City of Lynnwood, P.O. Box 5008, Lynnwood, WA 98046-5008.

*Art in Public Places Program, Mercer Island Arts Council, 8236 S.E. 24th Street, Mercer Island, WA 98040.

*Percent for Art Program, Mountlake Terrace Arts Commission, 5303 228th Street SW, Mountlake Terrace, WA 98043.

*Art in Public Places Program, Olympia Arts Commission, 222 North Columbia, Olympia, WA 98501.

*+Art in Public Places, Washington State Arts Commission, P.O. Box 42675, Olympia, WA 98504-2675.

*Percent for Art Program, Renton Municipal Arts Commission, 200 Mill Avenue South, Renton, WA 98055.

*+Public Art Programs, Cultural Resources Division, King County Arts Commission, 506 Second Avenue, 1115 Smith Tower, Seattle, WA 98104-2311.

*Public Art Program, Seattle Arts Commission, 312 First Avenue North, Seattle, WA 98109-4501.

*Percent for Art Program, Department of Arts and Cultural Services, City of Spokane, West 808 Spokane Falls Boulevard, Spokane, WA 98201-3333.

Percent for Art Program, Pierce County Arts Commission, 4916 Center Street, Suite H, Tacoma, WA 98409.

*Public Art Collection, Tacoma Arts Commission, 747 Market Street, Suite 836, Tacoma, WA 98402.

*Percent for Art Program, Wenatchee Arts Commission, c/o North Central Washington Museum, 127 South Mission Street, Wenatchee, WA 98801.

WISCONSIN

*+Percent for Art Program, Milwaukee Arts Commission, 809 North Broadway, Milwaukee, WI 53202.

*Public Art Program, Madison CitiArts Commission, 215 Martin Luther King Boulevard, Madison, WI 53701.

*Percent for Art Program, Wisconsin Arts Board, 101 East Wilson Street, 1st Floor, Madison, WI 53702.

WYOMING

*+Percent for Art Program, Wyoming Arts Council, 2320 Capitol Avenue, Cheyenne, WY 82002.

Mass Transit and Airport Public-Arts Programs

Note: Entries are listed in alphabetical order by state, then city, then the name of the rapid transit building or site.

*Art in Public Places Program, Sky Harbor International Airport, Phoenix Arts Commission, 3400 Sky Harbor Boulevard, Phoenix, AZ 85034.

Art in Public Places Program, Tucson Airport Authority, Tucson International Airport, 75005 South Plumer, Tucson, AZ 85706.

+Art for Rail Transit, Los Angeles County Transportation Commission, 818 West 7th Street, Suite 1100, Los Angeles, CA 90017.

Visual Arts Program, Santa Cruz Metropolitan Transit District, 230 Walnut Avenue, Santa Cruz, CA 95060.

*Percent for Art Program, Denver International Airport Art Program, 8500 Pena Boulevard, Room 9870, Denver, CO 80207.

*+Percent for Art Program, Metropolitan Atlanta Rapid Transportation Authority, 2424 Piedmont Road, NE, Atlanta, GA 30324-3330.

*Artery Arts Program, Central Artery Tunnel Project, 1 South Station, Boston, MA 02110.

*+Arts in Transit Program, Bi-State Development Agency, 707 North First Street, St. Louis, MO 63102.

*Public Art Program for McCarran Airport, McCarran Arts Advisory Committee, Clarke County Government Center, Department of Parks and Recreation, P.O. Box 551721, Las Vegas, NV 89155.

*Arts For Transit, Metropolitan Transportation Authority, 347 Madison Avenue, New York, NY 10017.

*+Percent for Art Program, Port Authority of New York and New Jersey, One World Trade Center, Room 82W, New York, NY 10048.

*Exhibitions and Acquisitions Program, Seattle-Tacoma International Airport, Port of Seattle, Aviation Marketing Office, P.O. Box 68727, Room 301, Seattle, WA 98168.

SLIDE REGISTRIES
Organizations

American Craft Council Library, 72 Spring Street, New York, NY 10012. Operates a
slide registry on American craft artists in all media.

Art Information Center, 55 Mercer Street, New York, NY 10013. Operates two reg-
istries: Unaffiliated Artists, an open file of slides and résumés of artists unaffili-
ated with commercial galleries, and Affiliated Artists, a file designed to help
artists, dealers, museum personnel, the press, collectors, and the public locate
the work of living artists.

Art League of Houston, 1953 Montrose Boulevard, Houston, TX 77066. Maintains
a slide registry of Texas or Texas-born artists.

Artists Space, 38 Greene Street, New York, NY 10013. Sponsors a computerized
slide registry of New York State artists who are not represented by commercial
or co-op galleries.

Center for Book Arts, Inc., 626 Broadway, New York, NY 10012. Nonprofit educa-
tional and exhibition facility that sponsors a slide registry for book artists.

Center for Book and Paper Arts, Columbia College, 218 South Wabash, 7th Floor,
Chicago, IL 60604-2316. An archives and registry of artists' books.

Chicago Artists' Coalition, 11 East Hubbard Street, 7th Floor, Chicago, IL 60611.
Sponsors a slide registry and an on-line registry.

Coast to Coast National Women Artists of Color, P.O. Box 310961, Jamaica, NY
11431. National membership organization dedicated to supporting women artists
of color. Maintains a slide registry.

The Drawing Center, 35 Wooster Street, New York, NY 10012. Exhibition, research,
and study center for contemporary drawings. Operates a slide registry for public
reference of artists' drawings.

Empire State Crafts Alliance, 320 Montgomery Street, Syracuse, NY 13202. Main-
tains a registry of craft professionals.

Florida Center for Contemporary Arts/Artists Alliance, Inc., P.O. Box 75184, Tampa,
FL 33605. Registry is open to artists in the Southeast region.

Georgia Artists Registry, Woodruff Arts Center, 1280 Peachtree Street, NE, Atlanta,
GA 30309. Open to artists living in Georgia.

Houston Center for Photography, 1441 West Alabama, Houston, TX 77006. Slide
registry is open to all photographers.

Indianapolis Arts Center, 820 East 67th Street, Indianapolis, IN 46220. Open to
artists who were born in, studied in, or currently reside in Indiana or within 250
miles of Indianapolis.

International Sculpture Center, 1050 17th Street, NW, Suite 250, Washington, DC
20007. Sponsors "Sculpture Source," a computerized slide registry for sculptors.

National Center on Arts and the Aging, 409 Third Street, SW, 2nd Floor, Washing-
ton, DC 20024. Sponsors a slide registry for artists over sixty-five years of age.

New Organization for the Visual Arts (NOVA), 4614 Prospect Avenue, Suite #212,
Cleveland, OH 44103. Maintains a slide registry for northeast Ohio artists.

Northwest Artists Workshop, 522 NW 12th Avenue, Portland, OR 97209. Maintains a registry of Oregon artists' slides.

Organization of Independent Artists, 19 Hudson Street, #402, New York, NY 10014. Registry is open to professional artists.

Resources for Artists with Disabilities, 77 Seventh Avenue, Suite PhH, New York, NY 10011-6644. Sponsors a slide registry and juried exhibitions.

Visual Arts Ontario, 439 Wellington Street West, Toronto, Ontario M5V 1E7, Canada.

Also see "Public Art."

SURPLUS-MATERIAL PROGRAMS
Publications

The Artist's Resource Handbook by Daniel Grant. New York: Allworth Press, revised 1997. See sections "Materials for the Arts" and "Obtaining In-Kind Contributions."

Materials for the Arts: A Handbook. Materials for the Arts Program, New York City Department of Cultural Affairs, 330 West 42nd Street, 14th Floor, New York, NY 10036.

Organizations

Materials for the Arts, Cultural Affairs Department, City of Los Angeles, 3224 Riverside Drive, Los Angeles, CA 90027.

Materials for the Arts, Bureau of Cultural Affairs, City Hall East, 675 Ponce de Leon Avenue, NE, Atlanta, GA 30308.

Materials for the Arts Program, New York City Department of Cultural Affairs, 330 West 42nd Street, 14th Floor, New York, NY 10036.

Notes

1. Reprinted by permission of The Putnam Publishing Group/Jeremy P. Tarcher, Inc., from *A Life in the Arts*, by Eric Maisel, 83. Copyright © 1994 by Eric Maisel.
2. Excerpts from *The Painted Word* by Tom Wolfe, 14. Copyright © 1975 by Tom Wolfe. Reprinted by permission of Farrar, Straus & Giroux, Inc.
3. From *The Artist's Guide to the Art Market*, 4th Ed., by Betty Chamberlain, 18. Copyright © 1970, 1975, 1979, 1983 by Watson-Guptill Publications.
4. Ralph Charell, *How to Make Things Go Your Way* (New York: Simon & Schuster, 1979), 149.
5. Ronald H. Silverman, "Art Career Education: The Third Imperative," *School Arts*, vol. 79, no. 6 (February 1980): 42.
6. Ibid.
7. Comment by Barbara Price, academic dean and vice-president for academic affairs, Maryland Institute, College of Art, Baltimore, published in "Support for Artists by Institutions: Comments and Discussion," *The Modern Muse: The Support and Condition of Artists*, ed. C. Richard Swaim (New York, 1989), 126. Reprinted with permission by © American Council for the Arts.
8. Jo Hanson, *Artists' Taxes, The Hands-on Guide: An Alternative to "Hobby" Taxes* (San Francisco: Vortex Press, 1987), 24.
9. From *Has Modernism Failed* by Suzi Gablik, 68. Copyright © 1984 by Suzi Gablik. Reprinted by permission of Thames and Hudson.
10. Annette Lieberman and Vicki Lindner, *The Money Mirror: How Money Reflects Women's Dreams, Fears, and Desires* (New York: Allworth Press, 1996), 56.
11. Ibid., 54.
12. Tad Crawford, *The Secret Life of Money: How Money Can Be Food for the Soul* (New York: Allworth Press, 1996), 42.
13. Press release issued by Allworth Press, announcing publication of *The Secret Life of Money: How Money Can Be Food for the Soul* by Tad Crawford, 1996.

14. Carol Duncan, "Who Rules The Art World?" *Socialist Review* 70, July–August 1983, 111. Copyright 1983, Center for Social Research and Education. Reprinted by permission of Duke University Press.

15. Ted Potter, "Introduction," *The Modern Muse: The Support and Condition of Artists*, ed. C. Richard Swaim (New York, 1989), 9. Reprinted with permission by © American Council for the Arts.

16. Excerpts from *The Practical Handbook for the Emerging Artist* by Margaret R. Lazzari, 11. Copyright © 1996 by Harcourt Brace & Company, reprinted by permission of the publisher.

17. Ibid., 12.

18. From *Art and Fear* by David Bayles and Ted Orland, 47. Copyright © 1993. Reprinted by permission of Capra Press, Santa Barbara, Calif.

19. Nancy Anderson, *Work with Passion* (New York: Carroll & Graf Publishers, Inc. and Mill Valley, Calif.: Whatever Publishers, 1984), 143.

20. Hanson, op. cit., 26.

21. Ibid.

22. Judith Appelbaum and Nancy Evans, *How to Get Happily Published* (New York: Harper & Row, 1978), 12.

23. Tad Crawford, *Legal Guide for the Visual Artist* (New York: Allworth Press, 1989), i.

24. Patrick Moore, *Future Safe: The Present Is the Future* (New York: The Estate Project for Artists with AIDS, The Alliance for the Arts, 1992), 2.

25. Crawford, *Legal Guide for the Visual Artist*, 163.

26. Hanson, op. cit., i.

27. Barbara A. Sloan, *Do-It-Yourself Quick Fix Tax Kit: General Tax Guide for Visual Artists*, Scottsdale, Ariz.: AKAS II, 1995, 2.

28. Artist statement by Ruth Green, Monterey, Mass.

29. From brochure advertising the book *How to Photograph Paintings* by Nat Bukar.

30. Shannon Wilkinson, "The Art of Self-Promotion: The Hum Below the Radar: News from the Art Front," *Art Calendar*, April 1996, 6.

31. Ibid.

32. Telephone interview with Dick Termes.

33. From *Conquering the Paper Pile-Up*, 2. Copyright © 1990 by Stephanie Culp. Used with permission of Writer's Digest Books.

34. *Artists Gallery Guide for the Chicago and Illinois Region*, Chicago Artists Coalition, 1990.

35. Ibid.

36. From a press release issued by Laura Foreman and John Watts for *Wallworks*, New York City, May 1, 1980.

37. Ibid.

38. Jack Anderson, "'Sold Out' Performances That Never Actually Took Place," *The New York Times*, 12 July 1981, 13. Copyright © 1981 by The New York Times Company. Reprinted by permission.

39. Daniel Grant, *The Business of Being an Artist* (New York: Allworth Press, 1995), 195.

40. Shannon Wilkinson, "Promoting Fine Art: New Developments: A Behind-the-Scenes View," *Art Calendar*, July/August 1995, 9.

41. From a press release issued by the Integral Consciousness Institute for *Synthesis*, an exhibition at the Soho Center for Visual Artists, New York City, June 1979. (N.B., Soho Center for Visual Arts no longer exists.)

42. From a press release issued by the Rotunda Gallery, Brooklyn, N.Y., for the exhibition *Sculptor's Drawings*, 17 February 1983.

43. From a press release issued by Adelphi University, Garden City, N.Y., for a one-person exhibition by Francine Fels, *Happy Birthday, Rev—A Dancework in 50 Paintings*, 31 May 1988.

44. From a press release issued by Lydia Afia for a one-person exhibition, *Behind Glass*, at Tiffany & Company, New York City, January 1988.

45. From a press released issued by the Bruce R. Lewin Gallery, New York City, for a one-person exhibition by Peter Anton, "Chocolate Throughout the Land," April 1996.

46. "Barbara Rose," interview by Eva Cockcroft, *Artworkers News*, April 1980, 13. (N.B., *Artworkers News* no longer exists.)

47. Interview with Nina Pratt, New York City, 1990.

48. Tom Wolfe, op. cit., 6.

49. From interview with Ingrid Sischy in the article "Profiles: A Girl of the Zeitgeist—II," by Janet Malcolm, 51–52. Copyright © 1986 by Janet Malcolm, originally appeared in the *New Yorker*, October 27, 1986, and reprinted by permission of The Wylie Agency, Inc.

50. Nancy Stapen, "The Thorn in Culture's Side," *Art New England*, July/August 1988, 9.

51. "John Perrault," interview by Walter Weissman, *Artworkers News*, April 1980, 19.

52. Edit de Ak and Walter Robinson, "Alternative Periodicals," in *The New Artspace: A Summary of Alternative Visual Arts Organizations*, prepared in conjunction with a conference held on 26–29 April 1978 (Los Angeles: Los Angeles Institute of Contemporary Art, 1978), 38. (N.B., *The New Artspace* no longer exists.)

53. Suzanne K. Vinmans, *On Opening an Art Gallery* (Madison, Wis.: Suzanne K. Vinmans, 1990), 30–31.

54. Donna Marxer, "Report from New York. A History Lesson—and a Primer on Vanities," *Art Calendar*, April 1995, 13.

55. Lisa Gubernick, "I was an Artist for *The Village Voice*," *The Village Voice*, 7–13 October 1981, 71. Reprinted by permission of the author and *The Village Voice*.

56. Elizabeth Bram, "Zero Gravity: Diary of a Travelling Artist," 91–92.

57. Ibid., 92.

58. Joan Altabe, "They Should Charge the Audience, Not the Artists," April 10, 1994, 2G. Copyright © 1994, *Sarasota Herald-Tribune*. Reprinted by express permission of the *Sarasota Herald-Tribune*.

59. Ibid.

60. Ibid.

61. Ibid.

62. "Recommended Guidelines for Juried Exhibitions" (Washington, D.C.: National Artists Equity Association, 1991).

63. Carolyn Blakeslee, "Entry Fees," *Art Calendar*, June 1991, 3.

64. Altabe, op. cit.

65. Ellen Baum, "The Whitney: Acquisitions Policies and Attitude Toward Living Artists," *Artworkers News*, December 1980, 13.

66. Ibid.

67. Brenda Bradick Harris, "The Benefits of Working with Art Advisors," *Art Calendar*, April 1990, 5.

68. Drew Steis, "Interview with Françoise Yohalem—Art Consultant," *Art Calendar*, May 1990, 4.

69. "Commissioned Artwork in the Mid-1990s: A Survey of GUILD Users," *The Designer's Sourcebook 11: Art for the Wall, Furniture & Accessories* (Madison, Wis.: THE GUILD, 1996), 201–2.

70. Carolyn Blakeslee, "Buying Ad Space in Artists' Sourcebooks," *Getting the Word Out: The Artist's Guide to Self Promotion* (Upper Fairmount, Md.: Art Calendar Publishing, Inc.), 164.

71. Ibid., 166–68.

72. Anne Barclay Morgan, "Getting Better: Art and Healing," *Sculpture*, September/October 1994, 26.

73. Elizabeth Bram, op. cit., 87.

74. From an undated press release issued by Pratt Institute, Brooklyn, N.Y., for an exhibition, *Empty Dress: Clothing as Surrogate in Recent Art*, in 1996, curated by Nina Felshin and organized by Independent Curators, Inc., New York.

75. From a press release for an exhibition entitled *A, E, Eye, O, U, and Sometimes Why*, organized by the Organization of Independent Artists, curated by Deborah Gardner and Karen Loftus, 15 May–20 June 1980.

76. An exhibition held at Ronald Feldman Fine Arts, New York City, March 1981.

77. From a press release issued by Ronald Feldman Fine Arts, New York City, for an exhibition entitled *Top Secret: Inquiries into the Biomirror*, March 1981.

78. Donna Marxer, "Career in the Doldrums? Consider the Open Studio," *Art Calendar*, October 1995, 7.

79. Nina Pratt, *How to Sell Art: A Guide for Galleries, Art Dealers, Consultants, and Artists' Agents* (New York: Succotash Press, 1992), 6.

80. Ibid., 26.

81. Ibid.

82. V. A. Shiva, *Arts and the Internet* (New York: Allworth Press, 1996), 18.

83. Ellen Pall, "The Neo-Dealers," *The New York Times Magazine*, September 1, 1996, p. 57.

84. *State of the Digital Arts Survey*, conducted by the New York Foundation for the Arts in 1995.

85. Shiva, op.cit., 19.

86. Ibid.

87. Ivan C. Karp, "The Artist and the Dealer: A Curious Relationship, *Art in America*, March 1989, 51.

88. Ibid., 53.

89. Interview with Nancy Hoffman, "How to Succeed (By Really Trying)," by Paul Gardner, *ARTnews*, February 1990, 134.

90. Edward Feit, "Securing Gallery Representation," *American Artist* Business Supplement, June 1989, 69. Reprinted from *American Artist Magazine* with permission from BPI Communications Inc., copyright © 1989, 1983. All rights reserved.

91. Jana Jevnikar, "An Incredible Journey: The Search for a Gallery," *American Artist*, September 1983, 103. Reprinted from *American Artist Magazine* with permission from BPI Communications, Inc., copyright © 1989, 1983. All rights reserved.

92. Interview with Walter Wickiser, "Artists' Career Development," by Daniel Grant, *American Artist*, September 1989, 12. Reprinted from *American Artist Magazine* with permission from BPI Communications, Inc., copyright © 1989, 1983. All rights reserved.

93. Interview with Louise Bourgeois, "How to Succeed (By Really Trying)," by Paul Gardner, *ARTnews*, February 1990, 134.

94. Interview with Judy Levy in *Artists Observed*, edited and photographed by Harvey Stein (New York: Harry N. Abrams, Inc., 1986), 61.

95. Interview with Tony Delap in *Artists Observed*, edited and photographed by Harvey Stein (New York: Harry N. Abrams, Inc., 1986), 70.

96. Interview with Nina Pratt, New York City, 1990.

97. Ibid.

98. Ibid.

99. Ibid.

100. Ibid.

101. Interview with André Emmerich in *The Art Dealers* by Laura de Coppet and Alan Jones (New York: Crown Publishers, Inc., Clarkson Potter, 1984), 62.

102. Grace Glueck, "Gallery Etiquette: A Duel of Dealers and Browsers," *The New York Times*, 8 March 1991, C1.

103. Hilton Kramer, "The Case Against Price Tags," *The New York Times*, 20 March 1988, Sect. 2, 33.

104. Letter to the editor by Alvin S. Lane, *The New York Times*, 24 April 1988, Sect. 2, 15.

105. Letter to the editor by Roy Bohon, *The New York Times*, 24 April 1988, Section 2, 15.

106. Prepared by the Task Force on Discrimination in Art, a CETA Title VI project, sponsored by the Foundation for the Community of Artists in conjunction with Women in the Arts, 1979.

107. Nancy Jervis and Maureen Shild, "Survey of NYC Galleries Finds Discrimination," *Artworkers News*, April 1979, A7.

108. Ibid., A8.

109. Reprinted from *The Art Biz: The Covert World of Collectors, Dealers, Auction Houses, Museums, and Critics* by Alice Goldfarb Marquis (Chicago: Contemporary Books, Inc.), 3–4. Copyright 1991 by Alice Goldfarb Marquis.

110. "Richard Lerner," interview by Jean E. Breitbart, *Artworkers News*, March 1981, 29.

111. *Guide to Arts Administration Training and Research 1995–97*, ed. Dan J. Martin (San Francisco: Association of Arts Administration Educators, 1995), 11.

112. "Lucy Lippard," interview by David Troy, *Artworkers News*, April 1980, 16.

113. Peter H. Karlen, "The 'Droit de Suite' Revisited," *Art Calendar*, July/August 1991, 11.

114. Jane C. Hartwig, "Betting on Foundations," in *Foundation Grants to Individuals*, C. M. Kurzig, J. B. Steinhoff, and A. Bonavoglia (New York: The Foundation Center, 1979), xiii.

115. Funding guidelines of the John F. and Anna Lee-Stacey Scholarship Fund.

116. From *Supporting Yourself as an Artist: A Practical Guide*, second edition, by Deborah A. Hoover, 136. Copyright © 1989 by Oxford University Press, Inc. Used by permission of Oxford University Press, Inc.

117. Hartwig, op. cit.

118. Sandra Gurvis, *The Off-the-Beaten-Path Job Book: You CAN Make a Living AND Have a Life* (New York: Citadel Press Book, 1995), xiv.

119. Ibid.

120. Toby Judith Klayman, with Cobett Steinberg, *The Artists' Survival Manual*, (New York: Charles Scribner's Sons, 1984), 186.

121. From exhibition proposal by Molly Heron, New York City.

122. From artist statement by Molly Heron, New York City.

123. Annie Dillard, *The Writing Life* (New York: HarperCollins Publishers), 33. © 1989 by Annie Dillard.

124. From artist statement by Molly Heron, New York City.

125. Bruce M. Holly, "Choices," *ArtCalendar*, May 1990, 7.

126. Jane Madson, *The Artist's and Critic's Forum 1*, 1 (1982).

127. Billy Curmano, "Rejecting Rejection," *Artworkers News*, January 1981, 34.

128. Ibid.

129. Ibid.

Index

work insurance, 37–38
Work with Passion (Anderson), 18–19
workshops, 191–92
 setting up, 192
World Arts, 140
Writer's Market, 26
Writing Life, The (Dillard), 195–96

Xerox art, 192

Yohalem, Françoise, 117
Yudkin, Marcia, 87

"Zero Gravity" (Bram), 108–9, 128
Ziff, Janet, 89

About the Author

*C*aroll Michels has helped hundreds of emerging and established visual and performing artists and writers develop their careers. She has served as a career coach and artist's advocate since 1978.

Her artwork has been exhibited in museums in the United States and abroad, including the Georges Pompidou Museum in Paris; the Kunsthalle in Vienna; the Walker Art Center in Minneapolis; and the Institute for Contemporary Art, the Clocktower, in New York City.

Caroll Michels has received numerous grants, including those awarded by the National Endowment for the Arts, the New York State Council for the Arts, the New York Council for the Humanities, and the International Fund for the Promotion of Culture/UNESCO. She has also received a fellowship from the Alden B. Dow Creativity Center in Midland, Michigan.

She is the chairwoman of the Fine Arts Advisory Board of the Fashion Institute of Technology in New York City. She conducts career workshops for artists throughout the United States and in Canada that are sponsored by arts councils, arts organizations, and colleges and universities.

Michels offers in-person and phone consultations to artists and writers in all disciplines. She is now based in East Hampton, New York, and can be reached at the following address:

Ms. Caroll Michels
19 Springwood Lane
East Hampton, NY 11937-1169
Telephone: (516) 329-9105
Fax: (516) 329-9107